DREAM HOMES

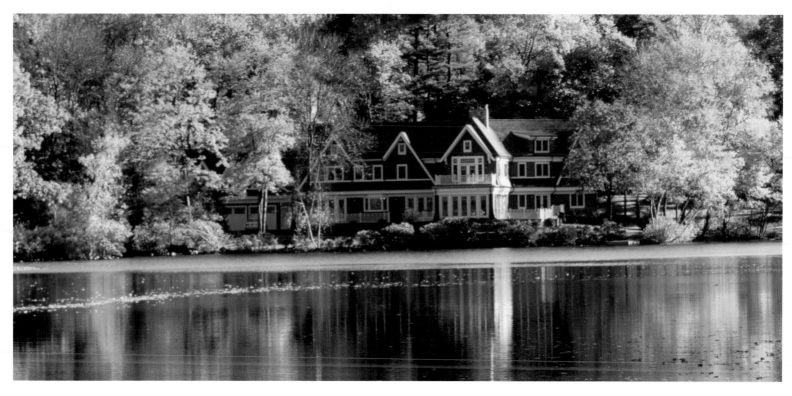

METRO NEW YORK

SHOWCASING NEW YORK'S FINEST ARCHITECTS, DESIGNERS & BUILDERS

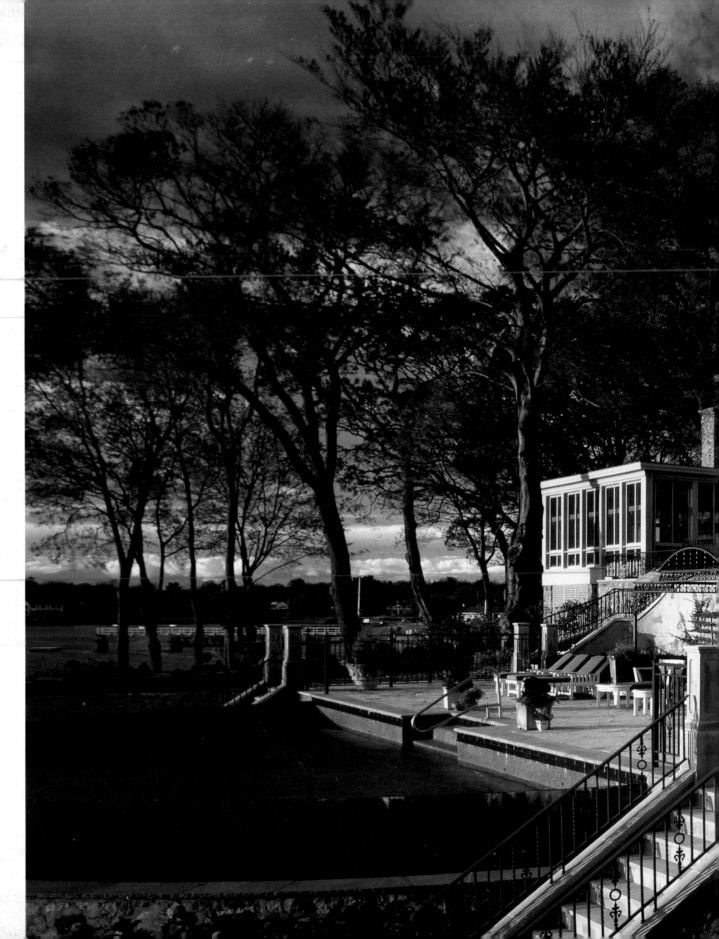

Published by

PANACHE
PARTNERS LLC

13747 Montfort Drive, Suite 100
Dallas, Texas 75240
972.661.9884
972.661.2743
www.panache.com

Publishers: Brian G. Carabet and John A. Shand
Executive Publisher: Phil Reavis
Senior Associate Publisher: Paul J. Geiger
Designer: Mary Elizabeth Acree

Printed in Malaysia

Distributed by Gibbs Smith, Publisher
800.748.5439

PUBLISHER'S DATA

Dream Homes of Metro New York

Library of Congress Control Number: 2006929743

ISBN 13: 978-1-1933415-14-7
ISBN 10: 1-933415-14-2

First Printing 2006

10 9 8 7 6 5 4 3 2 1

Previous Page: Jay Haverson, Haverson Architecture & Design
See page 97 Photo by Peter Paige

This Page: James Margeotes & Cormac Byrne, Jones Footer Margeotes Byrne
See page 113 Photo by Phillip Ennis

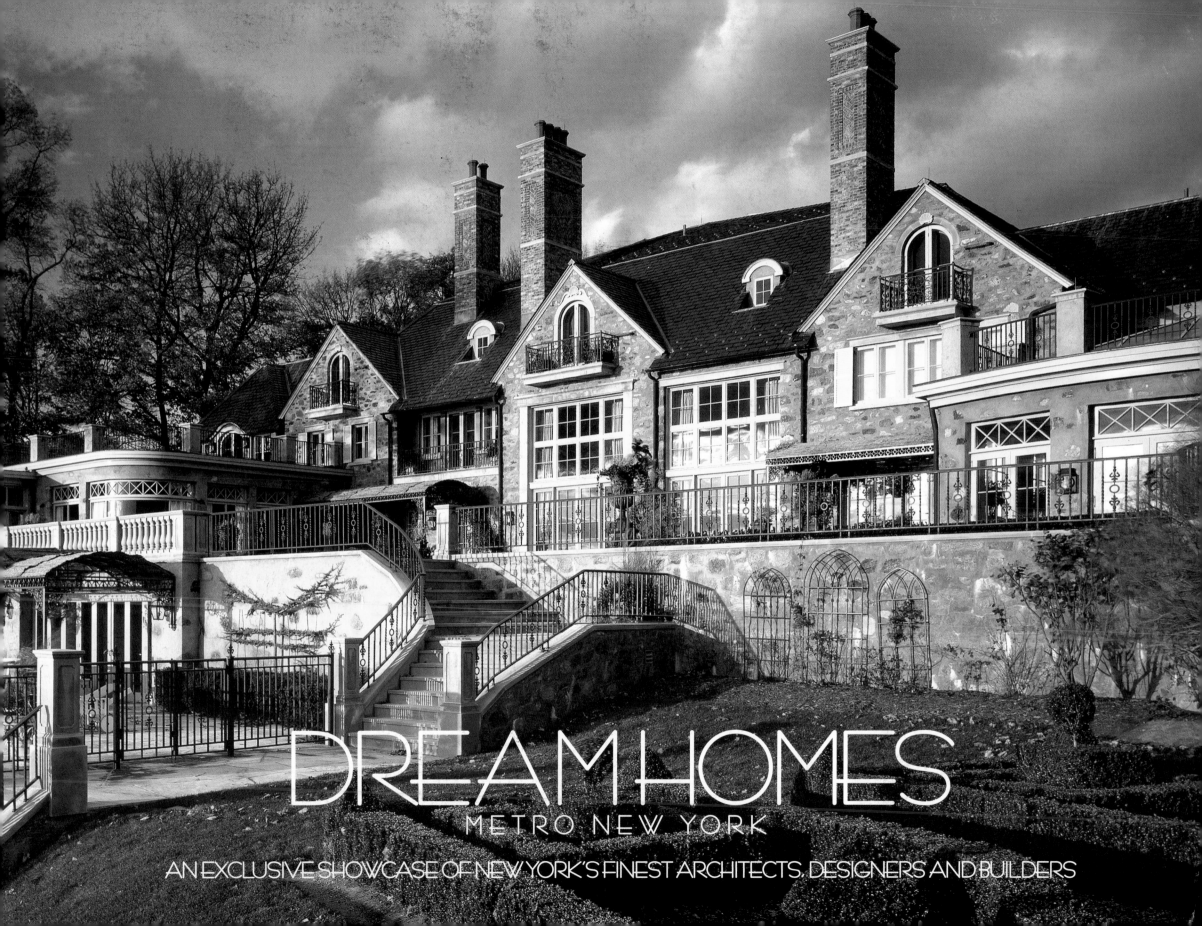

DREAM HOMES
METRO NEW YORK
AN EXCLUSIVE SHOWCASE OF NEW YORK'S FINEST ARCHITECTS, DESIGNERS AND BUILDERS

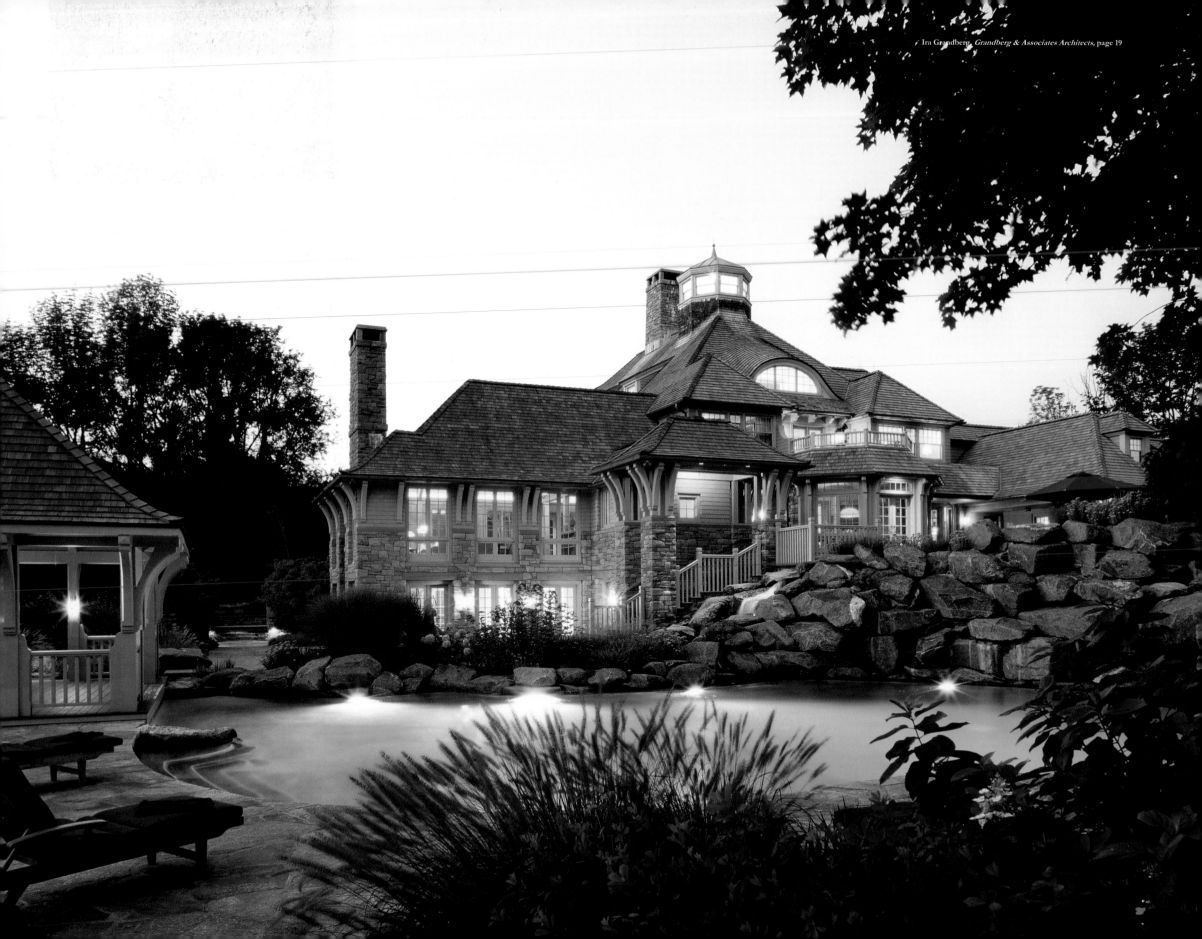

INTRODUCTION

Stuart Narofsky, *Narofsky Architecture & Design, PC,* page 47

Houses are funny things. They are merely structures made of wood and rock and glass, incapable of movement, unable to say "I love you," yet somehow they wrap us in their warmth, they comfort us, they speak to us. One woman I know, upon driving past a house that she likes, says: "It winked at me."

Friends seem confused when I call the little town of Seaside, Florida, my soul mate. But that's how strong the connection is. When my college boyfriend first introduced me in 1992 to the little Gulf Coast haven, with its sherbet-colored wood-frame cottages, white picket fences, and pedestrian pathways, my heart sang.

This was long before I would sit down across from Jaque Robertson in his Midtown Manhattan office to discuss the trajectory of architecture in America, but it was probably about the time that Jaque began designing Seaside's neighboring community, WaterColor, which has captured the imaginations of many like me. It was also more than a decade before I moved to New York, a city filled with notable buildings, including Charles Gwathmey's controversial new high-rise, Sculpture for Living.

Mark Stumer & Thomas Mojo, *MoJo Stumer Associates,* page 157

The curvy glass luxury apartment building at Astor Place, not too far from my SoHo office, and the quaint beach houses represent opposite ends of the spectrum: ultra-modern multi-family and wholly traditional single-family. And though they may look radically different, the architects involved insist they are built with the same principles in mind: the landscape, the climate, and the unique architectural and cultural heritage of their locations.

Such is the case with all 39 architecture firms profiled in *Dream Homes of New York.* In glorious four-color photography, this volume showcases the work of esteemed, award-winning designers recognized for their talents in the Tri-State area and beyond. To a man (or woman), these professionals have committed their lives to designing houses that are accountable to their environs and thrill the people who live in them. Without exception, they are passionate about architectural design, whether new construction or large-scale renovation. They have learned to really listen to their clients. And, of course, they have an innate ability to turn a wish list into reality.

The houses within were all designed with a specific client in mind, and they demonstrate the literal and figurative beauty of custom work with amenities like a floating ceiling to bring down the height of a tall space, lighting that highlights an art collection, a second-story exercise pool, a prayer room, or separate wings for each set of in-laws. Every house featured embodies someone's dreams — and will hopefully be inspiration for yours.

Cheers,

Allison Hatfield

Editor

Photo by Nathan Hamblen

FOREWORD

Michael Harris Spector

Being at home has always meant feeling welcome, safe and comfortable within the realm of our shelter. What started as an exercise in pure functionality where kitchens were designed for cooking and bedrooms for sleeping has evolved over the years to define and reflect our diversity as complex individuals. It is the architect's role to respond to our changing needs while consciously pushing the boundaries to adapt to our contemporary lifestyle. The houses included in this volume illustrate how our notions of "home" expand beyond conventional definitions.

In the early days of nearly every architectural career, it is the residential project that provides the training ground, the first actual venture into designing real space. The intimate details of renovating or adding on to the home space, allows the young architect to focus, apply and learn. It is in tackling the residence that the new professional becomes versed in dealing with individuals and their needs, refining the desires and challenges of a couple or family, and weaving them together into a three-dimensional living space. They must learn to foresee the future in anticipation of growth and change and sift through a myriad of design details to arrive at a harmonious solution. It is this interpretation of feelings and putting them into form that is the basis of this project type, from historical homes through to today's contemporary houses.

As they grow, it is the architect's desire to explore new media and horizons. How fortunate we architects are to work in a medium that has room for and is enhanced by the eclectic treatment of artistic adventure! When architecture encourages us to stretch the limits of grandeur and personal philosophy, it is architecture at its best.

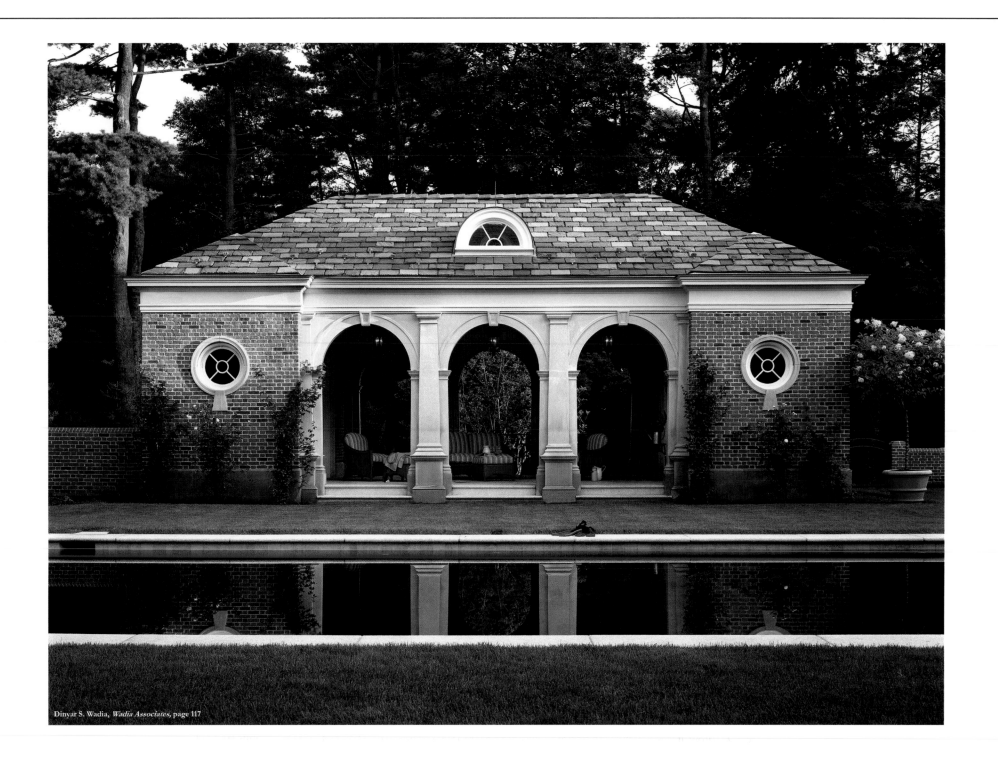

Dinyar S. Wadia, *Wadia Associates,* page 117

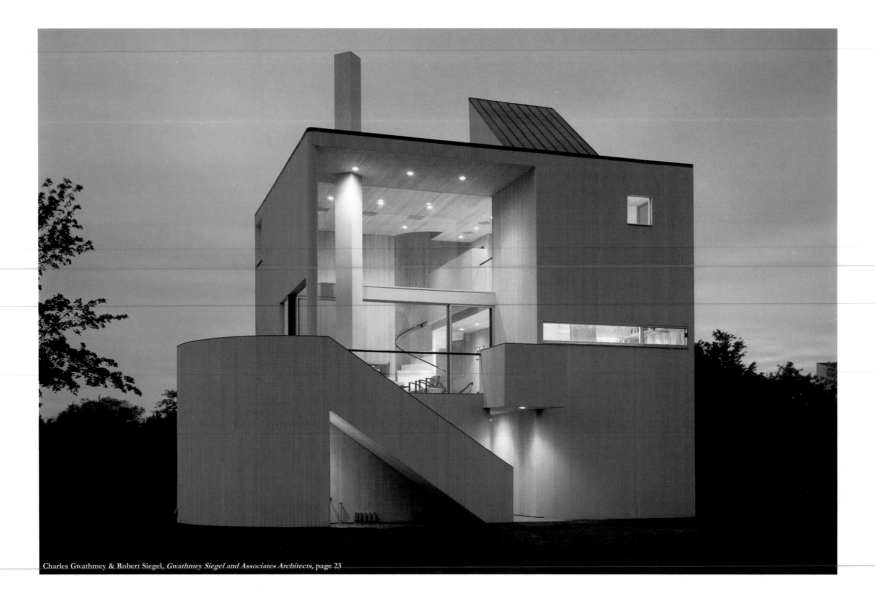

Residential architecture is responsive to its site, perhaps more so than any other type of architecture. Distinctions between interiors and exterior are blurred in homes where the inhabitants welcome natural light and nature. Green building materials increasingly allow the exterior environment to comfortably filter in, filling our homes with light, sky, landscape and vistas. Coupled with sensitive ambient lighting, the interplay of light and shadow quickens throughout the day and continues into night.

And what of the architectural processes explored in the projects within? In discussing the residences of Gwathmey Siegel, Peter Eisenman notes, "…reference to process is linked more…to the knotting of space or the carving out of space…than to the static organization of program." Hollowing of space and placement of interior and exterior volumes play with symmetry in design and create forms and voids that define it.

All that is created within is a function of this geometry. Architecture is always captured within this institutional frame. This is clearly the case in the individual home which has defined, more than any other project type, the social structure of its inhabitants. It can be argued that the gable-roofed, single-family, detached home of the American suburb has contributed more to the social and political institution of the nuclear family than any

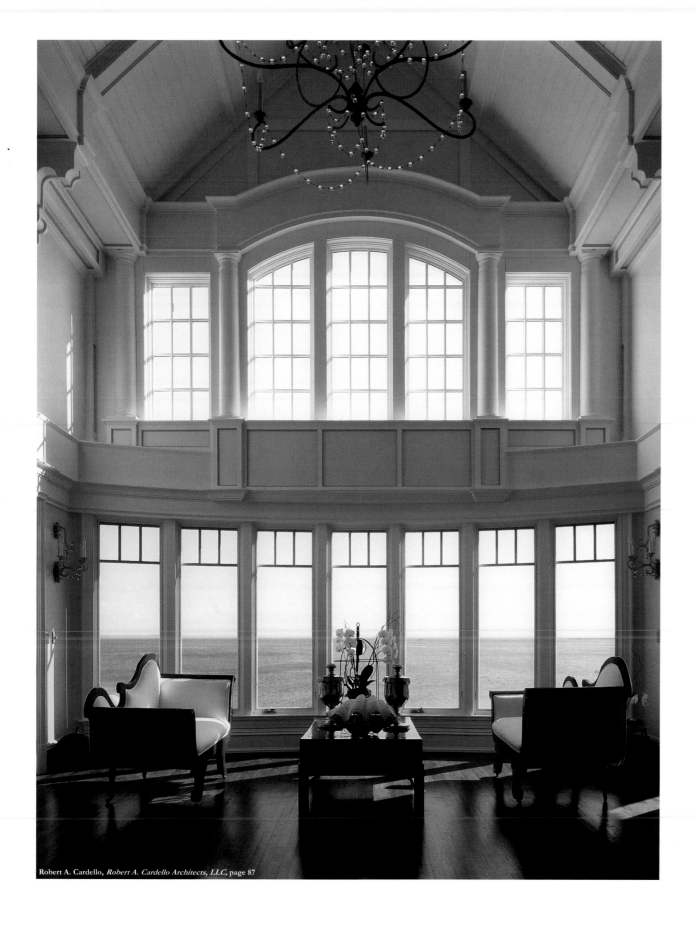

other comparable institution. Over the years, design applications have been challenged and stretched; its symbolism of shelter, comfort and safety altered. But the structure of middle-class life remains as always, because architecture, no matter how grand or simple, is an institutional frame, a firmly fixed guide for family life.

Designing houses can be a liberating experience for some architects, says Charles Moore. "They give me the freedom to try new ideas…if I don't like what I've done, I move on." There's risk, as well as excitement when design shapes live, proving the strong connection between buildings and the way we live.

At Spector Group, authenticity is an important concept, for each project is individual. There are no design stamps or easily categorical styles used as a formula to reach predictable results. Each architect's work must be a creative expression of elements, which make the solution unique. Each client and site is a unique constellation of opportunities, constraints, dreams and history; for design is exploration. Exploration of the past and a vision of the future, using all the parameters of a project as a wellspring from which we draw ideas. Creative work is not done by imitation. With the integration of timeless elements like quality of light, proportion of space, crafting of materials and connection of building to landscape, a life space is created that is bold and lively, yet severe and ordered. Well rooted to the ground plane as if it has always been there.

So when journeying through these pages, enjoy the exploration as you experience the freedom and diversity of design.

Michael Harris Spector, FAIA

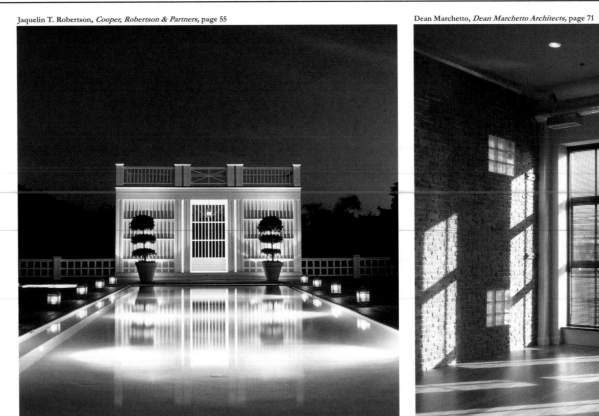

Jaquelin T. Robertson, *Cooper, Robertson & Partners*, page 55

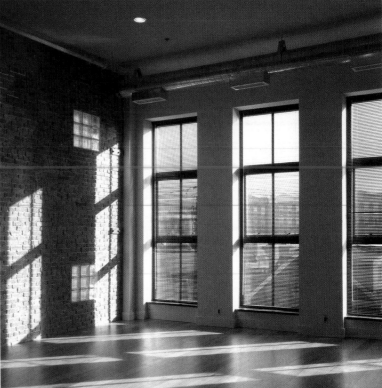

Dean Marchetto, *Dean Marchetto Architects*, page 71

MANHATTAN & WESTCHESTER

NORTHERN NEW JERSEY

CONTENTS

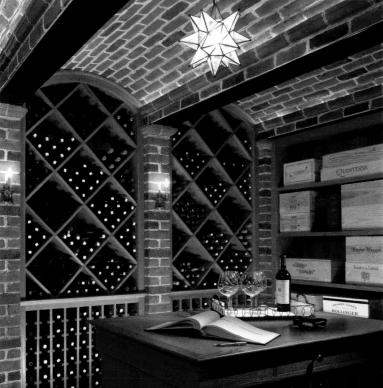
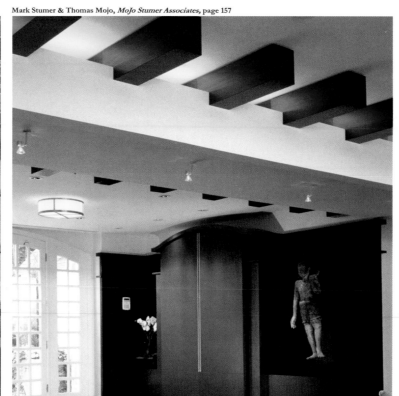
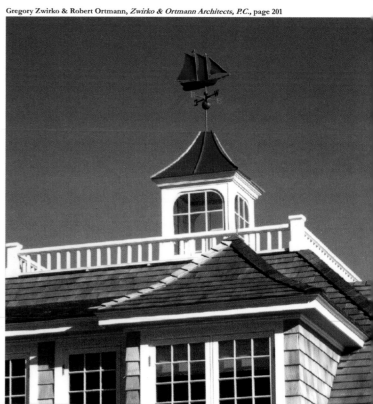

Michael Goldman, *Michael Goldman Architect, PC,* page 15

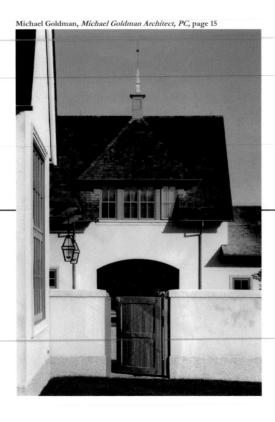

Mark Stumer & Thomas Mojo, *MoJo Stumer Associates,* page 157

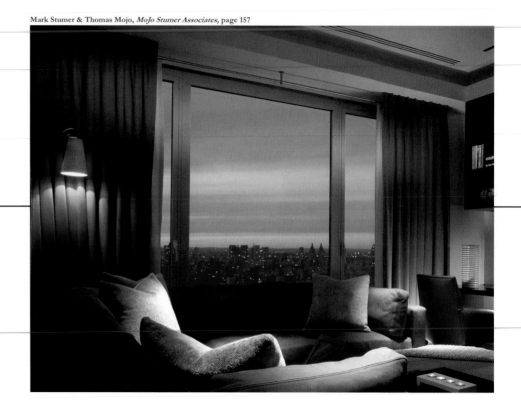

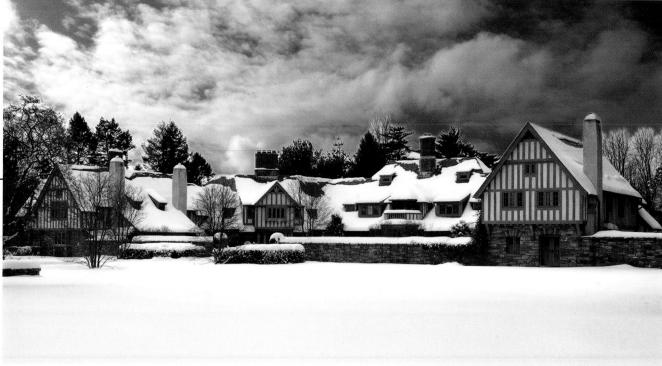

Ira Grandberg, *Grandberg & Associates Architects*, page 19

CHAPTER ONE

MANHATTAN & WESTCHESTER

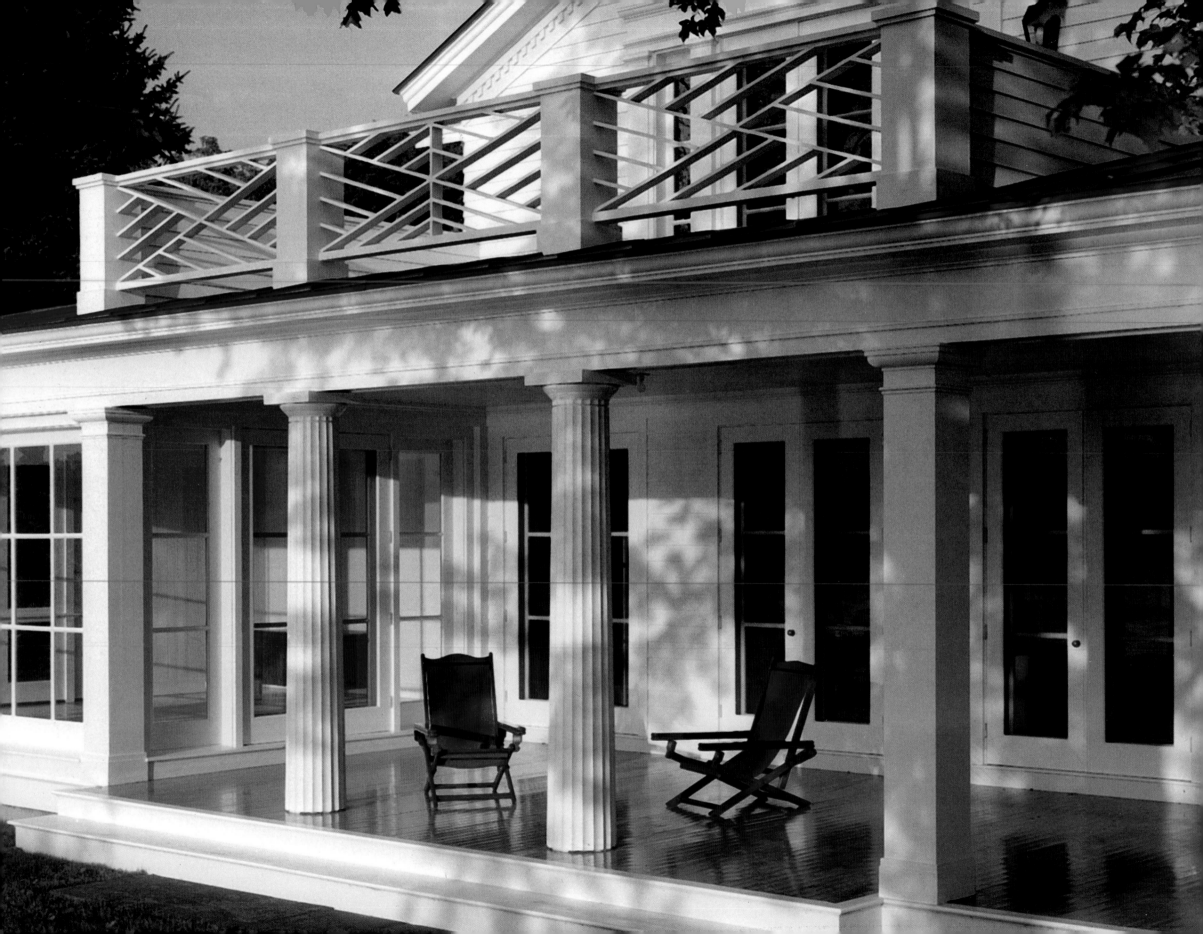

MICHAEL GOLDMAN

Michael Goldman Architect, PC

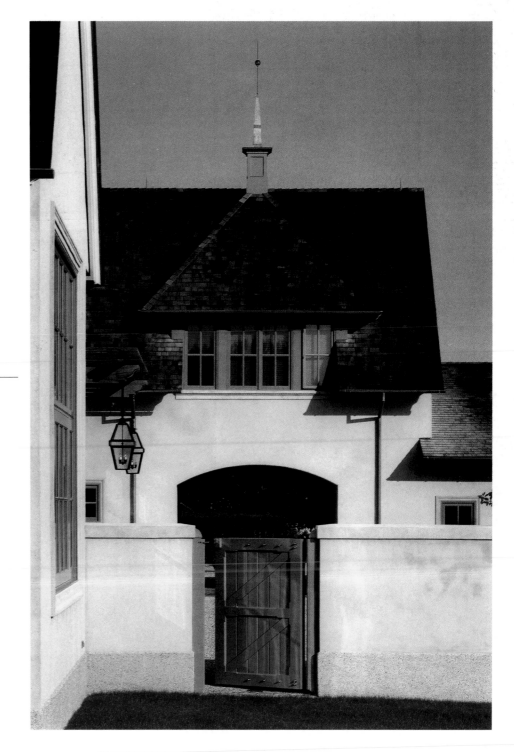

For Michael Goldman, one of the finest moments of a project is when he can walk through a completed home with his clients and share the delight in experiencing the fruits of their labor and passion. As in a symphony, it is the actual performance, when all the intended shapes, moods, and emotions come together in their realized form. Sharing the way the sunlight brings to life the spaces, proportions, and detail of the work is, for him, a truly special event.

Michael has been an architect for more than 25 years and opened his practice in 1998 after working for leading architects in Chicago and New York City on numerous projects throughout the country. He specializes in private residences and country houses, and although he readily acknowledges the importance of historic influences — among them: the Shakers, Japanese folk houses, Frank Lloyd Wright, and Andrea Palladio to name a few — he doesn't simply reiterate styles from the past.

Through an understanding of tradition and history, he strives to produce fresh yet timeless design solutions that manifest the simplicity and clarity of the very best modern architecture yet invoke the texture and sense of humanity embodied by older buildings. His signature work is relaxed, without a hint of pretense and firmly rooted in the vernacular of the region, be it a hillside farm site, a waterfront setting, or an urban context.

ABOVE: A garden gate opens to a courtyard and guides the way through the porte-cochère of this stucco Hampton's house. Completed in 2000.
Photograph by Chris Kendall

LEFT: The sun sets on the Hudson River casting shadows across this Greek Revival porch. Completed in 2002.
Photograph by Chris Kendall

By letting the characteristics and timbre of the landscape as well as the impressions one gets of the regional architecture become the backdrop for the projects, Michael delivers designs that are personal, unique, and geographically suitable. There is, however, a strong consistency in his architecture, in terms of the logic to the plans, the integration of exterior space, and landscape with interior spaces and the crisp refinement of detailing. There is also always a serious effort to grow the design from a meaningful geometric underpinning, thereby setting up a framework from the inception, for a well-proportioned building (or buildings), spaces, and architectural elements.

Michael's work has appeared in *Metropolitan Home, House & Garden, The Robb Report, Hampton's Cottages and Gardens* and *Konnichiwa*. He is also featured in *A Decade of Art & Architecture 1992-2002*, published by the Institute of Classical Architecture.

ABOVE LEFT: A child's bedroom above the kitchen bay catches the south light in this Shingle style home. Completed in 2005.
Photograph by Michael Goldman

ABOVE RIGHT: A Hudson Highland's farmhouse, delineated by clapboard, board and batten siding and a zinc-coated copper roof. Completed in 2003.
Photograph by Michael Goldman

FACING PAGE TOP: A skylit, trellised loggia connects all the main rooms, through French doors, to the pool terrace and lawn. Completed in 2000.
Photograph by Chris Kendall

FACING PAGE BOTTOM: A crushed stone drive flanked by apple trees leads out through the barn to the meadow beyond. Completed in 2002.
Photograph by Chris Kendall

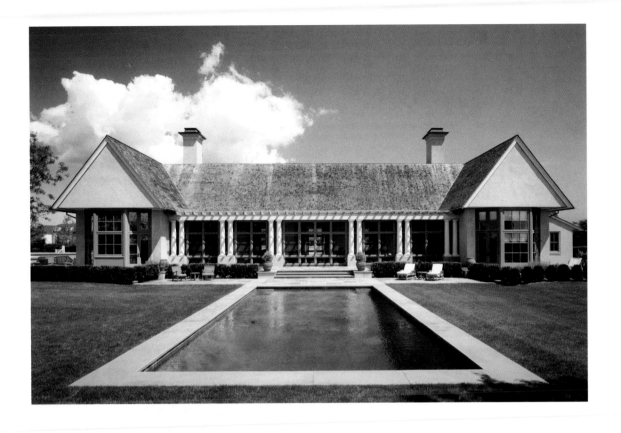

more about michael...

Q&A

What philosophy has he stuck to for years that still works today?
Michael says that the most meaningful bit of wisdom he was given during his schooling was "always care." I took that to heart and have never lost sight of that edict. I believe that this is evident in my day-to-day practice as well as my built work."

If he could eliminate one architectural style from the world, what would that be?
Michael deplores the suburban strip mall, and easily lists its evils: "It has aided the destruction of the sense of community, overlooked opportunities to create beautiful urban spaces, increased society's reliance on the automobile, wreaked havoc on the environment, served to facilitate the monochromatic look and texture of culture and delivered us a seemingly endless supply of downright ugly buildings."

What is the most unique/impressive/beautiful home he's been involved in?
When pressed to name a favorite project, Michael picks his own country home, for that's where he's shared many warm and meaningful times with his friends and family throughout the seasons.

What book is he reading right now?
Reading is one of Michael's favorite pastimes and whenever he's got a few minutes to spare he picks up one of the books he's involved in. He's currently reading *Over the Edge of the World*, by Laurence Bergreen; *The Essential Dali Lama: His Important Teachings*, by Ravi Mehrotra; *The Golden Ratio*, by Mario Livio; and *No Mercy: A Journey Into the Heart of the Congo*, by Redmond O'Hanlon.

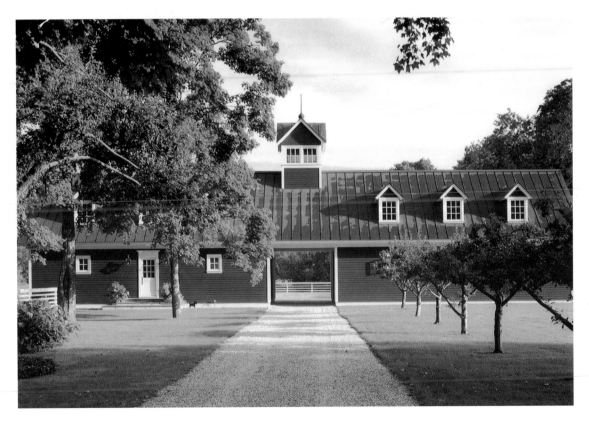

Michael Goldman Architect, PC

Michael Goldman
43 West 24th Street
Suite 8A
New York, NY 10010
212.989.9980
www.michaelgoldmanarchitect.com

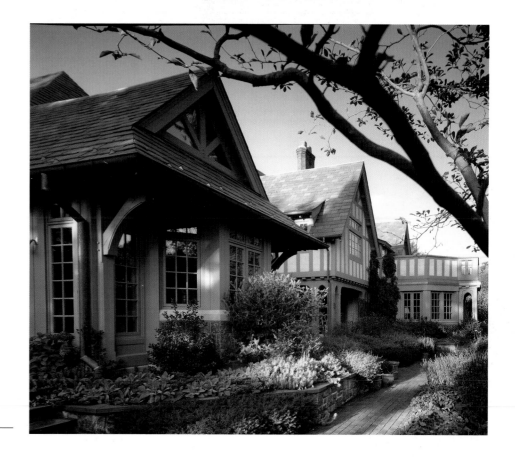

IRA GRANDBERG

Grandberg & Associates Architects

When Ira Grandberg, AIA, first visits a site with one of his clients, he makes every attempt to envision what the final home will become: "The site has to speak to you," he says. It then becomes the architect's job to capture the spirit of what he felt onsite, marrying his vision with the client's program, to design a home that complements its surroundings and suits its owner right down to the silverware drawer.

Problem solving and turning a dream into a reality, those are the things Ira enjoys most about his work as an architect. But he's more than an architect, really. He has the sensibilities of an artist (from his mother) and the common sense of a builder (from his father) — traits that balance one another, making Ira a well-rounded and grounded professional.

Though he's spent 36 years working in the field of architecture and is among the best in the Tri-State area, his demeanor is as enthusiastic and unpretentious as his buildings. He graduated from Columbia University with honors and has received several awards from the American Institute of Architects, yet Ira doesn't like to take himself too

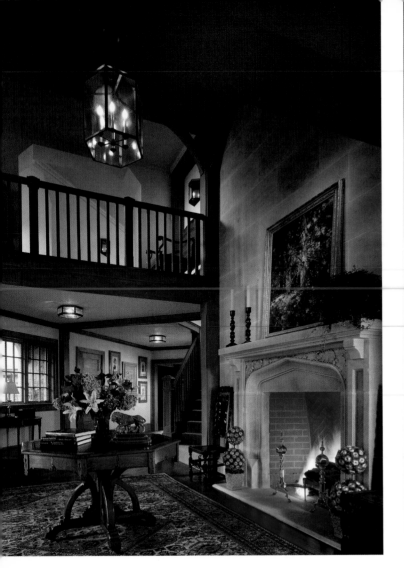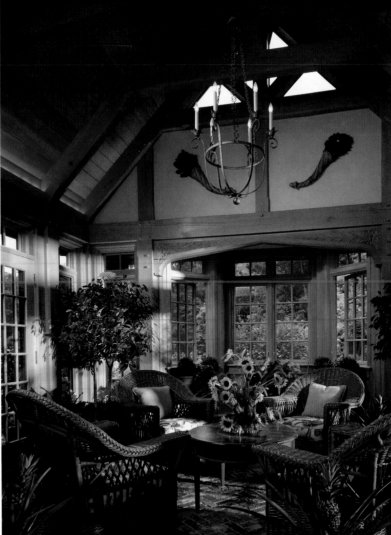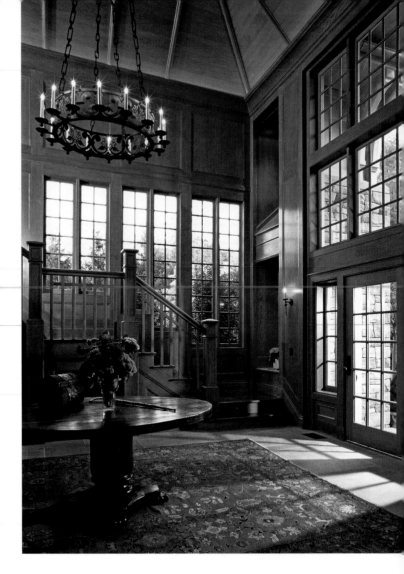

seriously. Likewise, while the high-end residences he designs are intellectual, sophisticated, and responsive to very strict guidelines, they are also comfortable, nonthreatening, and fun to live in.

The residents of one of the firm's most recent projects would agree. The family wanted an English manor-style house on their wooded property in Greenwich, Connecticut. Ira gave them a large, beautifully scaled stone and Shingle style design, and although it has Tudor and Art & Crafts influences, it cannot be categorized as either. Instead it has its own style that responds to the site. The house seems to grow out of the land by the appropriate use of natural materials. The house flows from the inside out, and its plan responds to modern lifestyles while being enriched by the level of detail throughout.

For Ira, the decision to defy "labeling" has been a conscious one. Strict adherence to a particular style or current vogue would be too limiting, he says. "Any architect can pick up clichés and glue them into houses. That's not what we do. We're not building boxes with fancy facades or interior stage sets. We're creating environments for people to live in that are totally aligned with their surrounding environment," capturing selected views, natural light, and prevailing winds, and balancing spaces that are open with those that provide a sense of shelter.

ABOVE LEFT: Stone and timber central arrival hall with flanking galleries opening up to formal rooms on left and informal rooms on right.
Photograph by Durston Saylor

ABOVE CENTER: Timber, stucco and brick garden room for informal gatherings.
Photograph by Durston Saylor

ABOVE RIGHT: Quarter sawn oak arrival hall for shingle and stone residence.
Photograph by Bruce Buck

FACING PAGE TOP: Evening view of shingle and stone manor house from pool and waterfall looking towards informal living space: family room, breakfast room, gym, and upper level children's play room.
Photograph by Bruce Buck

FACING PAGE BOTTOM: Aerial view of shingle and stone residence.
Photograph by www.steveturnerphotography.com

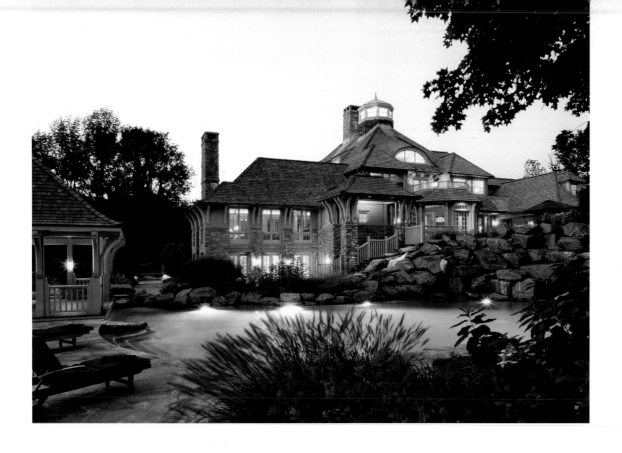

What does he do in his spare time?

He wishes he had more time to study watercolor and finish his pilot's license.

What's something most people don't know about him?

Though his friends might tell you that Ira is a serious, contemplative individual, he also has an easy-going manner and a wonderful, even edgy sense of humor. Working with a family for several years on a project requires perspective, patience, and an unending reserve of humor — something Ira has in abundance.

What home does he consider the most unique/impressive/beautiful that he's ever seen?

Ira finds Frank Lloyd Wright's Falling Water very special for its connection to nature, its energy, and its ongoing spirit.

Awards and recognition:

Grandberg & Associates earned an AIA Honor Award for architectural excellence, as well as an AIA Masonry Award. The firm's work has been featured in *Architectural Digest, Architectural Record, The New York Times* and in various books including: *Tudor Style* and McGraw-Hill's *New Spaces, Old World Charm.*

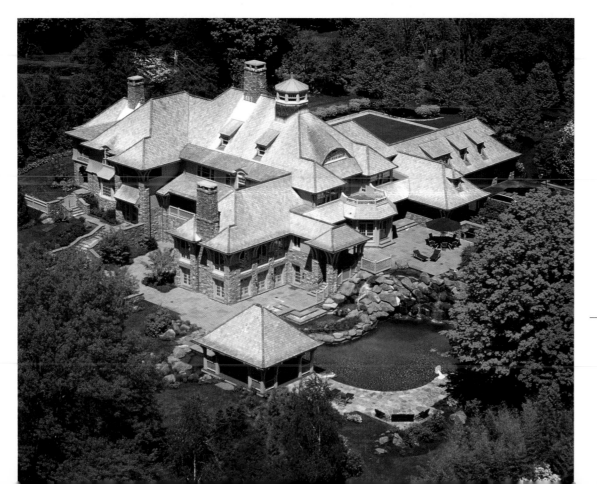

Grandberg & Associates Architects

Ira Grandberg, AIA
117 East Main Street
Mount Kisco, NY 10549
914.242.0033

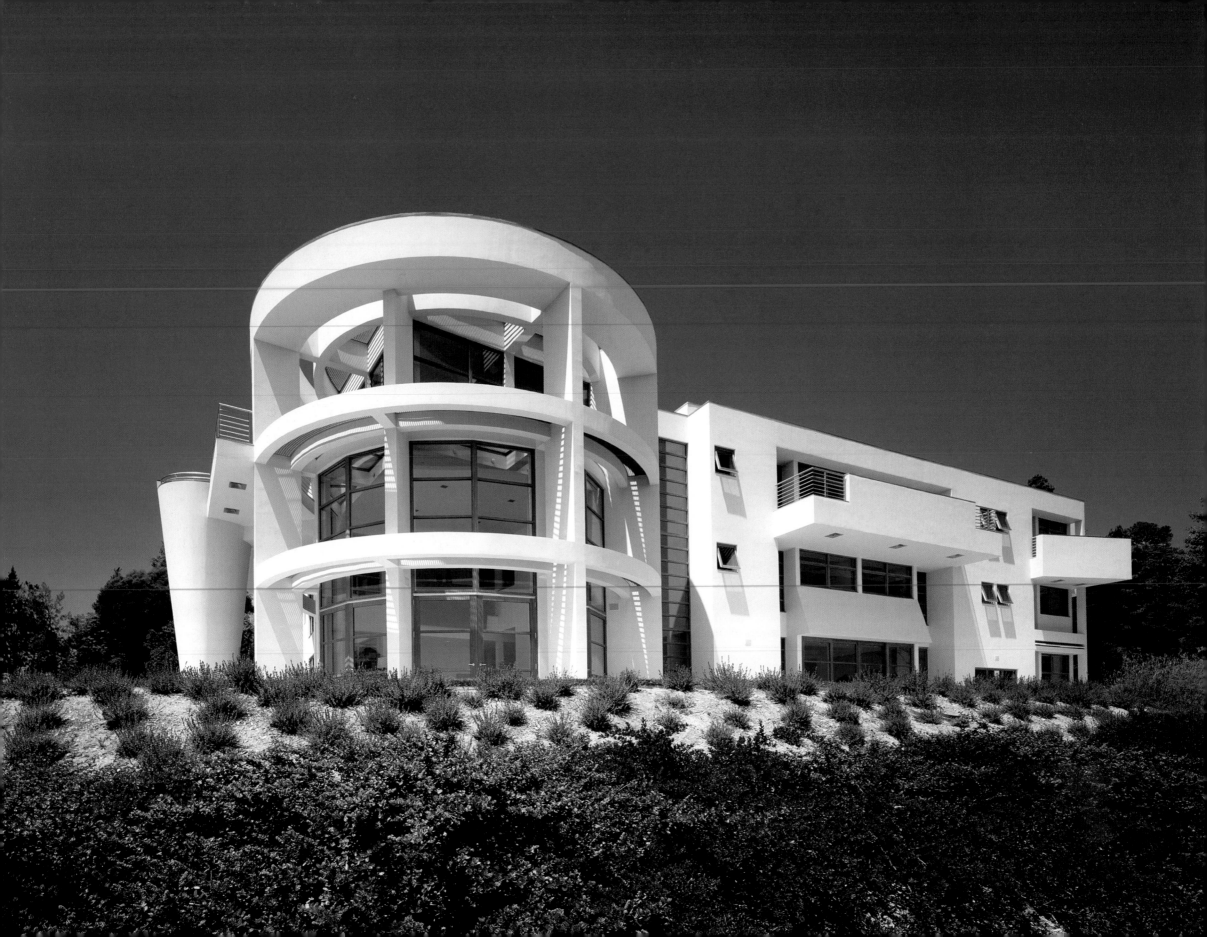

CHARLES GWATHMEY & ROBERT SIEGEL

Gwathmey Siegel and Associates Architects

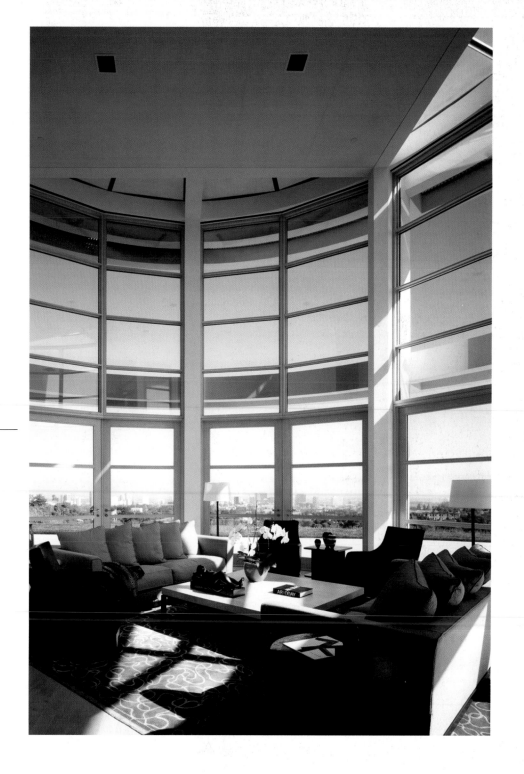

High-profile corporate, academic, and arts-related projects — like the gleaming IBM office building in Greensboro, North Carolina; unapologetically modern innards jutting from the old stone exterior of Princeton University's Whig Hall; the Museum of Contemporary Art that redefined downtown North Miami; and the 1982 renovation and addition to Frank Lloyd Wright's Guggenheim Museum in New York City — comprise some of Gwathmey Siegel & Associates's work.

But for the architects at the internationally renowned firm, residential projects are every bit as important. A house is a pedagogical microcosm, and as such it is a very informing project type, says the esteemed Charles Gwathmey, who, with Robert Siegel, founded the firm in 1968. A house presents the opportunity for investigation. Each serves as a laboratory for exploring strategies, experimenting with ideas, and inventing new building solutions on a small scale.

With a staff of 65 architects and draftspeople, Gwathmey Siegel has established its legacy worldwide and earned a reputation for architectural excellence, confirmed by more than 100 design awards, continuing recognition in the professional and general press, and inclusion in exhibitions and histories of contemporary

ABOVE: View of living room with view to Westwood, Bel Air Residence, Bel Air, California.
Photograph by © Scott Frances/Esto

LEFT: View of the south façade with living/master bedroom rotunda, Bel Air Residence, Bel Air, California.
Photograph by © Scott Frances/Esto

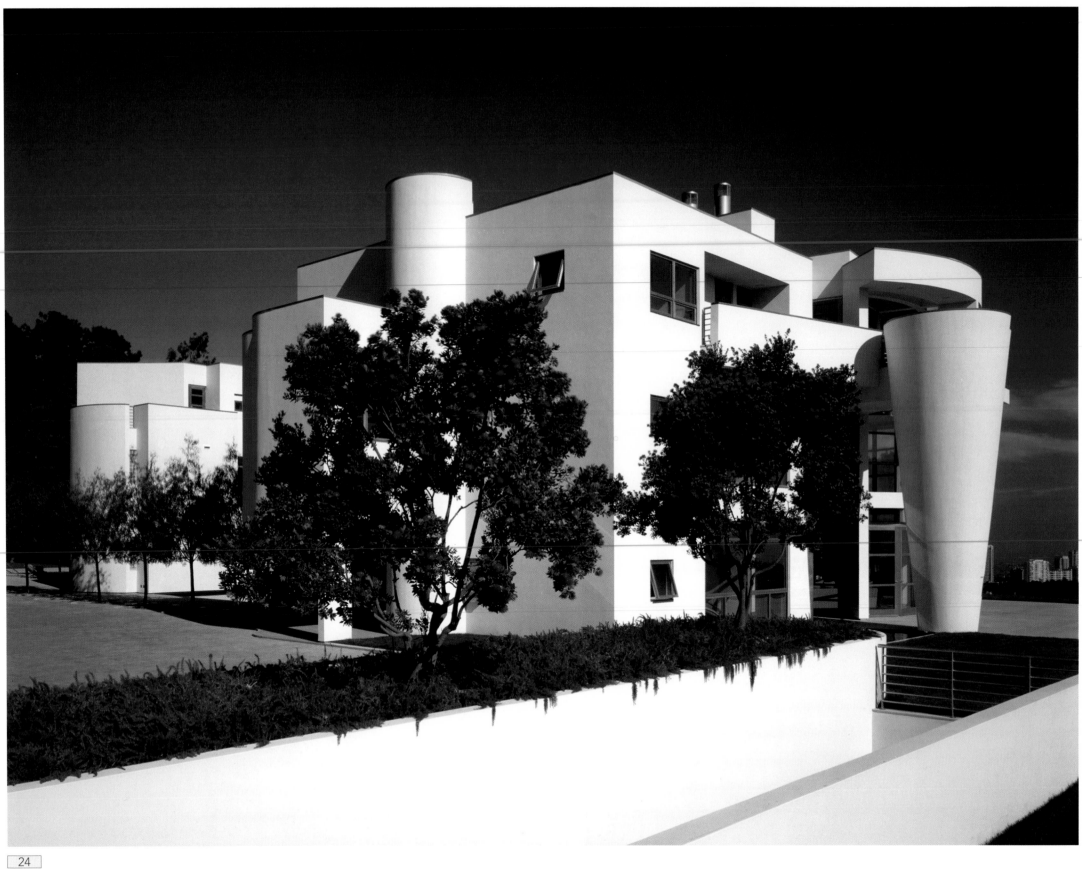

architecture. In 1982, Gwathmey Siegel became the youngest firm to receive the American Institute of Architects' highest honor — the Firm Award — for "approaching every project with a fresh eye, a meticulous attention to detail, a keen appreciation for environmental and economic concerns … and a strong belief in collaborative effort." Nearly 25 years later, that's a process that's still at work.

Expanding references and enriching the culture is the goal of every project designed by Gwathmey Siegel, whether residential or commercial. And the son of famed painter Robert Gwathmey sees his role as more than that of a designer, often referring to himself as "sculptor," "space maker," and "form maker," implying a greater artistic burden than that of an architect who pursues more traditional work. When Charles describes the creative process he does, indeed, sound like a sculptor: "We start with a solid block and start carving. What is left when we finish is the essence."

And that essence is consistently bold. A Gwathmey Siegel structure makes a definitive statement with sleek, unarticulated surfaces and clean geometric shapes. It is primary in form, graphic in space, and creates an irrefutable anticipation of a three-dimensional experience. The firm's designs have been called "clever," "chic," and "cunning." And they are always highly serviceable.

Charles's own home, which he designed in 1965 for his parents, is one of the purest examples of his work. Situated on a flat, one-acre parcel in Amagansett, Long Island, the 1,200-square-foot, three-story house represents an iconic moment in modern residential design. Constructed of cedar and glass, every façade is different — just as every Gwathmey Siegel commission is strikingly diverse.

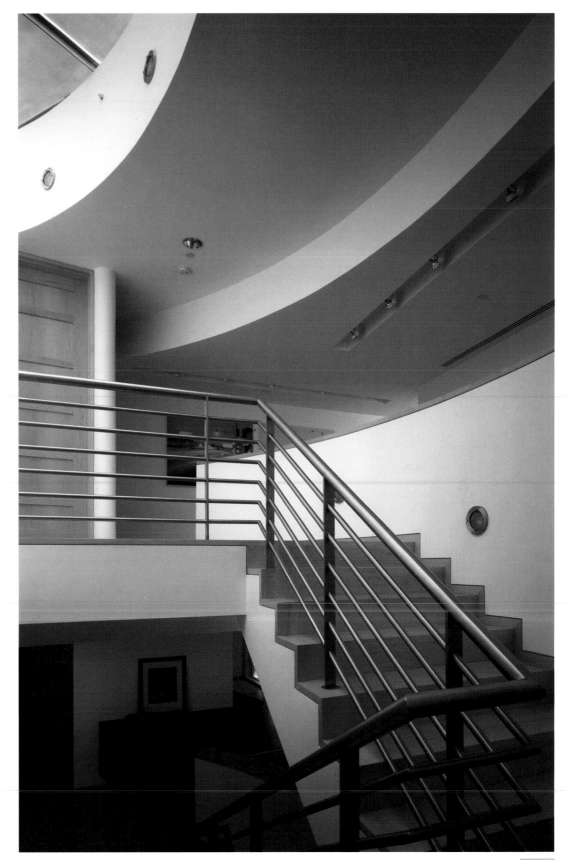

RIGHT: View of second and third floor stair landings accessing studies and master bedroom suite, Bel Air Residence, Bel Air, California.
Photograph by © Scott Frances/Esto

FACING PAGE: View from entry drive to southwest corner, Bel Air Residence, Bel Air, California.
Photograph by © Scott Frances/Esto

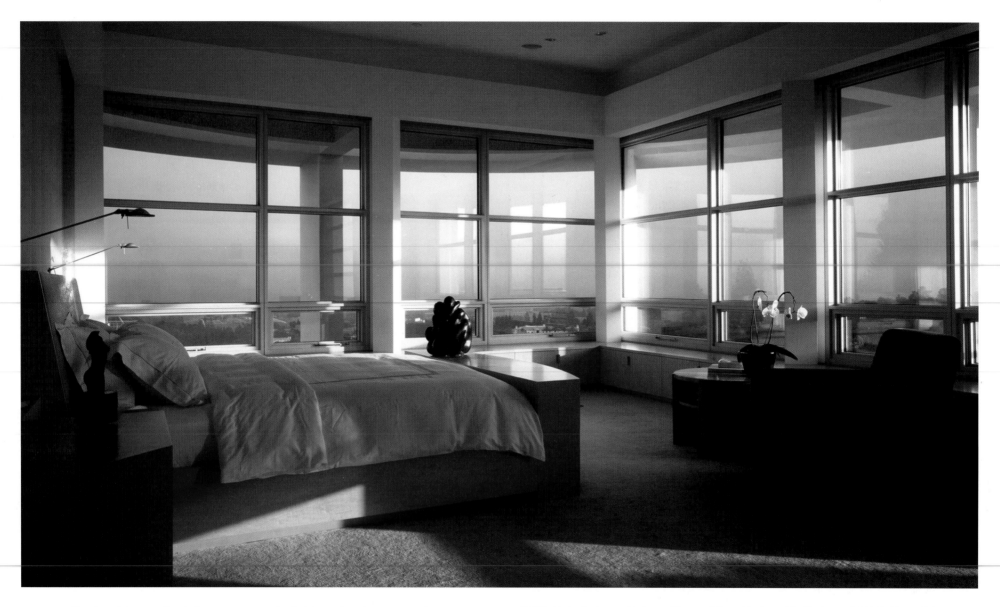

Charles objects to "style" categories and calls his work reductive, not decorative. He shuns historical representations, preferring instead to extend the present into the future through speculation and confrontation with the unknown, resulting in a striking break with all that has come before and the creation of a new brand of postmodern minimalism. He recognizes that not everyone will fall instantly in love with what he does. "The shock of the new," that's what it's about, he says. It can take a full generation for great work to be embraced. And that's okay.

"Architecture is an art," Charles says. "It's a historical documentation of its time. Great buildings inform the next generation. And modern architecture is a legitimate interpretation of our time."

ABOVE: Master bedroom with views to Westwood, Santa Monica and Pacific Ocean, Bel Air Residence, Bel Air, California.
Photograph by © Scott Frances/Esto

FACING PAGE TOP: South façade at dusk, Gwathmey Residence, Amagansett, New York.
Photograph by © Scott Frances/Esto

FACING PAGE BOTTOM: Living room, terrace, Gwathmey Residence, Amagansett, New York.
Photograph by © Scott Frances/Esto

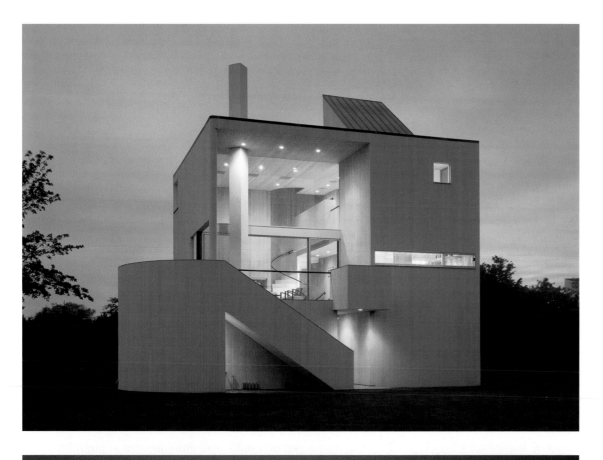

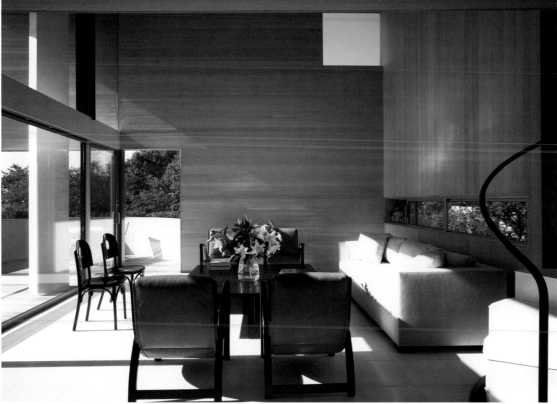

Education ...

Charles, a native of Charlotte, North Carolina, studied at the University of Pennsylvania School of Architecture under Louis I. Kahn, Robert Venturi, and Thomas Vreeland. In 1962 he graduated with a masters in architecture from Yale University, where he studied under Paul Rudolph and James Stirling.

Robert, who was born in New York City, received a Bachelor of Architecture degree from Pratt Institute in 1962 and a Masters of Architecture from Harvard University in 1963.

Awards ...

In 1970, Charles became the youngest architect to receive The American Academy of Arts and Letters Brunner Prize. He has also been awarded a Fulbright grant, the Medal of Honor from the New York Chapter of the AIA, and the Lifetime Achievement Award from the New York State Society of Architects.

In 1983, the New York Chapter of AIA recognized Mr. Siegel's skill and leadership as an architect with its Medal of Honor. He received the Pratt Institute Centennial Alumni Award in Architecture in 1988 and in 1990 accepted a Lifetime Achievement Award from the New York State Society of Architects. He was elected a Fellow of the American Institute of Architects in 1991.

Gwathmey Siegel & Associates Architects

Charles Gwathmey, FAIA
Robert Siegel, FAIA
475 Tenth Avenue
New York, NY 10018
212.947.1240
www.gwathmey-siegel.com

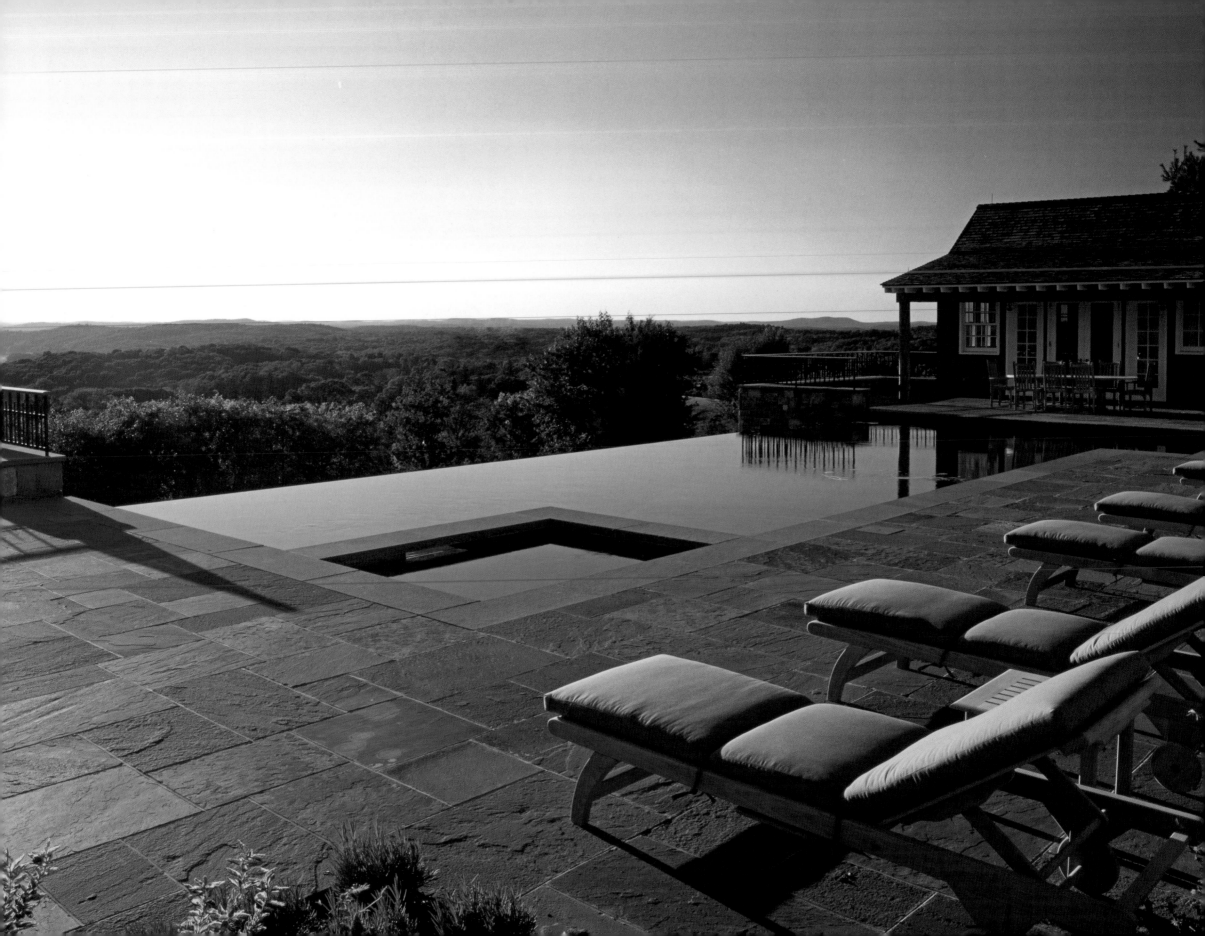

EDMUND HOLLANDER &
MARYANNE CONNELLY

Edmund Hollander Landscape Architect Design

Ian McHarg's seminal book *Design with Nature* revolutionized the way landscape architects and planners thought about design. It founded an ecological approach to landscape planning and provided the design inspiration for Edmund Hollander and Maryanne Connelly.

Both had read the book and been impacted in such a way that when the pair met at the University of Pennsylvania, where Edmund had gone to study after receiving a history degree from Vassar and a horticulture degree from the New York Botanical Gardens and Maryanne turned her sights from medical research to landscape architecture, a natural partnership bloomed. For more than 15 years now the pair has been involved with environmental planning and design projects in various locales and on varying scales.

Their work covers a wide range: estates and gardens in the Hamptons, Long Island's North Shore, Connecticut, Westchester, New Jersey, Virginia, and Europe; waterfront parks and developments; golf course restoration and planning; corporate headquarters; historic landscapes; horse farms; and urban rooftop gardens. But no matter what the size or scope, in what state or on what continent, a given set of principles run through Connelly's and Hollander's work like a river.

ABOVE: An inviting series of steps and landings draw the visitor into the landscape.
Photograph by Chuck Mayer

LEFT: The perfect calmness of the negative edge pool reflects the serenity of the distant horizon and the sky.
Photograph by Chuck Mayer

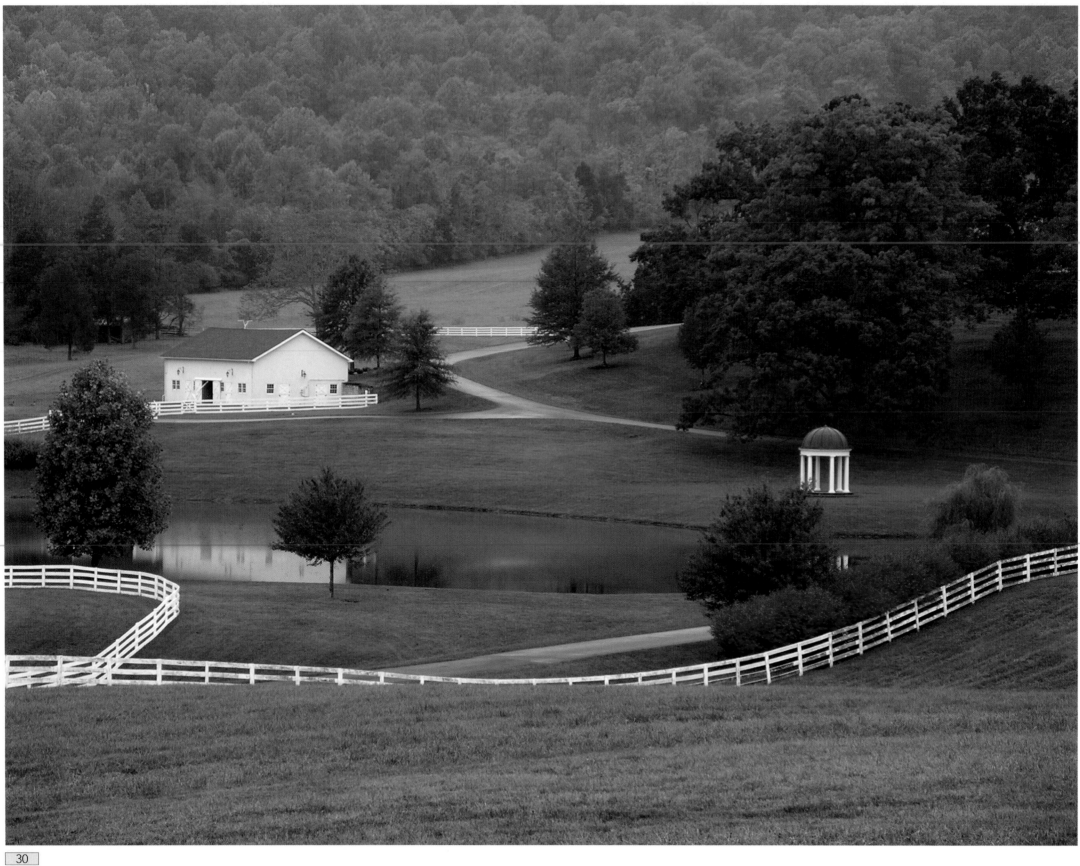

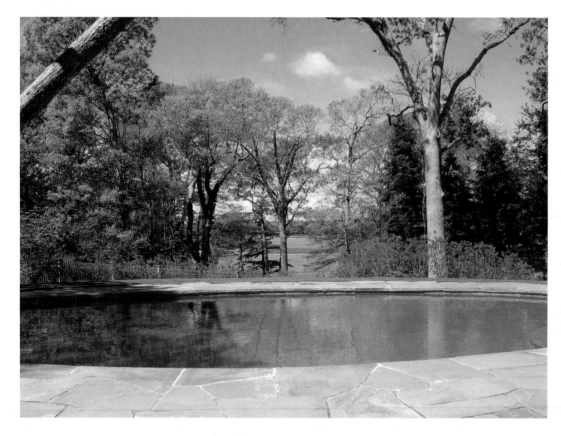

The first is to give the landscape spatial quality. Before a single plant can go into the ground the house site, the architectural composition, and the context and conditions of the existing landscape must be addressed.

The second guiding principle is to create an interconnectedness or dialogue between architecture and landscape. "We try to work side by side with the architects from day one," Edmund says. "Collaborating with the architect on the siting of the house and then taking cues from their designs to inform ours." With each project, Hollander and Connelly look to the architecture of the accompanying house for ideas or themes that can be extended, repeated, or highlighted in the landscape: stone on the facade that can be used in a retaining wall or a rhythm of a cornice that they will mirror in a hedge.

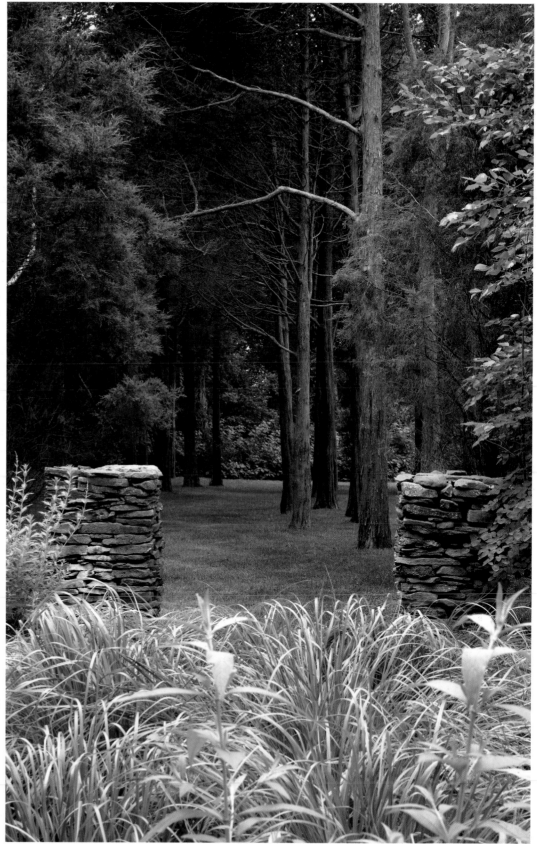

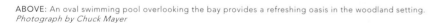

ABOVE: An oval swimming pool overlooking the bay provides a refreshing oasis in the woodland setting.
Photograph by Chuck Mayer

RIGHT: A mysterious stone gateway opens into a shady lawn beneath a grove of trees.
Photograph by Chuck Mayer

FACING PAGE: Fences and roads respond to the undulating topography of the Virginia horse farm.
Photograph by Chuck Mayer

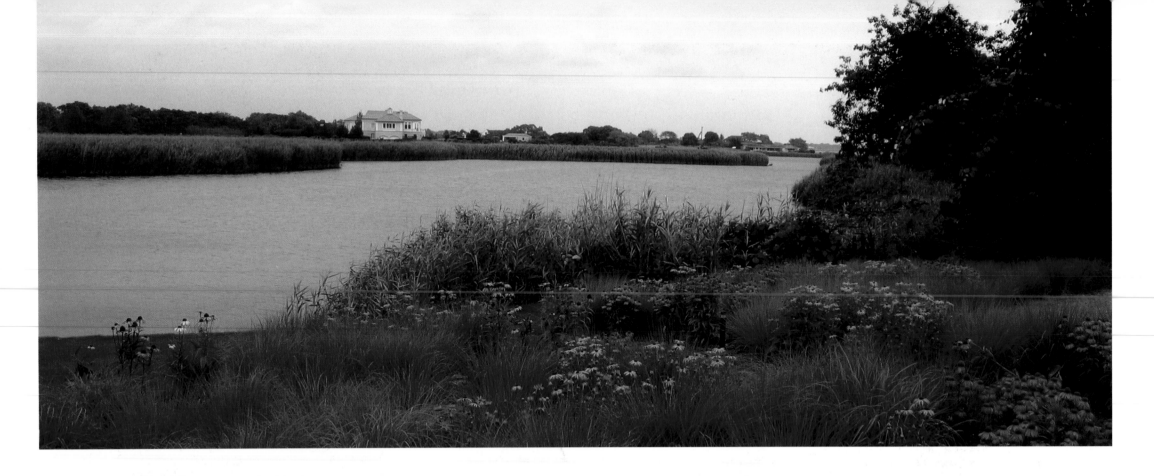

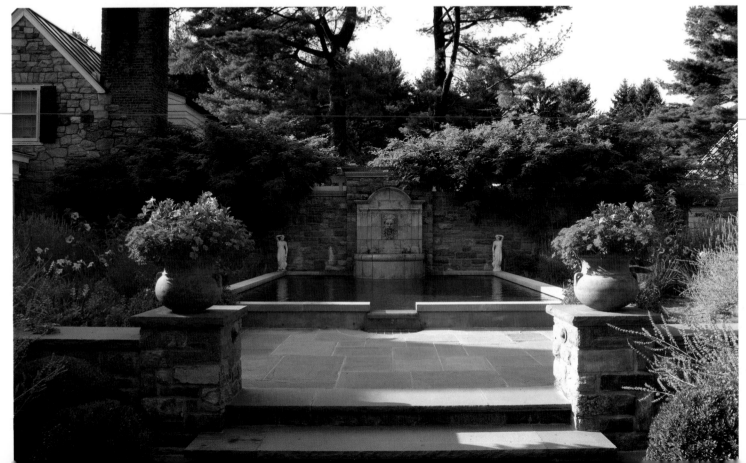

ABOVE: Bold summer wildflowers highlight the edge of the wetlands.
Photograph by Chuck Mayer

LEFT: Low stone walls, bluestone walkways, and colorful plantings frame this formal reflecting pool.
Photograph by Chuck Mayer

FACING PAGE: A rustic gateway and fence define this country garden adjacent a drift of lavender and Annabelle hydrangeas.
Photograph by Chuck Mayer

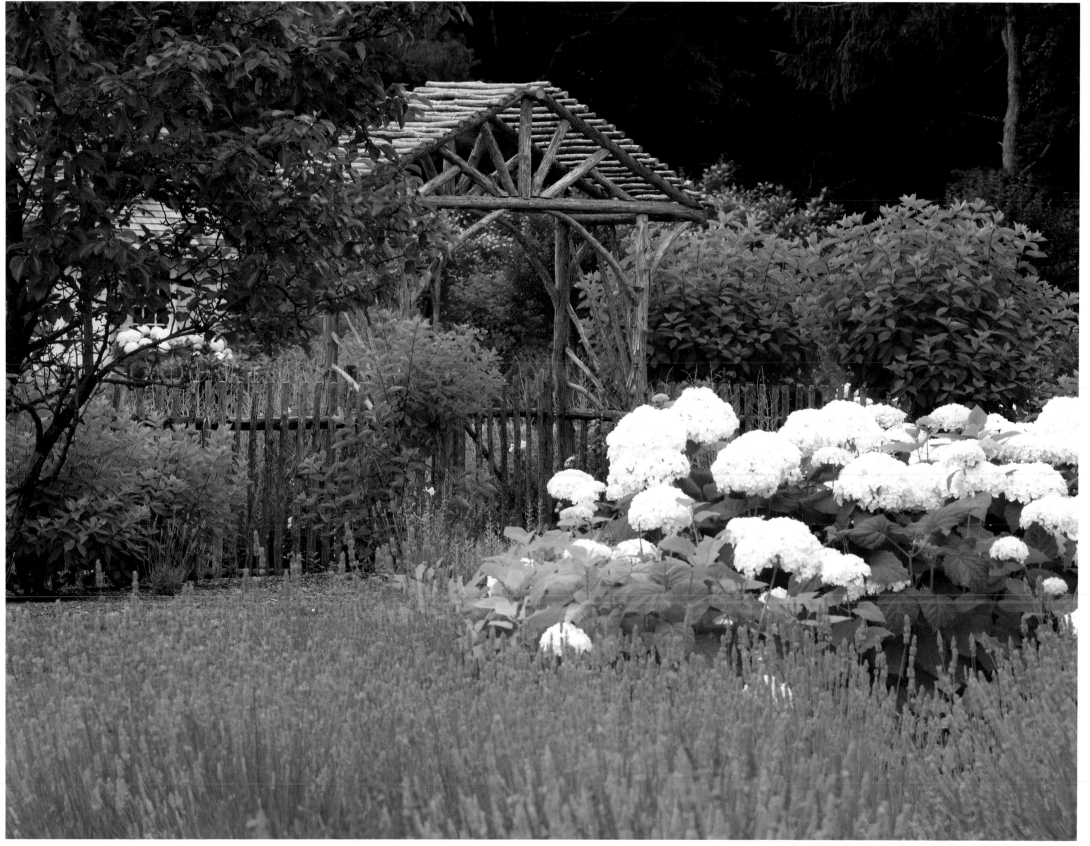

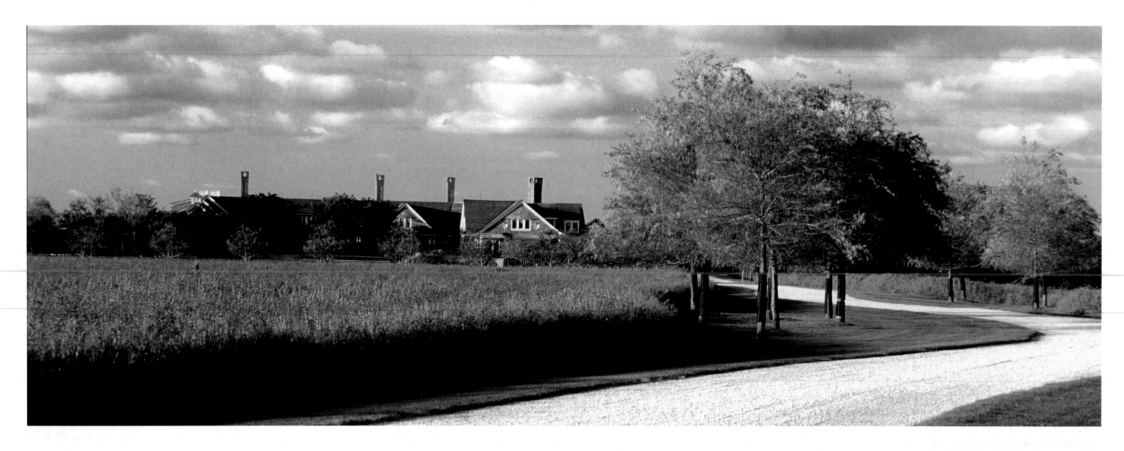

Finally, all of Edmund and Maryanne's landscape designs incorporate transitional moments, or spaces where the eye or the body moves from one into another, as from a sunny spot to a shady spot or from a formal area to an informal one. "We try to emphasize those transitions so that you have an experience of moving through the landscape as a whole, logical sequence," Maryanne says.

The best architects and landscape architects are concerned with the project site, the appropriateness of a design for its context, the impact of their project on the environment, and, of course, the client who has commissioned them for the project. Edmund and Maryanne spend countless hours contemplating these elements before designing anything. To this end, they study and analyze the topography, geology, hydrology, and ecology of the land on which they will work. The result is a design that not only works physically, but emerges from a place rather than appearing imposed upon it.

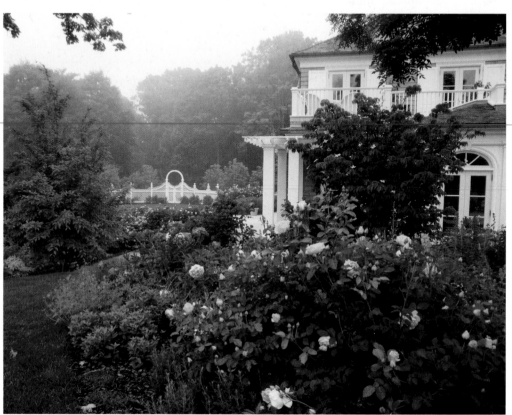

ABOVE: The late summer wildflowers sweep across this field and stop at the willow trees highlighting the entrance to the property.
Photograph by Chuck Mayer

RIGHT: Pastel roses and a morning mist create a romantic ambience in the gardens.
Photograph by Chuck Mayer

FACING PAGE: A calm, quiet pool invites a summer swim.
Photograph by Chuck Mayer

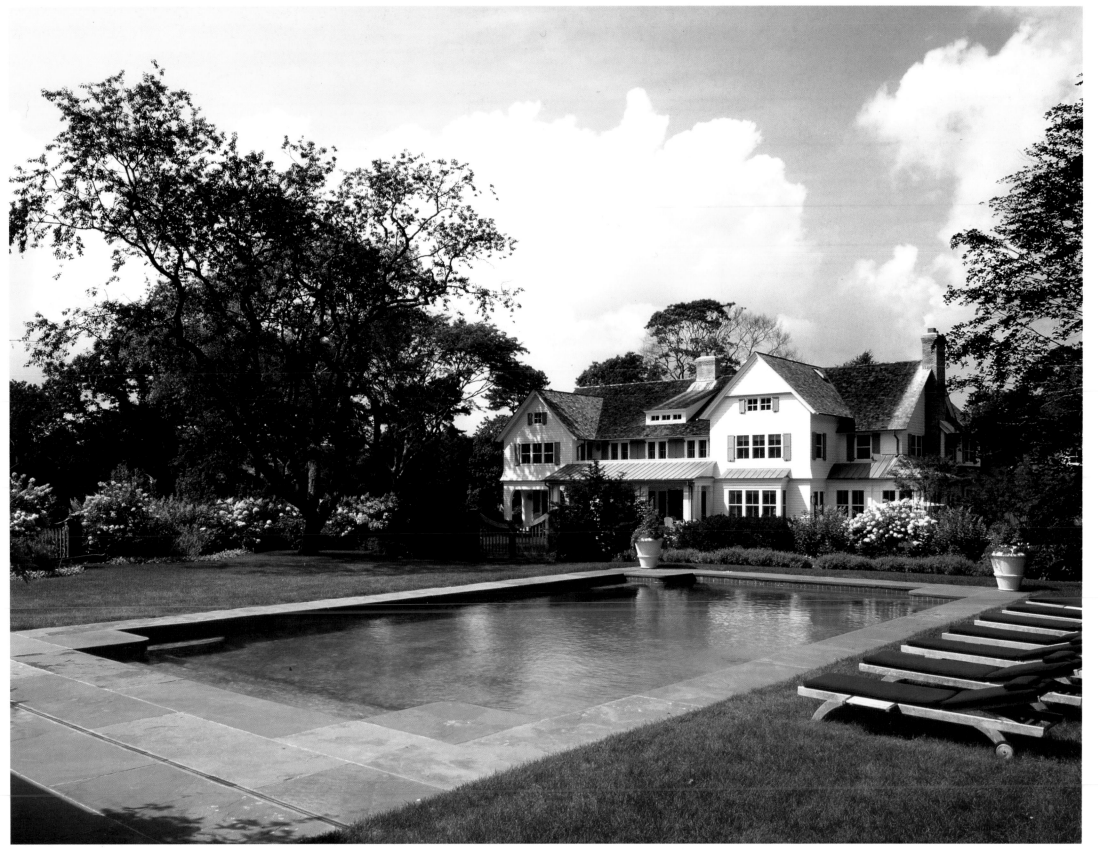

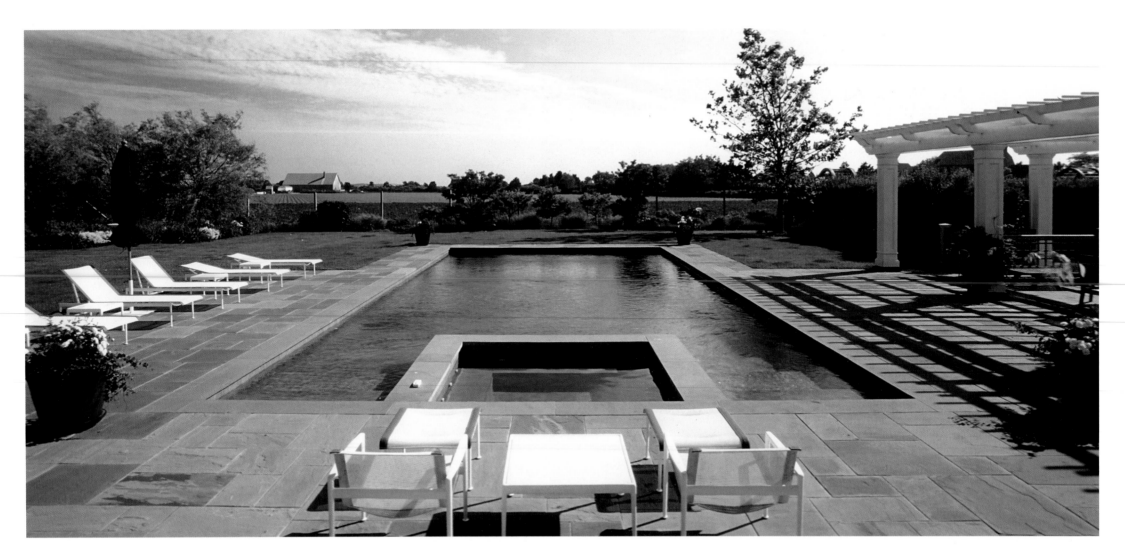

"It all starts with geology," Edmund says. "On Long Island you have glacial washout plains, which are flat. The gentle slopes and deep topsoil were conducive to agriculture, so the land was cut up into fields and hedgerows. Later, post-agricultural rural landscapes began referring to that agrarian past — large fields, geometric patterning of development, and rural-looking Shingle-style architecture.

"In Greenwich, it's entirely different. The bedrock explodes to the surface. There's a rocky escarpment that runs all the way down to the Long Island Sound, which creates a structure and rhythm in the landscape. That area has always been residential and the houses are fitted — almost organically — in between the rocks and the wetlands."

His point, of course, is that each parcel of land, each jobsite is unique in this world and as such it requires a very specific treatment; a broad-sweeping formula cannot be applied to every location. Understanding this is the job of a landscape architect.

Edmund Hollander Landscape Architect Design takes on only about 10 new projects each year. The firm currently has 12 landscape architects, as well as an in-house horticulturist and ecological planner. Though all design drawings are done by hand, the office is fully CADD capable, with most construction documents produced utilizing this method to allow for full coordination with project architects, engineers, and other consultants.

ABOVE: The pool is an extension of the spa, rectangles extending into the green fields that end at the horizon line.
Photograph by Chuck Mayer

FACING PAGE TOP: This landscape of horizontal lines responds to the orthogonal geometries of the contemporary architecture.
Photograph by Chuck Mayer

FACING PAGE BOTTOM: Stone walls articulate the entrance defining public and private space.
Photograph by Chuck Mayer

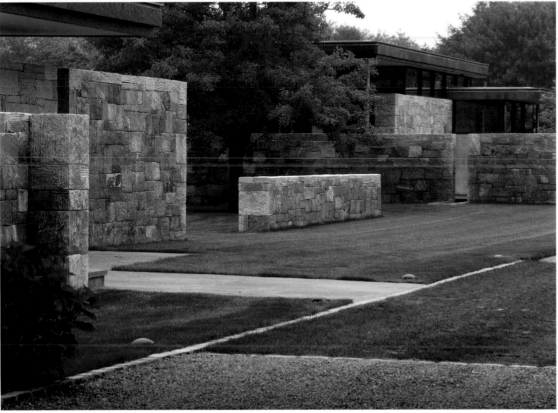

Who has had the biggest impact on their careers?

Ian McHarg, the charismatic founder and emeritus professor of landscape architecture and regional planning at Penn, and the author of such books as *Design with Nature* and *To Heal the Earth*, introduced them to landscape architecture. It was Ian's vision of the earth as a multilayered living organism deserving the highest level of reverence and his larger-than-life personality that so inspired them to take this journey.

What is something most people don't know about Edmund?

Clients are often surprised to learn that Edmund grew up in Manhattan, just about the last place you'd expect someone to grow up with an interest in horticulture. But Ed attributes his love of all things green to childhood weekends on his father's farm in Pennsylvania Dutch Country. "As a kid I remember burying my face in flowers," he says, "and I had this overwhelming sensation that was where my life was going."

When they are not working, where will you find Edmund and Maryanne?

They like to spend their leisure time at their homes in Sag Harbor.

Publications:

The work of Edmund Hollander Landscape Architect Design has been featured in numerous publications in addition to this book, including *Architectural Digest, The New York Times, Garden Design, House Beautiful, Landscape Architecture, and Metropolitan Home*, and the acclaimed book *Gardens for the New Country Place.*

Edmund Hollander Landscape Architect Design

Edmund Hollander
Maryanne Connelly
200 Park Avenue South
New York, NY 10013
212.473.0620
www.hollanderdesign.com

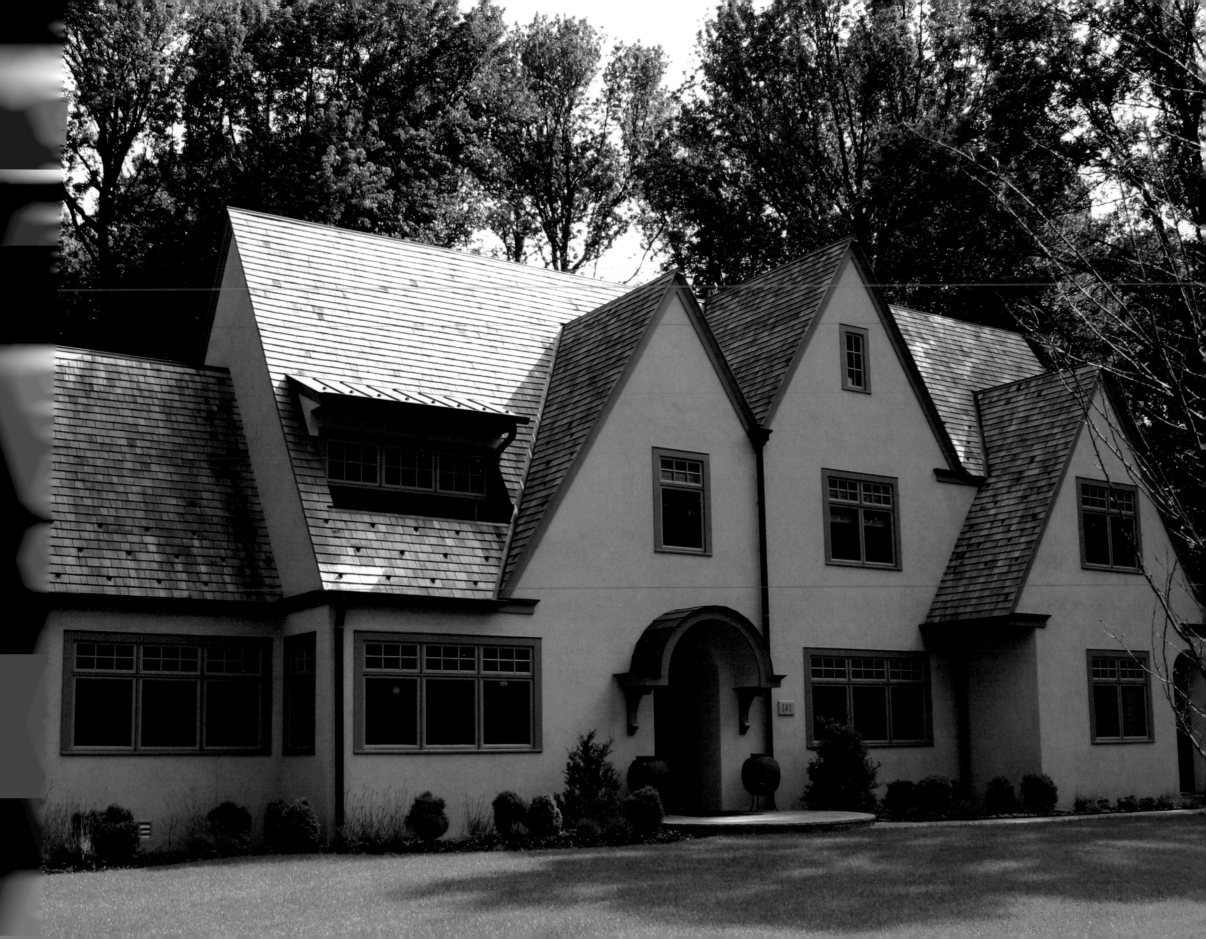

JO MACHINIST

Jo Machinist, Architect

ABOVE: Crafted copper snow guards and rain catchers are transformed into art.
Photograph by Barnett A. Zitron

LEFT: 2006 recipient of Rockland County's Historic Preservation Merit Award, Sneden's historical shell is seamed with modern lifestyle and technology.
Photograph by Barnett A. Zitron

When one Manhattan architect first saw the completed restoration and renovation of a 1929 English Tudor-style house that fronts the historic road to the famous ferry at Sneden's Landing, a tiny, affluent enclave in the hamlet of Palisades, he felt compelled to call architect Jo Machinist. He wanted to thank her, he said, for sparing Rockland County another McMansion. Jo laughed a little. She does not design McMansions.

She is renowned, however, for her unique residential designs that emphasize proportion and rhythm, incorporate open floor plans, and respect the landscape from which they emerge. As a 30-year architecture veteran, she's an expert in the field; as a woman, parent, and hostess, she's an expert at living in a house. "I understand the home as shelter and as sanctuary," she says. "Creating 'home' for my clients is my stock and trade." And it's what she does best.

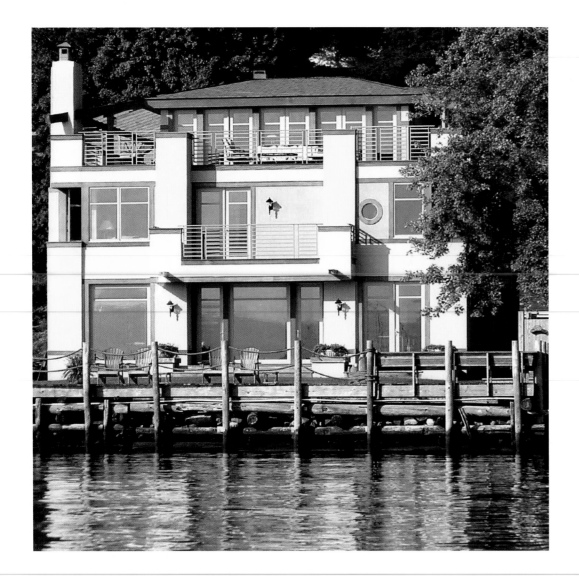

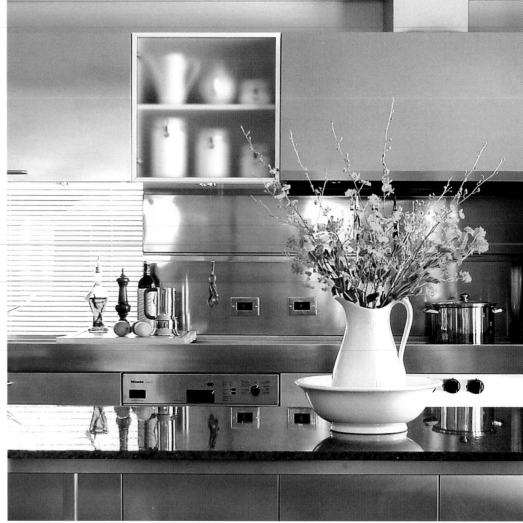

In the early 1970s, Jo was working at Davis, Brody & Associates, one of New York City's premier architectural firms. As Lewis Davis's secretary, she witnessed the energy, enthusiasm, artistry, and optimism of the DB&A team. So inspired was she by their values, drive, and talent, that Jo, with the encouragement of Lew, decided to enroll in architecture school. After graduation, for 15 years she worked with her husband at Machinist Associates Architects in SoHo, and in 1990, she opened her own practice uptown. Jo commutes into the city each day from her home in Piermont, New York, where she lives with her twin sons in a house she designed herself.

Jo's influences range from her former employer to the famed Louis Kahn and Frank Lloyd Wright, from American heritage to the beauty of the Far East. And though her passions include both historical recall and restoration to the very new and modern, Jo is most comfortable when seaming old with new. 19th-century-style houses that belie their 20th-century technology and integrate a modern lifestyle with a historical shell are her forte.

And though her work does not reflect one particular style, all of Jo's projects are distinguished by an uncompromising commitment to design excellence. Repetitive and recognizable themes — exposed beams, window runs, trellises — appear throughout her work, but the recurring element that brings the ultimate harmony is balance, not just in the design but also in its execution.

Working closely with the contractors, demanding meticulous craftsmanship and careful execution of the details is an integral part of Jo's philosophy: "As Mies van der Rohe said, 'God is in the details.' Ask any contractor I've worked with — I am there, too."

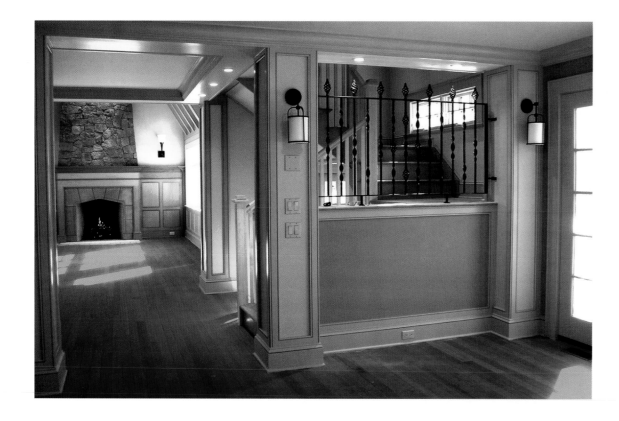

What does she like best about being an architect?

"There are so many bests," she says, "but the best of the best is the experience of designing my own home with Ricardo Herrera and Kenneth Bingham, my most talented and loyal staff, and then living in it with my family. It's truly a sanctuary."

What is the highest compliment she's received professionally?

Jo says that the highest praise comes in the form of personal notes, not just from clients but from passersby who take the time to let her know her work is appreciated. She saves them all.

What color best describes Jo and why?

Green, she says, because it can be the forest or it can be the tree. Likewise, the architect toils at times in the background, working out the big picture; while at other times she's center stage with the client.

What would her friends say about her?

She's great to laugh with.

What single thing would Jo do to bring a dull house to life?

Infuse it with natural light. One technique Jo uses to exemplary effect is to view a house as a sundial, manipulating light patterns to generate shadows and movement.

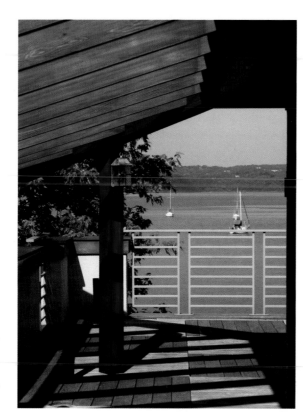

ABOVE: Exterior and interior boundaries meld through the repetition of materials and color palette.
Photograph by Jo T. Machinist

RIGHT: Daylight interacts with façade recesses while open trelliswork borders the roof to create shifting shadows.
Photograph by Barnett A. Zitron

FACING PAGE LEFT: Although inspired by the Arts & Crafts idiom, this house is decidedly today. Sea and sky are an integrated part of the design.
Photograph by Jo T. Machinist

FACING PAGE RIGHT: Stainless and sitting proud of an open plan, the kitchen reflects the Hudson River beyond.
Photograph by Jo T. Machinist

Jo Machinist, Architect

Jo Machinist, AIA

654 Madison Avenue

New York, NY 10012

212.355.7171

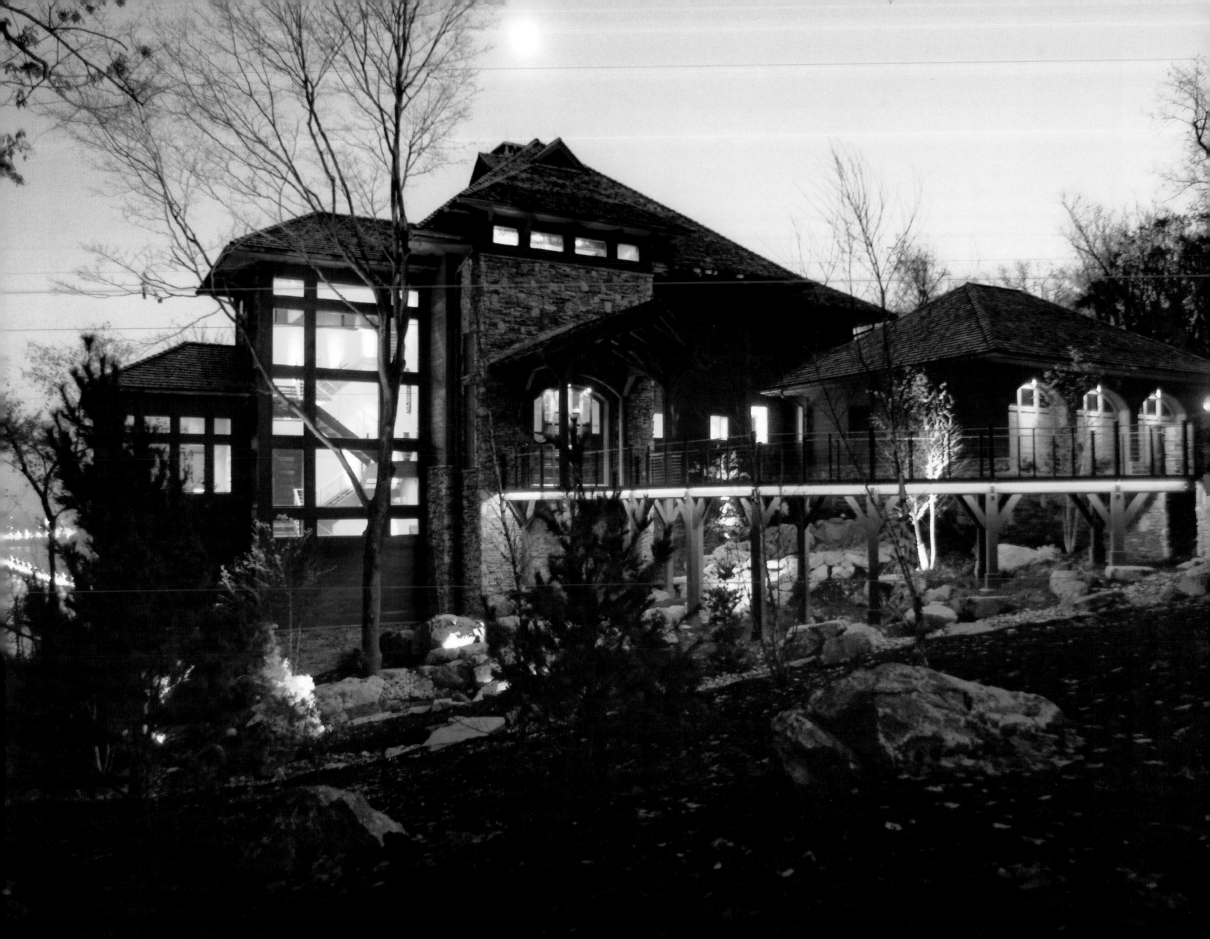

KENNETH NADLER

Kenneth R. Nadler Architects

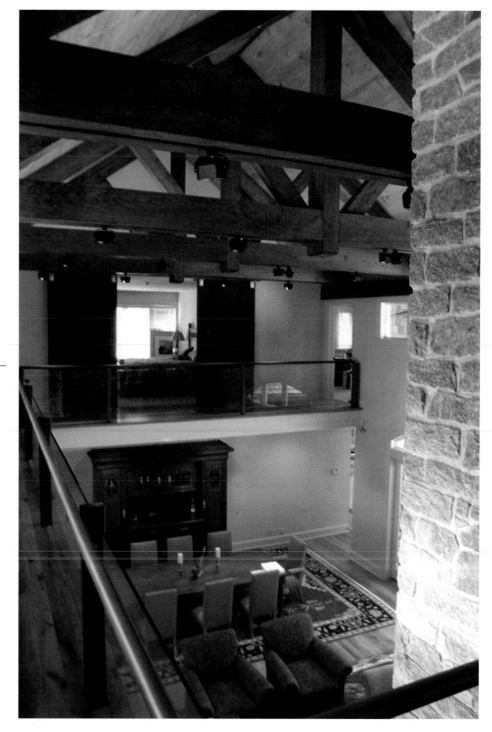

When you get right down to it, says architect Ken Nadler, we all want the same things. As human beings we are pleased and comforted by classic proportions, substantial quality, and simple elegance, no matter who we are or where we live. Regardless of whether we like traditional or modern designs, we respond intuitively to certain broad-sweeping categories. And those categories are the foundation of good architecture.

A New York native, Ken has more than 30 years of architectural experience. His award-winning firm, Kenneth R. Nadler Architects, is deeply committed to a high standard of quality design, both residential and commercial. The firm's goal, no matter the project size (dog house, pool house, tree house, or 7,000-square-foot beach house), is to help clients meet their needs and realize their visions.

ABOVE: A new home designed to resemble an old converted barn. The heavy timbers and glass rail offer a bridge between yesterday and today.
Photograph by Paul Zeller

LEFT: A cliffside home with a dramatic view of the Hudson River. The entry bridge connects the house to the hillside, preserving the existing natural landscape.
Photograph by Bob Vagara

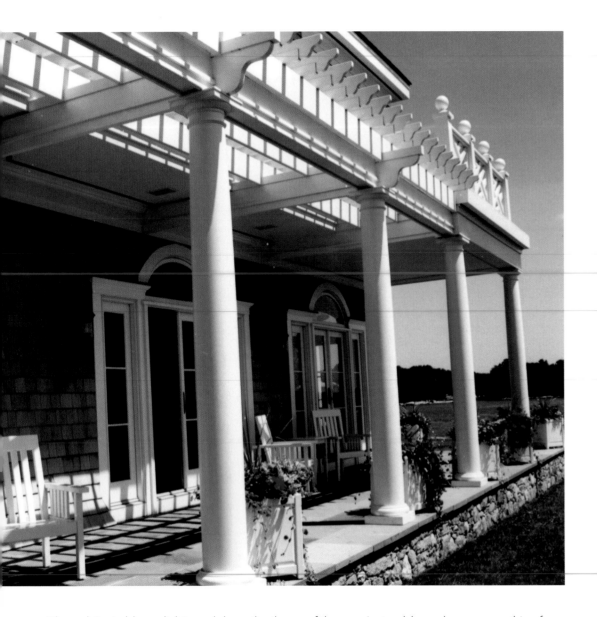

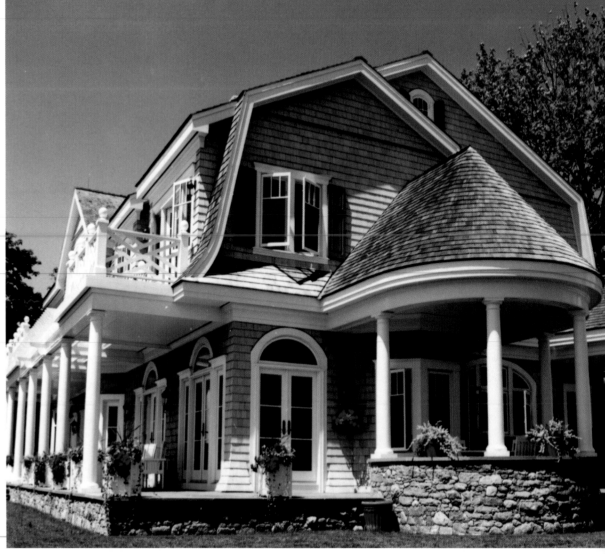

The architect abhors clichés and shuns the theme of the year. Instead, he embraces everything from the historical to the contemporary, resulting in unique sophisticated designs.

At KRN, the 10-person staff practices a team-oriented strategy that calls upon the individual strengths of each designer. "When we work on a design, no one is the boss," Ken says. "We develop our designs together." This method is also how the firm manages the construction of its projects.

The collaborative approach extends to the client, as well. Ken is a registered architect in 14 states and has worked on projects throughout the United States, the Caribbean, and South America. No matter where they are located, the best clients are those who are engaged in and excited about the process. "We realize that building or renovating a house is one of the biggest events in most people's lives. We know that as thrilling as it is, it can also be very daunting, so we try and form close relationships with the clients and make it fun for them," he says. To that end, Ken insists on mock-ups of everything before its built and weekly conversations or meetings so that there are no surprises. This keeps clients involved every step of the way.

The designs of KRN always strike a balance between yesterday and today. They incorporate Old-World techniques and materials made desirable by the patina of age, yet they are light and airy and infused with 21st-century technology. Drive by a Ken Nadler home and you get a sense of permanence and substance — as if the house always has been and always will be, even if the last contractor just left the site. The work of the firm expresses the architect's belief that thoughtful design will ensure timeless beauty.

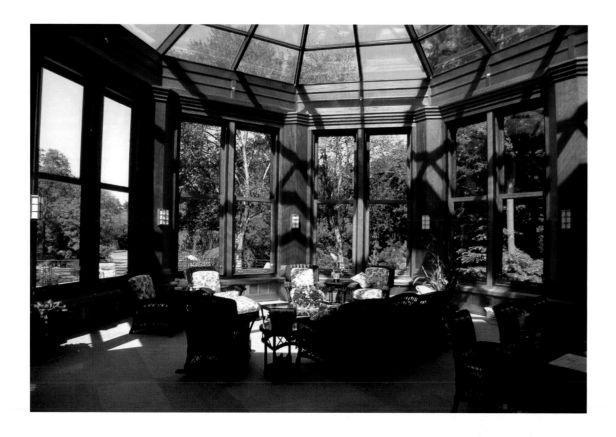

more about ken...

Q&A

When he's not working, where will you find him?

Ken finds architecture exhilarating, and it's rare that he turns off his enthusiasm for his profession. His wife calls him a workaholic, as he works seven days a week. Still, Ken is a man who likes his sleep. When he's not dreaming up dream homes, he's dreaming of dream homes.

Who has had the biggest influence on Ken's career?

The architect says that his mother always steered him to do what he believes in.

What is the most impressive house he's ever seen and why?

Ken says it's a tie between The Breakers, in Newport, Rhode Island, and Vizcaya in Coral Gables, Florida—both constructed around 1900. "Your spirit just lifts when you walk into these places," he says. "There's such quality, such grandeur."

What's the biggest compliment he's received professionally?

Although Kenneth R. Nadler Architects has won numerous awards for its buildings, Ken is modest about his achievements. He's reluctant to give the names of prizes he's garnered and says that the only real satisfaction comes when a client looks at his firm's work and smiles.

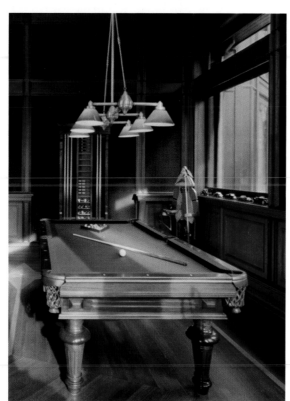

ABOVE: This conservatory converts to a screen porch in the summer with the use of large historic weight and chain windows and roof glass filled with krypton gas.
Photograph by Paul Zeller

RIGHT: This new billiard room is built around an antique table, in both spirit and detail.
Photograph by Paul Zeller

FACING PAGE LEFT: The rear terrace overlooking the Long Island sound offers a tranquil retreat.
Photograph by Paul Zeller

FACING PAGE RIGHT: The forms on this new home are traditional New England style. The curved roof form creates an outdoor eating space off the breakfast room.
Photograph by Paul Zeller

Kenneth R. Nadler Architects

Ken Nadler

103 South Bedford Road

Mount Kisco, NY 10549

914.241.3620

www.nadlerarchitects.com

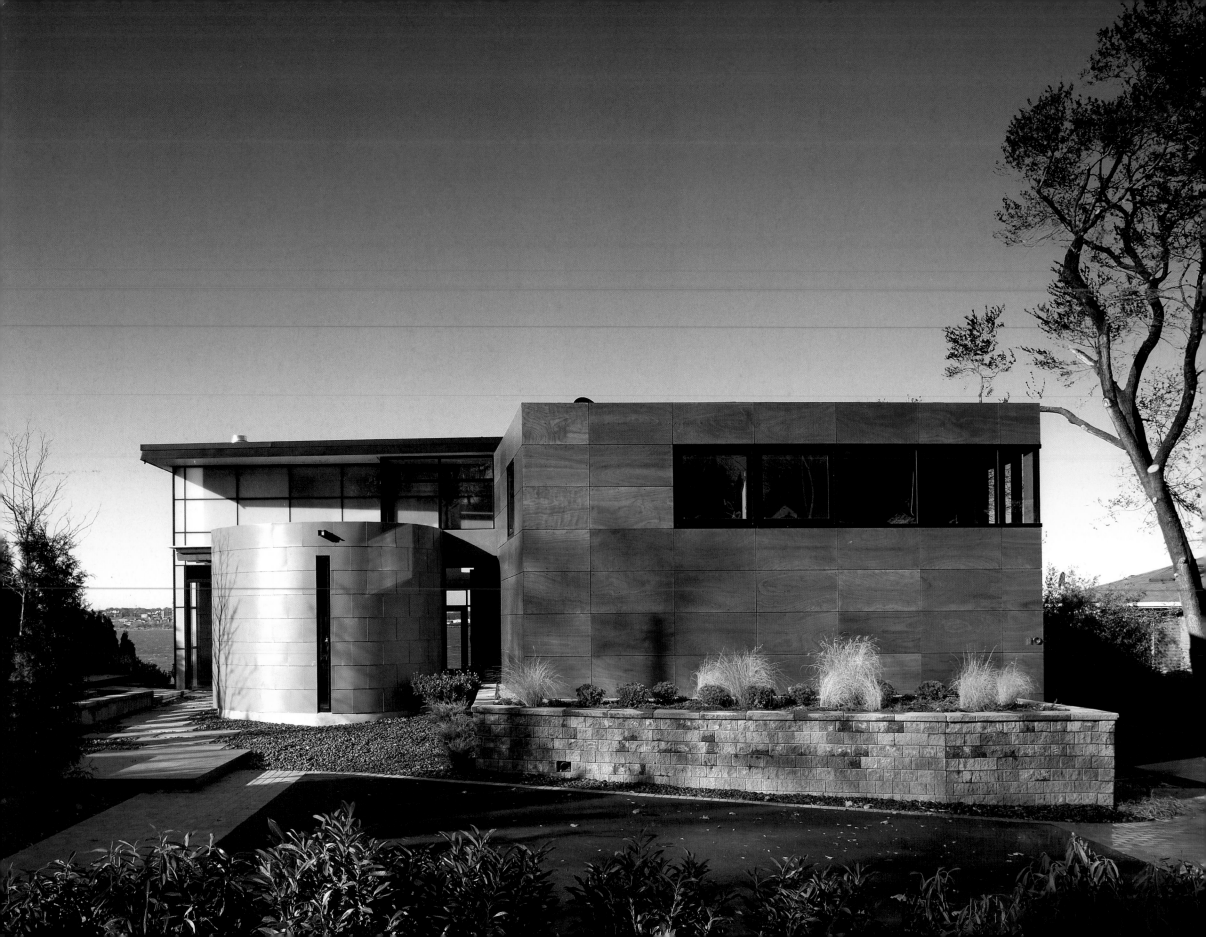

STUART NAROFSKY
Narofsky Architecture and Design, PC

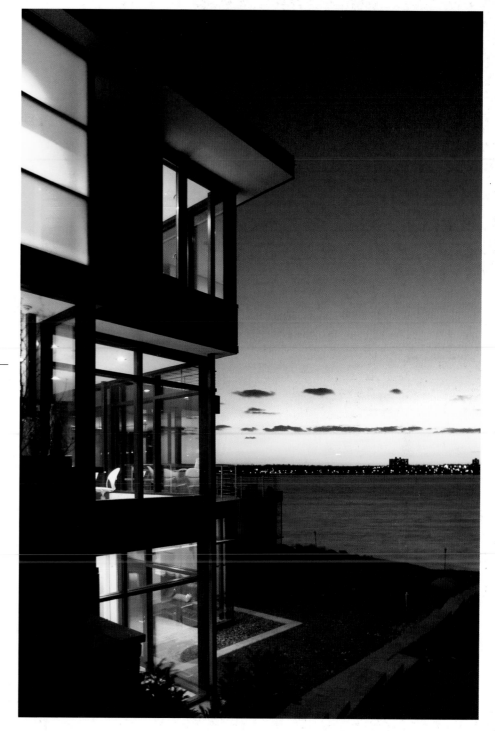

ABOVE: A view to New York City at dusk.
Photograph by Phillip Ennis Photography

LEFT: The approach to this waterfront home on Long Island's North Shore expresses the primary materials: Wood and resin rain screen panel, zinc and translucent glass.
Photograph by Phillip Ennis Photography

"We are a full-service architectural firm," says Stuart Narofsky of his 22-year-old company. "We're architects, interior designers, furniture and accessories designers, landscape designers; and we're even construction managers." Narofsky Architecture has attracted a mix of residential and commercial clients seeking an architect's expertise for single- and multi-family homes, renovations, apartments, townhouses, offices, and retail businesses. No matter the calling or the client, the small atelier of talented professionals is dedicated to excellence in design and comprehensive, personalized service.

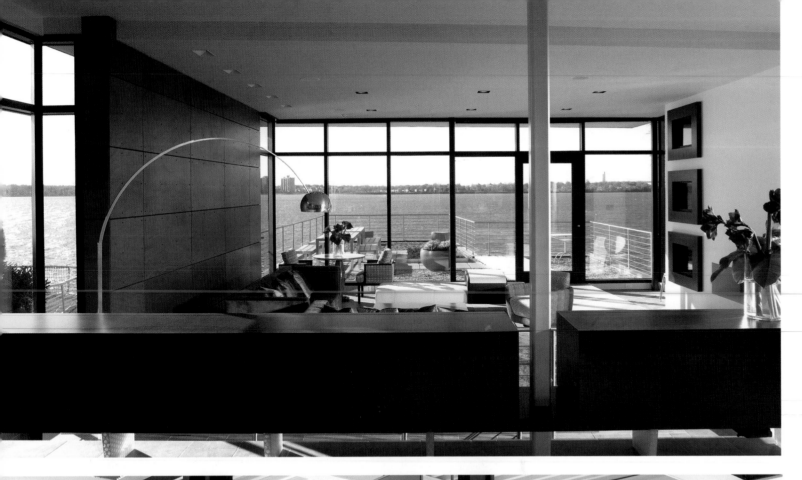

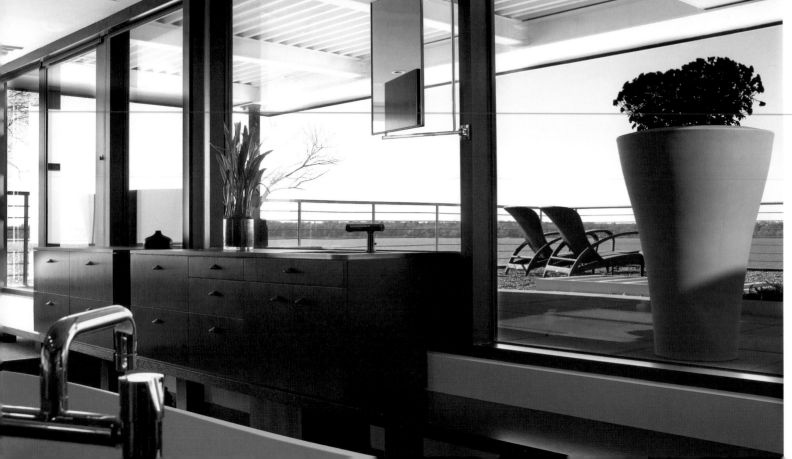

Whether single-family hillside residence overlooking the waterfront on Long Island's North Shore, a penthouse in Williamsburg, Brooklyn, or a prefab multi-unit apartment condominium in Jamaica, Queens, all Narofsky projects start out the same way. That's not to say that Stuart's work is formulaic or that he simply modifies a standard design — quite the contrary, for the 51-year-old architect has no prototypes. Every commission begins in its own particular universe, and all the elements of a project are conceptualized and then developed into an original and fresh interpretation of the client's desires.

The team approach and philosophy is consistently "modern," as opposed to "contemporary," a word to which Stuart objects, saying that it connotes a 1960's and '70's aesthetic. Modern, he says, means working toward a unique solution organizing materials innovatively into a minimal composition. "We take the opportunity to push the envelope and explore new techniques and materials, and we use conventional materials in exciting ways."

Staying abreast of evolving trends is important, and sustainable design is a trend at the forefront of both architecture and design. Narofsky has a member of its team concentrating specifically on this burgeoning field. "There's a growing attitude of being respectful of what's available in the world," Stuart says, "and people are increasingly attracted to issues of sustainability and are incorporating associated ideas and materials into their homes and places of business." Though designing sustainable structures is challenging —"It affects everything from the materials you choose to how you orient a building," he says — Narofsky is leading the way.

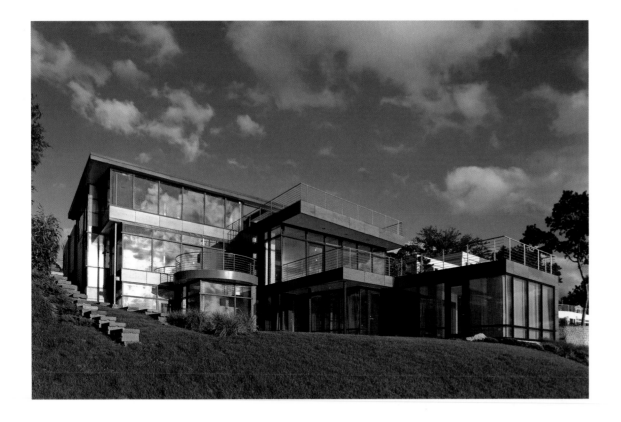

What personal indulgence does he spend the most money on?

"I buy a lot of books," he says. A voracious reader who often reads several books at once, Stuart explores a wide range of subjects in art, architecture, and philosophy, and delves into biographies, technical books, and journals, enjoying every minute of his explorations.

Who has had the biggest impact on his career?

"My great friend John DeFazio, AIA, a well-respected and highly gifted architect, teacher, writer, and artist, has encouraged me for more than 20 years to explore and push the limits of what I think and do," Stuart says. "I am deeply grateful for his invaluable mentorship."

Awards and recognition:

Narofsky Architecture has received numerous awards from the American Institute of Architects and the Society of American Registered Architects, including recognition in 2001 for the interior architecture of MCA Records offices in New York City. The firm's work has been showcased in such publications as *The New York Times, Dwell, Residential Architect, Newsday, Corporate Interiors, Distinction,* and *1,000 Architects.*

ABOVE: View from dock.
Photograph by Phillip Ennis Photography

RIGHT: A quiet room for reading and contemplation (the "Zen Room").
Photograph by Phillip Ennis Photography

FACING PAGE TOP: Dining and living room open to views across the bay.
Photograph by Phillip Ennis Photography

FACING PAGE BOTTOM: View from master bath through covered terrace.
Photograph by Phillip Ennis Photography

Narofsky Architecture and Design, PC

Stuart Narofsky, AIA
4 West 22nd Street
5th Floor
New York, NY 10010
212.675.2374
www.narofsky.com

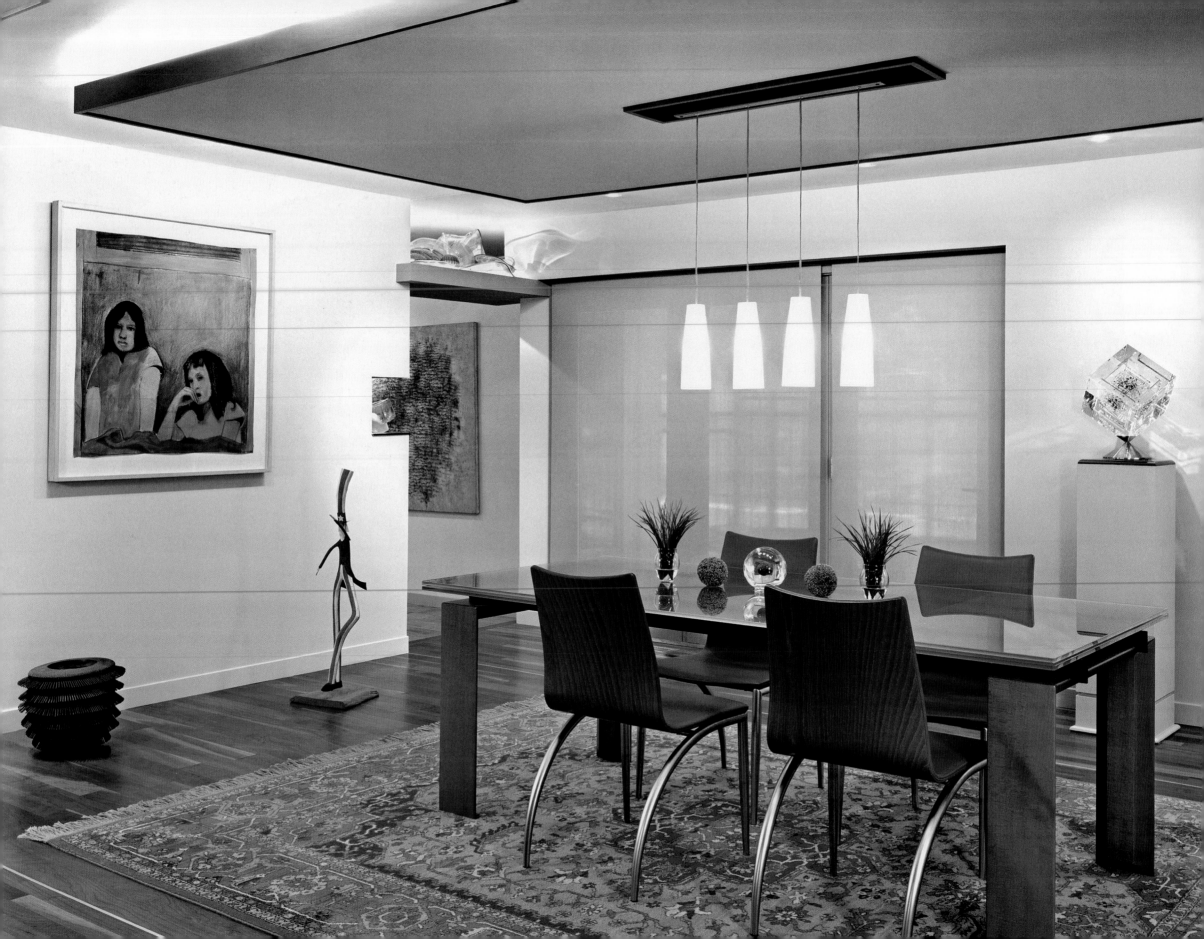

BRAD PRESSMAN

DESIGNimpulse

ABOVE: In this kitchen of a world-renowned glass artist and his wife, decorative downlights and indirect lighting create a sense of drama. A collection of *objets d'art* is woven into the space with cantilevered steel shelves and floating soffits.
Photograph by Carol Bates

LEFT: Above the dining table, a glowing tray hovers weightlessly, giving definition to the dining area. Seamlessly integrated lighting adds allure while bringing the artwork to life.
Photograph by Carol Bates

When architecture transcends...

At one time or another, we've all contemplated our "dream house." As children, the tendency was to focus on specific features — a spiral staircase, a zebra rug. As adults, we're likely to become overwhelmed by a house's intricacies and the infinite possibilities. The endeavor is, in fact, complex and far-reaching. How *does* one create a dream house?

"At the start of a project, I ask clients to describe what they're looking for in abstract, qualitative terms," explains Brad. "Initially there's resistance because they think they have to provide a detailed description, so I guide them to talk about the mood, the feeling, the experience. My role includes tuning in to my clients, understanding their lifestyle, their dreams and aspirations. Often, it's not until construction is nearing completion and the clients are standing in the space that it strikes them — the ambience they had described at the outset of the project has magically taken form."

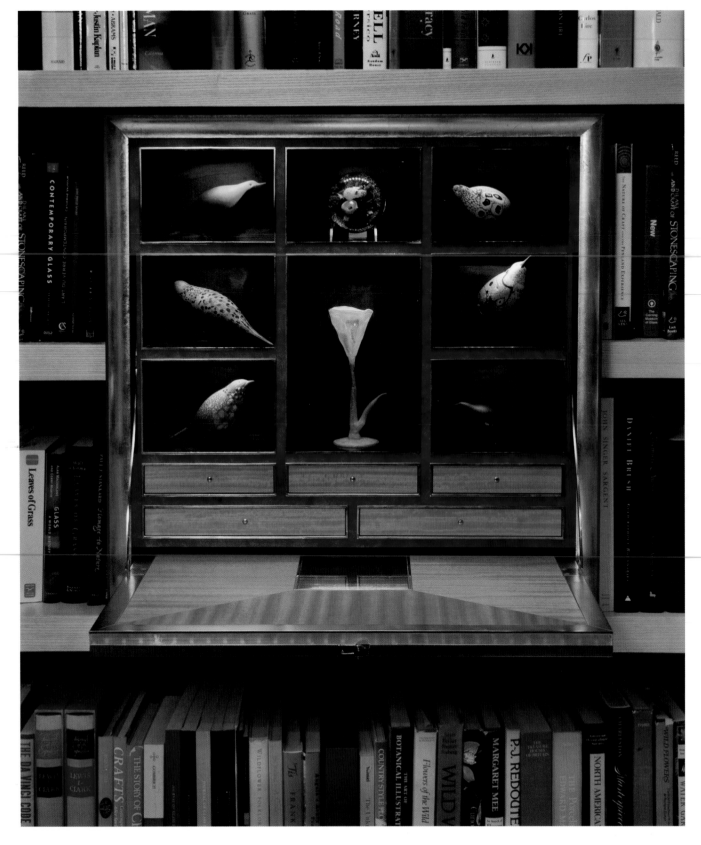

As the process moves forward, a synergy and trust develop between architect and clients. Once this is galvanized, the design flows easily, even playfully. There is exploration, discovery, invention — this is when the real fun begins. What emerges is a unique expression of fresh, inspiring design. Says Brad, "I go through my due diligence, developing a deep understanding of all aspects of the project — the site, the program, lifestyles, bringing form to the house, defining the spaces, etc. Then at a certain point, it becomes intuitive; the building lives inside my head, very much like a dynamic three-dimensional computer model."

From his 20th floor office in Midtown Manhattan, Brad has a view of the city with two of New York's classic skyscrapers, a fitting backdrop for creating inspired designs. Pressman possesses a quiet intensity which reveals itself when he talks about design. "You could say that I'm obsessed with design. But the truth is, I find it absolutely thrilling. The more I develop my skills, the more thrilling it becomes. One of the great rewards is sharing this with other people, enriching their lives."

Distinguished by boundless creativity, Brad brings forth designs which are distinctive, personal, and moving. One of many aspects which set him apart is the quality of the spaces he designs — they flow effortlessly; they're "clean" without being austere; they have a distinct human touch, a warmth. The end result is a harmony which magically draws you in.

LEFT: The focal point of the library, an exquisite, hand-crafted display case, sits amidst a wall of books. A refined palette of rich materials provides an elegant setting for the artwork.
Photograph by Carol Bates

FACING PAGE TOP: Adding on to a 180-year-old stone house demanded great sensitivity. The design solution, a transparent element connecting the old with the new, created this welcoming entrance to the house.
Photograph by Brad Pressman

FACING PAGE BOTTOM LEFT: This inviting breakfast nook sits playfully beneath the stairs' upper landing. The clever use of materials and details creates an enchanting space.
Photograph by Carol Bates

FACING PAGE BOTTOM RIGHT: A charming antique tub became the master bathroom's centerpiece. A hand-blown Murano glass chandelier overhead combines with other elements to create a room which delights and nurtures.
Photograph by Carol Bates

more about brad...
Q&A

What accounts for his unique approach?

Having lived in both France and Japan, Brad's background and education are diverse. When asked how these experiences influenced him, he responds, "Everything I've been exposed to finds its way into my designs. In France, the ancient cities, the craftsmanship, the wonderful ornament; in Japan, more than anything else, the traditional tea houses. They're truly awe-inspiring."

What does he like most about being an architect?

The entire process of design, from the initial conception through bringing it into reality — creating something wonderful where before there was nothing. And certainly, sharing this with people and seeing them light up.

What's the greatest compliment he's received professionally?

It was after completing the house for the glass artist and his wife. They shared with me that, "there isn't a day that goes by that we don't stop to appreciate the beauty of what you created for us."

What's something most people don't know about Brad?

Throughout his teenage years, he was a competitive figure skater, starting at 6:00 a.m. most mornings and training as much as eight hours a day.

When he's not working, what does he like to do?

Photography has been one of his passions for years, most especially when traveling. Another is food, whether he's exploring New York's many restaurants or creating a delectable meal in the kitchen.

DESIGNimpulse

Brad Pressman
519 Eighth Avenue, 20th Floor
New York, NY 10018
212.244.8499
www.designimpulse.com

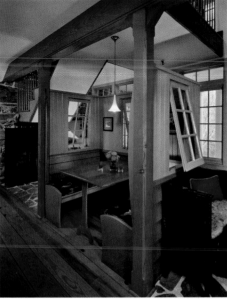

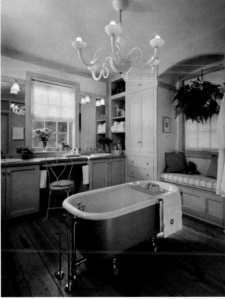

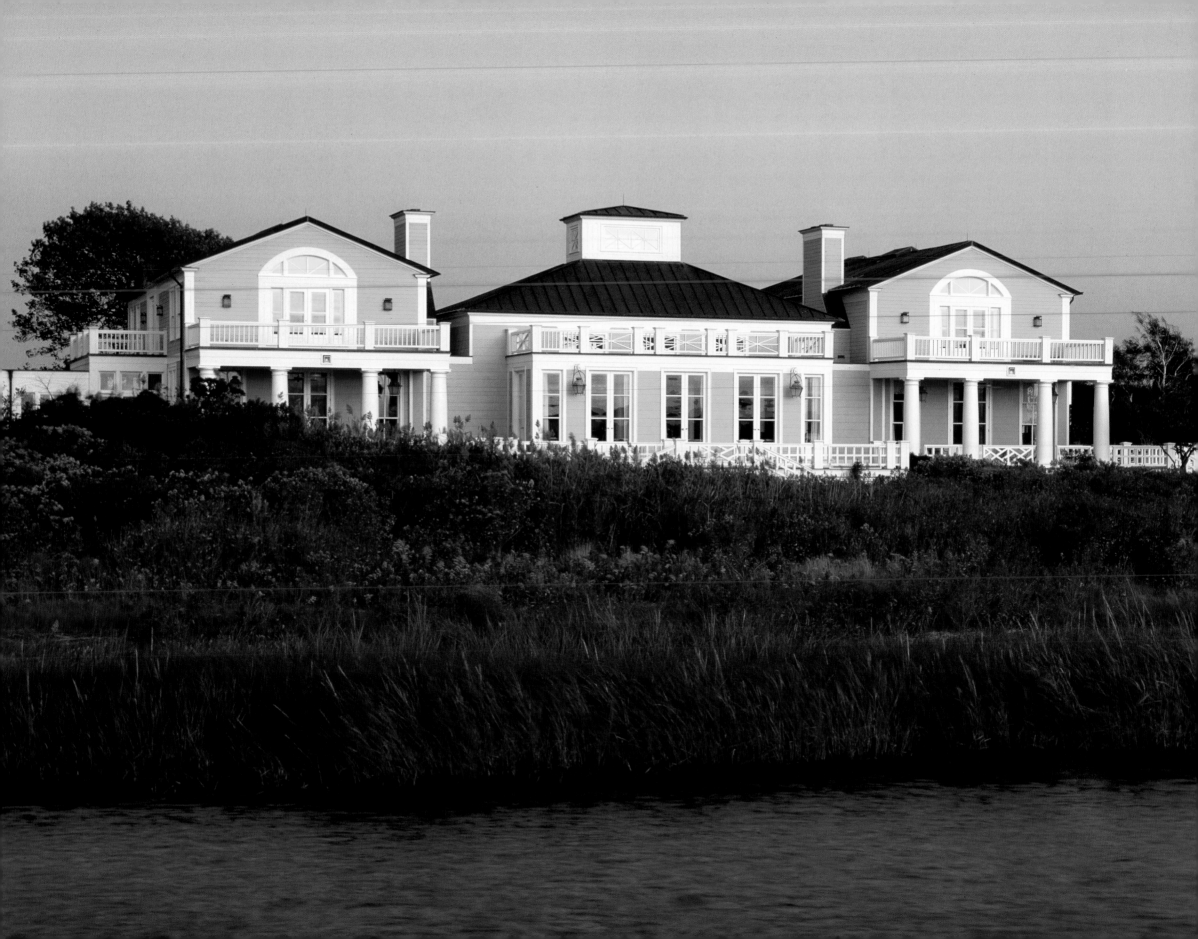

JAQUELIN T. ROBERTSON

Cooper, Robertson & Partners

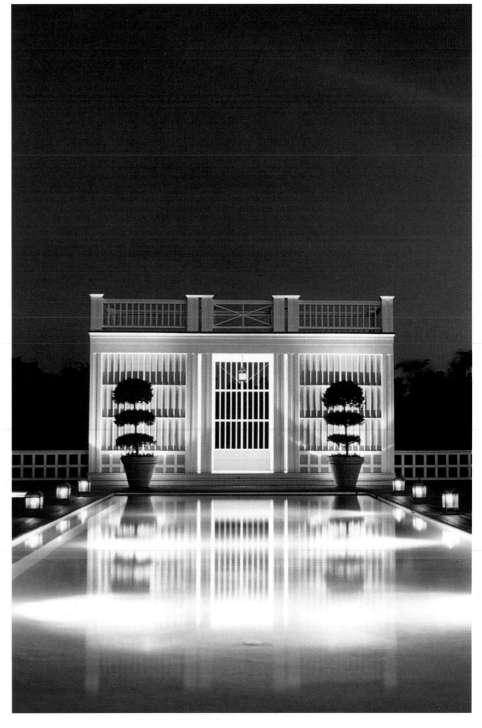

"That's one of the ugliest things I've ever seen," says Jaquelin Robertson, gesturing toward the window. "Just look at it."

The renowned architect sits behind his desk on the 13th floor, surrounded by colored drawings of ongoing projects, a metal car tag touting the name of one of the Florida communities he helped plan, and a black and white Polar Sport ad featuring his wife, Anya Robertson. He is talking about the nondescript modernist brown building that lies across the street from his office in New York City's theater district.

A long time Fellow in the AIA, Jaque was recently inducted into the Fellows of the American Institute of Certified Planners, an award bestowed on the foremost urban planners in the United States. The 72-year-old professional has seen his share of ugly buildings and cities. Architectural eyesores litter the country from coast to coast, in big cities and small towns, built without context or regard for history, region, or tradition.

ABOVE: A long swimming pool deck acts as a 'water carpet' reflecting the changing pavilion and tying it visually to the main house.
Photograph Elle Decoration, Marianne Haas

LEFT: A Neo-Classical villa for Mr. and Mrs. Ahmet Ertegun in Southampton, New York has two-story wings flanking a single story 'great room' topped by a lantern.
Photograph by Scott Frances

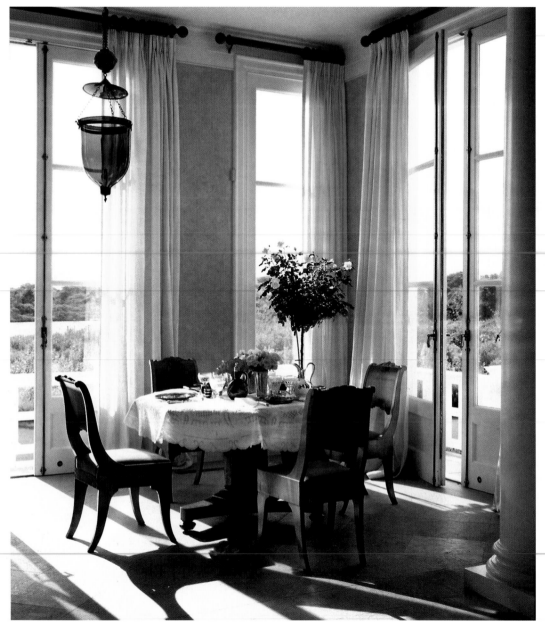

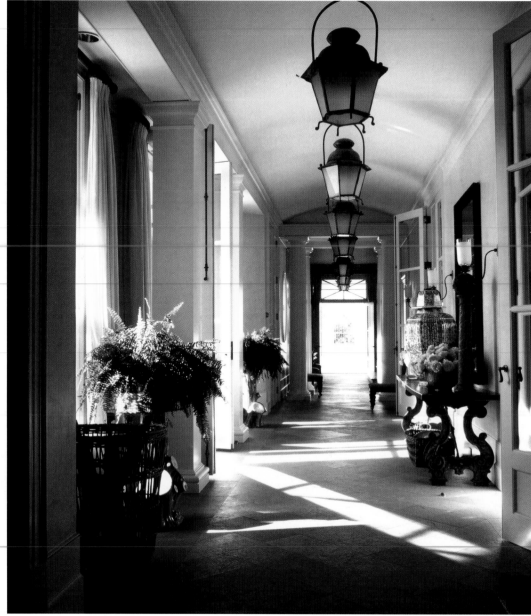

But Jaque has devoted his life to fighting such urban crimes: Through his work he's given the world a myriad of corporate, commercial, academic, retail, resort, mixed-use, and residential facilities, as well as a large number of high-end single-family residences, from apartment renovations to entire compounds spread over many acres — all of which embody the finest architectural standards.

A Virginia native, Jaque went to Yale and was a Rhodes Scholar at Oxford. As a young architect he apprenticed in England and New York City before going to work for Mayor John Lindsay. He was a founder of the New York City Urban Design Group, the first director of the Office of Midtown Planning and Development, and a New York City Planning Commissioner. In 1975, he went to Tehran,

Iran for three years to direct the planning of the country's new capital center, Shahrestan Pahlavi. Jaque thereafter practiced on his own and with Peter Eisenman and spent eight years as dean of the School of Architecture at the University of Virginia, rediscovering his own "architectural turf." In 1988, he joined with his Yale classmate, Alexander Cooper, in Cooper, Robertson & Partners.

Though large-scale urban design, new community, and campus planning projects comprise much of his firm's work, Jaque and his colleagues continue to take on selected residential commissions. His first private house, for a Belgian bank president, was commissioned while he was still in architectural school. Since then, he's designed more than 40 houses for a variety of clients from

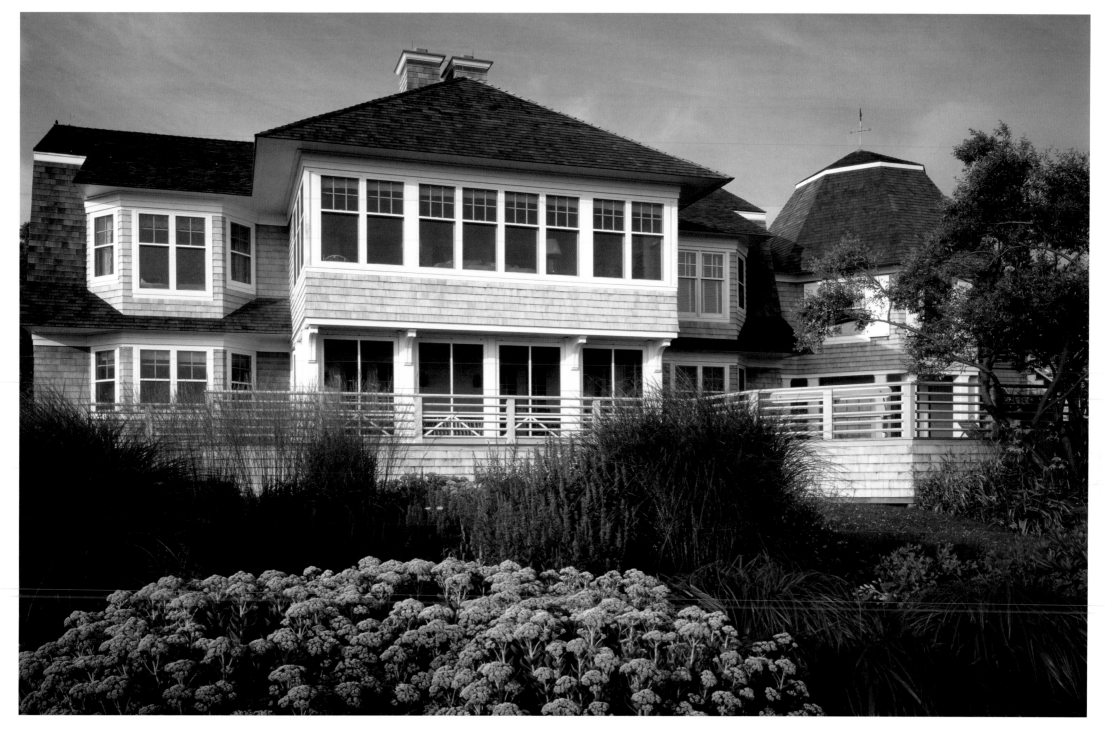

ABOVE: A cottage for a TV legend and gifted journalist overlooks the beautiful marshes and waters of Mecox Bay in Bridgehampton, New York.
Photograph by Steven Brooke

FACING PAGE LEFT: The winter garden, an extension of the great room opens onto wide porches overlooking the water.

FACING PAGE RIGHT: The villa's vaulted entry hall runs the length of the house out across the pool deck to the changing pavilion.
Photograph Elle Decoration, Marianne Haas

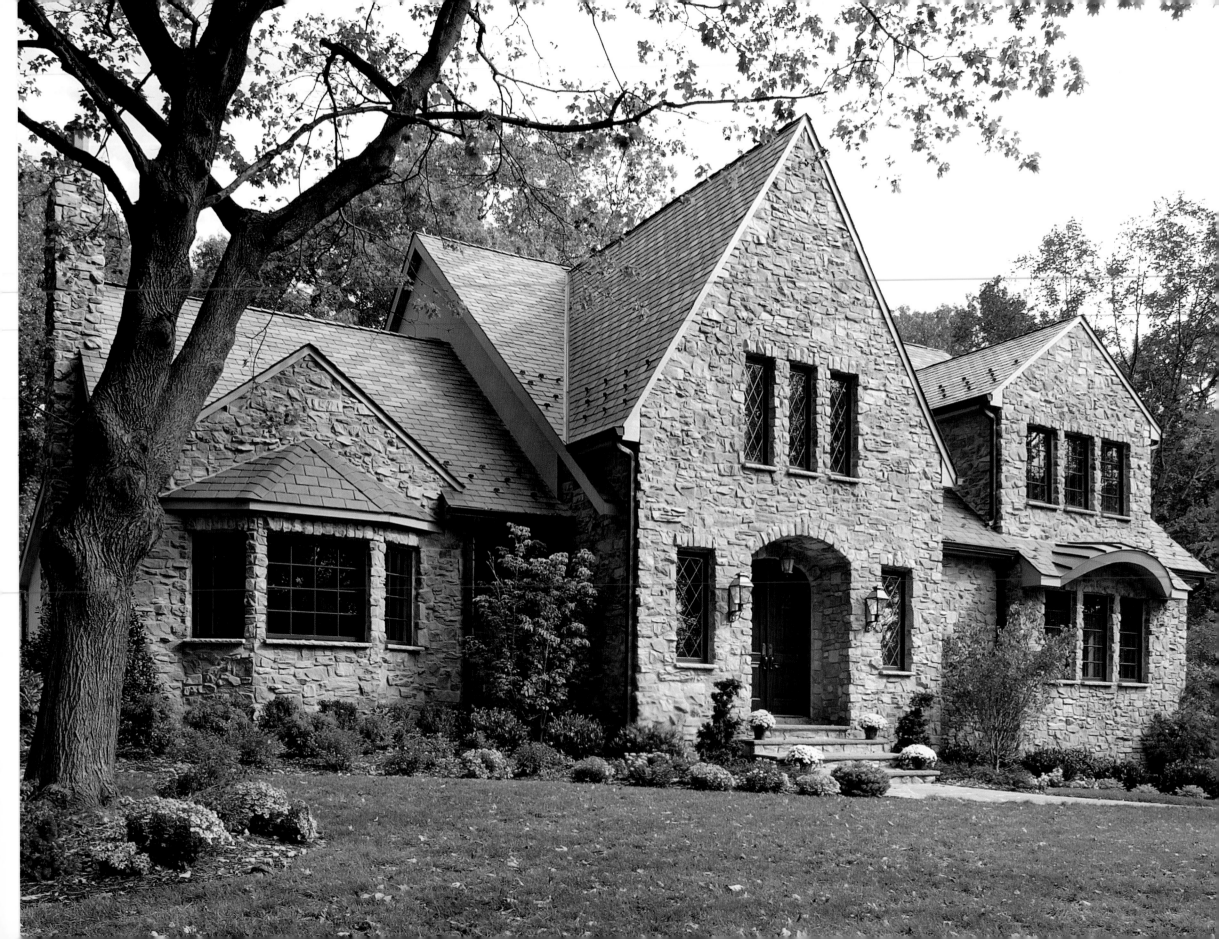

ROBERT COZZARELLI & ROGER CIRMINIELLO

Cozzarelli Cirminiello Architects

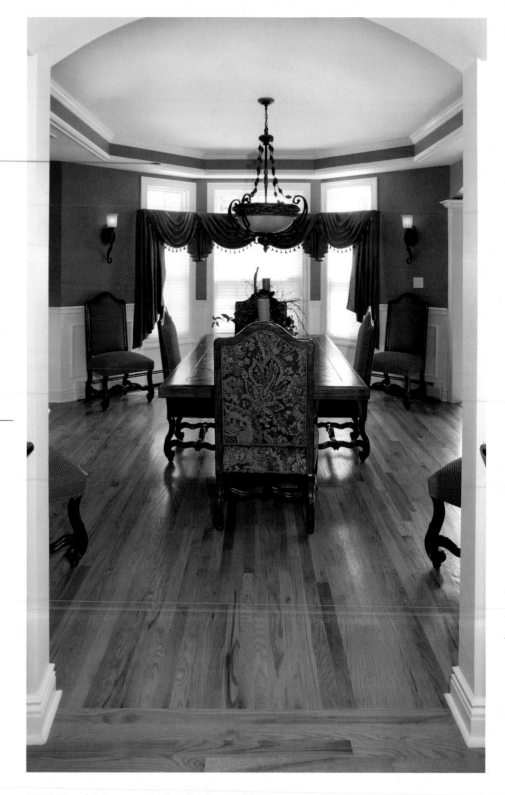

The success of most relationships lies in the chemistry of individuals and the sharing of their ideas. This holds true with the firm of Cozzarelli Cirminiello Architects.

Robert Cozzarelli founded his practice in 1986, Roger Cirminiello joined three years later, and the pair quickly discovered that they were simpatico, with complementary design perspectives and skill sets. Today, the partnership provides design, construction management, and design/build project delivery services in the commercial and residential realms — a diverse portfolio for a modest-size firm with talented architects who understand the design process and the philosophy of the firm.

The advantages of compatibility and collaboration extend to the architect-client relationship as well. Bob and Roger foster those beliefs through communication with their

ABOVE: View of dining room at Fairfield, New Jersey residence.
Photograph by Wing Wong

LEFT: Front view of residence in Essex Fells, New Jersey.
Photograph by Wing Wong

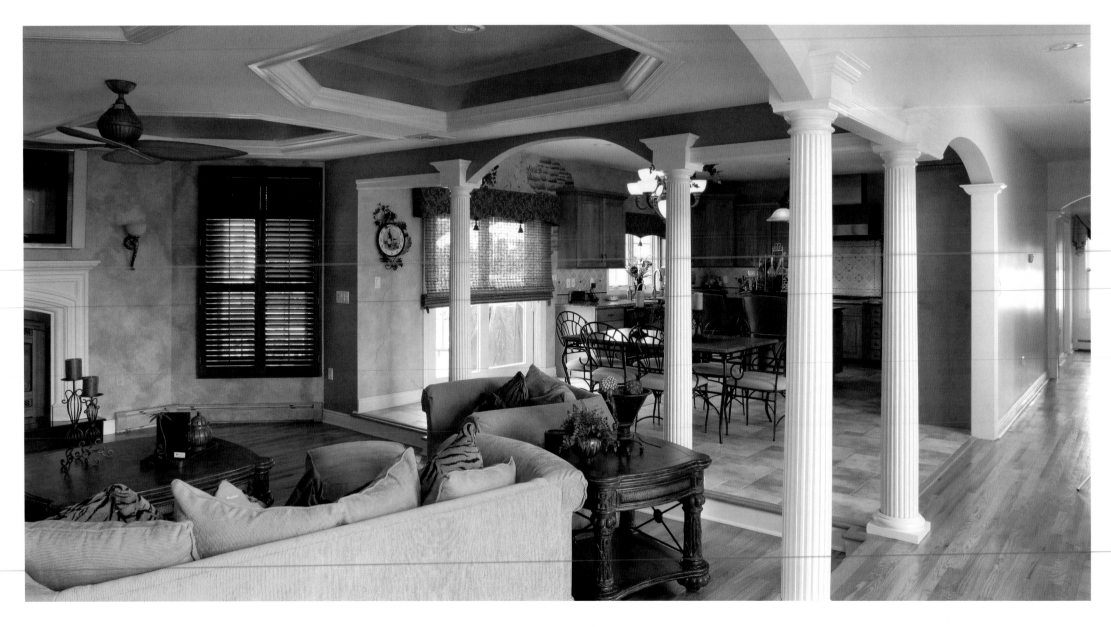

clients. They take their responsibility to the individuals who will live in their houses seriously, listening to their client's wishes from the initial meeting. "You can design all day," Bob says, "but half the equation is the client. You have to design for the client, and the client has to embrace the work. First and foremost, the architect must respond to the client's needs."

As members of the American Institute of Architects (Bob served as state president of AIA New Jersey in 2004), they also find that their association with other architects has helped to contribute to their accomplishments. Drawing on the fellowship that the organization offers — networking, continuing education, mentoring — they've been able to sensibly expand their practice and continually offer more progressive services to their clients.

ABOVE: View of family room at Fairfield, New Jersey residence.
Photograph by Wing Wong

FACING PAGE TOP: Rear view of residence in Essex Fells, New Jersey.
Photograph by Wing Wong

FACING PAGE BOTTOM: Front view of residence in Nutley, New Jersey.
Photograph by Wing Wong

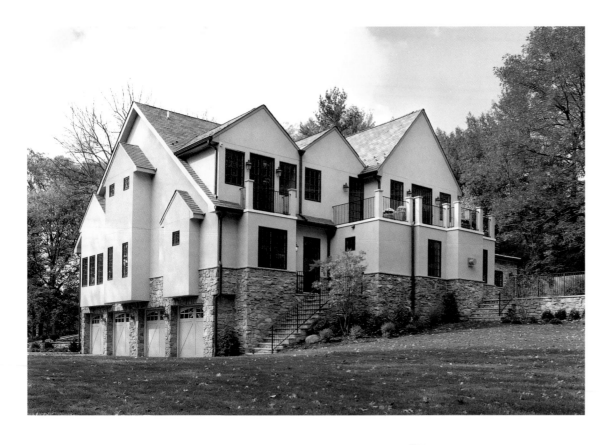

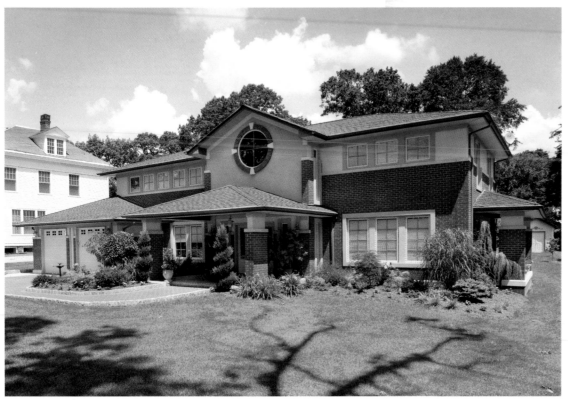

more about bob & roger...

When they're not working where can you find them?

Bob is cheering on his son at a wrestling match or his daughter at a track meet.

Roger enjoys taking long road trips with his wife and two sons.

What personal indulgence does Bob spend the most money on?

Architecture and art books are two indulgences, wine is another — Cakebread is among his favorites.

Name one thing most people don't know about Bob.

He is a great cook. As you might expect, Italian is his specialty. He has the advantage of old family recipes.

What color best describes Bob and why?

"Green," he says "because it indicates growth, change, and wealth."

What book has had the greatest impact on them?

Bob credits *Brunelleschi's Dome: How a Renaissance Genius Reinvented Architecture*, by Ross King. Rogers' choice is *Dune* by Frank Herbert.

Who has had the biggest influence on Roger's career?

His father. As a carpenter, his father taught him from a young age how a building is put together.

Cozzarelli Cirminiello Architects

Robert Cozzarelli, PP, AIA

Roger Cirminiello, AIA

Ron SanFillipo, Nehal Jhaveri, Gary Bielicka

727 Joralemon Street

Belleville, NJ 07109

973.450.4454

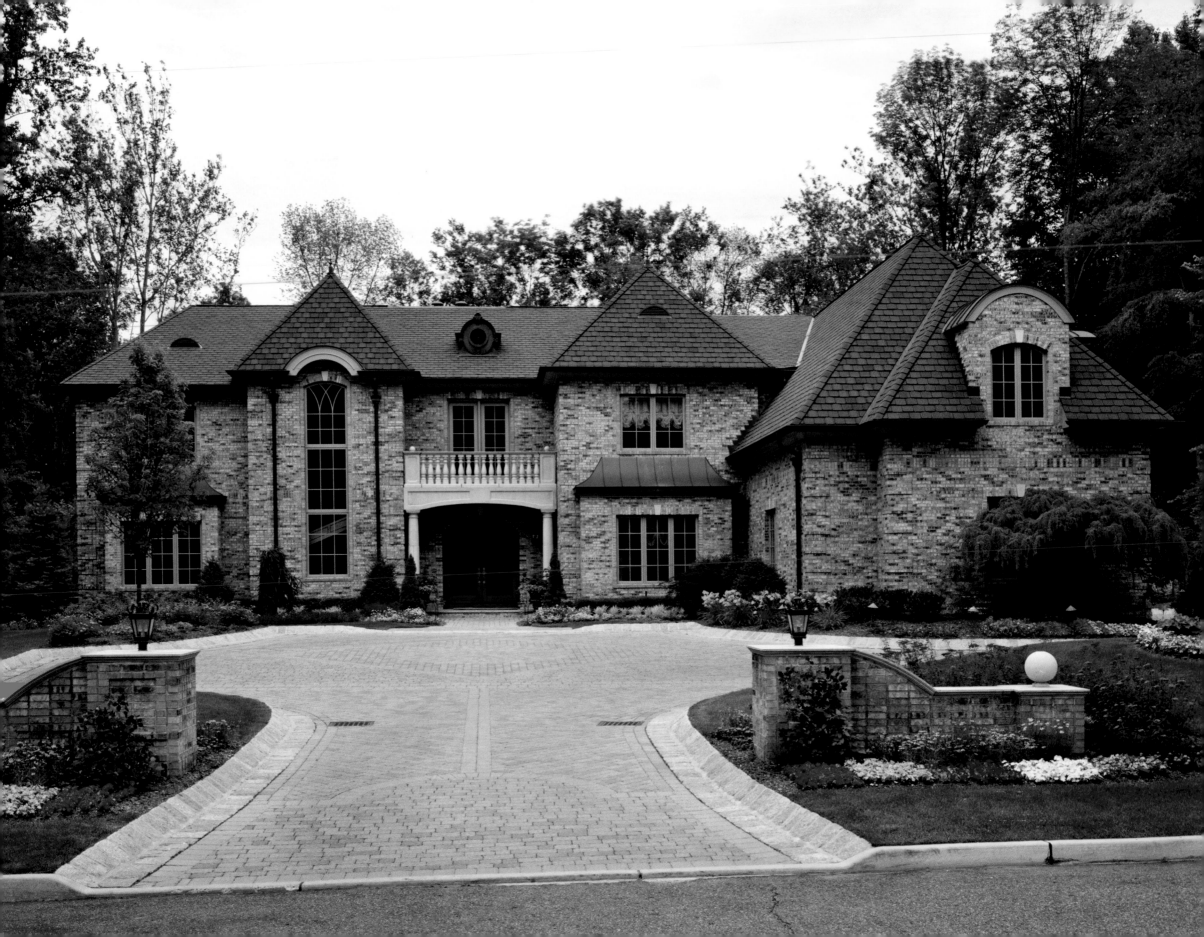

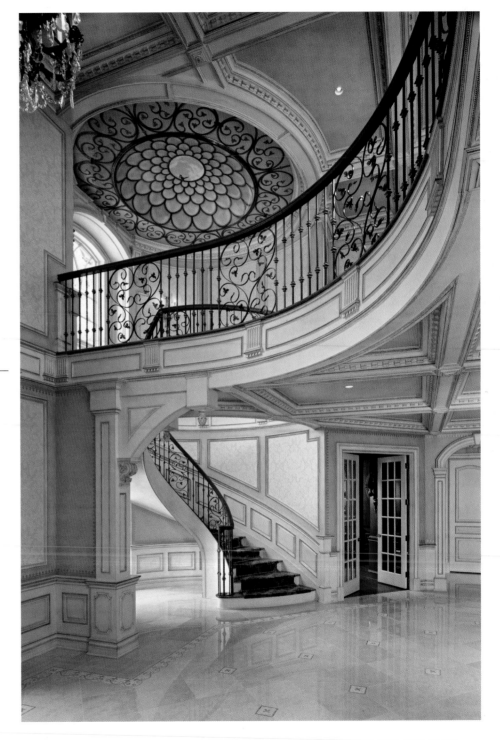

SCOTT FORBES
Forbes Enterprises

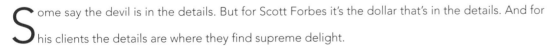

Some say the devil is in the details. But for Scott Forbes it's the dollar that's in the details. And for his clients the details are where they find supreme delight.

In the last eight years, the 37-year-old developer has earned a reputation for the kind of high-end homes in which no corner goes unfinished, no inch untrimmed. And whether it's a $1 million manse or a $10 million estate, he takes special care with each and likens all to works of fine art.

As an architectural entrepreneur, Scott's business approach is a bit unusual. Most of the work he does is on spec, so he doesn't design with a specific client in mind. Instead he's able to create anew as a project unfolds and modify as he sees fit — and as the budget allows. With a keen instinct for what will work, he's more apt to draw a picture on the wall of a house than to present a client with a stack of

ABOVE: Natural light illuminates the two-story stair tower in the foyer.
Photograph by Carol Bates

LEFT: A grand front entry of an Upper Saddle River residence.
Photograph by Carol Bates

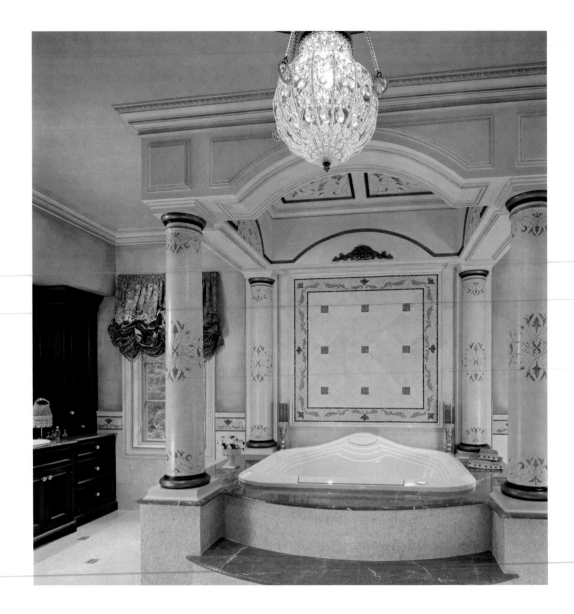

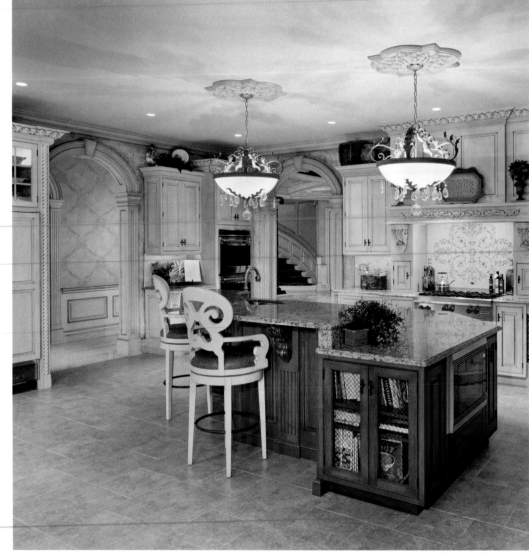

sketches. And when he is doing custom work on a ground-up project for a certain client, he quickly earns their trust when they step into the houses that he's designed and built for other people. One look and it's clear that Scott is a man who knows how to make architectural — and millwork — magic happen.

A hands-on professional with a staff of just three people, Scott spends his mornings in Saddle River and neighboring communities such as Park Ridge and Montvale, visiting each of his jobsites, inspecting the work and talking with an array of contractors and subcontractors. He spends afternoons meeting with clients and assessing future projects. His is a job that requires long hours and a lot of thinking. "You have to prepare for everything," he says. "You have to know where every switch will fall, where every knob and handle will be placed."

The homes that Scott designs and builds are one-of-a-kind treasures, unique in this world. And he loves his job. "It's not everyone who gets to do what I do," he says. His clients agree: Not everyone can.

ABOVE LEFT: The luxurious master bathroom boasts intricate tile work, custom millwork and a crystal chandelier.
Photograph by Carol Bates

ABOVE RIGHT: This spacious gourmet kitchen features an eat-in island with storage as well as brilliant custom millwork.
Photograph by Carol Bates

FACING PAGE TOP: A perspective from the foyer offers a spectacular view of stunning craftsmanship.
Photograph by Carol Bates

FACING PAGE BOTTOM: The formal great room offers a luxurious entertainment area complete with television built-ins and cozy fireplace.
Photograph by Carol Bates

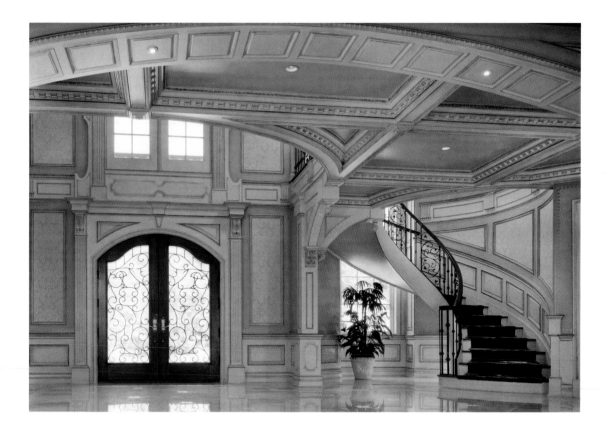

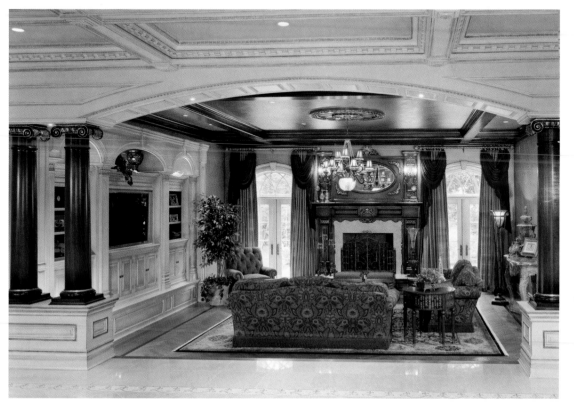

Who has had the biggest influence in his career?

Scott grew up around his stepfather's HVAC business, visiting jobsites and learning the ins and outs of high-end residential construction. He also credits his mother with giving him the confidence and support to pursue anything he sets his mind to. Those experiences planted in him a seed to someday start his own business.

What is the most unusual thing he's incorporated into one of his projects?

Scott built a second-floor prayer room in a residence he designed for an Indian family. That same house had a secondary kitchen especially for cooking spicy curries.

What is the most impressive home he's seen?

The architect is enamored with the mansions of Newport County, Rhode Island: The Breakers, The Elms, Rosecliff, Kingscote, etc. "What was done in that day was astonishing, especially when you consider the limited equipment," he says. The same applies to the great churches of Italy.

When he's not working, where will you find Scott?

The architect has been snow skiing since childhood and loves to hit the slopes in Colorado. He spends his summers at his home on Long Beach Island, where he takes to the water as often as possible.

Forbes Enterprises

Scott Forbes
PO Box 69
Saddle River, NJ 07458
201.934.8885

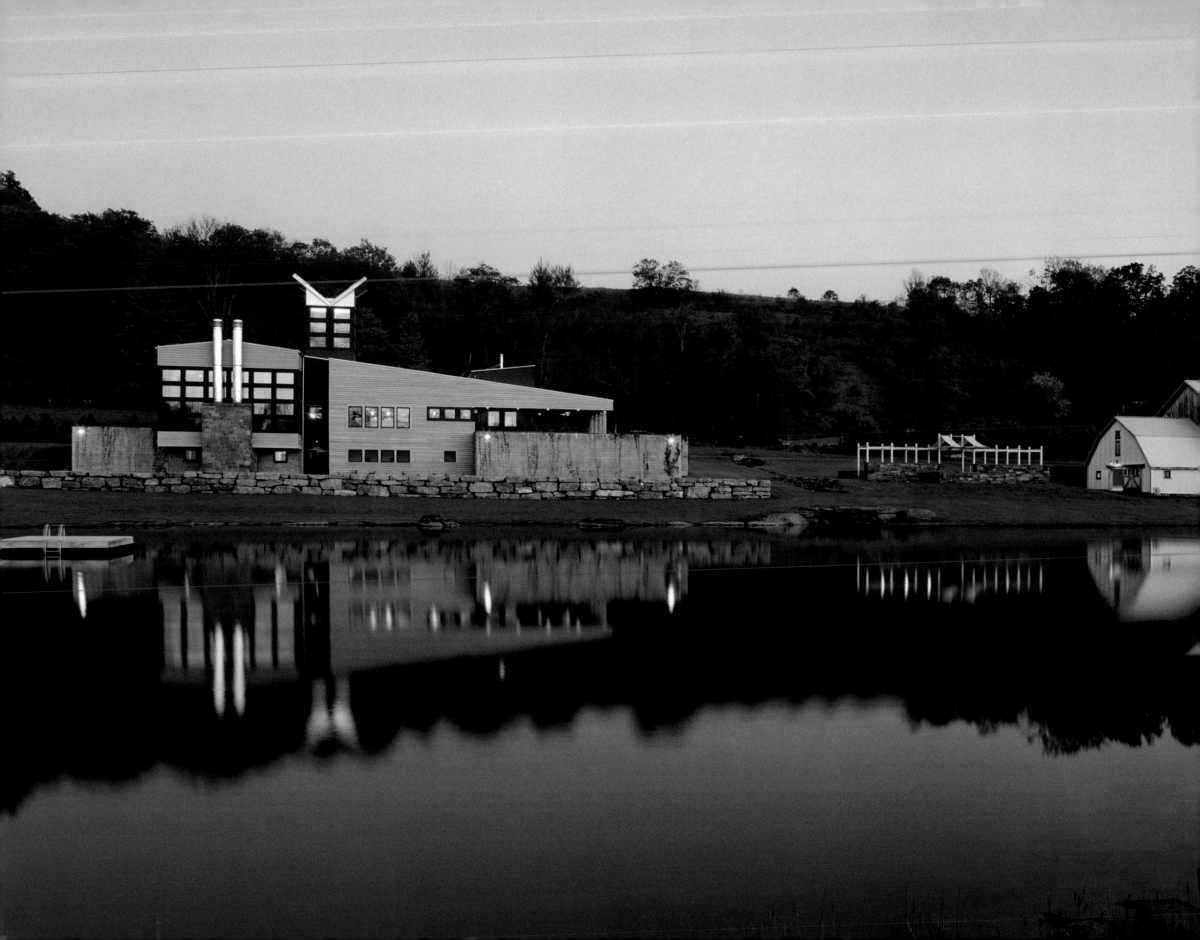

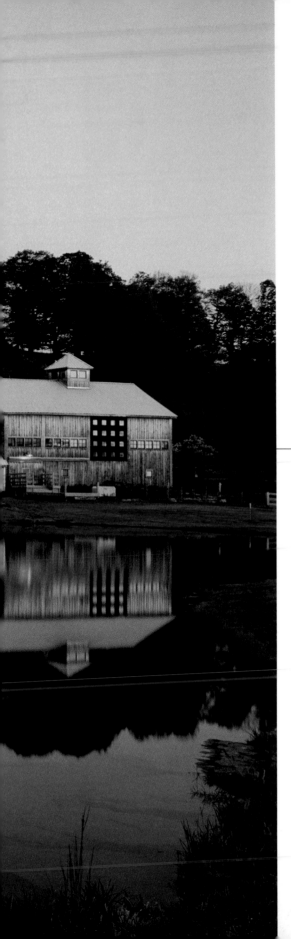

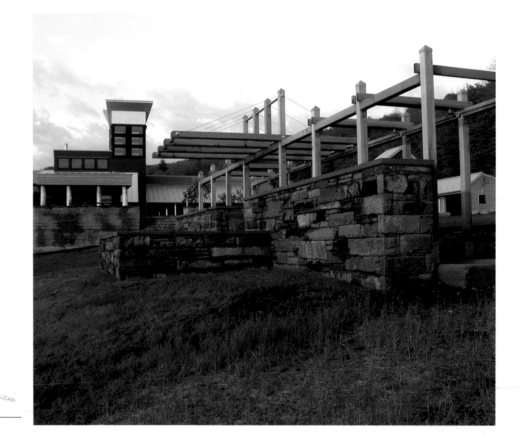

DEAN MARCHETTO
Dean Marchetto Architects

ABOVE: The garden structure was built on the foundation of an old dairy barn and serves as a link on axis between the restored barn and the house.
Photograph by Dean Marchetto

LEFT: Viewed from across the lake this house makes reference to the organization and scale of the restored barn once the primary structure of this former Catskill Mountain dairy farm.
Photograph by Bilyana Dimitrova

Though his friends will tell you that he's always busy working, Dean Marchetto makes time for mountain climbing. He goes with his three sons — 18-year-old Vincent, 16-year-old Steven, and 12-year-old Peter — and his wife, Irene. Twice he's climbed Mount Rainier in Washington. He's climbed Mount Conness at Yosemite National Park and to the base of the Tetons. He's conquered Mount Fuji in Japan and several peaks in Alaska at the Gates of the Arctic National Park.

There are parallels between mountain climbing and architectural design: Both take diligent preparation, patience, commitment, and appreciation for the surrounding landscape, and, often, team work.

A native of New Jersey, Dean founded his architecture firm in 1981, after graduating from the New York Institute of Technology with the Gold Medal for Highest Achievement in the architecture school and apprenticing with the acclaimed Gwathmey Siegel & Associates Architects in New York City — facts that can easily be seen as forerunners to his trajectory of success.

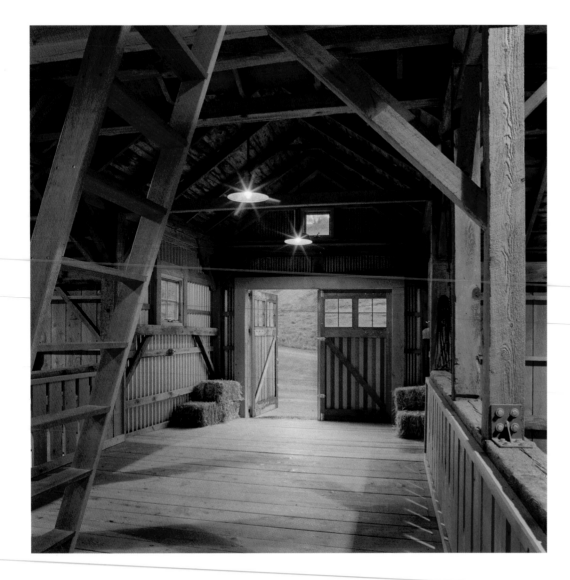

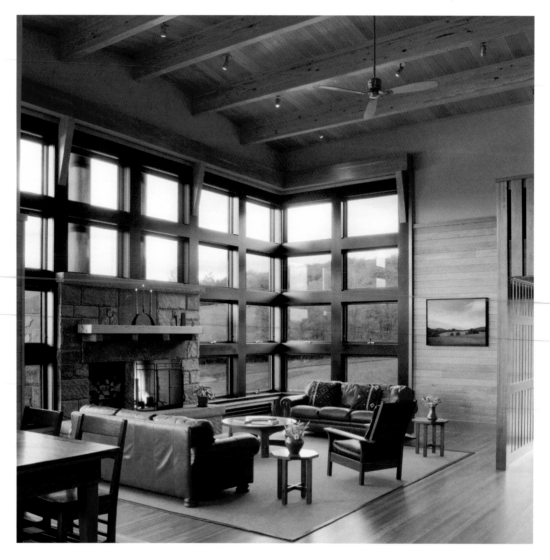

The architect credits Charles Gwathmey as having the biggest influence on his career. Under Charles's tutelage, Dean learned the importance of working with a grid and how to draw with pen and ink in a way so precise way that it affected everything else about his practice. And, he says, his firm's extraordinary record of built works is his proudest accomplishment. The firm employs just 12 people, including partners Bruce Stieve and Michael Higgins, who work with Dean on every project it designs and builds each year, many of them in the form of townhouses and condominiums. So many of his designs are built in the community of Hoboken, in fact, that there are many residential blocks where there are multiple buildings by the award-winning Dean Marchetto Architects.

ABOVE LEFT: Looking out from the hayloft through the barn doors. The ladder leads up to the cupola which provides panoramic views to the Catskill Mountains surrounding the property.
Photograph by Bilyana Dimitrova

ABOVE RIGHT: The living room windows express the organizing grid of the plan and also provide long views in three directions.
Photograph by Bilyana Dimitrova

FACING PAGE TOP: Motorized windows in the tower serve as a natural ventilation system for the entire house eliminating the need for air conditioning. The inverted roof is designed to catch rainwater for the plantings under the roof overhangs. Metal roofs on all of the buildings suggest a contemporary farm vernacular.
Photograph by Bilyana Dimitrova

FACING PAGE BOTTOM LEFT: Oak paneled walls and stone floors are natural local materials used throughout the interiors.
Photograph by Bilyana Dimitrova

FACING PAGE BOTTOM RIGHT: Fold down floor panels in the tower keep the heat down in the winter and provide a floor for the observatory.
Photograph by Bilyana Dimitrova

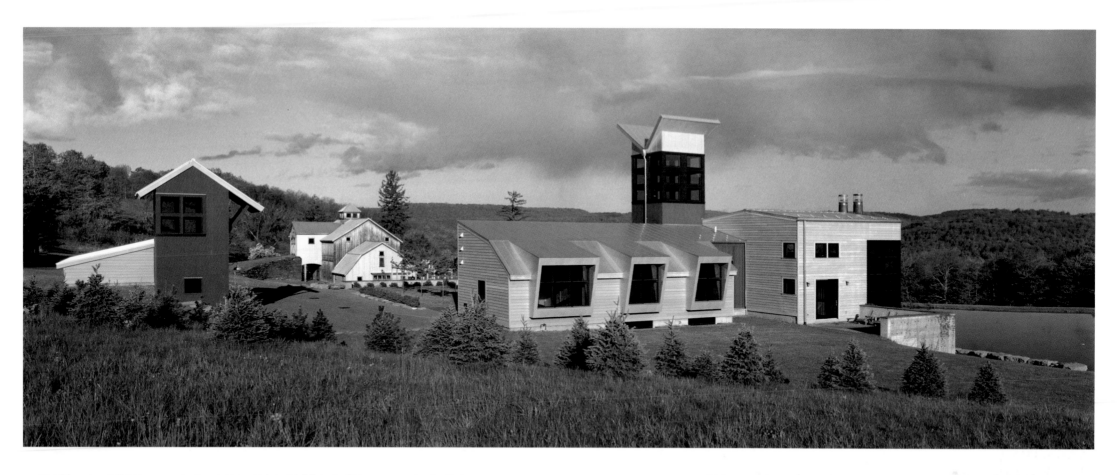

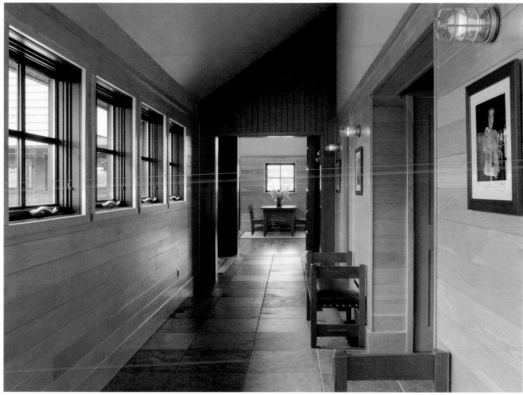

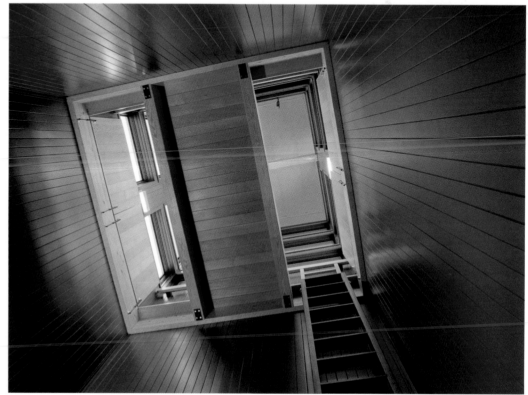

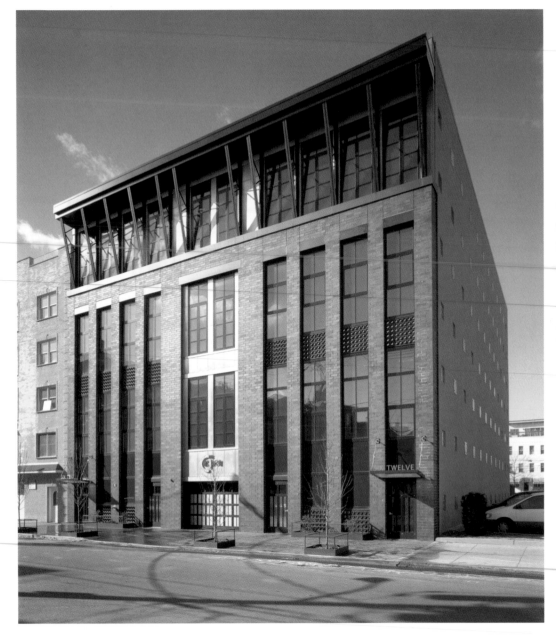

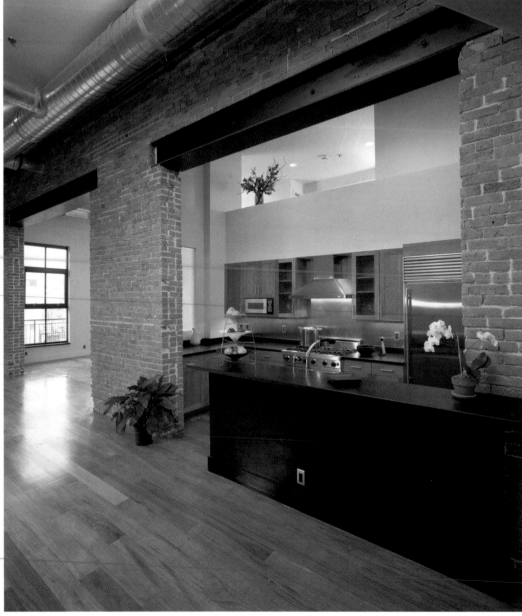

Dean is dedicated to good design and is seen as an artist by clients and peers alike. He gets his creativity from his father, an amateur sculptor who spent endless hours in his garage/studio making statues, ceramic tiles, plaster molds, and furniture. Today, Dean spends the same kind of time and energy in his Hoboken office finding modern architectural solutions for new buildings in existing contexts.

And for Dean that means being concerned about and respectful of the environment, using sustainable materials when possible, and working with a "green" philosophy. In 2005, the firm received two of three Smart Growth awards (presented by the New Jersey's Department of Community Affairs in association with the American Institute of Architects) for its work on the Mulberry Street Promenade in Newark and the Jersey City Greenway Project. "Recognition for Smart Growth design is important to me as an architect because as the world becomes more compact we must learn to reurbanize in ways that protect our environment and conserve our natural resources," Dean says.

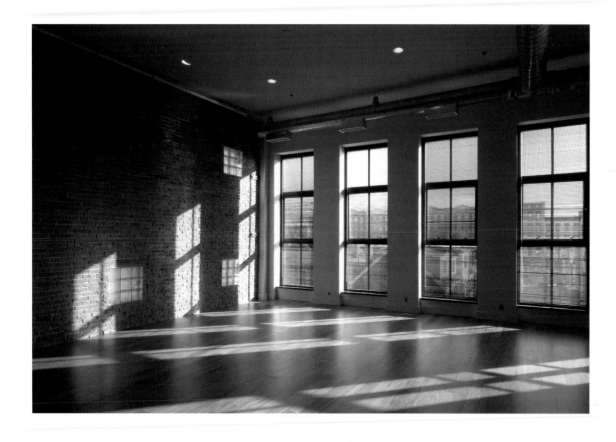

What personal indulgence does he spend the most money on?

Dean has an impressive collection of Arts & Crafts-style antique furniture and pottery. He likes Stickley pieces because the design is modern yet the natural wood finish gives them warmth.

What book has had the greatest impact on Dean?

Like many, Dean recognizes *The Death and Life of Great American Cities*, Jane Jacobs's 1961 critique of modernist city planning policies, as arguably the most influential book written on the subject in the 20th century.

What single thing would the architect do to bring a dull house to life?

Bring the outdoors inside by incorporating big windows, skylights, expansive doorways, etc.

What is the most unusual/expensive/difficult design or technique he has incorporated into one of his projects?

Dean uses natural copper or zinc metal cladding as a component of the exterior skin of a building. "Intense detailing and craftsmanship are essential for a successful result, the finished product is often elegant, sustainable, and lasts maintenance free for 90 to 100 years," he says.

Publications:

The work of Dean Marchetto Architects has appeared in *Architectural Record, Residential Architect, Architecture New Jersey, Home* magazine, *New Jersey Monthly,* and *The New York Times.*

Dean Marchetto Architects

Dean Marchetto, AIA
1225 Willow Avenue
Hoboken, NJ 07030

201.795.1505

www.dmarchitects.com

ABOVE: The CastIron is a brick industrial warehouse in Hoboken New Jersey which was converted into a loft condominium. High ceilings and oversized windows provide an abundance of light and views to the Manhattan skyline.
Photograph by Stephen J. Carr

RIGHT: Stainless steel fixtures together with black and white finishes suggest an urbane industrial loft style.
Photograph by Stephen J. Carr

FACING PAGE LEFT: Black Ironspot brick and zinc panels together with the truss framed cornice at the roof line help to integrate the CastIron façade into the existing urban context.
Photograph by Stephen J. Carr

FACING PAGE RIGHT: Designed in association with boutique developer Jenniann C. Barile the original brick walls were preserved to establish the character of the interiors.
Photograph by Stephen J. Carr

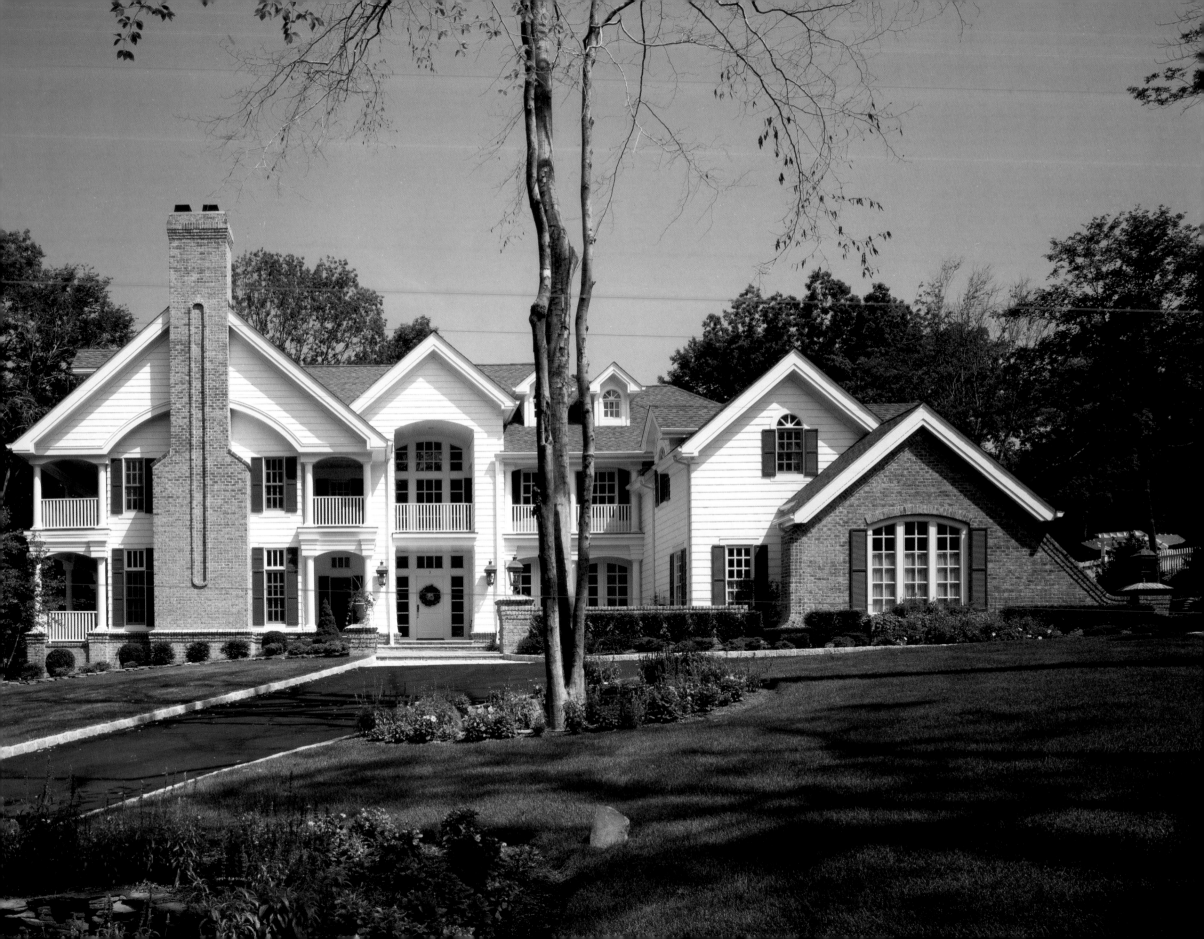

JOHN W. & CONSTANCE K. SALUSTRO

Salustro Partnership Architects

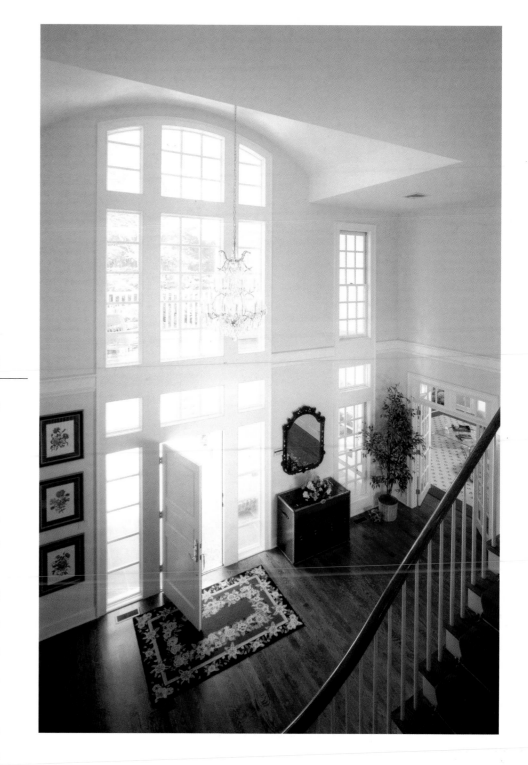

John and Connie Salustro met at the esteemed School of Architecture at the University of Miami. Right away, they knew that a passion for the built environment wasn't all that they shared. They quickly became partners in life and work, aspiring to one day have their own architecture practice.

They opened Salustro Partnership Architects in 1984 and today provide a full range of architectural and interior design services — from design/build expertise to custom interiors, additions to new home construction — for both residential and commercial projects. Together, John and Connie have a combination of talents that makes for a creative whole, developing all of their projects together, giving their clients the benefit of their broad range of talents.

With a staff of just five, the Salustros have kept their practice small because they like to be involved in every part of a project, beginning with the site design. "Architects are often thought of as simply building designers," John says. "But you don't just design a house in your office, at your desk, then plop it down on a plot of land. You have to consider how the house will be oriented on the site,

ABOVE: Entrance foyer of the home shown at left.
Photograph by Michael Slack

LEFT: A home with porches blending a mix of wood shingles and brick.
Photograph by Michael Slack

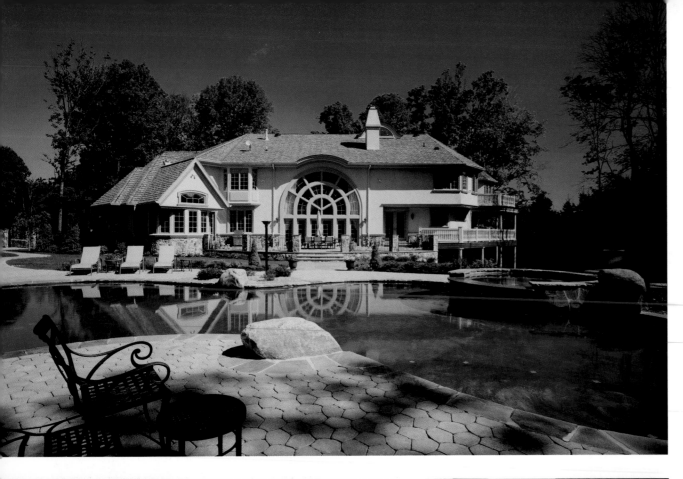

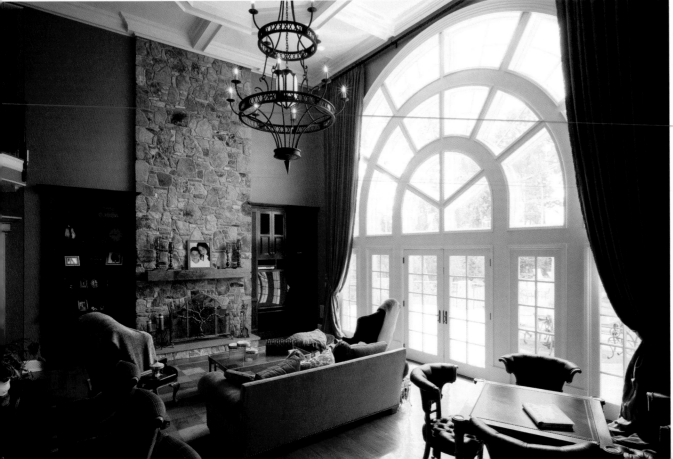

how the winds will effect the house, where the sun rises and sets." Such are the things that subtly alter the experience of being in a house.

However, for a small firm Salustro Partnership does some pretty ambitious work. The firm takes on about 45 jobs a year; half involve giving clients a version of their dream homes. "We focus on turning out stand-alone, one-of-a-kind, custom structures, and we have developed our office with the purpose of producing this kind of work," Connie says. A dedicated staff of skilled individuals, who work with the Salutstros not for them, makes that possible.

When it comes to design, John and Connie truly listen to what their clients ask for. They recall one project, 15 years ago, in which they were the third architects brought in for a job (one of their first custom-home clients). The client's first two architects didn't give her what she wanted, so her builder finally sent her to Salustro Partnership. To this day, the client still beams when she talks about her experience with the Salustros and her wonderful home.

Additionally, the Salutros like to surprise and educate their clients. In the area in which they practice — New York, New Jersey, Connecticut, Rhode Island, and Pennsylvania — most people fall on the conservative side of architectural preferences, and though that's not the architects' personal choice, they are adept at doing traditional — with a twist. With an eye toward originality, John and Connie mix styles for a fresh perspective with historical influences. People recognize their designs as something different — indeed, special — right away.

TOP LEFT: Rear view from the pool. Visible is the large feature window in the family room, kitchen to the left and porch to the right.
Photograph by Michael Slack

BOTTOM LEFT: Rear feature window, fireplace, wall unit and coffered-ceiling of the two-story family room.
Photograph by Michael Slack

FACING PAGE TOP: Interior view of the interior living room of a New York City, Park Avenue apartment.
Photograph by Michael Slack

FACING PAGE BOTTOM: Master bathroom of the New York City, Park Avenue apartment.
Photograph by Michael Slack

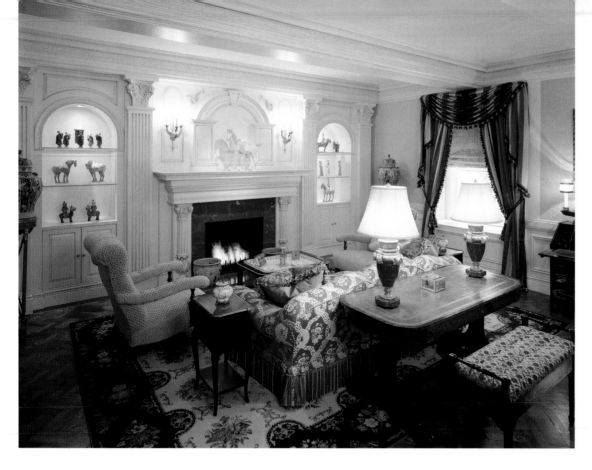

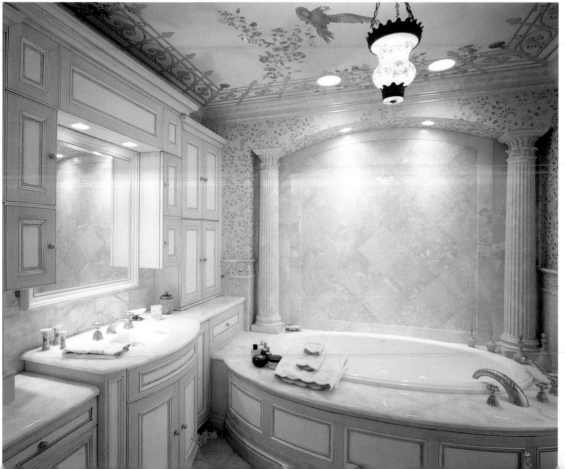

more about john & constance...

When they aren't working, where will you find the architects?
John and Constance have two girls, ages 11 and 15, who are involved in lots of extracurricular activities. As parents, they're their children's biggest fans and spend their time supporting their endeavors.

What's the greatest compliment that they've received professionally?
"It is very gratifying to have a client tell you that what you have designed is perfect for them," Connie says. "To repeatedly hear that kind of feedback lets you know that you have accomplished something for that person and that he or she truly appreciates and enjoys it."

If they hadn't become architects, what profession would they have chosen?
Connie's mother encouraged her early on to pursue a career as an architect. She found that she loved the work and devoted herself to it. Architecture is her true calling and Connie has never given much thought to other professions. John also realized at a young age a keen interest in architecture, but he is also a gifted guitar player; given his determination and dedication to whatever he does, he would likely have been a successful one.

What's the most impressive home they've ever seen?
Hands down, John says, it's Frank Lloyd Wright's Fallingwater. He admires the way that the famed architect constructed the house over the waterfall instead of across from it — an example of the kind of out-of-the-box thinking to which Salustro Partnership aspires.

Salustro Partnership Architects

John W. Salustro, AIA, PP, NCARB
Constance K. Salustro, RA, PP, NCARB
784 Chimney Rock Road
Martinsville, NJ 08836
732.764.8866
www.salustroarchitects.com

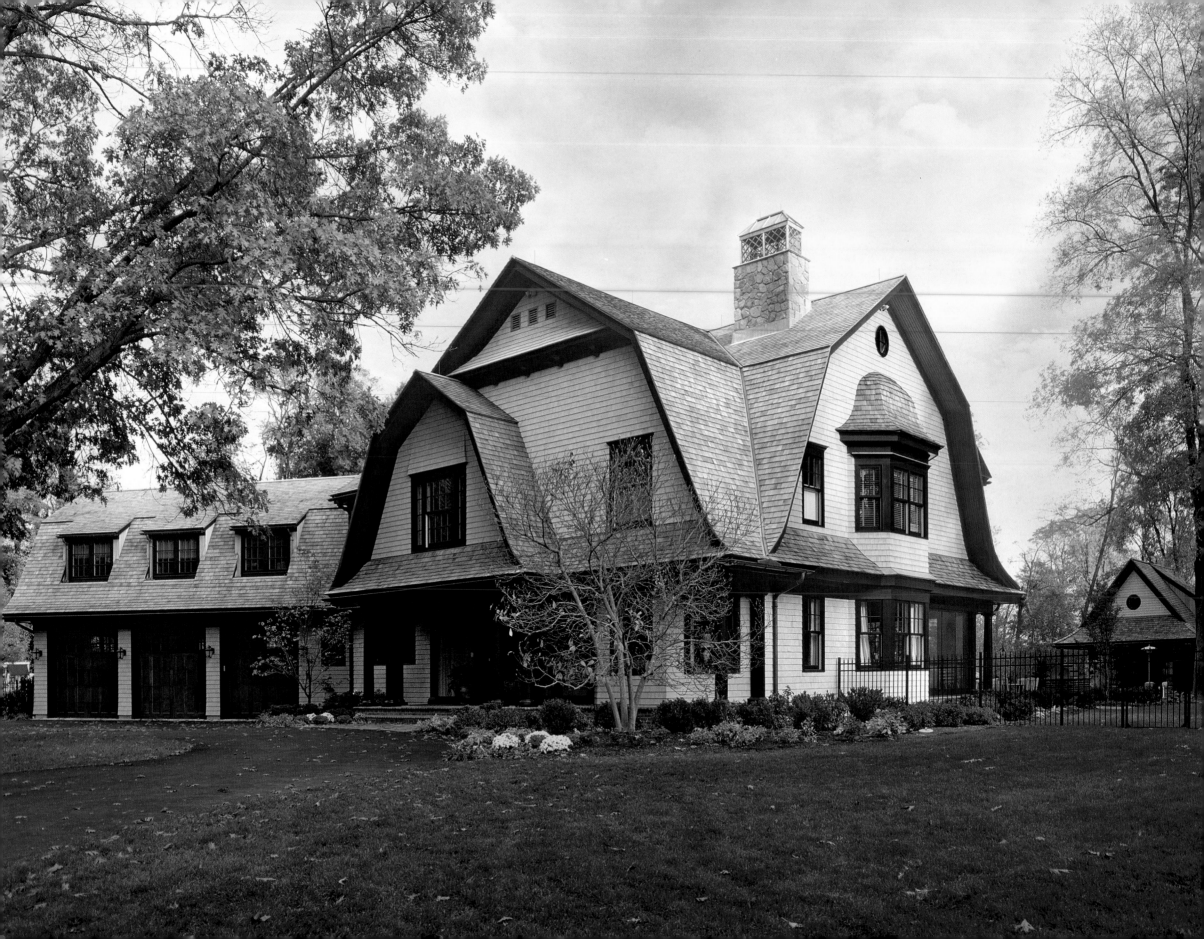

MICHAEL UNGER &
MICHAEL MAHNS

Unger & Mahns Architects

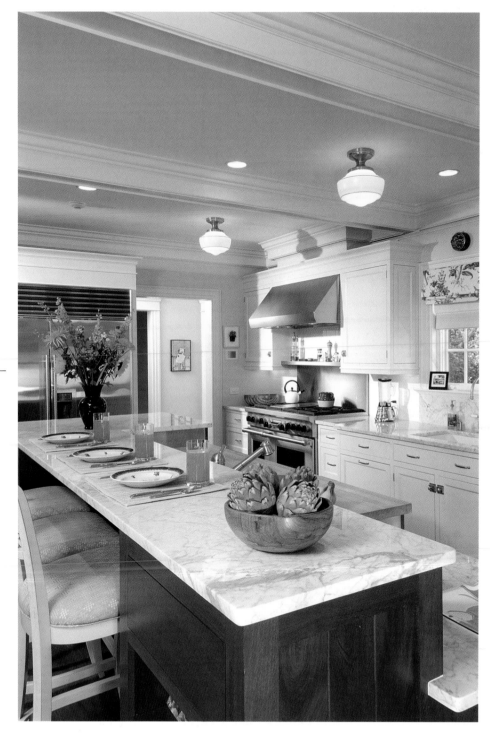

Forged from a mutual appreciation for the art of architecture and an alliance of complementary philosophies, Michael Unger and Michael Mahns founded Unger + Mahns Architects 13 years ago.

Drawing from past experience mixed with a bit of realistic idealism, each brought to the table definite ideas of what a "successful" architecture firm meant. For Unger, working for a large firm had its advantages, no doubt, but also its draw backs. Namely, he enjoyed learning each aspect of architecture, but didn't want to become an expert in one small piece of a very big puzzle. Desiring to reignite his passion for the entire process of architecture, he joined a small New Jersey firm. After the firm's principal retired, Unger inherited a client base that has expanded over time.

Mahns became acquainted with Unger while consulting for him and the two clicked. It just happened to be the right time in their respective careers as Mahns was looking for an effective partnership with the right firm. Unger + Mahns was born. Today, this firm works on about two to three

ABOVE: In a Fair Haven residence, the kitchen is a bright and cheerful place for family and friends to gather for good times. It opens to a pool and spa area.
Photograph by Jeff Smith

LEFT: This Rumson residence is an informal Shingle-style home with some classical elements. The details reflect the clients' love of craft with deference for neighborhood context.
Photograph by Jeff Smith

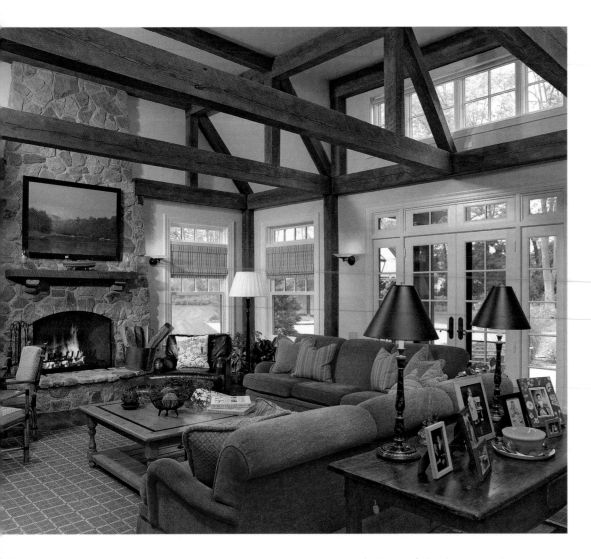

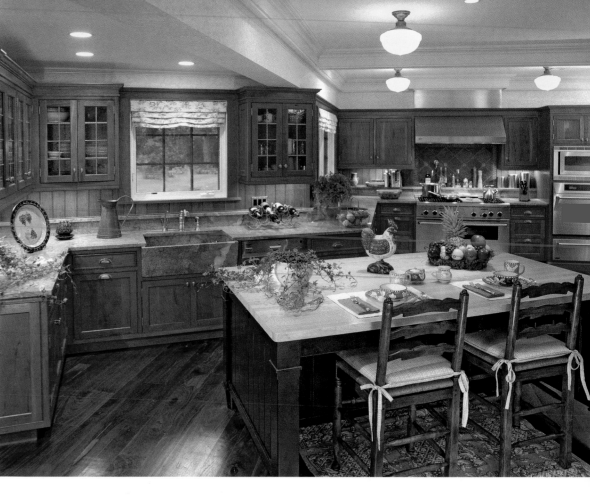

dozen projects a year primarily in Central New Jersey, each of which unfailingly garners the partners' personal attention and design expertise.

Both Unger and Mahns believe in following the roots of traditional architecture in which designers focus on the entirety of the project from the inside out. It is not unusual for the duo to design kitchens including elaborate cabinetry and entire interiors as well — feeling that each aspect of the house, whether large or small in scale, is inherently connected.

The partners don't adhere to a particular "style," because styles, like fashions, come and go. Unger and Mahns believe this to be directly antithetical to architecture and building which should endure, expressing a timeless quality.

Much more important than style has been their commitment to professional service for their clients. Understanding their clients is where design begins. Architecture evolves from the site, the program, the client values, the economic realities, and the appropriateness of the availability

of technology to respond in kind. In essence, great architecture is the harmonious expression of all these elements.

This intimate firm quite literally proves that bigger does not necessarily mean better. Take for example, a renovation project for which they were honored in 2002 by the Monmouth County Historical Commission. When the project was completed, the Depression era Colonial Revival home, designed by Arthur Jackson, ended up 4,000-square feet smaller. The designers removed an incompatible '50s-era indoor swimming pool addition and brought the interior up to a level worthy of the estate's rich lineage. They also added a vineyard on the estate which already contained an orchard of pear and apple trees traced to Colonial times.

It is somewhat of an anomaly in renovation work to end up with less square footage in the end, but it is very telling of Unger and Mahns' dedication to improving the architectural environment around them.

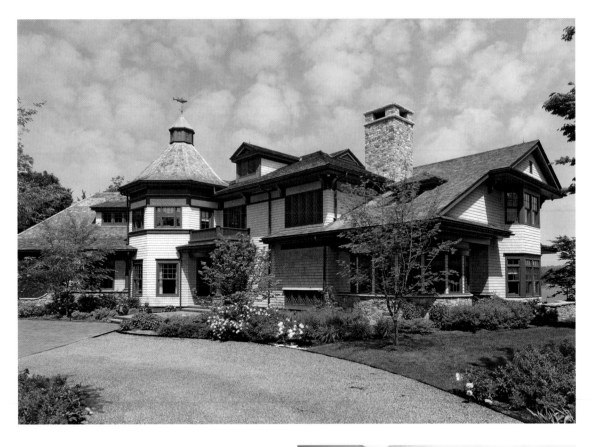

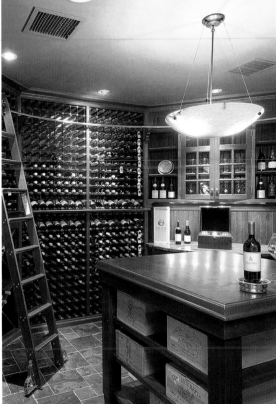

ABOVE: This Fair Haven residence makes the best use of a complex site to provide stunning views of the Navesink River and a comfortable setting.
Photograph by Jeff Smith

RIGHT: The distinct octagon shape, a prominent feature at the front of the house, is recalled in the wine cellar below.
Photograph by Jeff Smith

FACING PAGE LEFT: In the Rumson residence, a view to the living room shows heavy timber framing and a stone fireplace with a raised hearth.
Photograph by Jeff Smith

FACING PAGE RIGHT: A view of the kitchen shows knotty cherry cabinets and a painted island that lets some character of the wood show through.
Photograph by Jeff Smith

more about michael & michael...

Q & A

What book has had the greatest impact on them?

In terms of architecture, *Building the Getty* by the Architect Richard Meier has been inspiring. It is the author's personal account of the twelve year process of design and construction of the Getty Museum in Los Angeles. It reinforces Unger & Mahns philosophy that architecture and construction are never really done in isolation but are the product of the designer's values and a team effort including a committed client, consultants, and builder.

What do they most enjoy about being architects?

The most rewarding part is seeing ideas come to fruition as a physical form that has meaning to their clients. There are not many professions where the results are quite as tangible.

Who has had the biggest influence on their career?

Of the architects that have been important to them, the most influential have been the great "house" architects such as David Adler, Julia Morgan, and Stanford White. The books authored by Vincent Scully have also been inspirational.

What is the most unusual, expensive, difficult design or technique they have used?

Many new house projects involve the removal of an existing structure as un-built sites are in short supply. The methods of responding to hilly terrain or waterfronts have contributed significantly to the hard costs of construction. In addition to this there are the soft costs, time factors, and restrictions that come with addressing various federal, state, and local zoning agencies. The part that requires some subtlety is in not allowing the solutions to these issues compromise the beauty of the architecture or livability of the home.

Unger + Mahns Architects

Michael Unger

Michael Mahns

43 West Front Street, Suite 9

Red Bank, NJ 07701

732.741.6911

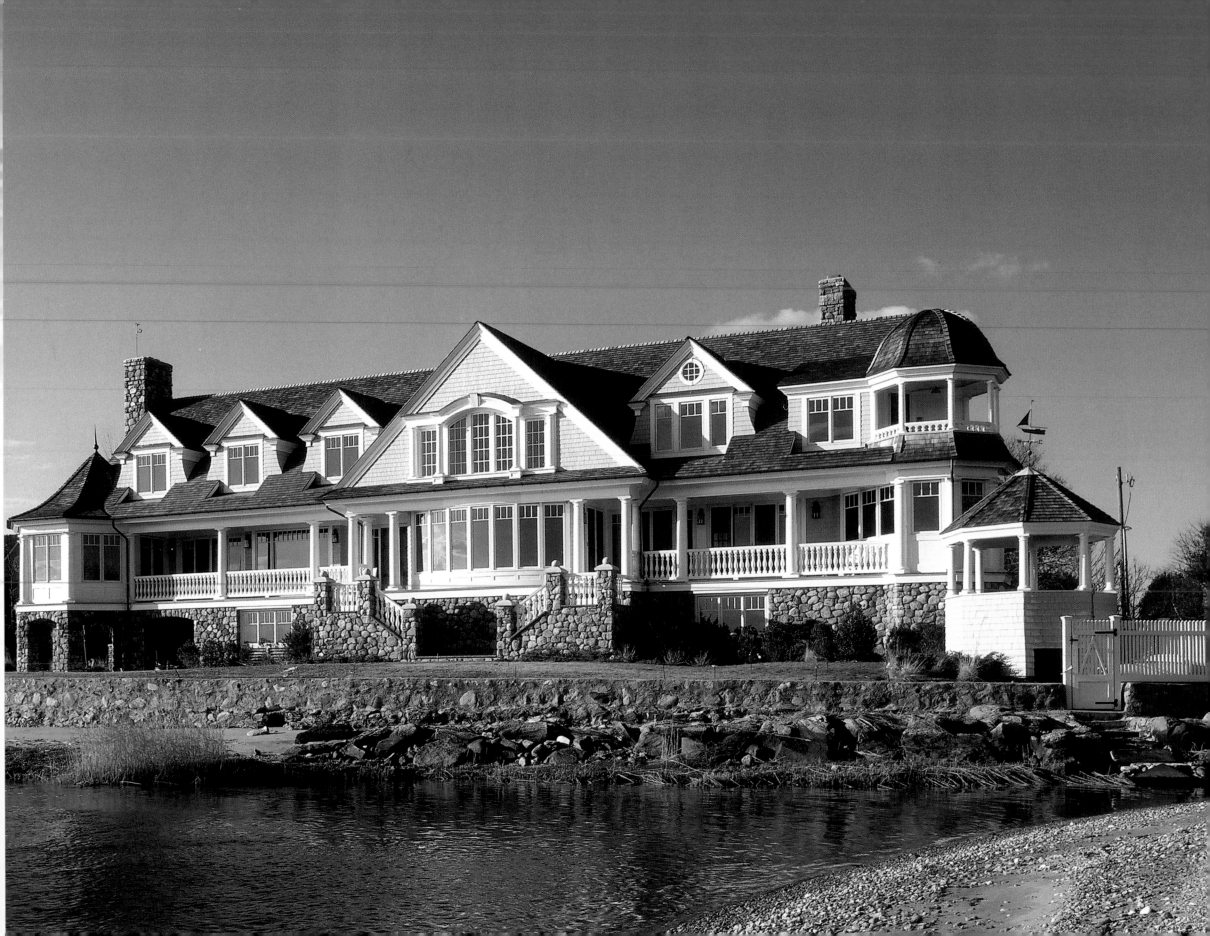

ROBERT A. CARDELLO

Robert A. Cardello Architects, LLC

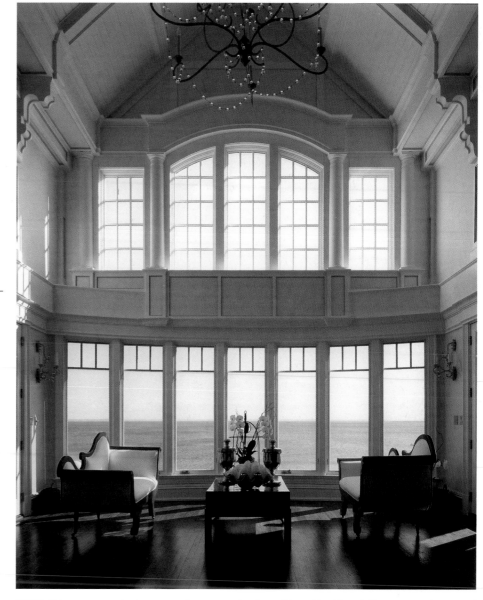

M ake exceptional design your priority and you will succeed as an architect. This is the belief of Robert Cardello. His unwavering commitment to the perfect balance of proportion, light, and client needs stands above all else.

Robert's 12-person firm offers a full scope of services — from consultation to bidding to construction administration. Though the architect handles both commercial and residential design, the Connecticut native focuses on the kind of coastal, Shingle-style homes he grew up with. It's a vernacular that allows the architect some measure of freedom in design yet maintains a traditional language.

Whether for an art studio, public plaza, or single-family home, Robert collaborates with his clients to exhaust the design process, acting as an interpreter and giving his clients a sense of ownership in their projects. "Since the onset of my practice, it has been my wish to show our clients the thrill of building their dream home," he says, adding that he considers his profession a privilege and his clients a blessing.

As in carving a beautiful piece of sculpture, the details related to a building evolve as the process unfolds. "In the pursuit of perfecting this process, I act as a shepherd of sorts."

Robert A. Cardello Architects, LLC

Robert A. Cardello, AIA
97 Washington Street
South Norwalk, CT 06854
203.853.2524
www.cardelloarchitects.com

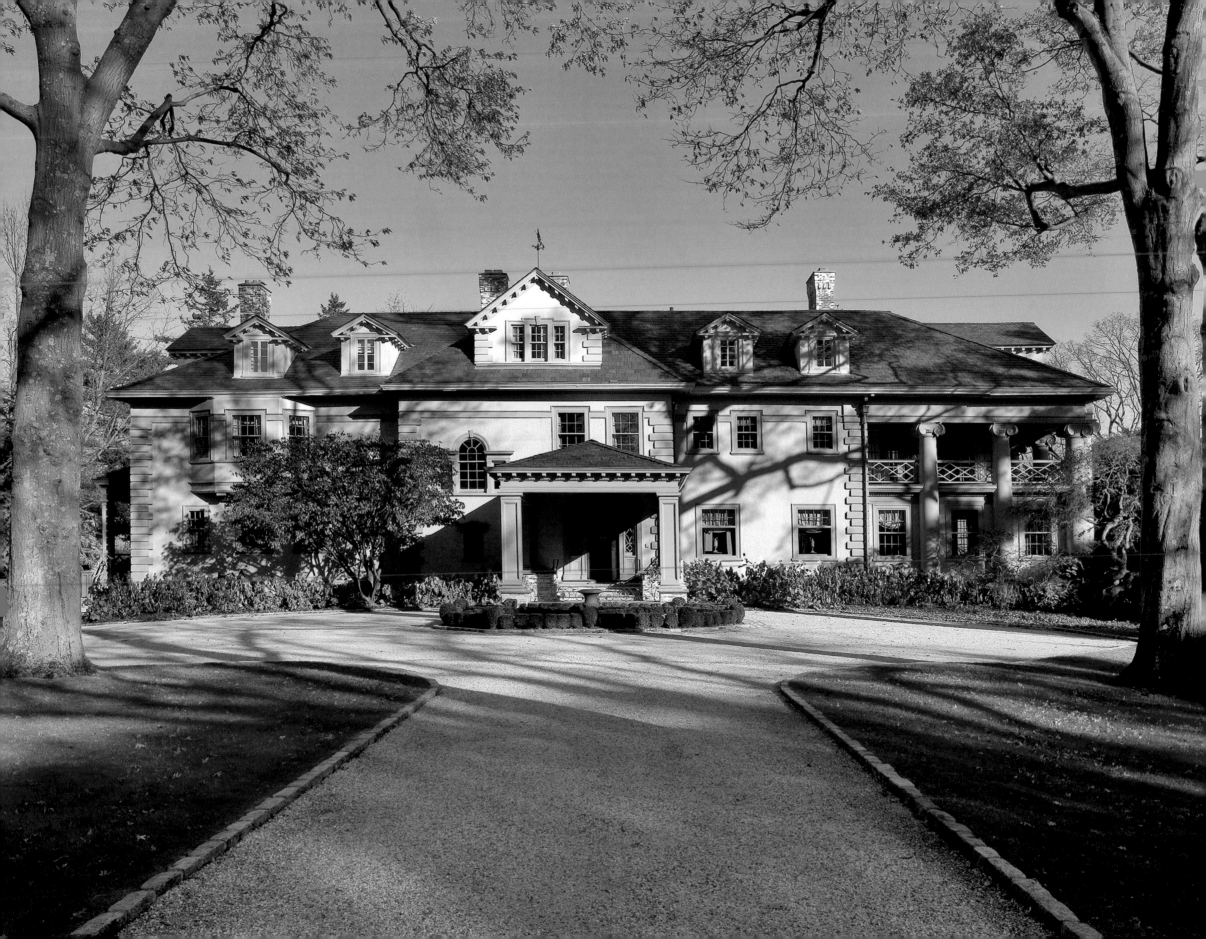

ROBERT DEAN

Robert Dean Architects

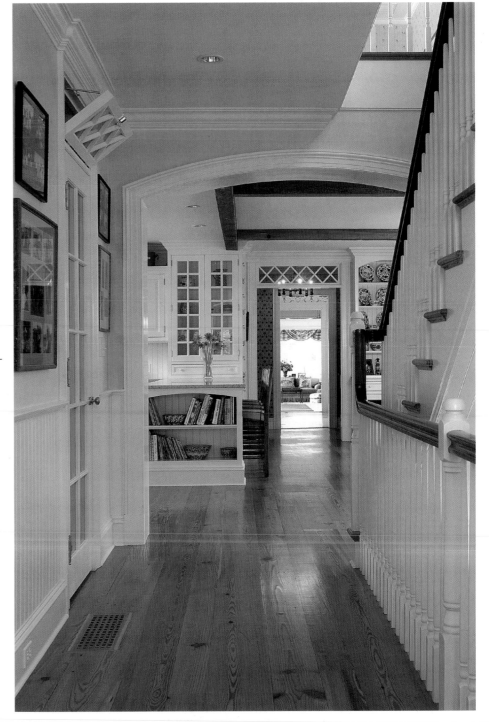

ABOVE: The family entrance at a rambling New England country house harkens back to a relaxed and comfortable style of life.
Photograph by Tim Lee Photography (courtesy of Kenneth Bacco Inc.)

LEFT: The restored front facade of a distinguished Italian-Renaissance Revival house sustains the elegant presence of a 100-year-old landmark.
Photograph by Olson Photographic LLC

We're architects of the old school, more interested in the beauty than in the logic of creation yet searching for the transcendent point at which beauty and logic merge. That's how Robert Dean describes himself and his firm.

This 27-year architecture veteran also speaks of his work as a commitment to a "design ethic" extending both forward and backward in time, making connections that are both historical and original. Architects, he says, must align themselves with the past to fully understand its design values, but they also must carry those values into the future and make their own contributions to the body of knowledge and tradition. He elaborates with a literary analogy: "An author does not set out to write a new dictionary. He uses words and syntax that have been assembled by many hands, over a very long time — and from those words he builds meaning. And the same dictionary of English words can give us Shakespeare and Kerouac."

For his design philosophy, he looks to those architects of 75 to 100 years ago who took style seriously and saw it as something that added meaning to their craft and to the world around

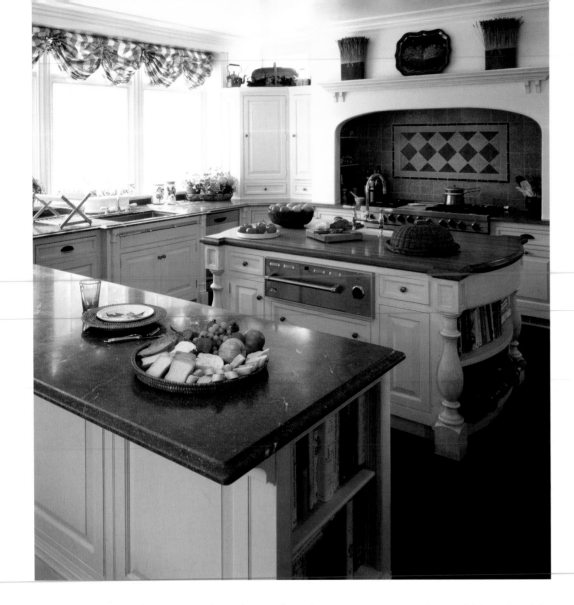

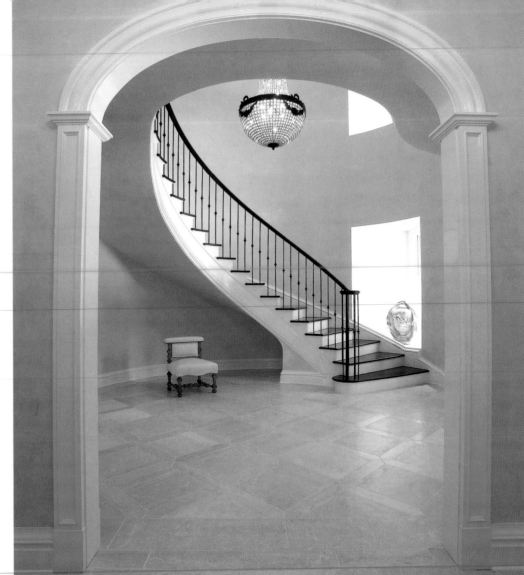

them. "Style should not come through in a forced way or as an attention-grabbing gimmick, but as a language that a sophisticated person uses elegantly and unconsciously, every day," Robert explains.

Like many architects, Robert grew up around the construction business. He also grew up with an abiding interest in history, with a particular interest in old buildings. He found their details exciting, their relationship with their surroundings gentle compared to newer constructions that often seemed sleek but simplistic. He describes seeing, even in old buildings that were devalued and in decline, the way that their builders had tried to apply their innate sense of beauty as a means of modeling their worldly values — embodying John Keats's observations that "Truth is beauty, beauty truth. That is all ye know on earth, and all ye need to know."

After graduating from Columbia University's architecture program, Robert went to work for noted architects and firms such as Skidmore, Owings & Merrill; Philip Johnson; and Robert A.M. Stern, and taught design at Syracuse and Columbia. He opened his own firm in 1986 and today devotes himself to designing buildings that are undeniably new yet sometimes seem so familiar that visitors refuse to believe that they haven't been around for ages.

ABOVE LEFT: Bright and open kitchen sits at the heart of a new house on an old farm site.
Photograph by Georg Mueller-Nicholson

ABOVE RIGHT: Classic circular stair and entry centers a Neo-Georgian design.
Photograph by Olson Photographic LLC

FACING PAGE TOP: A library of exceptional elegance can still be a cozy place to read.
Photograph by Olson Photographic LLC

FACING PAGE BOTTOM: This house merges with the pool and terraces to make the most of a view-oriented waterfront site.
Photograph by Olson Photographic LLC

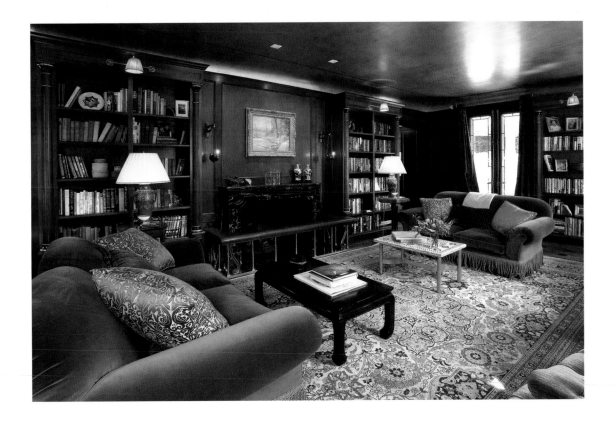

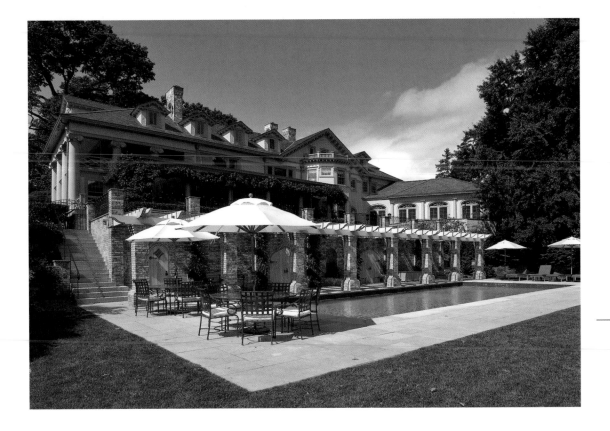

What does he find most rewarding about being an architect?

"Architects are among the small sliver of society that get to spend their lives thinking about what the world around us looks like — and why it's important for our world to be a beautiful place. If, as Shakespeare said, the world's a stage, architects set the stage. And while the actors may take the setting for granted sometimes, they need someone to create that perfect platform for their entrances and exits, their soliloquies, their heroic acts, and silly moments," Robert says.

If he could eliminate one design/architectural/building technique or style from the world, what would it be?

Robert loathes how speculative builders subscribe to catalogues of historical gewgaws and hang them on their buildings in the name of "branding."

What home does he consider the most unique/impressive/beautiful that he's ever seen?

Thomas Jefferson's Monticello, designed by our only architect/president as his own home, stands out to Robert above all others. "Jefferson's design is tied to a classical tradition that was deeply meaningful to him — both on a personal level, from his education and travels, and as an expression of what high art should be like in a new world. He made it his own in an inventive and sure-handed way. The house — and its setting and situation — are elegant and beautiful in an almost scientific manner, as a scientist refers to an experiment as "elegant" when there is nothing more or less that is needed, and the meaning comes through with exceptional clarity."

Robert Dean Architects

Robert Dean, AIA
111 Cherry Street
New Canaan, CT 06840
203.966.8333
www.robertdeanarchitects.com

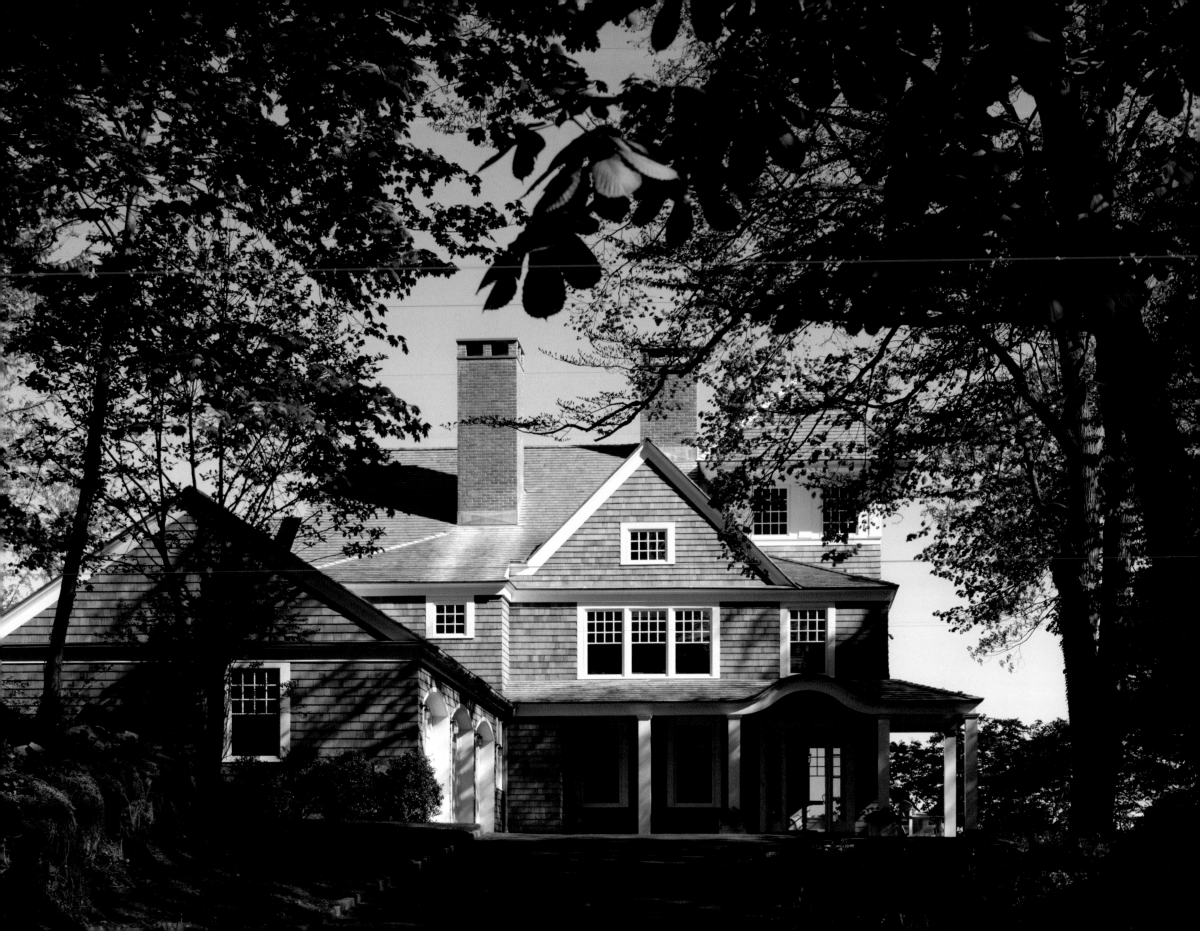

GEORGE DUMITRU

Studio Dumitru Architects

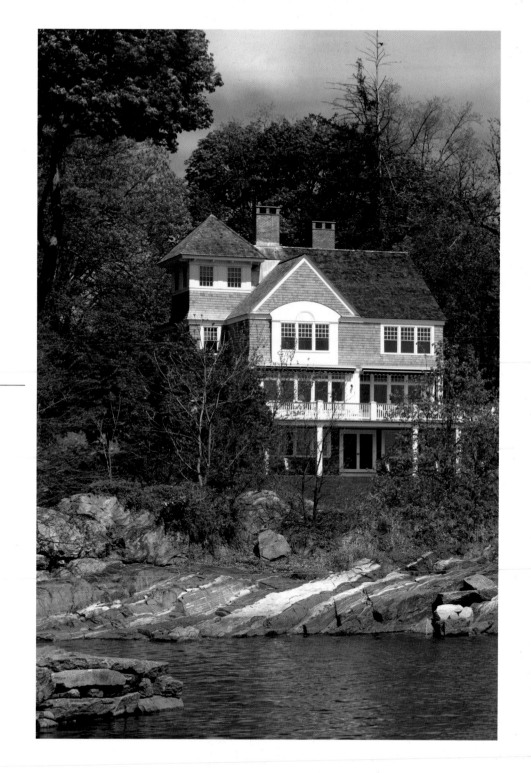

George Dumitru appreciates fine wine. French Bordeaux, Italian Super Tuscans, California Cabs — wines with strong character; big wines that tell a story; extraordinary wines that warm your heart, put a sparkle in your eye, and make you want to shove a glass in someone's hand and insist that they try it. The houses that the architect designs are a lot like those wines: They have depth and spirit; they speak to those who take the time to really look at them.

And like a boutique winemaker, the small firm of Studio Dumitru Architects considers quality the most important aspect of creation. Quality is the thing above all else that matters in his work. "If we do something, we make it exquisite," George says, "rather than settle for something ordinary or do it just for the sake of doing something." The essence of his work is the quality and the details, the character and the personality of the results of the act of creating something new.

With no preference for traditional or modern design, the 20-year architectural veteran, emphasizes purity of style when he designs for a client. If his client likes Georgian houses, he wants to give that client the most beautiful Georgian home he can. If the client likes modern homes, he will give him the most spectacular modern home possible.

ABOVE: Private residence, Long Island Shore, Rye, New York – waterfront facade.
Photograph by Durston Saylor

LEFT: Private residence, Long Island Shore, Rye, New York – driveway facade.
Photograph by Durston Saylor

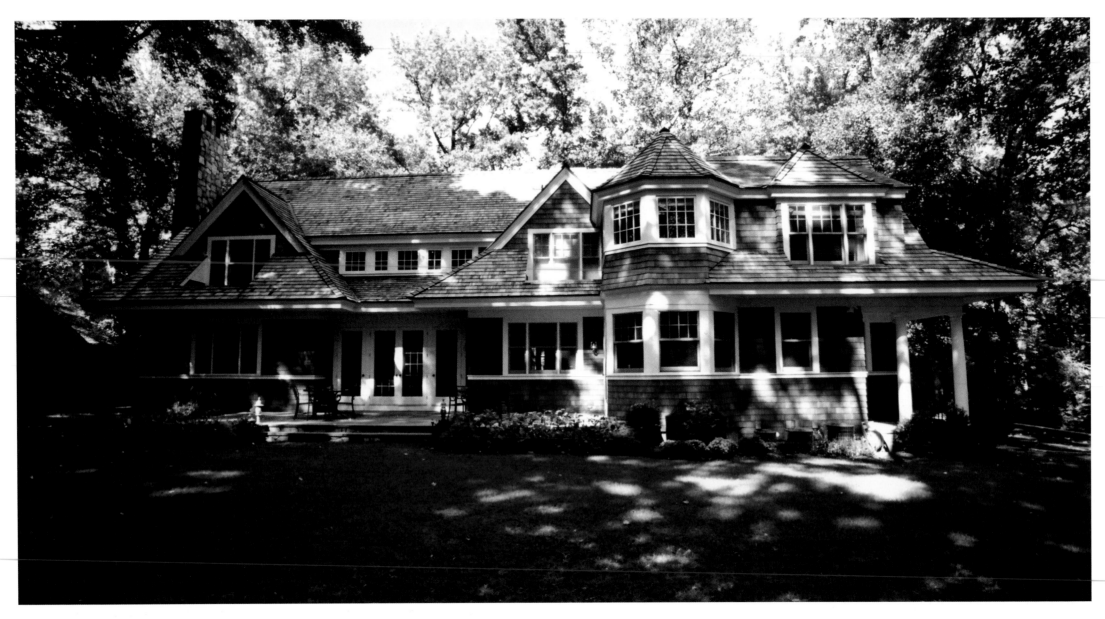

George knows that architecture is a very personal experience. What one person loves another might despise, so he sees his role as giving clients a place they can call home, whatever home might mean for them. "You know a house is beautiful when it talks to you," he says. "Each person's reaction to beauty is different, and that's what makes a thing beautiful." George's clients are worldly, affluent people of discriminating tastes who appreciate and can afford quality at every turn.

The architect's high standards are rooted in his European heritage. George was born in Romania and studied les beaux arts — painting, drawing, and sculpture. With a propensity for building things and arranging objects in a pleasing way, he fell in love with architecture before moving to the United States in the 1980s. Growing up with the historical references and traditions of Europe, spending time in important spaces made a big impression on the architect as a young man. Today, he's conceiving substantive, meaningful spaces of his own.

ABOVE: Private residence, Riverside, Connecticut – back yard.
Photograph by Studio Dumitru

FACING PAGE TOP: Private residence, Long Island Shore, Rye, New York – living room view.
Photograph by Durston Saylor

FACING PAGE BOTTOM: Private residence, Stamford, Connecticut – kitchen family room.
Photograph by Studio Dumitru

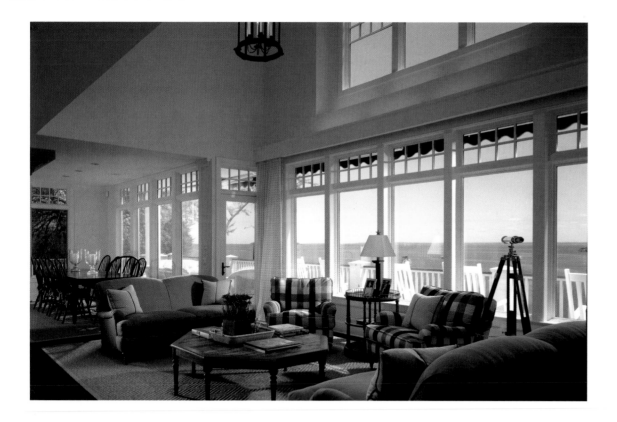

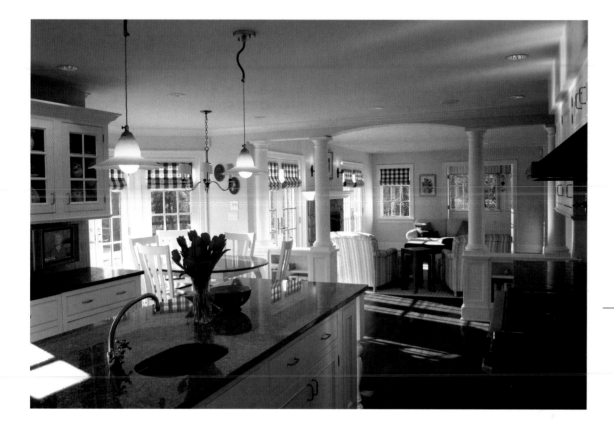

What does he like most about being an architect?

Looking on a finished project, thinking back to the time before its conception is his most satisfying moment.

When he's not working, where can you find the architect?

At his home in Weston, Connecticut, with his family and his friends.

What color best represents him?

Because the architect is honest to a fault, white is the color that he's most like. "There are two colors that go with anything: black and white," George says. "They are the basics of life. That's where we start. Anything in between is debatable. Black we associate with absolute darkness; white with lightness and cleanliness. I think that the color white is very unforgiving. It's an honest color, and it's beautiful in its honesty and integrity."

If he could eliminate one thing from the world of architecture, what would it be?

George doesn't like spec houses. "A house without a specific client is a house without a soul," the architect says.

What is the most impressive home he's ever seen?

Peles Castle is considered by many, including George, to be one of the most beautiful castles in all of Europe. Located in at the foothills of the Bucegi Mountains, the king's residence was built under the order of the Viennese architect Wilhem Doderer. The only thing that mattered was quality — of details, materials, and design.

Studio Dumitru Architects

George Dumitru

The Mill

49 Richmondville Avenue, Suite 106

Westport, CT 06880

203.226.5156

www.studiodumitru.com

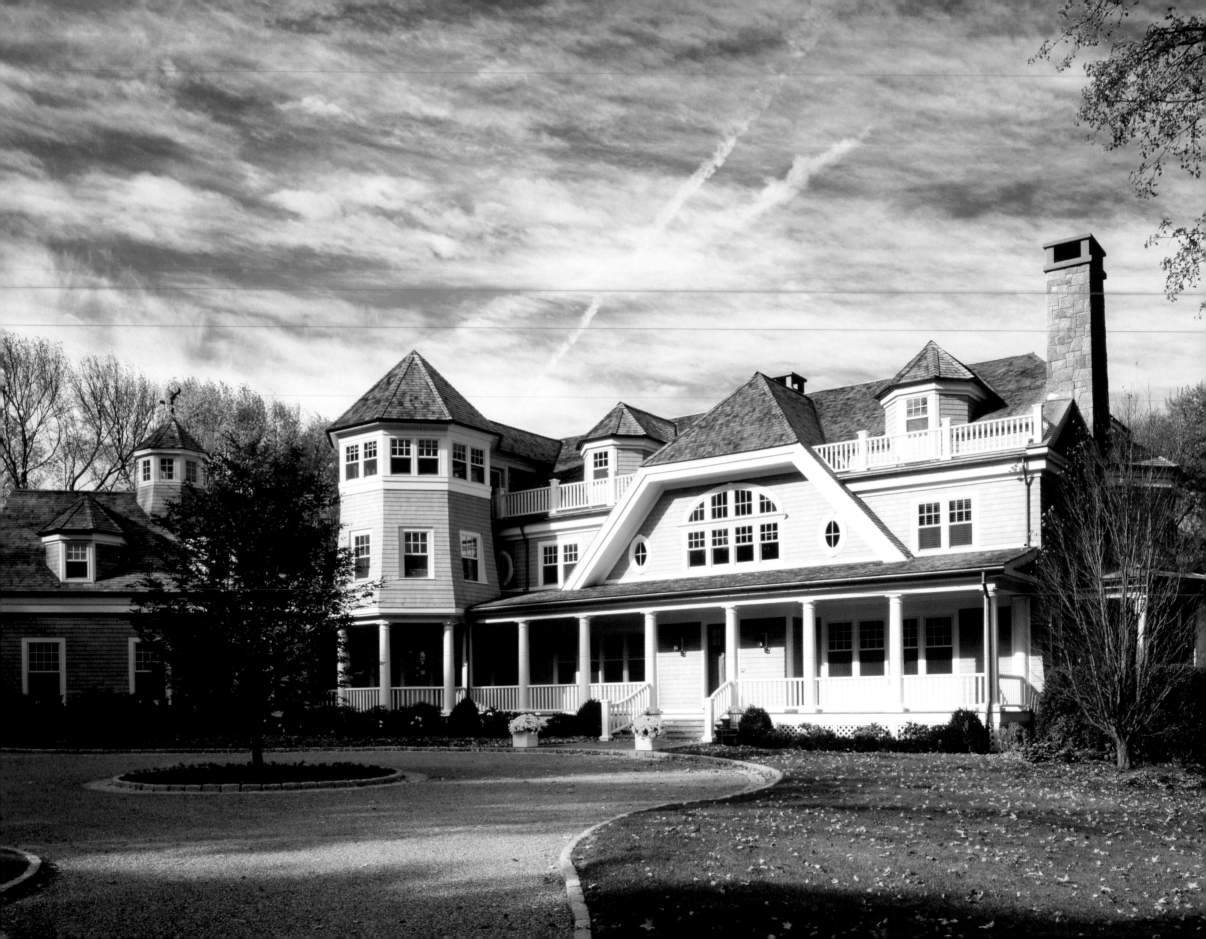

JAY HAVERSON

Haverson Architecture and Design

" In order to be a creative person, you need to dream. Everybody does it, but I do it for a living," says Jay Haverson, architect.

As an undergraduate architecture major at Syracuse University and a graduate student at Columbia University's architecture school, Jay dreamed about how things could be and what was possible. He'd grown up in Northeast Philadelphia, amid a neighborhood of row houses and strip malls, dismayed by his unimaginative surroundings. But he'd begun to recognize how creative architecture could yield places that are not only pleasant to look at but also inspire people to interact with one another — two things that would lead to a better quality of life.

Today, as an award-winning architect with more than 200 projects to his credit, Jay continues to dream. Only now he's able to implement his dreams while interpreting the desires of his clients, designing residential, commercial, and institutional projects.

As Jay works, he gives careful consideration to what his clients envision, how his designs will reflect who they are — how they live, work, and inspire. A seasoned professional, he's learned to

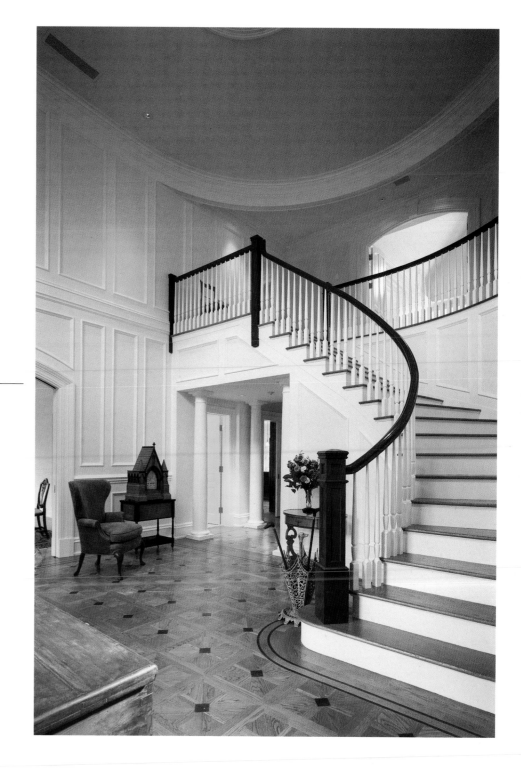

ABOVE: Private residence, entry stair hall, Greenwich, Connecticut.
Photograph by Paul Warchol

LEFT: Nantucket by the Sea, Greenwich, Connecticut.
Photograph by Peter Paige

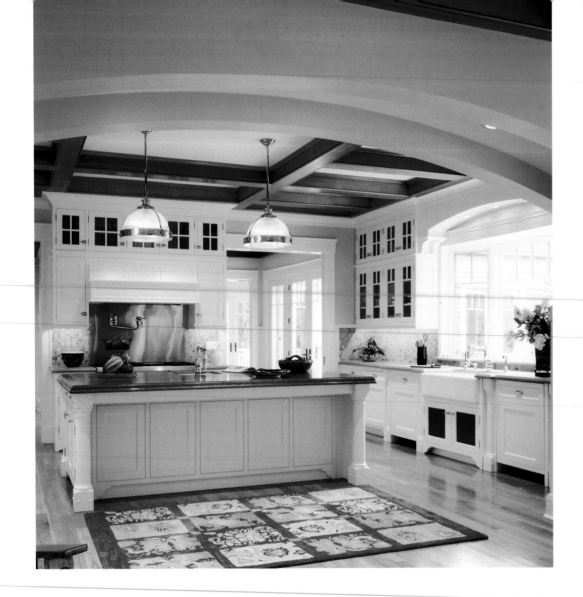

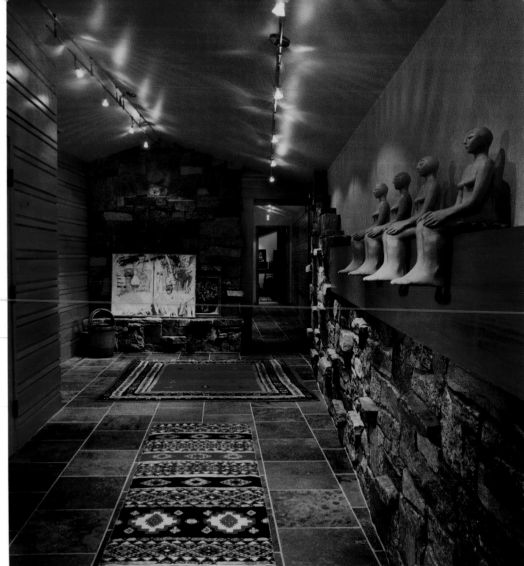

invest time and energy in the early stages, getting to know his clients and developing a concept thoroughly before advancing to the next step. Custom design at its best also means in the case of couples (which most of his residential clients are) having both parties involved in the decision making throughout the process of designing and building their houses. Of course, there are realities that must be dealt with along with the dreams.

The value of a significant other's input is something Jay knows a lot about. His business partner is also his wife. "Carolyn has been with me through two architectural schools, two architectural practices, two homes, two children, and too many ups and downs," he jokes. Carolyn handles the operations side of their firm and acts as a sounding board for Jay's ideas; she also designs the graphics for all of the firm's jobs.

Carolyn has certainly contributed significantly to her husband's success, but it wouldn't have been possible without Jay's passionate dedication to the art and craft of fine architecture. The art is the manifestation of a dream. The craft, he says, is ensuring that the vision is carried out in a way that is sound and lasting. Jay notes: It is our goal to balance, meet and exceed the client's expectations.

ABOVE LEFT: Lakeview kitchen, Fairfield County, Connecticut.
Photograph by Peter Paige

ABOVE RIGHT: Entrance hall, residence at Usonia, Pleasantville, New York.
Photograph by Paul Warchol

FACING PAGE TOP: Private residence, Mid-Country, Greenwich, Connecticut.
Photograph by Peter Paige

FACING PAGE BOTTOM: Lakeview, Fairfield County, Connecticut.
Photograph by Peter Paige

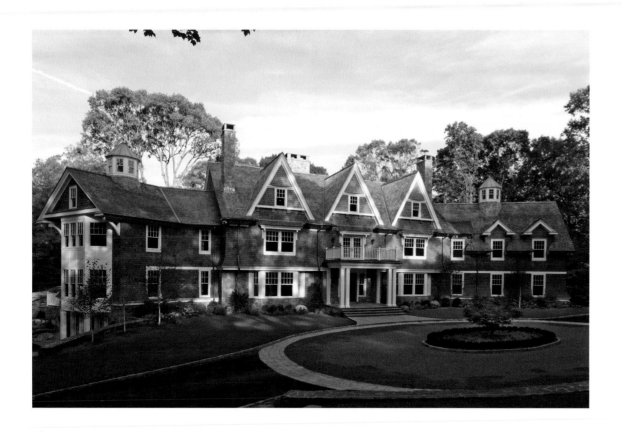

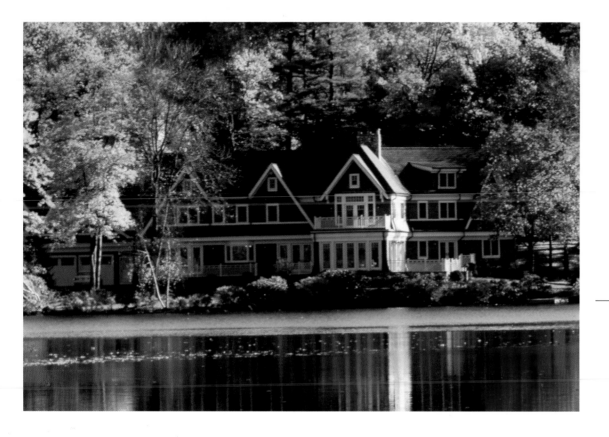

more about jay...

Q&A

What color best describes him and why?

Jay says that he relates most to the color green for its cool temperature but warm tones, natural hues, and spicy extremes.

When he's not working where can you find him?

The architect enjoys watching sports. He's a fan of the Philadelphia Eagles, the New York Jets, the Yankees, and the basketball team at Syracuse University (his alma mater).

What book has had the greatest impact on him?

Tracy Kidder's *House* is the story of the design and construction of a new house in central Massachusetts as told through the relationships between an architect, his clients, and the contractor. Jay calls it "wonderful" and says that the book demonstrates how to create a balance between the parties during the process of building a home.

What single thing would he do to give new life to a dull house?

Jay says he'd select a color for the exterior of the house to reflect the personality of the owners and to make the house unique in the neighborhood. On the interior he would develop a defined paint scheme with fresh colors, each intended to bring out the best attribute of the rooms they are recreating.

What's the most unique/impressive house he's seen? Why?

"Frank Lloyd Wright's Oak Park residence and studio is a great example of a young architect's transition from interpreting the styles of the day to taking a new approach — uniquely his own — to design, using his own house as a laboratory," Jay says, adding that the famed architect reinvented himself several times.

Haverson Architecture and Design

Jay Haverson, AIA
63 Church Street
Greenwich, CT 06830
203.629.8300
www.haversonarchitecture.com

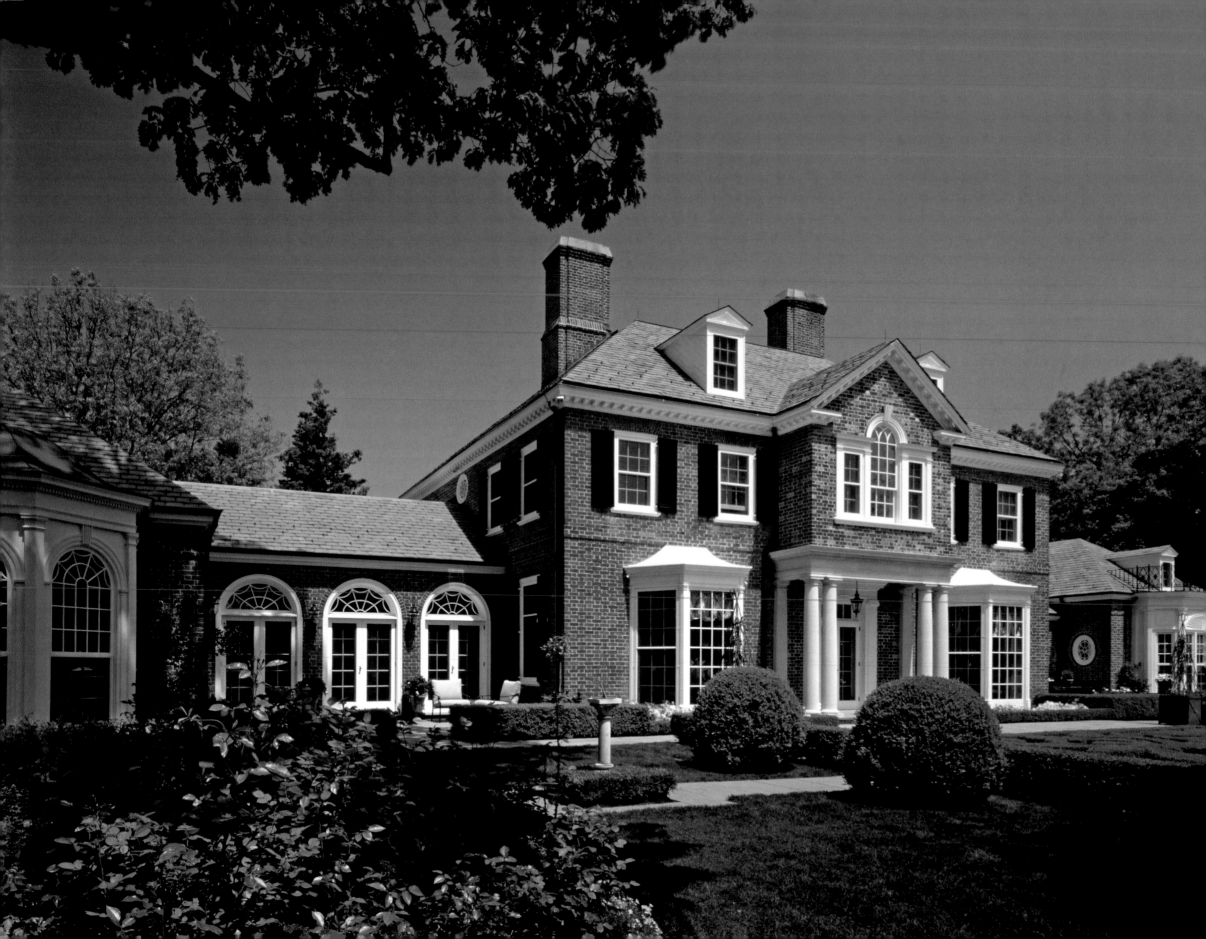

CHARLES HILTON & DOUGLAS VANDERHORN

Hilton-VanderHorn, Architects

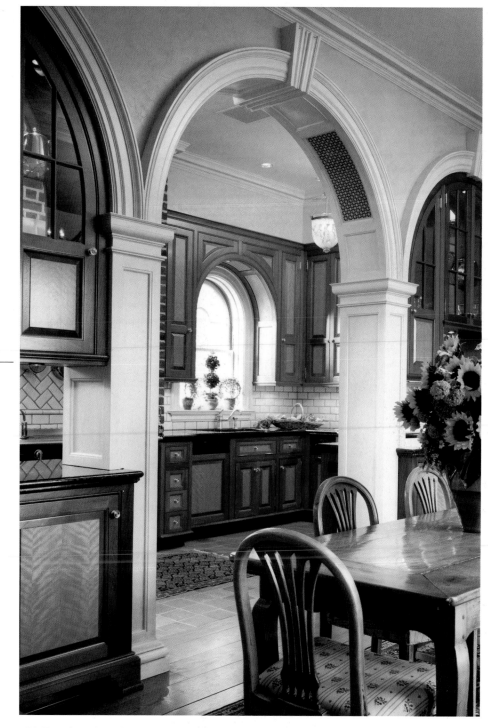

ABOVE: A classical arcade simultaneously divides and unifies the prep and dining areas of this stunning kitchen. Generous use of millwork, rich materials and antique accessories enhance the classic design.
Photograph by Scott Frances

LEFT: The garden façade of this 1942 Georgian home features the addition of a central portico, a newly composed façade on the right wing and a newly constructed left side wing, which seamlessly blend with the original home.
Photograph by Woodruff - Brown

Design excellence, attention to detail, and exceedingly thorough construction documents are the hallmarks of Hilton-VanderHorn, Architects. The last, says Charles Hilton, who took his first job in an architect's office in 1980, while still in high school, is probably the single most overlooked characteristic of an architectural firm's work. The importance, he says, cannot be overestimated.

Chuck and his partner, Douglas VanderHorn, who grew up working in his father's construction business, met at Penn State University, where both men earned a Bachelor's of Architecture degree. With a similar philosophy and a shared appreciation for fine craftsmanship and traditional residential design, they founded in the spring of 1991 what is today an esteemed 12-person firm.

Though the architects' work reflects the traditional building styles of Fairfield County, Connecticut, and Westchester County, New York, where their projects are concentrated, Hilton-VanderHorn does not have a signature style; instead, the architects have a broad repertoire of stylistic knowledge and experience. With consideration for a client's personal taste and programmatic requirements, they choose a stylistic direction and pursue it both inside and out. "Our designs embody the great architecture of the past," Chuck says, "while seamlessly integrating the modern amenities our clients expect."

Projects run the gamut from one room to 20,000 square feet; though typical jobs range from a 3,000-square-foot renovation to a 10,000-square-foot new construction. Regardless of the size of the project, the project's success hinges on the quality of the documents, Chuck says. "Our plans are efficient, our elevations classic, and our detailing exquisite." He adds, "If the documents aren't extremely detailed, a great deal is open to interpretation by the contractor. The average amount of detailing is not sufficient for the high-end products we deliver."

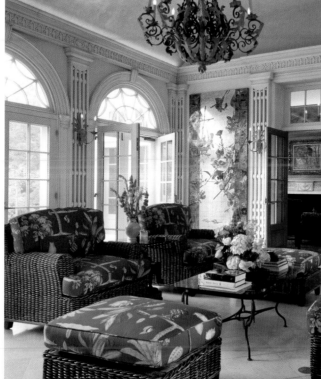

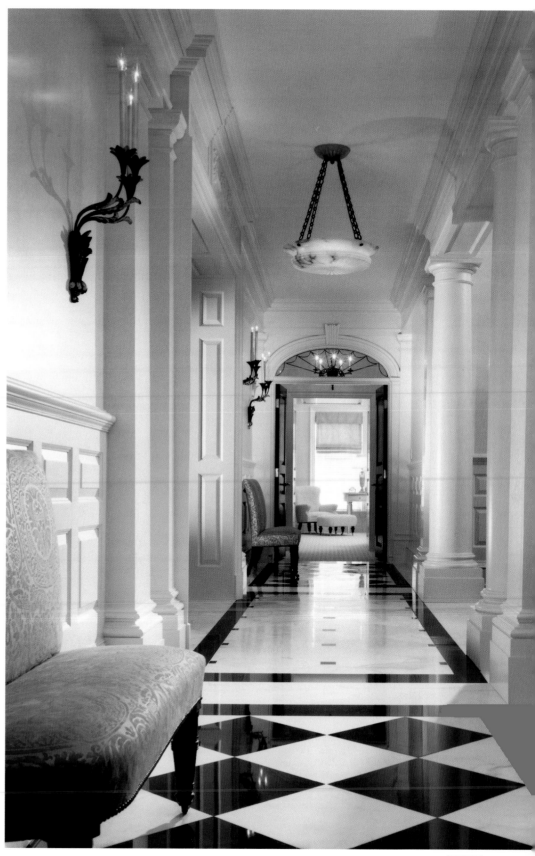

ABOVE: Ionic pilasters frame the view through the bay of this striking red lacquered dining room. The adjacent classical doorway invites guests into the adjoining living room.
Photograph by Woodruff - Brown

RIGHT: This garden room features lattice pilasters that support a Venetian plaster barrel vaulted ceiling. The painted panels were commissioned to incorporate flora from the client's gardens.
Photograph by Scott Frances

FAR RIGHT: Paneled wainscoting, Doric columns and a two-toned marble floor grace this first floor hallway. A pair of mahogany doors with fanlight above, lead to the guest wing beyond.
Photograph by Woodruff - Brown

FACING PAGE LEFT: This handsome mahogany entrance doorway features leaded glass sidelights and an elliptical fanlight supported on fluted ionic columns.
Photograph by Steve Wegener

FACING PAGE RIGHT: This dining porch provides the perfect setting to enjoy the outdoors. The herringbone brick floor and granite façade are complemented by the mahogany trim and tray ceiling.
Photograph by Steve Wegener

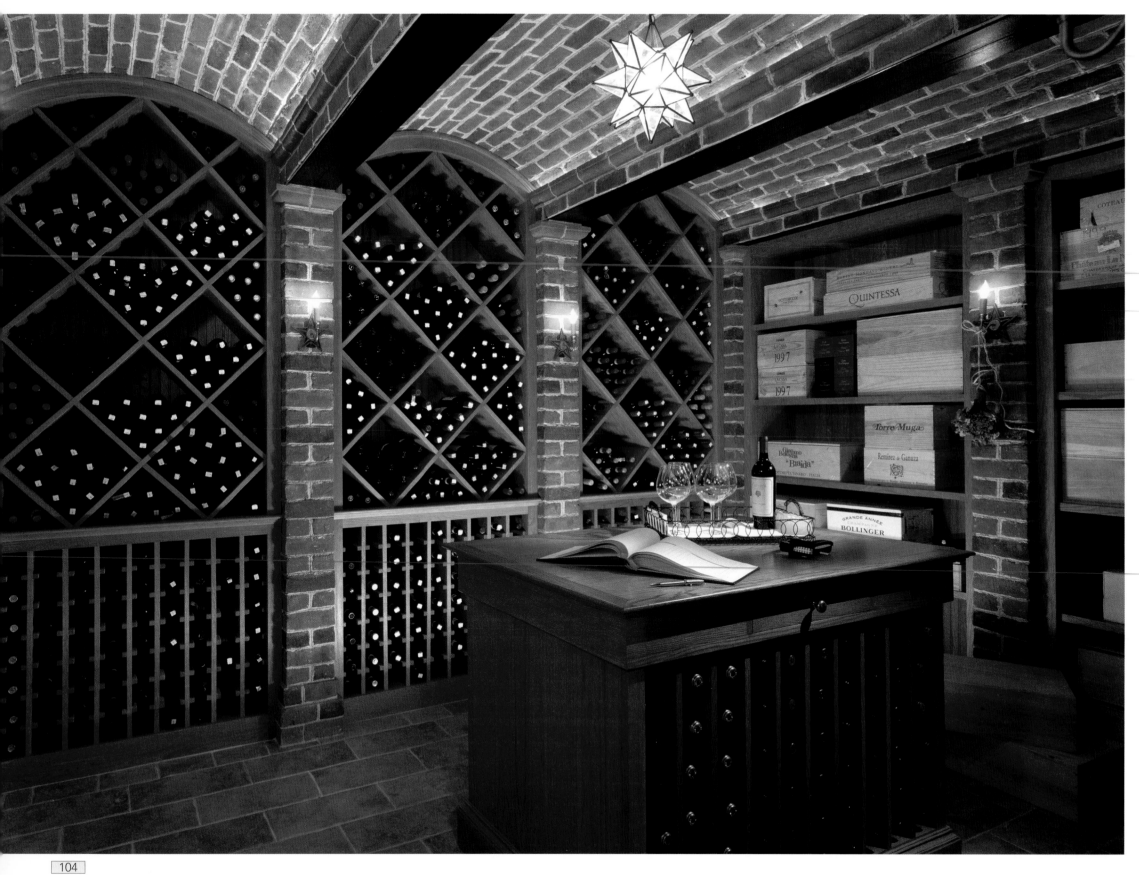

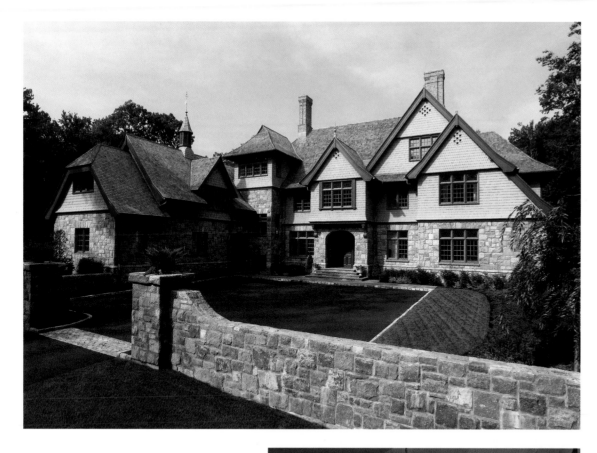

Describe your style or design preferences.

The firm does not have a signature style, choosing rather to develop a broad repertoire of stylistic knowledge from which to draw on during design. A client's personal taste and programmatic requirements are considered, along with the site and existing context. A stylistic direction is chosen and pursued from inside to out. Our designs embody the great architecture of the past, while seamlessly integrating the modern amenities our clients expect. We aim for timeless designs that facilitate modern living.

Civic service:

The firm's leadership is involved in their community. Principal Charles Hilton is a past president of the Greenwich Rotary Club and is active in a number of church and school projects. Principal Douglas VanderHorn is a member of the Greenwich Historical Society and participates on a school building committee. Associate Daniel Pardy is a past president of the Alliance for Architecture in New Haven, Connecticut.

Awards and recognition:

In 2004, the firm received an honorable mention in the first Alice Washburn Award for Design, given by the AIA, Connecticut Chapter, honoring outstanding contemporary interpretations of the state's traditional residential architecture, for their work on a new midcountry Georgian estate in Greenwich. The firm's work has been showcased in such publications as *Connecticut Cottages & Gardens, Greenwich Magazine, Connecticut Magazine, This Old House, Period Homes*, and *A Decade of Art & Architecture 1992-2002.*

Hilton-VanderHorn, Architects

Charles F. Hilton, AIA

Douglas A. VanderHorn, AIA

31 East Elm Street

Greenwich, CT 06830

203.862.9011

www.hilton-vanderhorn.com

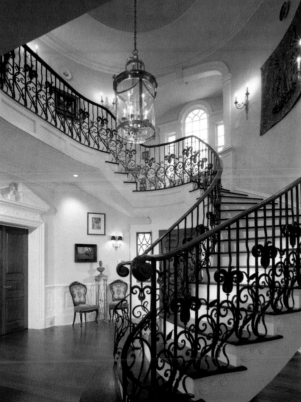

ABOVE: Multiple gables and a variety of forms add charm to this country estate. Wide eave boards accent the wood shingled gables. A granite base anchors the composition.
Photograph by Steve Wegener

RIGHT: This gracious entry hall is classically appointed with a paneled wainscot and decorative plaster cornice and trim. The sweeping staircase invites one to the second floor alcove and family spaces.
Photograph by Steve Wegener

FACING PAGE: A brick barrel vaulted ceiling supported on steel beams and brick pilasters highlight this stunning wine cellar. Fitted oak cabinets provide a variety of storage options.
Photograph by Scott Frances

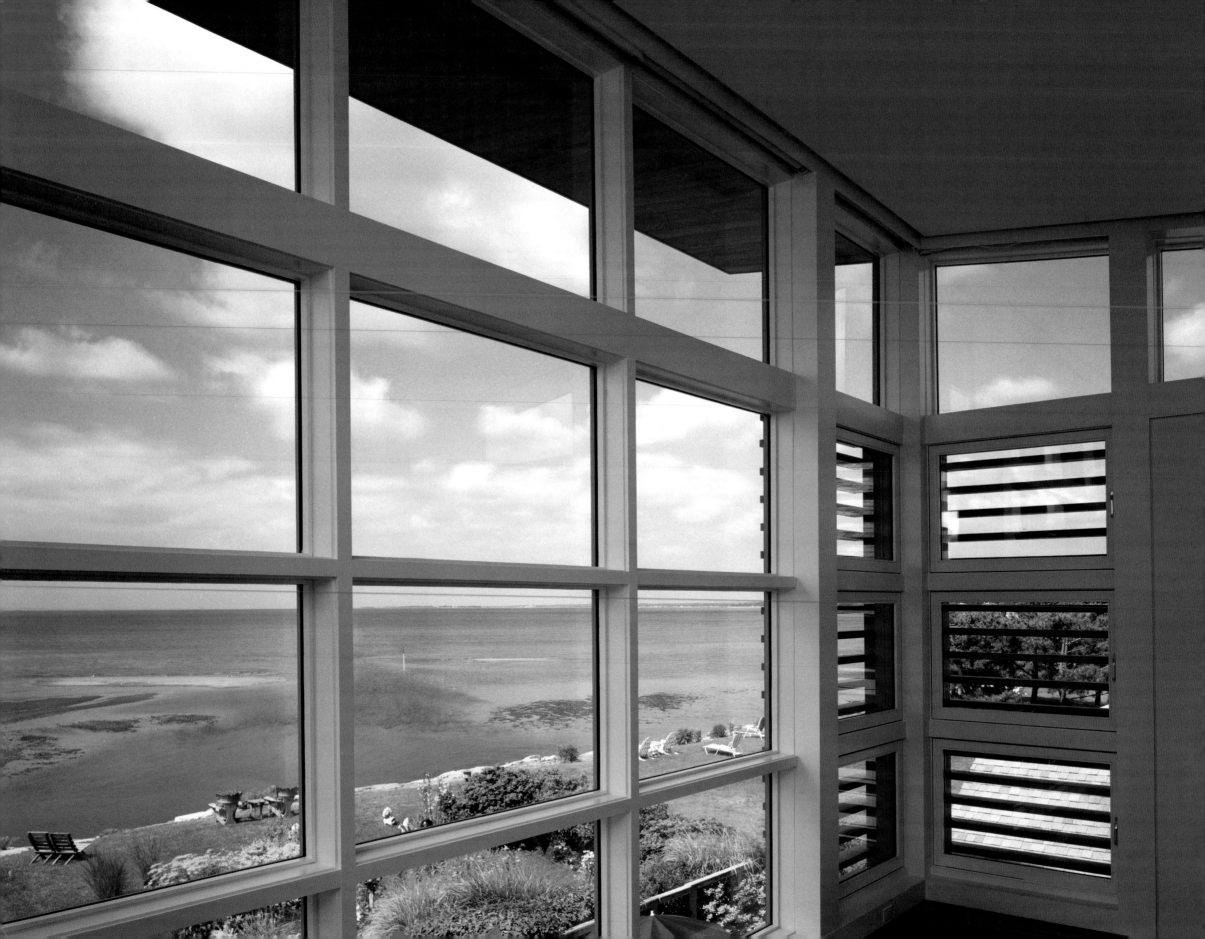

ROGER FERRIS

Roger Ferris + Partners, LLC

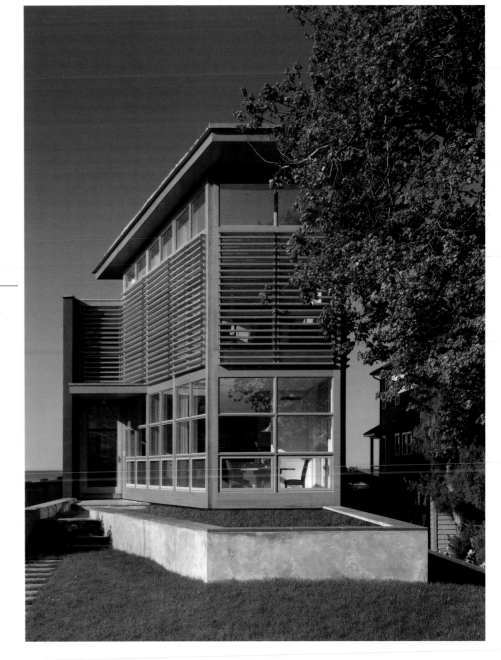

A look through Roger Ferris' press clippings reveals something out of the ordinary. Among the myriad of local and regional newspapers and business journals and national design, architecture, and shelter magazines lies a surprise: The architect has been featured in *WWDScoop* alongside Hollywood angel Gwyneth Paltrow and within the same pages that *Esquire* hails Jessica Biel the sexiest woman alive. He's shared an issue of *Town & Country* with actor Jeff Bridges and was recently in the Sunday Styles section of *The New York Times*, arms casually crossed, leaning against a vintage Porche.

All of this is to say that Roger is not your typical architect: He's also a stylemaker, a trendsetter, a progressive thinker who's shaping the way people live and work.

Roger began traveling the path that would lead him to become an architect when, at 14 years old, he went to work for Victor Christ-Janer, a well-known modernist. And what began as a Saturday-morning apprenticeship would be the very thing that shaped Roger's career. He went on to study at Harvard University's Graduate School of Design, where he received a master's degree and was named a Loeb Fellow in Advanced Design.

ABOVE: Sound house, Fairfield, Connecticut. Entry with louver detail.
Photograph by Woodruff/Brown Photography

LEFT: Sound house, Fairfield, Connecticut. Bedroom water view.
Photograph by Woodruff/Brown Photography

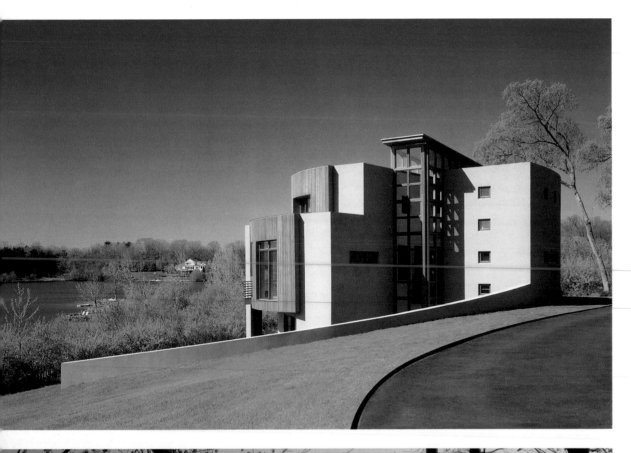

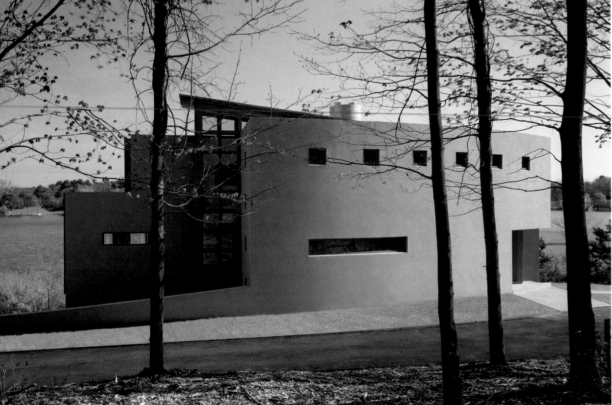

When he started his firm 20 years ago, Roger committed to not commit, meaning that he resisted specialization in high-end residential or commercial projects. Instead, he focused on diversifying his practice. "I wanted to be a specialist in everything," he says. "I believe that the more varied your experiences, the more creative and inventive you can be." And so as he designed homes all along the East Coast, he also worked on trading floors and country clubs and restaurants, growing his architectural firm to one of the largest in the area.

A heterogeneous approach is one way Roger Ferris + Partners — which includes principals David Beem, Robert Marx, and Phil Hubbard — has stayed on the leading edge of contemporary design. "Our passion for diverse and challenging projects is enhanced by the ability to cross-pollinate design skills among building typologies," he says. "Practicing architecture and planning at a variety of scales in a multitude of project categories is not only a component of the firm's root philosophy, it supports and advances our work." It's also earned the firm 32 regional and national design awards in both commercial and residential architecture.

Today the range of projects includes a modernist clubhouse for The Bridge in Southampton, a United States headquarters in Stamford for the Royal Bank of Scotland, and a contemporary addition to the St. Jude Children's Research Hospital in Memphis, not to mention several dream homes underway for high-profile clients (the typical RF+P client is a captain of industry, financial leader, or celebrity) throughout the United States and the Bahamas. Though they are not necessarily linked stylistically, all of the firm's projects have one thing in common: They are seen as a collaborative venture that responds not only to the environment and the site, but also to the needs and desires of the client. The results are noteworthy architectural statements that go beyond the norm — just like Roger himself.

TOP LEFT: Lake house, Weston, Connecticut. View from East.
Photograph by Michael Moran

BOTTOM LEFT: Lake house, Weston, Connecticut. View from street.
Photograph by Michael Moran

FACING PAGE LEFT: Lake house, Weston, Connecticut. Deck detail with view towards lake.
Photograph by Michael Moran

FACING PAGE RIGHT: Lake house, Weston, Connecticut. View from lake.
Photograph by Michael Moran

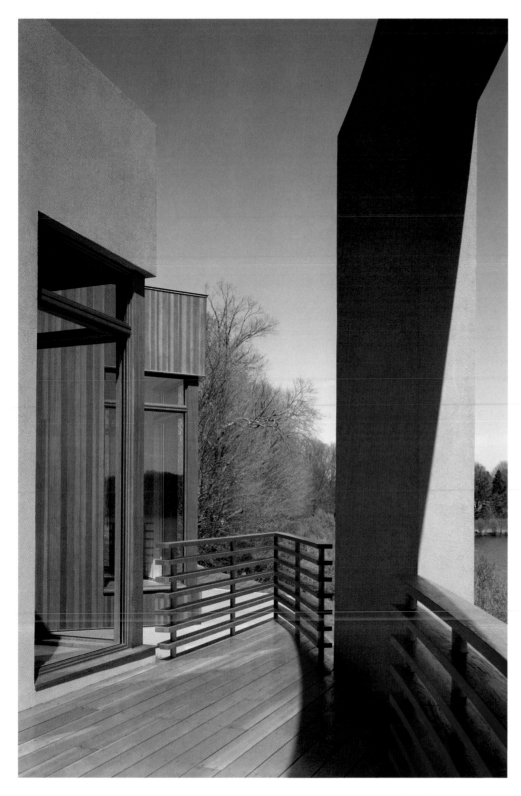
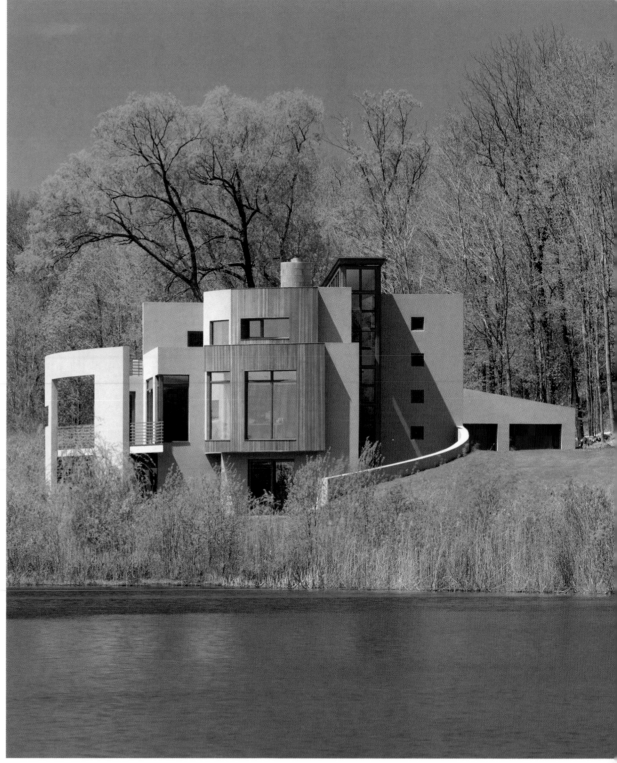

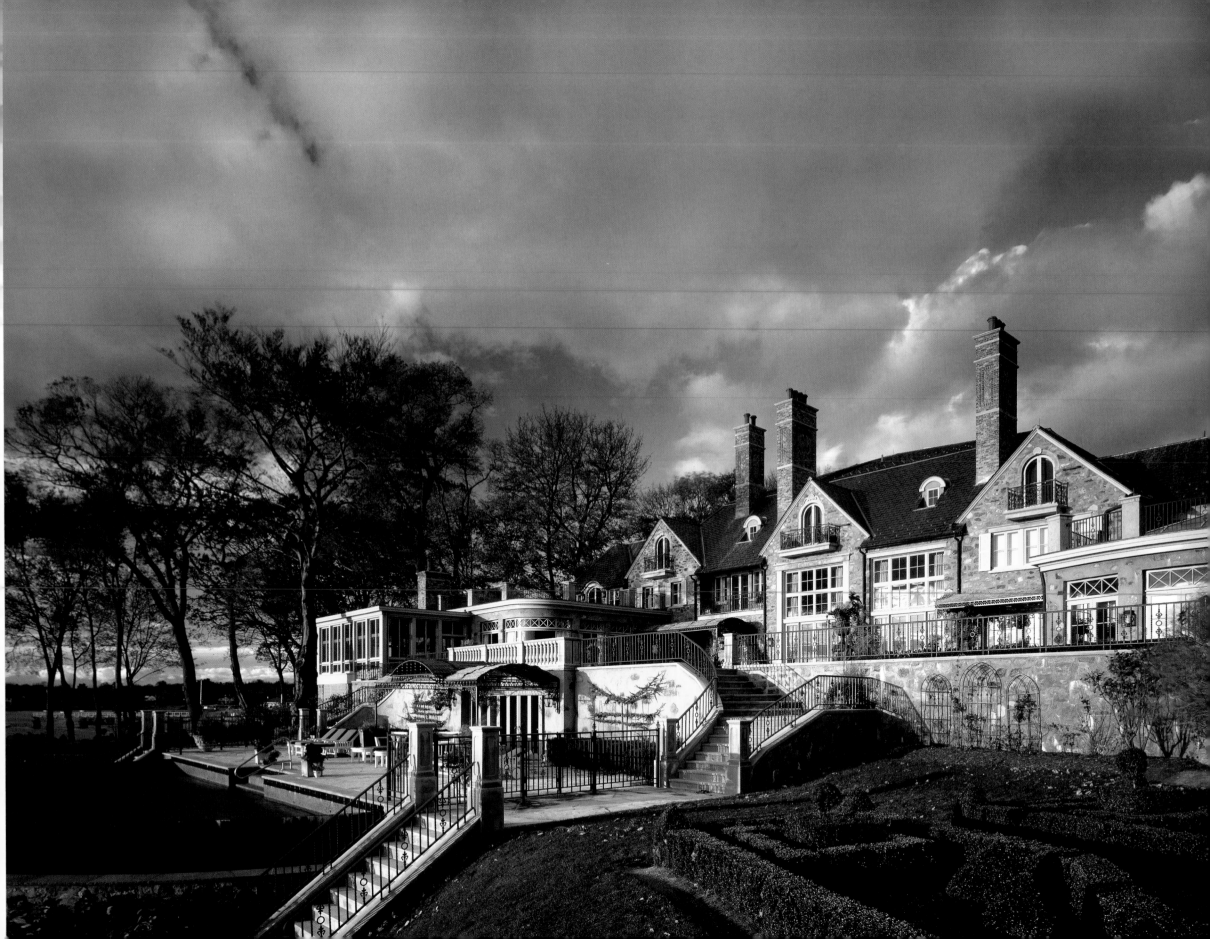

JAMES MARGEOTES & CORMAC BYRNE

Jones Footer Margeotes Byrne

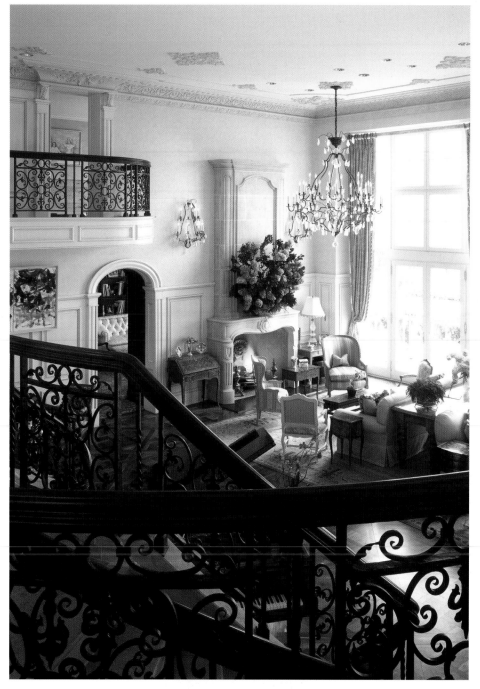

ABOVE: This main two-story reception room includes curved limestone stairs with wrought iron railings. On the walls: glazing, custom-painted wood paneling, dual flanking limestone mantles and decorative fibrous plaster trim and moldings make the magnificent room warm and exquisite. Basketweave walnut wood floors offer the perfect aesthetic complement.
Photograph by Phillip Ennis

LEFT: This considerable French Country waterfront home, with expansive views of Manhattan, features an imposing stone and stucco exterior with decorative brick chimneys and a slate roof. The rear elevation is as lovely as its front with triple gable roofs, custom mahogany windows, wrought iron railings and trellis work. Infinity-edge pool grotto built under the main terrace.
Photograph by Phillip Ennis

In architecture, there exists a triangle: quality, time, and cost. What you gain in one area, you will lose in another. Managing the three is a balancing act. And if you want something wonderful from Jones Footer Margeotes & Partners — like a 7,500-square-foot retreat in the style of an English manor house, with exquisite interiors and sweeping views of Long Island Sound — you're going to have to weigh the value of time and money. Because compromising on quality isn't something the 25-year-old architectural firm will even discuss.

Known for high-end custom residential design, Jim Margeotes and Cormac Byrne, principals at JFMP, have exacting standards, and they are relentless in their pursuit of good design and client satisfaction. With complementary skill sets (Cormac's strong suit is in the initial big-picture phase of a project; Jim's forte is in the management of the details) and differing perspectives (Jim is 46 and a Westchester native; Cormac is 36 and spent much of his life in Ireland), they serve their clients, unique

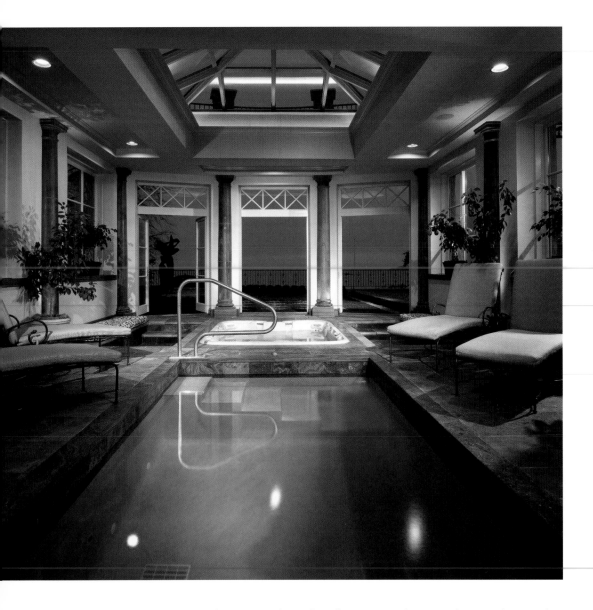

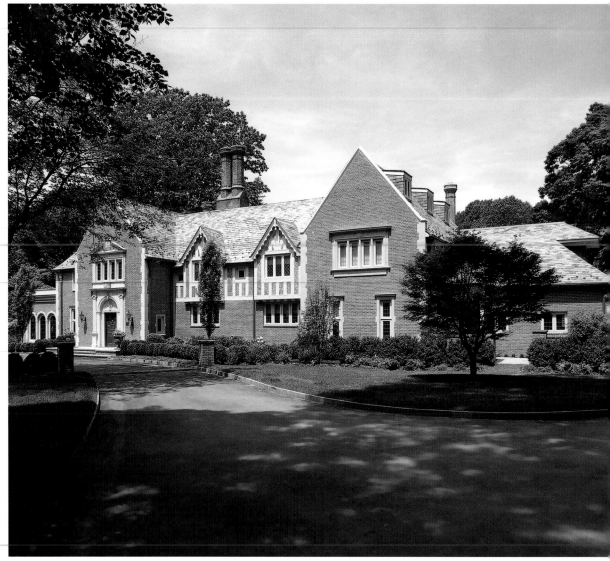

people with style and vision in their own right, with architecture and interior design solutions that are as fresh and delightful as the dramatic environments that they are built in.

The firm specializes in master planning and excels at orchestrating full-service support and oversight for all of its projects. Jim emphasizes that JFMP likes to handle a project from property line to property line, meaning it not only provides interior and exterior design services but also coordinates consultations on landscape architecture, interior decorating, lighting design, pool and tennis court design and installation, and art and antiques acquisition. And they strive to bring something new and innovative to every project — whether an environmentally friendly geothermal heating system, state-of-the-art custom electronics, or dimensionally stable engineered lumber to frame the house.

Designs are client-driven and collaborative, revolving around a typically lengthy wish list. Understanding the client is the cornerstone of the process. And a partnership is essential. "Because the typical clients are captains of industry and extremely successful at what they do, we want to bring their wealth of knowledge and experience to the team and the final product," Cormac says.

Listening to the clients, paying careful attention to what they say is a given, but at JFMP it doesn't stop there. "To design a truly custom home that suits the client's lifestyle, I have to almost become a member of the family," he says. "I get to know not only their tastes and preferences, but their dogs, wine cellar contents, kids' soccer scores, and even the extended family." It is only then that the architects can deliver a design that goes beyond what the clients need and gives them more than they ever dreamed of.

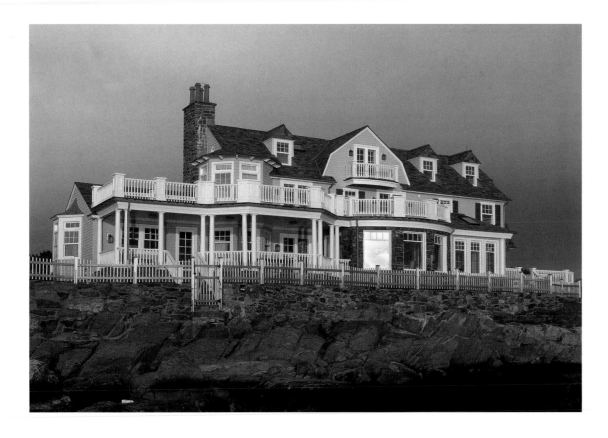

ABOVE: The Shingle-style, luxurious waterfront weekend retreat offers beautiful 360-degree views. Wraparound stone terraces and wood decks maximize outside space and water views. Curved stone wall at great room. Interesting lines, including the octagonal second floor office at master suite add distinction all below the Gambrel style slate roof.
Photograph by Phillip Ennis

RIGHT: This great room overlooking the Long Island Sound features curved walls with floor to ceiling picture windows.
Photograph by Phillip Ennis

FACING PAGE LEFT: From the privacy of this Solarium one can take in the water views across the main terrace while enjoying the pool and spa. With assistance from the custom skylight, natural light illuminates the room. Marble flooring with recess seating by the spa.
Photograph by Phillip Ennis

FACING PAGE RIGHT: This stately English manor features many of the elements which lend an authentic flavor: brick façade with custom limestone surrounds and quoins, slate roof with mahogany, lead glass windows, decorative brick chimneys and scalloped wood rakes at central main dormers. The formal English gardens complete the feel with natural splendor.
Photograph by Tom Young

more about jim & cormac...

What philosophy have they stuck with through the years that still works today?
Make the client a partner in the process. "We understand that we are in the service business," Jim says.

Who has had the biggest influence on their careers?
Jim studied with the internationally renowned modernist Paul Rudolph in college and post-graduation. He learned much from his mentor, including this bit: "Do not let the engineers take over the project."

Cormac spent his early career in South Florida working with an architect by the name of Derek VanderPloeg on luxury condominiums and large-scale office and retail projects throughout the Southeast, where he learned to navigate the potential maelstrom of regulations and restrictions for waterfront projects.

What is the highest compliment they've received professionally?
At a time when the firm was courting an important potential client, they were asked for a reference, who when asked about JFMP called them honest. Fairness and honesty are things that Jim and Cormac are particularly proud of. They instill trust and confidence in their clients.

What one thing would they do to bring a dull house to life?
"It's all in the details: Properly detailed eaves, rakes, and trim can dramatically enhance the appearance of a dull house. Along, perhaps, with a change in window sizes and configurations they can make all the difference," Cormac says, adding that treating the exterior and architectural interiors with utmost concern for scale is what really complements functional floor plans and creates a structure that is fun to both look at and be in.

Jones Footer Margeotes Byrne

James Margeotes, AIA
Cormac Byrne, Associate AIA
245 Mill Street
Greenwich, CT 06830
203.531.1588
www.jfmp.com

DINYAR S. WADIA

Wadia Associates

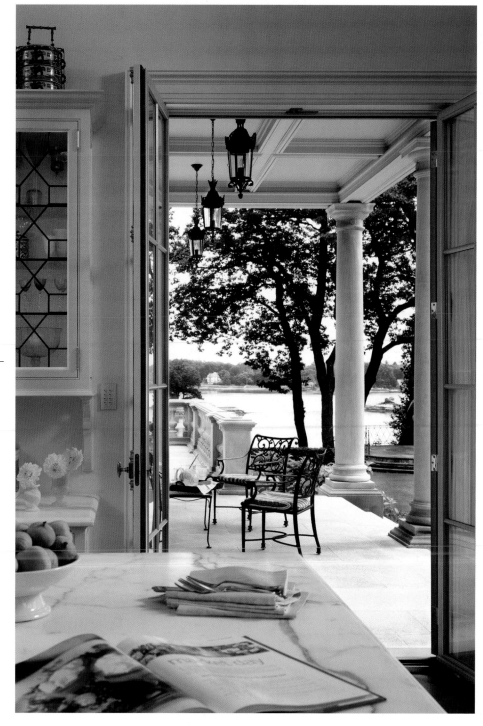

ABOVE: A coffered ceiling porch opens off the kitchen to the magnificent view of the landscaped lawn and sandy shore.
Photograph by Jonathan Wallen

LEFT: Facing west, with views of Long Island Sound, this porch extends this beautiful Queen Anne style house into the landscape of mature trees, gardens and the setting sun.
Photograph by Durston Saylor

Dinyar Wadia grew up in Bombay, surrounded by such architectural wonders as Victoria Terminus, the Prince of Wales Museum, the Taj Hotel, and the Gateway of India. He moved to the United States in the late 1960s, and after graduating as a William Kinney Fellow from Columbia University's Graduate School of Architecture, Dinyar settled with his wife, Gool, in New Canaan, Connecticut.

At a time when the area was best known for Philip Johnson's modernist houses, Dinyar, whose mother was a builder, found beauty and charm in the area's more traditional buildings. He also found an appreciation for the community's focus on family and time-honored values. He enjoys knowing that when he designs a home he is designing the backdrop for morning coffee, holiday dinners, birthday parties, and quiet evenings — a place where people create everlasting memories.

Since starting Wadia Associates more than 30 years ago, Dinyar has earned a reputation for designing and building quality, high-end homes, interiors, and gardens in Fairfield County and further afield. The 17-person full-service firm, which includes six talented designers and four experienced construction managers, hasn't a specific style but rather works in a diverse range of periods and styles.

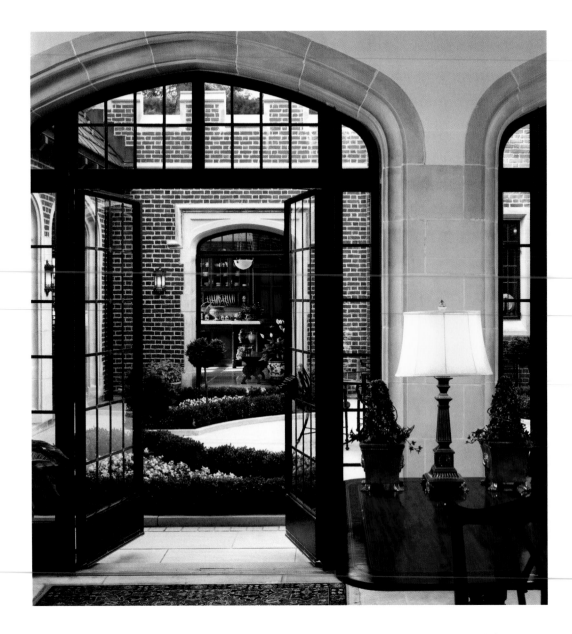

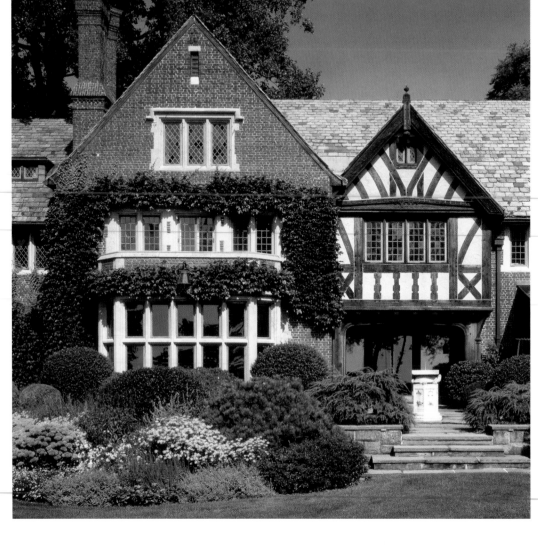

The firm's portfolio includes everything from a stately Elizabethan manor to a quaint English Country potting shed, a Georgian-style manse to an informal American Shingle-style house, a Colonial Revival farmhouse to a French Normandy chateau.

Regardless of genre, Dinyar and his team approach their projects with a couple of goals in mind. The first is to respect the clients' budget and timeline yet remain true to historical context and stick with tried-and-tested techniques rather than inventing a new brand of architecture. The second is to create designs that perfectly express their clients' individual needs and lifestyles — in Dinyar's words, "traditional architecture that is contemporary in the modern world, easy to live in and offering a casual elegance."

ABOVE LEFT: The courtyard of this home connects the main living areas and kitchen to the outdoor light and air of the changing seasons.
Photograph by Jonathan Wallen

ABOVE RIGHT: The home was renovated to add light and functionality while preserving the integrity of the design and building materials chosen in the 1920s.
Photograph by David Sloane

FACING PAGE TOP: Elegantly designed to visually connect with the main house's architecture, the pool house's open archways and aged brick provide shelter for family and friends.
Photograph by Jonathan Wallen

FACING PAGE BOTTOM: Dramatic columns frame the spectacular view from the entrance hall through the living room and beyond to Long Island Sound.
Photograph by Jonathan Wallen

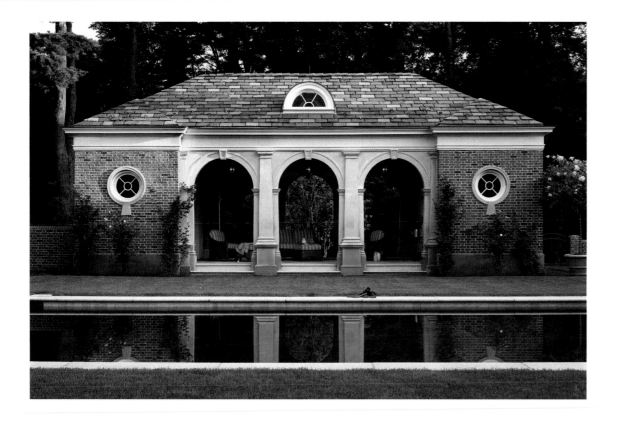

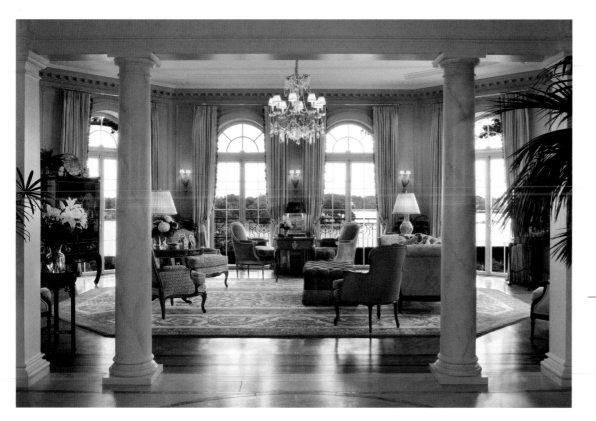

more about dinyar...

Q&A

What personal indulgence does he spend the most money on?

Dinyar has an extensive architectural library. Among his favorite volumes are a compilation of a series of booklets once used to sell lumber, known as *The White Pine Series of Architectural Monographs*; and a pair of original books, *Great Georgian Houses of America*, published during the Depression by the Architects Emergency Committee.

What is one thing most people don't know about Dinyar?

A real joy in his life are his two rough collies, Draupadi and Arjun. They greet him each evening, eager for a treat, when he comes home from work. "They've got my number," he says with an affectionate laugh.

What color best describes him?

A man who is vibrant yet understated, gleeful but not loud, Dinyar says that if he were a color, he would be mustard.

Who has had the biggest influence on his career?

Victor Christ-Janer was one of his professors at Columbia and the first architect Dinyar ever worked for. He instilled in the young designer the importance of really listening to people and taught him that ego has no place in successful design.

When he is not working, where can you find Dinyar?

"I am always working!" he exclaims. "Because it's not really work — I love what I do." But on the rare occasion he takes time off, he and Gool take in the gardens and classical architecture of Europe.

Wadia Associates

Dinyar S. Wadia
134 Main Street
New Canaan, CT 06840
203.966.0048
www.wadiaassociates.com

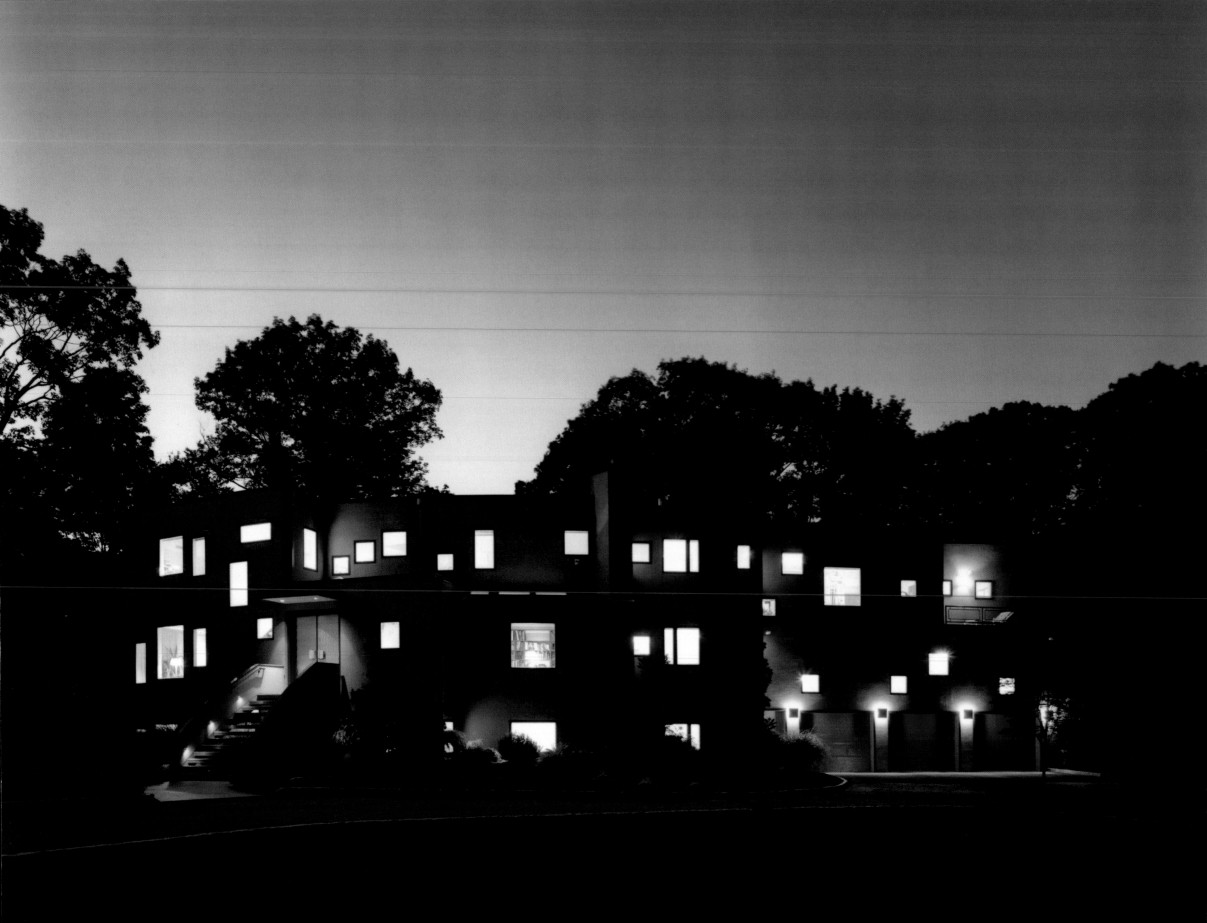

HARVEY WEBER

Weber & Associates

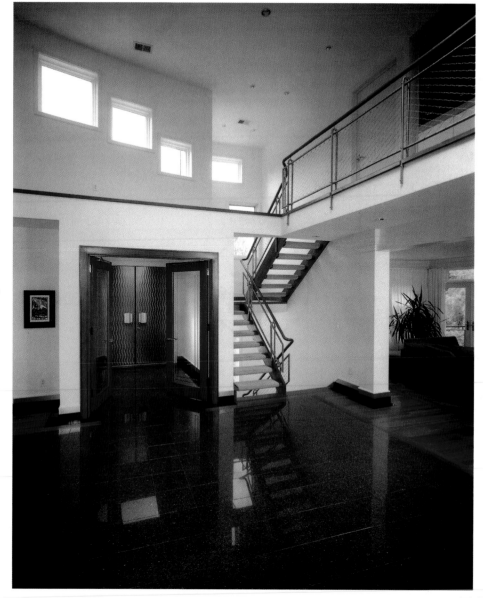

ABOVE: View from the gallery facing the entrance vestibule, which displays the stainless steel front doors, the wire mesh upper handrail and the granite and cherry wood floors.
Photograph by Dan Lenore

LEFT: View of the front at dusk which highlights the "random" placement of the windows.
Photograph by Dan Lenore

H arvey Weber creates dream homes. His own home is a dazzling 9,000-square-foot contemporary structure on a three-acre lot in Stamford, Connecticut. Unique to the neighborhood of more traditional architecture, it's a subtly curved mass with about 75 windows of varying sizes and shapes that complements its surroundings. Though provocative on the outside, it's warm, inviting and functional on the inside.

Harvey established his architecture practice in 1979, when he was just 26. In the ensuing years, he has developed an eclectic practice, designing everything from corporate and medical office interiors to award-winning new homes and residential renovations.

"My ability to listen to my clients and create designs that reflect their desires, needs, and budgetary constraints helps set me apart from the average architect," says Harvey, who lists Moshe Safdie amongst his biggest influences. He prides himself on his problem-solving skills, something that is critical to success in his profession.

Although each project is very different, they all contain some basic themes that are common to all of Harvey's designs. They all reflect his creative and innovative style and his dedication to the highest levels of quality and efficiency. He proudly stands behind each of his designs as do his highly satisfied clients.

Weber & Associates

Harvey Weber, AIA
313 Long Ridge Road
Stamford, CT 06902
203.327.7677

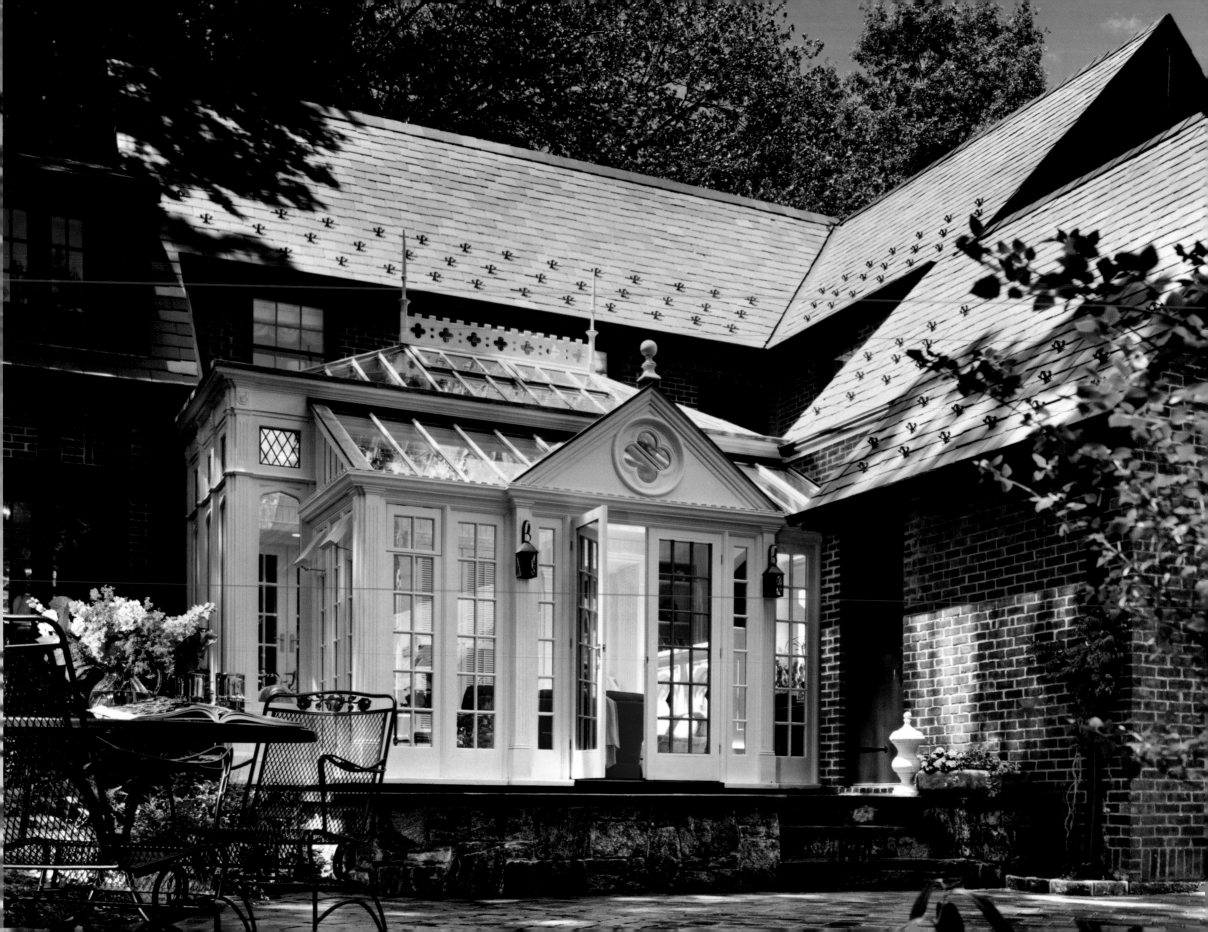

T.J. COSTELLO

Hierarchy Architects & Designers

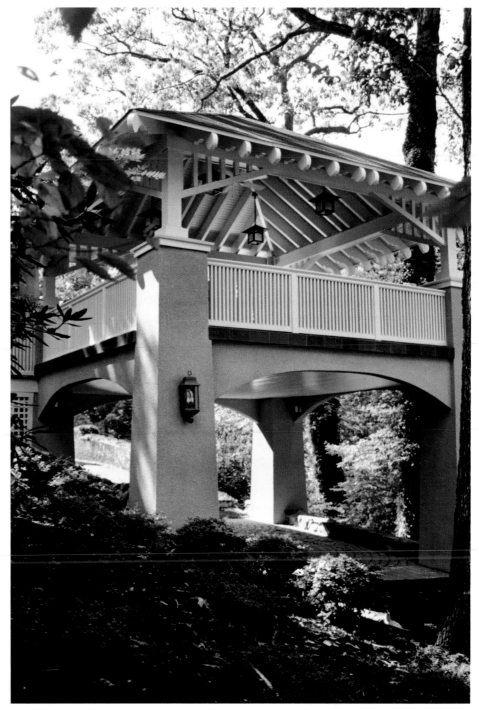

Unsympathetic alterations can spoil a home and the character of an entire neighborhood. That said, since 1989, with his contagious enthusiasm for older homes and a handful of willing clients, architect T.J. Costello has set out to change all that. T.J. has quickly raised the bar for his colleagues on the North Shore of Long Island, setting higher expectations in all residential alteration niches, one house at a time.

Born and raised in Massachusetts, T.J. has been involved in the architectural industry since 1977, having worked his way through the ranks, beginning as a junior in high school and later earning his degree from Cornell University. Today, as principal, T.J. finds his firm's name, Hierarchy, perfect for two reasons. First, he wanted the firm to be known for its philosophy of order and problem solving, second, delivering good architecture is never about one person, it is about the talent and dedication of its team players. T.J. has been fortunate enough to have had the same two key individuals for eight years. Ben Hurwitz is project architect for the majority of the firm's projects while Jesse Escue is a designer who

ABOVE: Originally conceived as an open wood deck built onto a sloped sideyard, T.J. maximized the site by using the air space over the driveway, while maintaining the mature vegetation of the hillside. The covered deck also serves as a port cochere for arriving guests.

LEFT: For this one story family room addition, in response to an existing shady rear courtyard, T.J. proposed a glass conservatory. Designed to T.J.'s specifications, crafted in England by Vale Garden Houses from solid mahogany, this glass room reinvigorated a charming but dark Tudor with daylight streaming to all adjoining rooms. The quartrefoil gable window, harlequin leaded transoms, and delightful cresting is inspired from Gothic Tudor details of the home.
Photograph by B. Rothchild

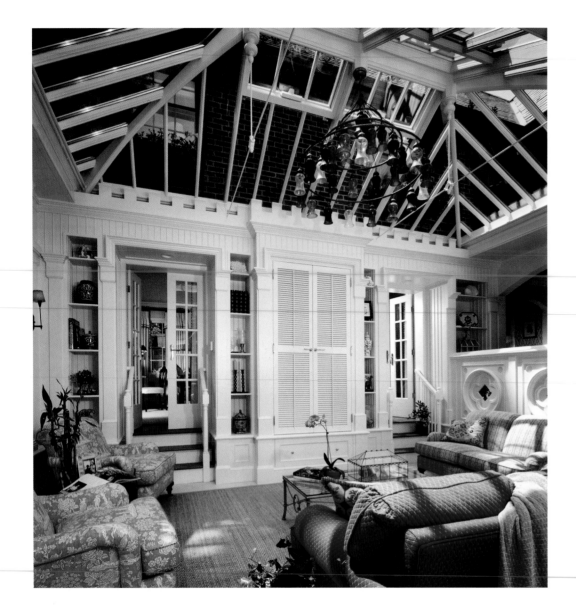

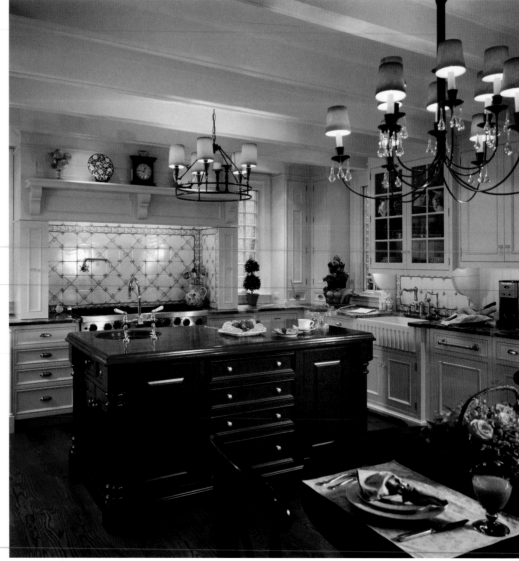

focuses on interior design and decorating. Susan Frooks, RA, has been a senior project architect with the firm for five years and her focus is on design as well as construction management. As registered architects, certified kitchen designers, landscape designers, decorators, Hierarchy tackles any project as an integrated team.

Hierarchy is not just a name; it is the firm's guiding philosophy and they tirelessly strive to embody T.J.'s favorite quote by Einstein, "Genius is making the obvious apparent." T.J. listens to the homeowner, the program and the budget. "Then I listen to the house, and it often tells me a different story." To create optimal solutions, he "designs a seamless addition to look as if

it was never added, or in the case of a major make-over, the way it always *should* have looked." Costello tinkers with designs long after most would have stopped to find the world of difference between elegantly simple versus expediently simplistic. "We know we've done our job when the alteration looks like the original intent." He adds, "It takes humility not to be noticed." Published in several national and regional magazines including *This Old House*, and numerous times in regional publications, such as *House* magazine, *Builder & Remodeler* magazine, *Elements* and *At Home* magazine, Costello's pursuit of "achieved simplicity" is very noticeable.

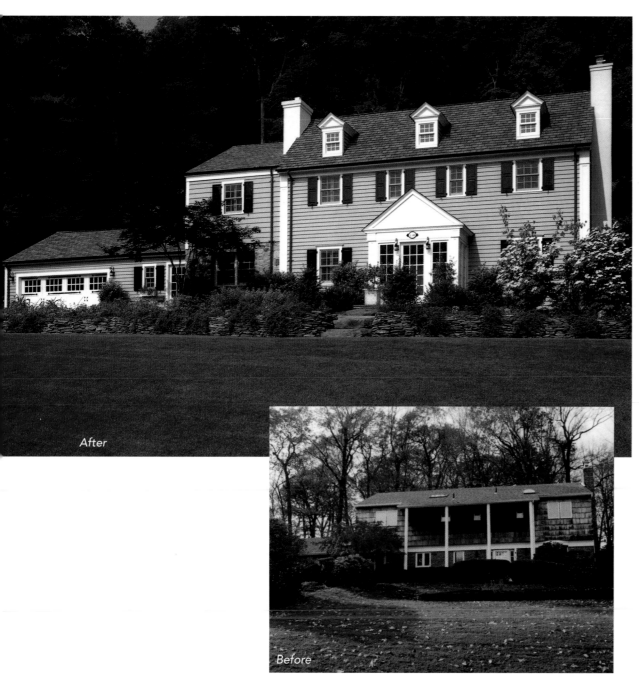

After

Before

more about t.j. ...

Q&A

What does he find most rewarding about being an architect?

When T.J. is working for clients, his goal is to create a tangible representation of his clients thoughts, to freeze a moment in time while still giving them a home that's fluid enough to adapt to their changing needs. It's an art and a challenge, he says. And it's highly rewarding. "There are things you do for love, and there are things you do for money. For me, as an architect, at the end of the day there's a lot of crossover," he says. "There are rare and special houses in which I leave a bit of my heart and spirit, and when I get a call from a client who says, 'I can see you in it,' that's what inspires me."

Who are his mentors?

Samuel White, Romaldo Giurgola, Moshe Safdie, Earl Flansburgh, Builders, Professors, and the masters of history pages, Jefferson, McKim Mead & White, Lutyens and Voysey.

What do you find most exciting about being featured in this book?

T. J. believes it is an important honor to be recognized for inclusion in *Dream Homes* as testament to the seriousness of his work. "It is exciting for regional firms who rarely have an opportunity to be showcased to a national audience, to share shelf space with admired international firms. Operating in the suburban market, where the style and quality of homes vary tremendously, exhibiting our work to a wider audience will market our efforts to like-minded home owners. Clients who may not know us by word-of-mouth will feel validated by selecting a recognized name."

ABOVE (AFTER) & INSERT (BEFORE): The "makeover" solution re-focused the eye to the center. By designing a traditional glass-enclosed portico, and re-pitching the center portion of the roof with three new dormers, the illusion of a central Manor house with wings was created. Hierarchy removed the outdated two-story colonnade (inset existing condition), from a 1960's Developer Colonial. Added nuances were: full story corner pilasters; juxtaposed clapboard widths; and a faux chimney to give balance. The mature garden entrance, designed by Christine Doctor, anchors the house, evoking a pastoral country-road appeal.
Photograph by R. Pappageorge, T.J. Costello

FACING PAGE LEFT: Two former windows of the living room looking into a dank exterior rear courtyard, were transmogrified into two French doors stepping into a glass world. The gothic revival millwork was custom built with Bobby Lambaski, cabinetmaker. The chandelier is an Egyptian antique. Furnishings by Windham House.
Photograph by B. Rothchild

FACING PAGE RIGHT: This French country kitchen has a sophisticated rather than rural twist. The island is celebrated in a rich delft blue. The beamed ceiling gives scale to the breakfast and sitting room which are connected as one large "keeping room" with the kitchen. Cabinetry by Great Kitchens, New York City.
Photograph by B. Rothchild

Hierarchy Architects & Designers

T.J. Costello, RA, AIA, CKD

7 Gaynor Avenue

Manhasset, NY 11030

516.627.7007

www.hierarchyltd.com

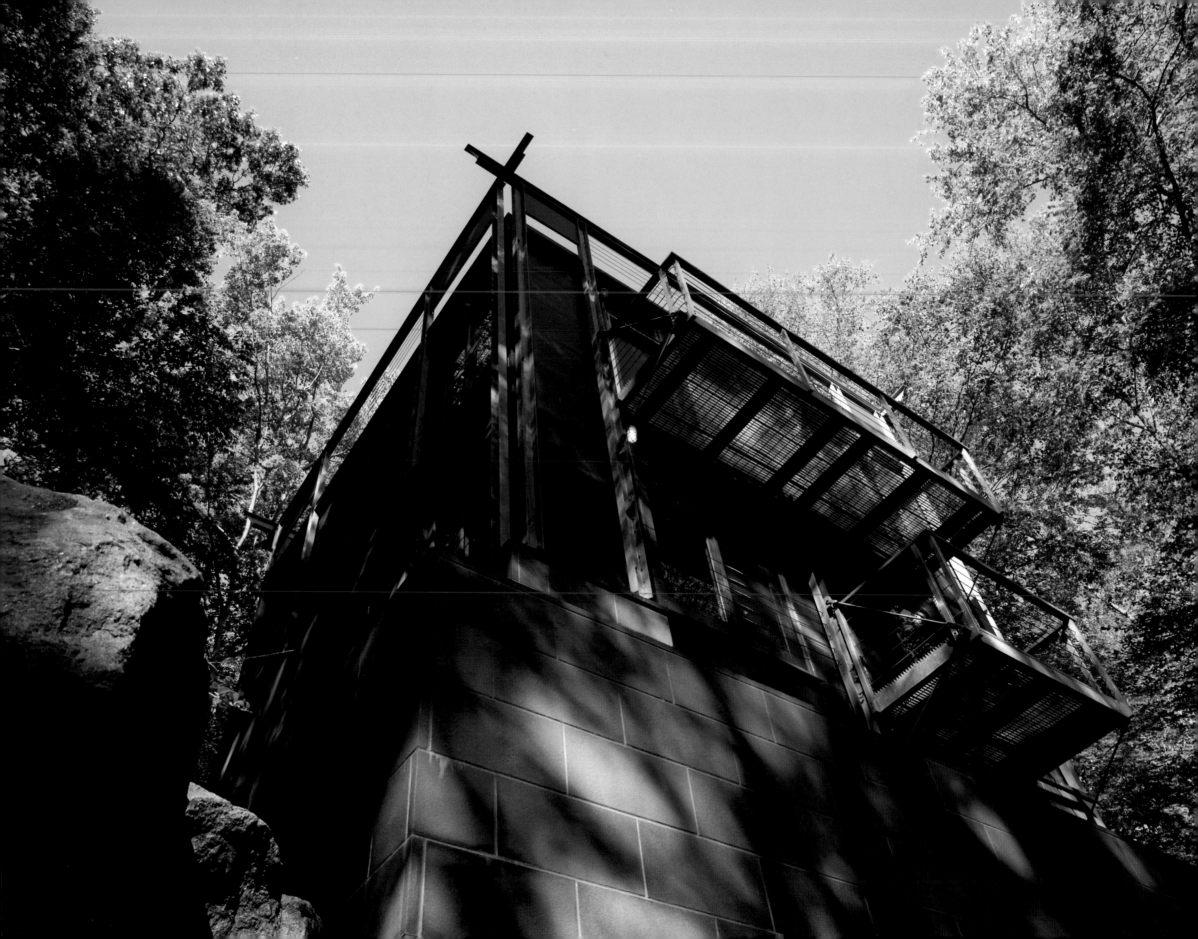

EDUARDO LACROZE

Lacroze-Miguens-Prati Arquitectos

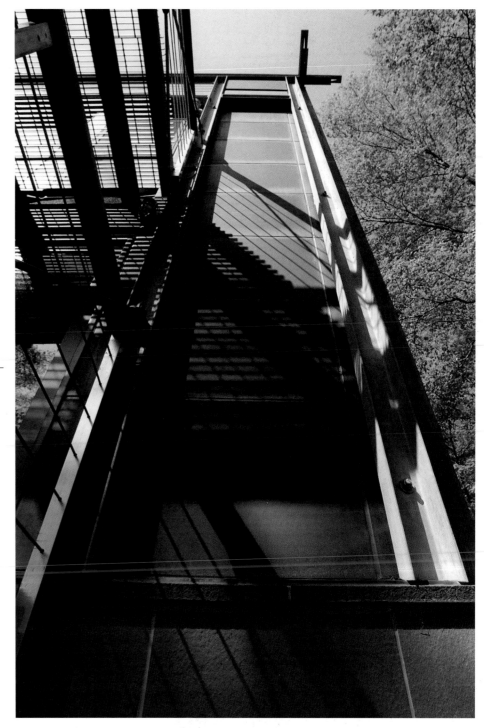

In 1981, Eduardo Lacroze came to New York City from Buenos Aires to work on a couple of assignments — turning single-family brownstones into apartment co-ops — that were to be the beginning of a long design journey throughout the Americas. For several years, the architect traveled back and forth between the United States and his homeland until, as one commission led to the next, Lacroze-Miguens-Prati Arquitectos established a practice in New York in 1989 and he made his home in the United States for good.

Well known in the fields of architectural, interior, and furniture design, the firm focuses primarily on residential planning and hotel and resort development, design in the States and throughout Central and South America, as well as on the undertaking of interesting community-scaled government and public works jobs. It was hired for the renovation and expansion of the Argentine Consulate in New York City (originally the famed Stanford White's Harry B. Hollins residence), as well as the more recent

ABOVE: Sunlight filtering through foliage and a multilayered grid of cantilevered platforms and structural members casts shadow graffiti on the multitextured building envelope.
Photograph by Pablo Corradi

LEFT: Progressively shedding stone, steel and copper, the Cold Spring Harbor TreeHouse emerges from the bedrock and telescopes skywards to reach the surrounding green canopy.
Photograph by Pablo Corradi

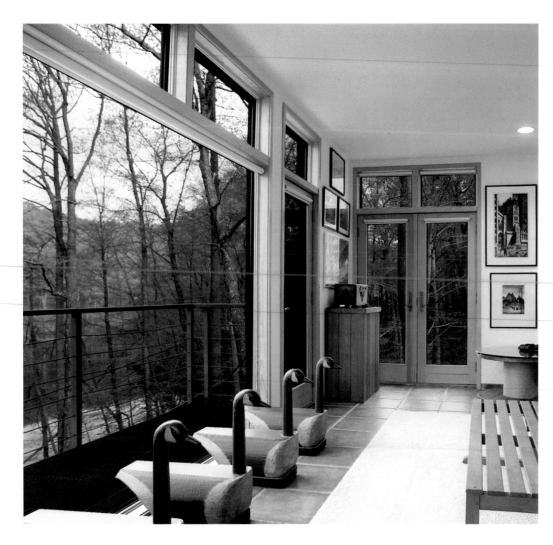

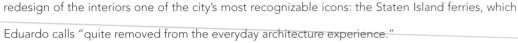

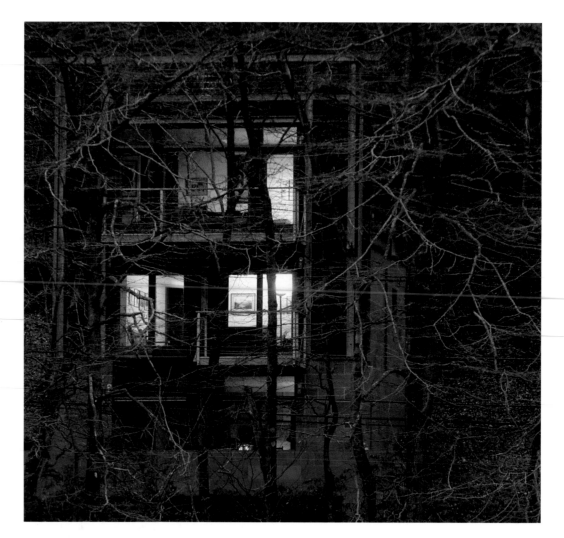

redesign of the interiors one of the city's most recognizable icons: the Staten Island ferries, which Eduardo calls "quite removed from the everyday architecture experience."

That sentiment extends to all of the firm's projects, however, including the few selected challenging residential jobs it takes on each year. The firm always tries to explore an extra little individual twist with every building, taking each to a level beyond the obvious. Among the current projects, the renovation and extension of Marcel Breuer's Beech Hill House in Lloyd Harbor, the Museum of Pre-Columbian Art in Montevideo, Uruguay, and a hotel in the foothills of Machu Picchu exemplify the range and depth of the firm's undertakings.

Regardless of size, whether poolside cabana, a 1,500-square-foot "mini high-rise," on a protected slope, or the Westin Camino Real Hotel amid the Mayan ruins of Tikal, the foremost principle behind the firm's work is the elimination of dogma: The architects don't start with a set of rules or a stylistic preference. Instead, they approach each project from a thoroughly contextual

perspective — physical, cultural, historical, or technological. "At the end of the day, the architectural response in our case is usually much more reflective of the particularities of site, program, or client rather than any preconceived notions," says the architect.

Educated and trained in the early '70s in both Buenos Aires and Copenhagen, the architect's influences have been strictly modernist. Even historical structures with traditional forms and language are approached with a modernist sense of space and light, and whether the building is ultra modern or conceived in the most approachable New England vernacular, every design follows an unmistakable conceptual path: simple but flexible floor plans, precise spatial modulation, carefully interlocking areas for privacy and community, and an unorthodox complexity in the layering of urbanity and rurality. Thus a most modern structure is made to feel at home in the most bucolic of rural settings, and an apparently traditional response is strongly imbued with a forward-looking sense of modernity.

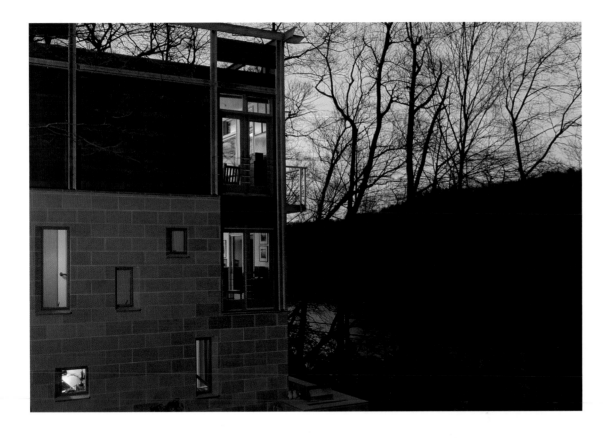

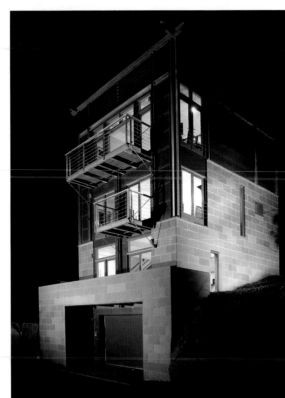

ABOVE: Perched atop the pond, the TreeHouse is an exercise in fenestration, its syncopated, punctured windows positioned to capture the few elusive beams of sunlight that penetrate the summer canopy.
Photograph by Pablo Corradi

RIGHT: By night, the slender structure reverts and becomes a lighthouse of sorts, glimmering in the surrounding darkness.
Photograph by Pablo Corradi

FACING PAGE LEFT: The metal clad shell unfolds into a glass wrapped rooftop penthouse with full - view command of its pristine surroundings.
Photograph by Pablo Corradi

FACING PAGE RIGHT: Rising four stories on a minimal footprint, this rural " townhouse" coexists within the untouched green mesh that engulfs it.
Photograph by Pablo Corradi

more about eduardo...

Q&A

What personal indulgence does he spend the most money on?
Eduardo collects antiques and works of art that convey the layering of culture and history of each place where the firm has been fortunate to work. With projects and buildings in more than a dozen countries, that makes for a pretty varied and interesting field of indulgence.

What book has had the greatest impact on the architect?
Like most of his generation, Eduardo says it's probably Sigfried Giedion's *Space, Time and Architecture* — and a number of the subsequent efforts to disprove it.

If he could eliminate one design/architectural/building technique or style from the world, what would it be?
"There is no single style that needs be eliminated," he says, "only bad renditions of any and all styles. And maybe, by the way, the concept of 'style' as a recipe should be done away with."

What single thing would he do to bring a dull house to life?
Incorporate interconnections — of spaces, of paths of use, of interiors and exteriors.

What is the most unique/impressive/beautiful home he's seen and why?
His partner Pancho Prati's home in Buenos Aires is low on budget, high on content. It makes the luxury of light and space affordable and avoids the tempting trappings of overdesign, managing a balanced mix of contextual sensitivity and intellectual underpinning. And it withstands the test of time.

Lacroze-Miguens-Prati Arquitectos

Eduardo Lacroze, AIA

85 Forest Avenue

PO Box 597

Locust Valley, NY 11560

516.674.4239

www.lacrozemiguensprati.com

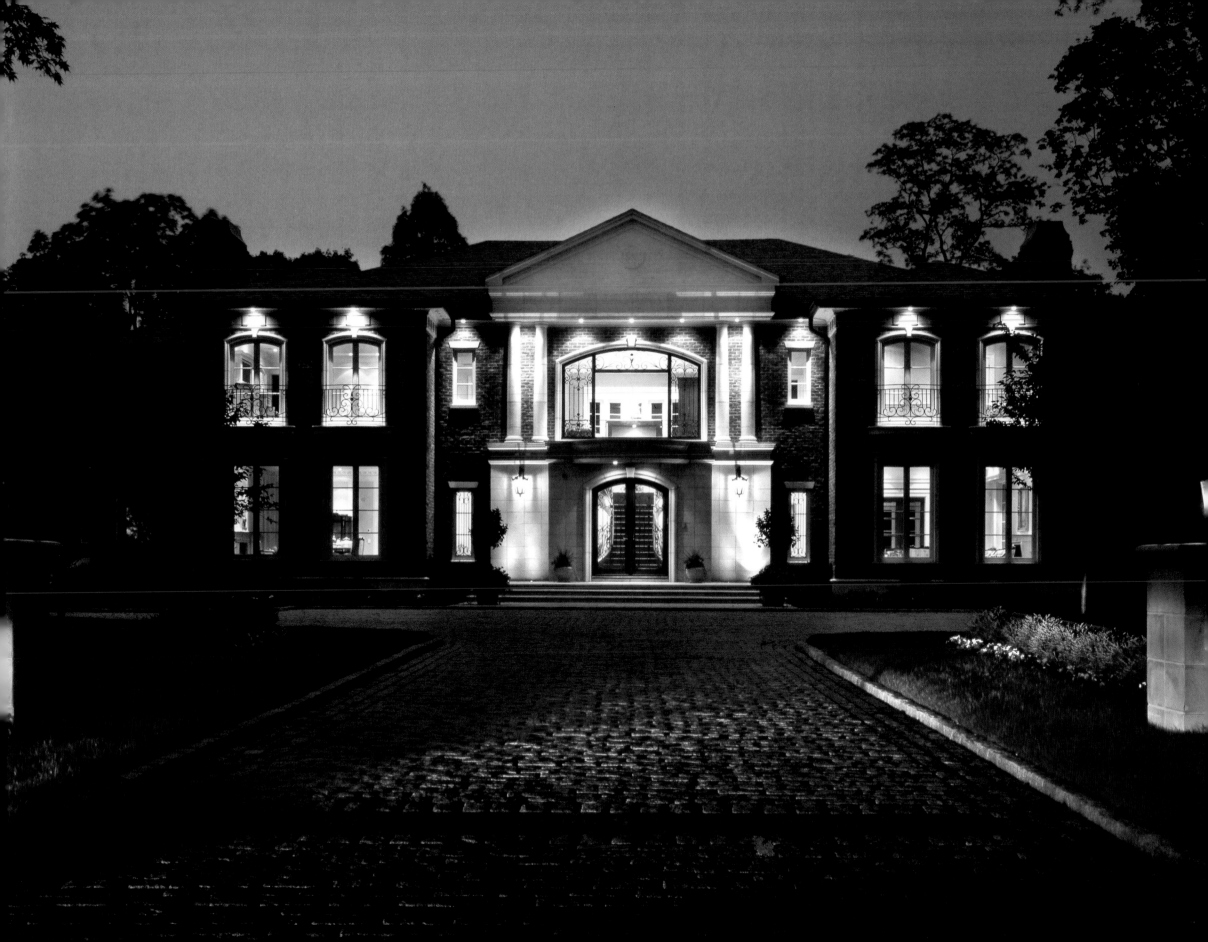

SUSSAN LARI

Sussan Lari Architect, PC

Sussan Lari loves New York. Although the architect enjoys nature and the outdoors, she calls herself "a true urbanite." She lived for many years in Manhattan before moving to Long Island with her musician husband, and she still heads into the city at least once a week. "I thrive on the life source of New York," she says, adding that she finds the ethnic mix, the museums, and the restaurants particularly exhilarating.

On a broader scale, it's also a great place for Sussan to do business. The 28-year architectural veteran appreciates the diversity of residential projects that the New York area affords her. Within a two-hour radius she can work on townhouses, penthouses, and apartments in Manhattan; villas and large-scale homes in the suburbs; beach houses in the Hamptons; and country homes in upstate New York and Connecticut. Since opening her own firm in 1992, she's completed 40 residences, two offices, and a major corporate headquarters, covering the full spectrum of design, from exterior and interior architecture and garden design to all aspects of interior design and decorating.

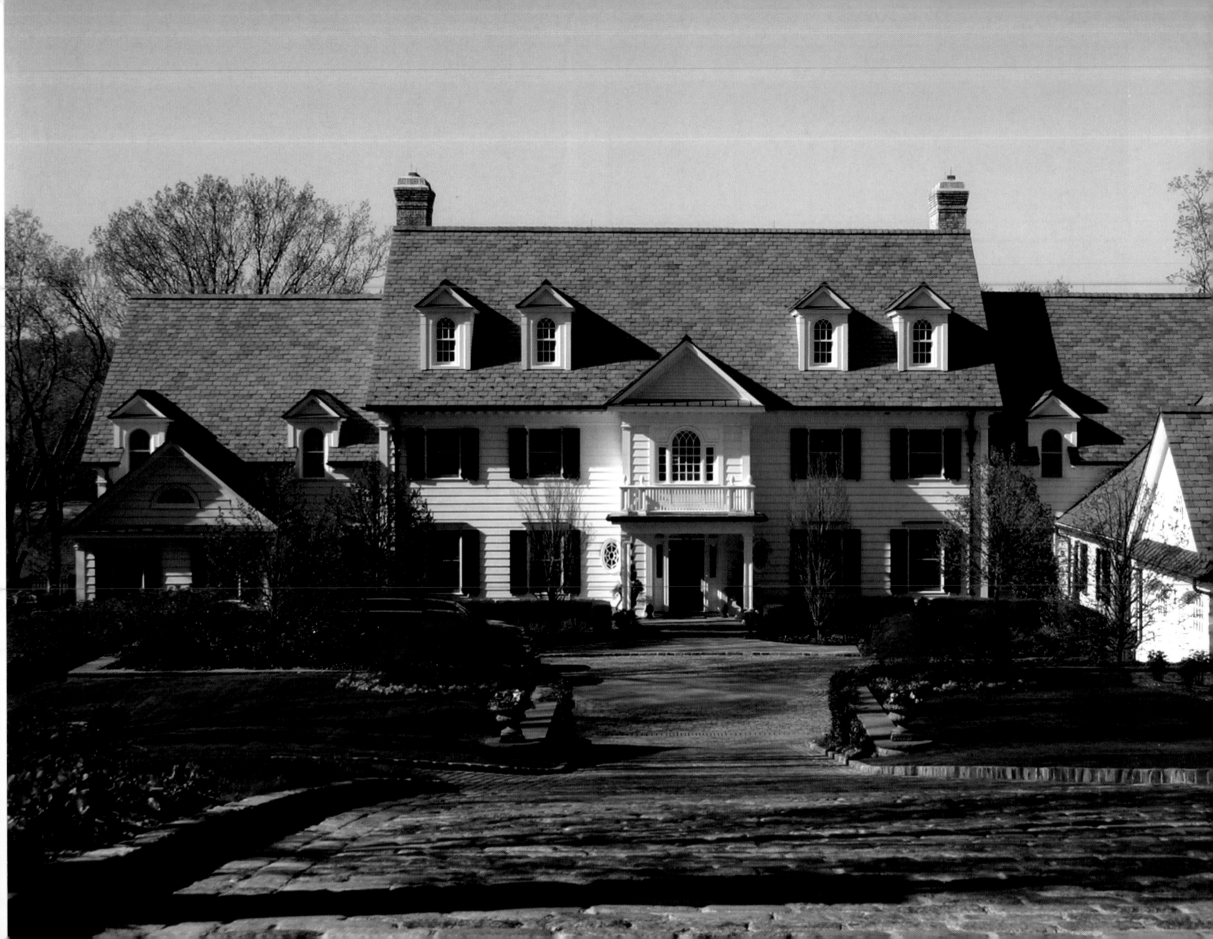

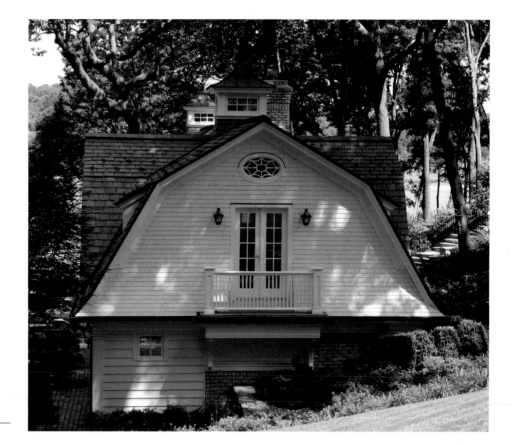

ALEXANDER D. LATHAM III

ADL III Architecture, PC
Architects—Town Planners

As a senior in high school, Alex Latham wanted to be a ski bum. His dearest love was the outdoors; nothing made him happier than being outside, climbing mountains, backpacking, or riding the slopes. Today, however, few things please the award-winning architect more than standing in the yard in front of one of his finished designs or driving through one of the communities that he's consulted on, surveying the tangible results of his ideas.

A licensed architect since 1990, Alex is the owner and principal of ADL III Architecture, a multifaceted firm that focuses on residential and commercial architecture and town planning. The company has worked on significant waterfront residential projects around Long Island and upstate New York, as well as numerous Main Street mixed-use projects, comprising first-floor retail and second- and third-floor office/apartments. It's done historical renovations from Oyster Bay to Utah and everything from golf clubs to senior centers on the commercial side.

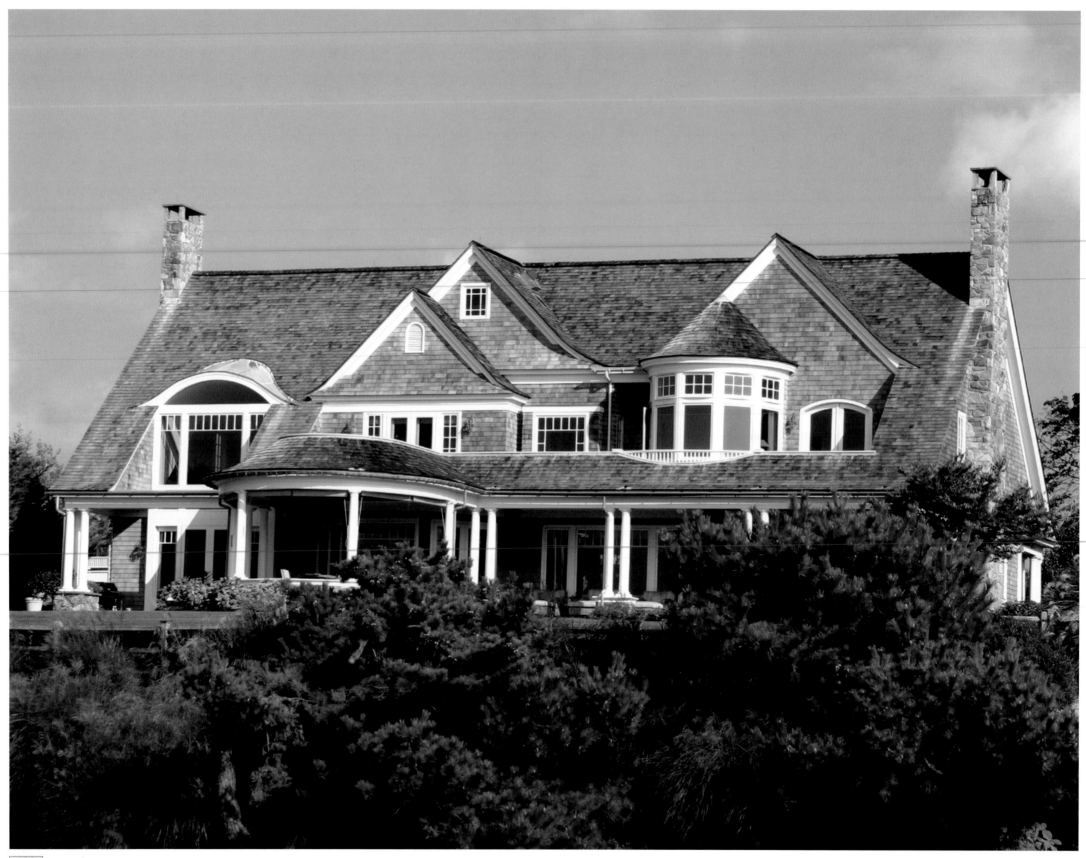

Irrespective of project type, the company operates with a single overriding philosophy: to provide exceptional service on many levels. This means giving clients the attention and direction they need to convey their needs and wants; giving clients well-thought-out design that is both highly detailed and high functioning; and following through with budgeting, scheduling, and supporting clients through the sometimes difficult construction process.

As one of the area's leading architectural firms, ADL III is called upon for a range of jobs but must be selective when taking on new projects. The scope of ADL III's residential work varies from a modest 400-square-foot addition to the renovation of a 30,000-square-foot Gold Coast mansion to building from scratch a grand 18,000-square-foot estate with three detached carriage

ABOVE: The interiors for this stately shingled home are appointed with well balanced mouldings, and built-in furniture that was detailed by Alex Latham. Beachy pastels and a hand-hewn cherry floor complete the look.
Photograph by Gwen N. Ferry

RIGHT: The front entry to this Shingle-style home is understated and casual, reflecting the client's personality.
Photograph by Alexander Latham

FACING PAGE: This Shingle-style house is perched on a bluff overlooking Northport Harbor. "The massing, composition and balance are subtle yet important aspects of the Shingle style and warrant the utmost attention to detail."
Photograph by Alexander Latham

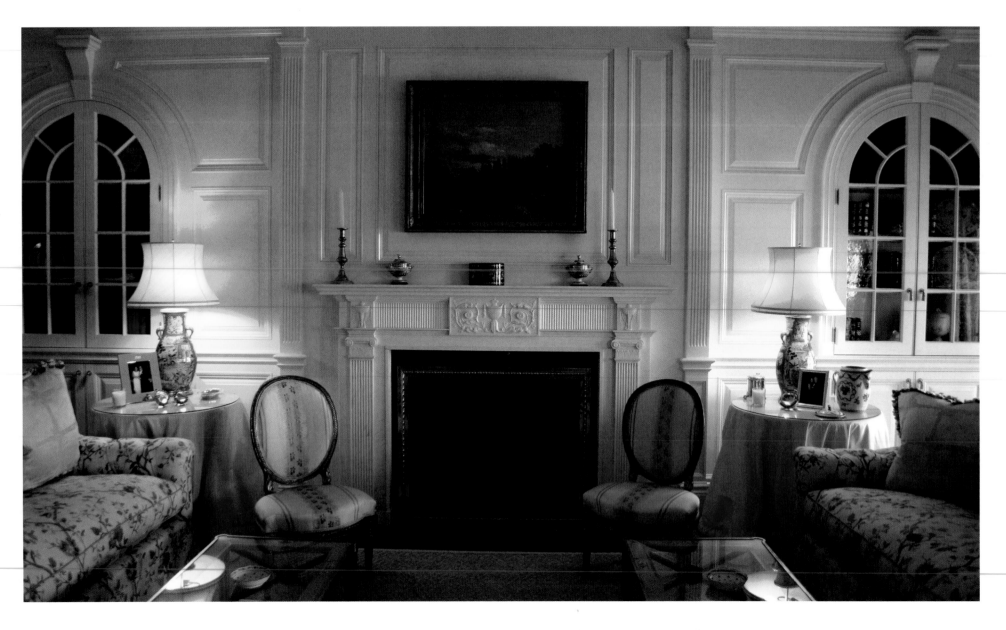

houses. Regardless of size, the consideration of detail is taken to the nth degree and guidance is offered till the very end. "We don't just design homes and hand them over," Alex says. Built-in furniture, fireplaces, shelving, moldings, and closets get the same scrutiny as, say, the floor plan or front elevation. And if clients want help choosing light fixtures, hardware, and paint, they get it.

Ninety-nine percent of the people who come to ADL III are looking for a traditionally styled home — something that's going to fit well in the established neighborhoods of Long Island. Alex appreciates the specific characteristics of such buildings and has taken special interest in the traditional style through continuing

education for himself and his staff. When the architect says, "It's in my blood," you can hear in his voice and see in his face that he means it.

ABOVE: The Colonial Revival home, highlighted a few pages before, features this classically detailed formal living room with a marble mantle from England. The moulding and paneling were all detailed by Latham.
Photograph by Elissa Ward

FACING PAGE TOP: This Tuscan-style villa is located in Glen Cove and fronts the Long Island Sound. The main feature of this 4,000-square-foot addition and remodel, is a three-story stair tower connecting the existing to the new.
Photograph by Ela Dokonal

FACING PAGE BOTTOM: This quiet corner of the villa faces a garden court and features a classical Italian sculpture.
Photograph by Alexander Latham

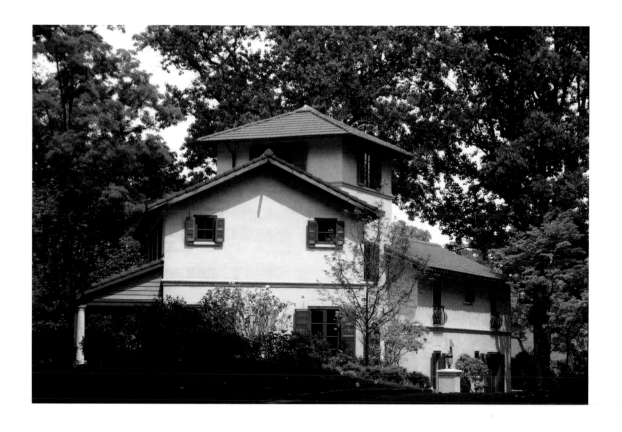

What personal indulgence does he spend the most money on?

Architecture is not only Alex's profession, it's his passion, so it's as much a part of his personal interests as it is the way he makes his living. He's always looking for rare old books that pertain to architecture. Old architectural prints fill his office walls, and whenever he travels he keeps an eye out for books and architectural graphics, such as charts and maps.

Who has had the biggest influence on his career?

A trained architect, Alex's father was very skilled at painting, drawing and building things. He passed those interests along to his son. Other architects, including Robert Stern, John Nash, and John Nolen, also have impacted his work.

When he's not working where will you find Alex?

The father of three — ages 3, 7, and 16 — relishes the time he can simply sit and draw or color and play with his kids.

Awards and recognition:

For its town planning work, ADL III Architecture has received a number of Smart Growth Awards from Vision Long Island. The firm's residential work has been showcased in such publications as *Better Homes & Gardens, Elegant Homes, Beautiful New Homes,* and *House Magazine.*

ADL III Architecture, PC

Alexander D. Latham III, AIA, APA, CNU
Architects-Town Planners
24 Woodbine Avenue, Suite 1
Northport, NY 11768
631.754.4450
www.adl3.com

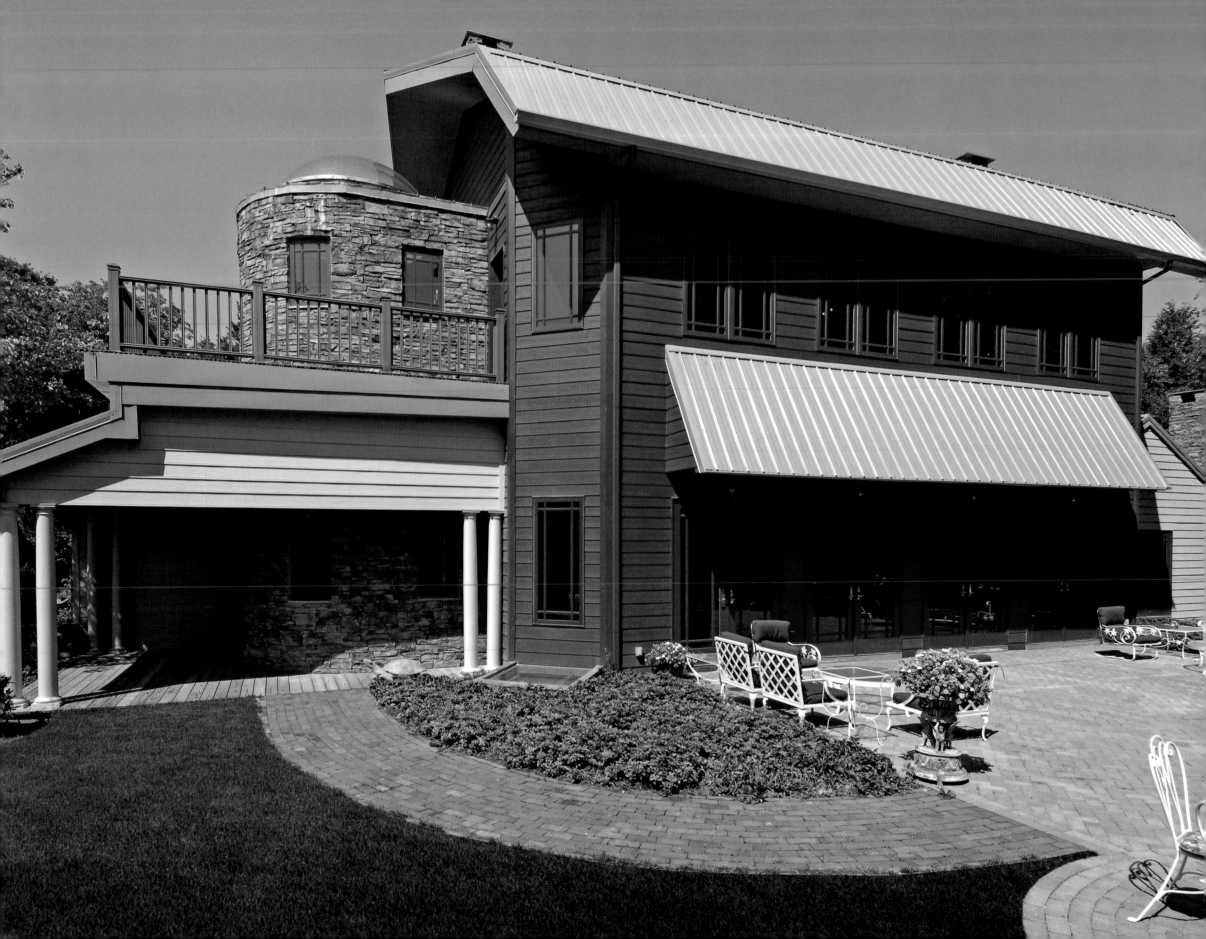

PAUL RUSSO

Paul Russo Architect, PC

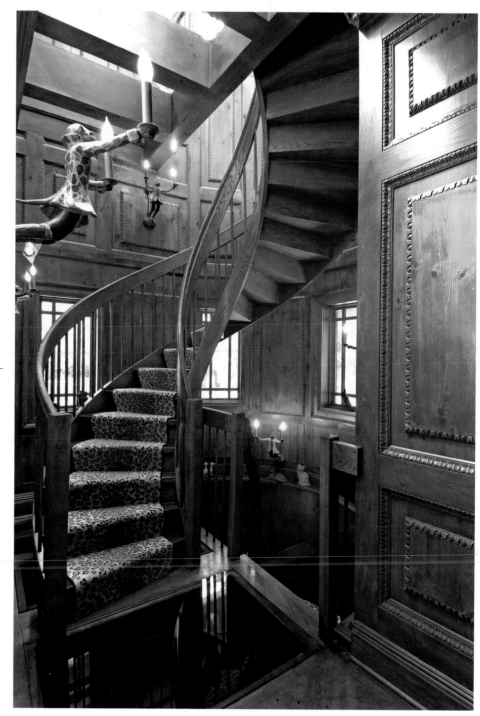

ABOVE: Double helical free standing stair within silo leading to second floor master suite. The landings are two-inch thick glass. The silo features a dome skylight and raised paneling in pine.
Photograph by Ron Papageorge

LEFT: This two-story barn-like structure is situated on five acres in Matin-ecock, New York. It features a two-story stone silo with walkout terrace, metal roofing, clapboard siding, Queen Anne-style windows and doors. The first floor is comprised of a great room, library, eat-in kitchen, dining room, maids' quarters, walk-in pantry, and two guest suites. The second floor has a 1,100-square-foot master suite with two fireplaces and a walkout terrace.
Photograph by Ron Papageorge

Paul Russo leans toward simple, organic design. For the nature-loving New York native, Frank Lloyd Wright's Fallingwater represents residential architecture in its purest and most impressive state, and Wright's influence can be seen throughout the young architect's work.

Long before receiving his master's degree in architecture from Syracuse University in Florence, Italy, Paul began renovating his parents' home one room at a time while still in high school. But it is his own house (where his offices are also located) that stands out from among his greatest professional achievements. Situated on a hill and built from the ground up by Paul with the help of his father, a retired mason, the bold three-story structure displays Tudor, Victorian, Picturesque, and Prairie influences. And it earned him a prestigious award from the American Institute of Architects in 2002.

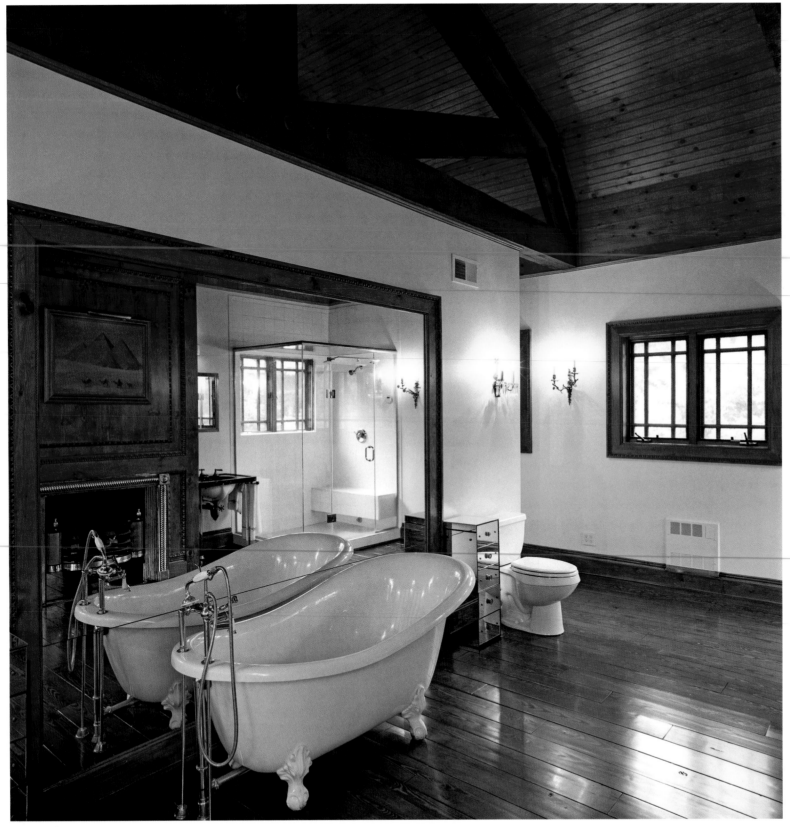

The small size of Paul's firm — five employees total — provides him with an advantage over larger companies, as he's able to devote himself personally to each of his clients, taking on their hopes and dreams as his own. This kind of individualized attention is something Paul's clients appreciate.

Paul's work has been featured in *The New York Times*, *House Magazine*, and *Newsday*, as well as on HGTV's *Before & After*.

LEFT: Second floor master bath features claw foot tub, his and her sinks/toilets, fireplace, vaulted ceilings with exposed heavy timber trusses and wide-plank pine floors.
Photograph by Ron Papageorge

FACING PAGE TOP: New 5,550-square-foot Victorian-style home situated on two acres in Lattingtown, New York. The home features a walk-out tower, front porch, attached garage, painted clapboard siding and stone façade. It has a slate-style roof. First floor features entry foyer, eat-in kitchen, dining room, family room, crafts room, play room, study, and library. The second floor contains five bedrooms including a master suite with a walkout deck, and two bathrooms.
Photograph by Ron Papageorge

FACING PAGE BOTTOM: West façade with a two-bay garage and carriage style doors.
Photograph by Ron Papageorge

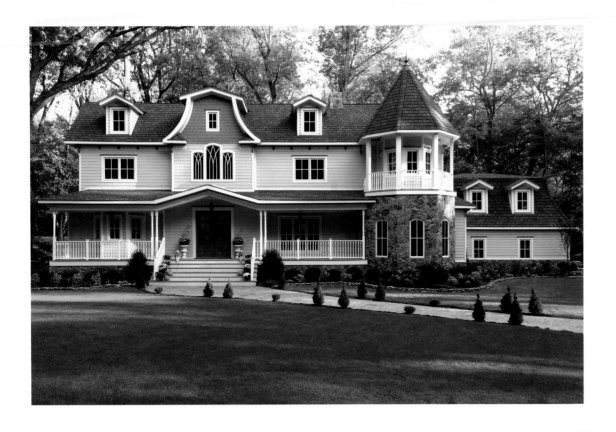

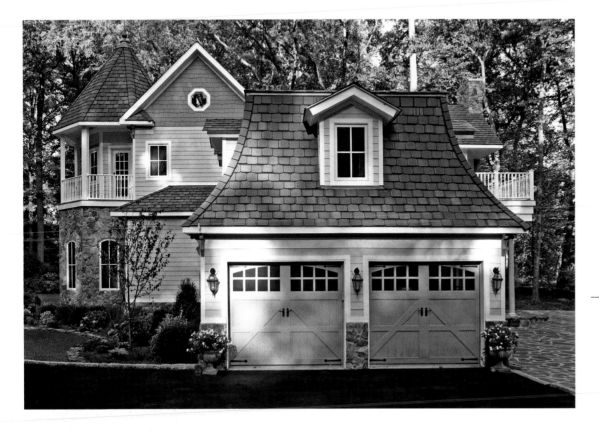

more about paul...

Q&A

What color best describes him and why?

Relaxed and cheerful, blue is the shade Paul says fits him best.

What personal indulgence does he spend the most money on?

Paul makes a point to travel to a different location twice a year, enjoying the variety of architecture each location has to offer. Some of his favorite spots are in Italy and Southern France, and he finds cloisters and monasteries especially intriguing. "To see how the monasteries function in terms of the monks' personal spaces versus shared spaces, and to see the beautiful arched cloisters that surround the gardens — it is something I would love to have the opportunity to design in the near future, if not for a client, then for myself," he says.

What does Paul enjoy most about being an architect?

"I love that each project is unique and comes with its own set of challenges, which keeps my job very interesting," he says. The architect understands that most people have a distinct vision of what they would like their dream home to be, and he's thrilled when he's able to help them realize their dreams while giving them a home that functions well for their lifestyle.

Paul Russo Architect, PC

Paul Russo

114 Birch Hill Road

Locust Valley, NY 11560

516.671.5082

www.russoarchitect.com

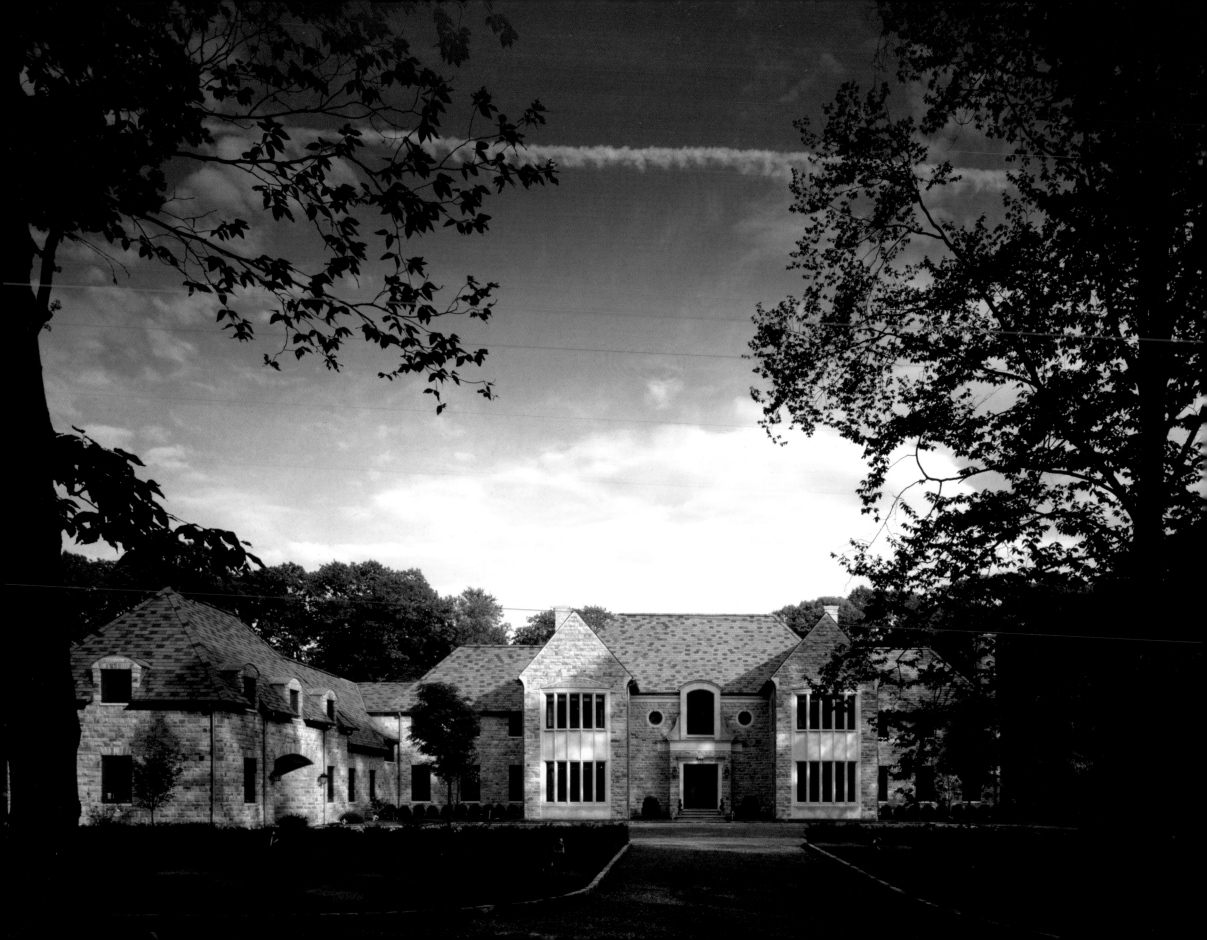

LAURA SMIROS & JAMES SMIROS

SMIROS & SMIROS Architects, LLP

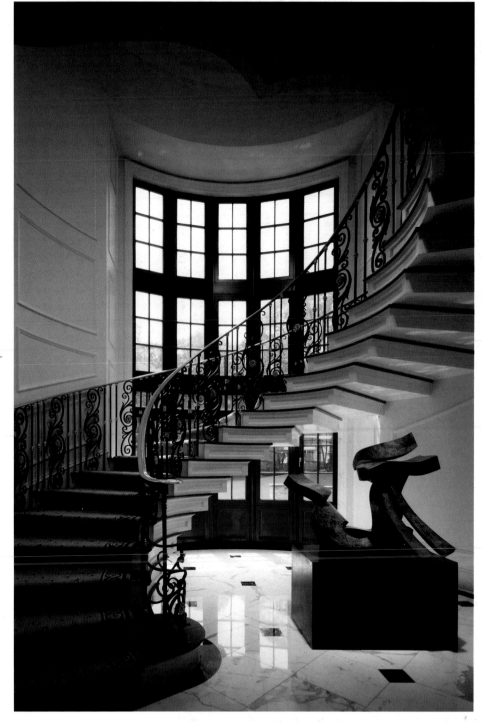

S MIROS & SMIROS Architects has, since its inception in 1993, developed a practice that has expanded from their base in New York to include projects along the Eastern seaboard, from New York to Palm Beach, and in Europe, from England to Russia. Drawing extensively on traditional forms, the founding partners, Laura and Jim Smiros, have established a design idiom that combines a classical architectural vocabulary with creative design solutions to create modern programs with a focus on the art of building, a passion for detail, fine materials, exceptional workmanship, and a superior level of service.

With each change in location, S&S was challenged to explore diverse styles. Empowered in varying geographic regions, the firm's adept design sensibilities marry context with fundamental American design, allowing for a seamless and unique amalgamation of the client's vision with the architectural requirements of each site.

ABOVE: The classical stair hall composed of floating elliptical stair and scalloped landing is accented by natural light through the two-story estate window.
Photograph by Durston Saylor

LEFT: This Harrie T. Lindberg inspired new country home is built on a linear plan where all of the major spaces enjoy southern light and views of the gardens and golf course beyond.
Photograph by Durston Saylor

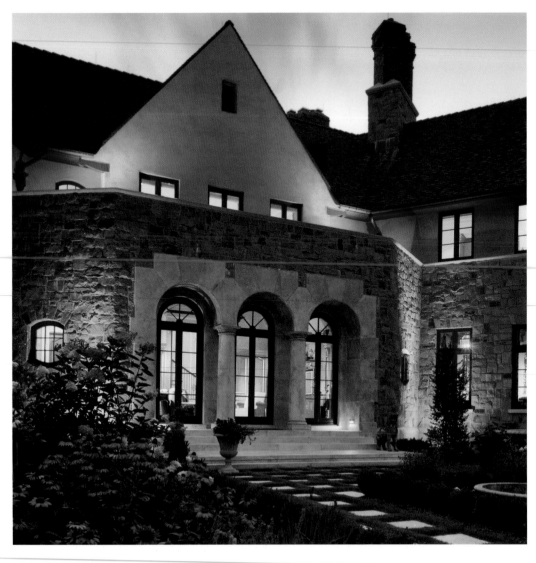

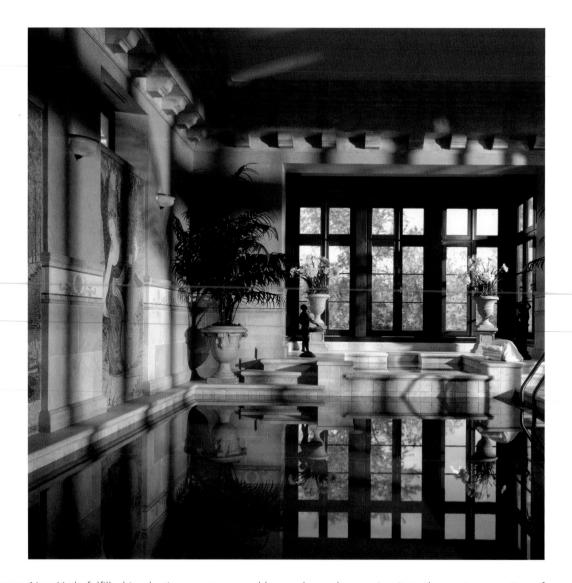

The inner workings of the firm are equally unique; at SMIROS & SMIROS Architects clients enjoy direct partner involvement, analytical analysis, and an interactive collaboration. Intrinsically at S&S, there is a strong governing motif (call it Feng Shui) melded with intimate-scale textural details like pecky cypress beams and ceilings, carved French limestone entries, and hand-hewn wide-plank oak floors — unique details for each and every project.

As Laura and Jim explain, "We do more than build a house; we help people realize their dreams. Not only do we allow them to enjoy their successes, we give them special spaces in which to celebrate life and take refuge from today's fast-paced world. Our work returns energy to their lives."

And that's what prompts clients to return again and again for new homes, in new settings, with a new flavor. One client in particular, upon completing an English Country Manor home in

New York, fulfilled its destiny as a treasured legacy home by passing it to the next generation of the family. The retired couple then hired Laura and Jim to develop a more intimate place for them to live.

While the Smiros' designs are often based on historical precedents, they strive to be both faithful and innovative in their use of classic themes. The layout of their homes reflects the way people live today, incorporating modern technology and conveniences while never losing sight of the traditions of proportion and detail that inspire them. "We prefer to explore unique solutions for each project. By bringing our clients into the design process to develop their dreams, we infuse the architecture with their personality and enrich it with their involvement. Together, we've been successful at creating projects with strong individual character to embody the clients who commission them."

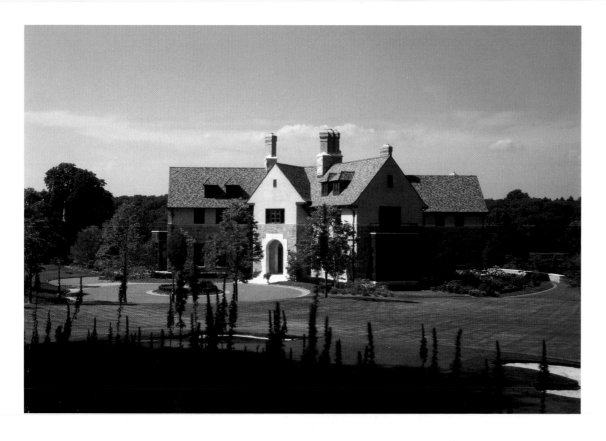

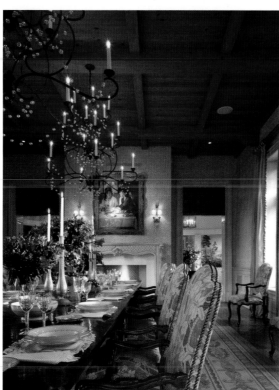

ABOVE: The structure features a "sun trap" plan that maximizes daylight and provides unique views of surrounding idyllic landscape and the waterfront from almost every room in the home.
Photograph by Durston Saylor

RIGHT: The dining room wing is reflective of the more formal architectural attributes of this home, balanced by the elegant ballroom wing about the classically designed rotunda entry hall.
Photograph by Durston Saylor

FACING PAGE LEFT: Inspired by the architecture of Edwin Lutyens and garden designs of Gertrude Jekyll, this stately English country manor home in New York is based on the 'golden section' principle of classical proportions.
Photograph by Durston Saylor

FACING PAGE RIGHT: The Natatorium, which completes the fourth wing of the home, features handset mosaic panels depicting muses of Art, Science, and Literature.
Photograph by Durston Saylor

more about laura & jim...

Q&A

What personal indulgence do they spend the most money on?
The couple loves to travel, especially to what they call "layered cities," international destinations such as Rome, Athens, and Barcelona. In the United States, Washington, D.C., is a particular favorite.

What is something most people don't know about them?
Jim and Laura spend their time out of the office supporting the community of their hometown, Oyster Bay. Jim has served on the Oyster Bay East Norwich Board of Education, and Laura is involved in the Parent Teacher's Association. Jim is chair of the local Cub Scouts Troop 253 and Laura serves as treasurer of the Girl Scouts.

What is their design style or preference?
The fundamentals of Classical architecture remain the cornerstone of their practice as well as a belief that those fundamentals have a place in defining modern design. Paramount is an aesthetic unity that ensures a consistent theme throughout the project while maintaining a simplified elegance.

What do they enjoy about working together?
Jim enjoys the creative aspects of architecture. Laura is the technical engineering expert. When one presents an idea, the other may suggest a different approach. Working in a two-heads-is-better-than-one way means that their designs can be that much better. Collaboration is part of the fun of their job, they say — though they wouldn't call it a job, but rather a lucrative hobby.

SMIROS & SMIROS Architects, LLP

Laura Smiros, AIA

James Smiros, AIA

51 Glen Street

Glen Cove, NY 11542

516.676.9200

www.smiros.com

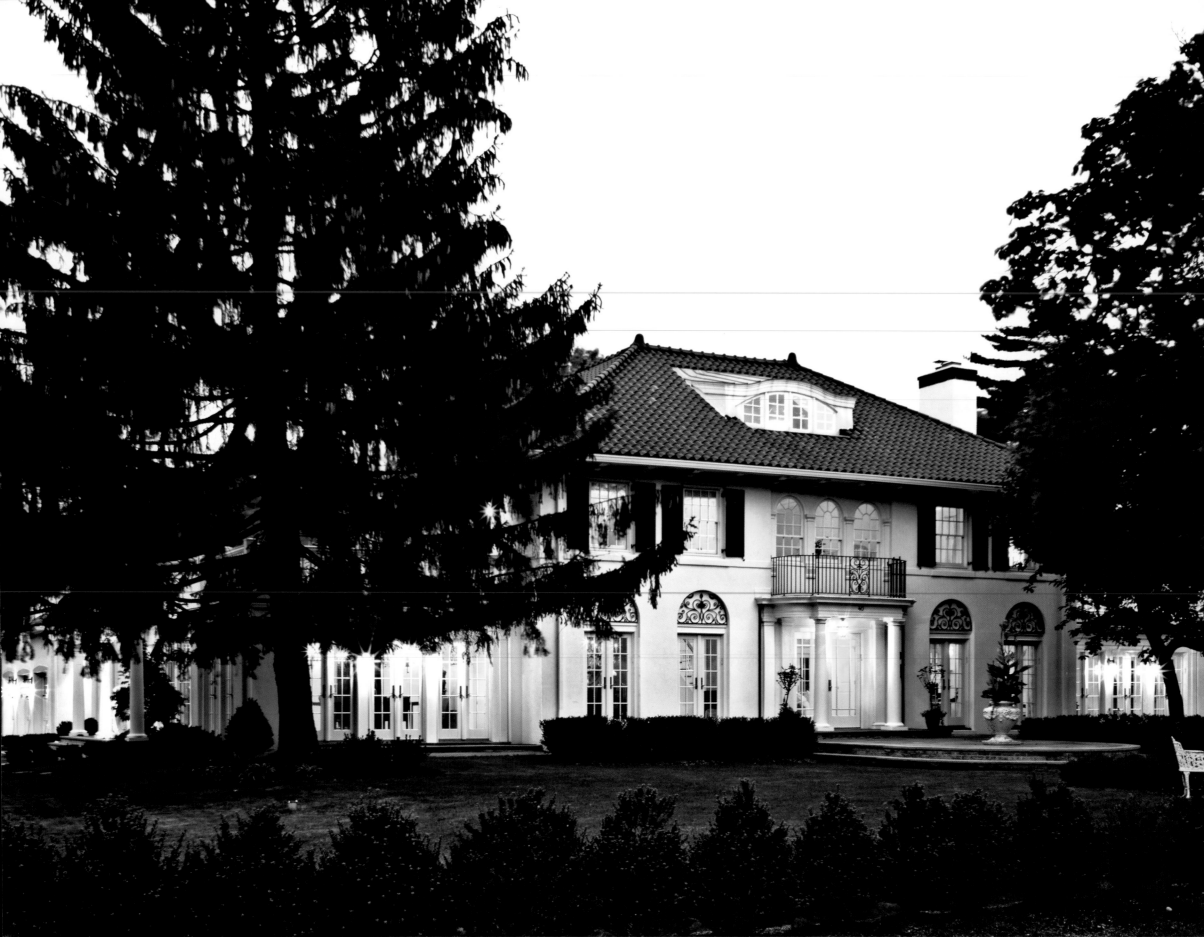

MARC B. SPECTOR

Spector Group

The Spector Group has been referred to as Long Island's First Family of Architecture. And it's a title well-earned. Since 1965, Spector Group's architecture and interior design has impacted the greater metropolitan area with iconic buildings and interiors that exude a dynamic energy and a strong sense of presence. Through three generations of leadership, the fundamental objective of the international firm has remained consistent: to create timeless buildings and spaces that are innovative and to enrich the lives of the people who inhabit them.

As one of the principals of Spector Group, Marc Spector has great passion for the studio he formed five years ago, Spector Group Home, which specializes in all aspects of residential design architecture, interior design, and interior decorating. The focus is on large-scale, single-family homes that are as individual as the families who live in them. "We view each client and site as a unique constellation of opportunities, constraints, dreams, and history; design is exploration," Marc says, emphasizing that the American family is changing. "They want and deserve a certain standard of amenity." And giving clients an original expression of exactly what they want is the Studio's mantra.

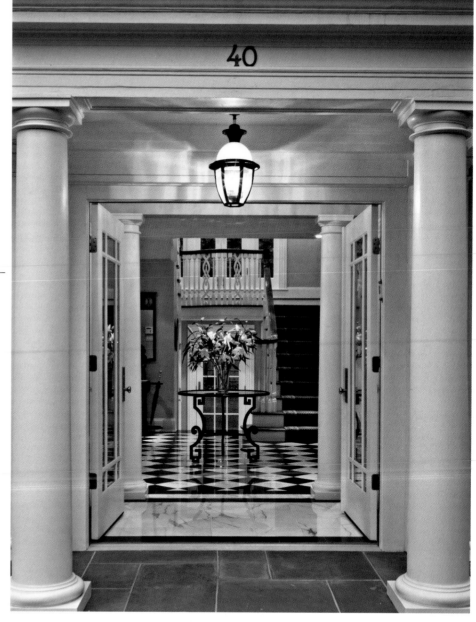

ABOVE: The fully restored entrance portico with its leaded glass French doors acts as a gateway to the home's grand foyer. The black and white diamond checkerboard pattern and ornamental stair balustrade coupled with an Art Deco flower table restored the space to its 1920's grandeur.
Photograph by Eric Laignel

LEFT: The historic restoration of this Mission-style mansion included a complete overhaul of the exterior hand-crafted stucco, ornamental ironwork, moldings and columns enabling the expanded portion of the home to become seamlessly linked to the existing.
Photograph by Eric Laignel

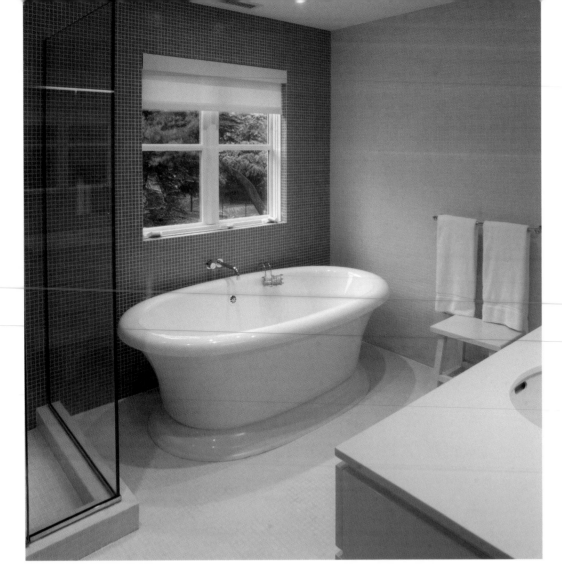

One thing that sets Spector Group apart is the team of professionals who understand the need to give each design a certain flair. "Our residential work is a hybrid of history and modernism," Marc says, referencing a current project: one of the largest new homes on Long Island's North Shore, an English American Tudor with modern influences. "We are not reinventing architecture but rather truly personalizing it to the homeowner, starting with a preferred style and honing down to the most minute details."

Home means more than an individual residence. Home can be a neighborhood or entire community, both of which the Spector Group provides in its Master Planning Studio. Marc calls the explosive interest in master planning and urban design "outrageous" and the scope of two current opportunities — a mixed-use waterfront development in New Jersey and the creation of a desert oasis in Southern Utah — "staggering." Whether revitalizing an entire downtown as in Riverhead,

New York, or creating a suburban community that has heretofore been nonexistent, Spector Group fully applies the principles of urban design — diversity, scale, and public space. "Our goal is to apply the best of master planning and urban design to both the region and the neighborhood — applying them to a new context and at a new space."

And it is in that way that Spector Group is leading the way in designing not only dream homes, but homes as a part of larger communities where people live work, shop, pray, and play.

ABOVE LEFT: The bathroom possess a minimalist feel, featuring a single long white tub.
Photograph by Ken Spencer

ABOVE RIGHT: Custom cabinetry is grand in scope and simple in function.
Photograph by Ken Spencer

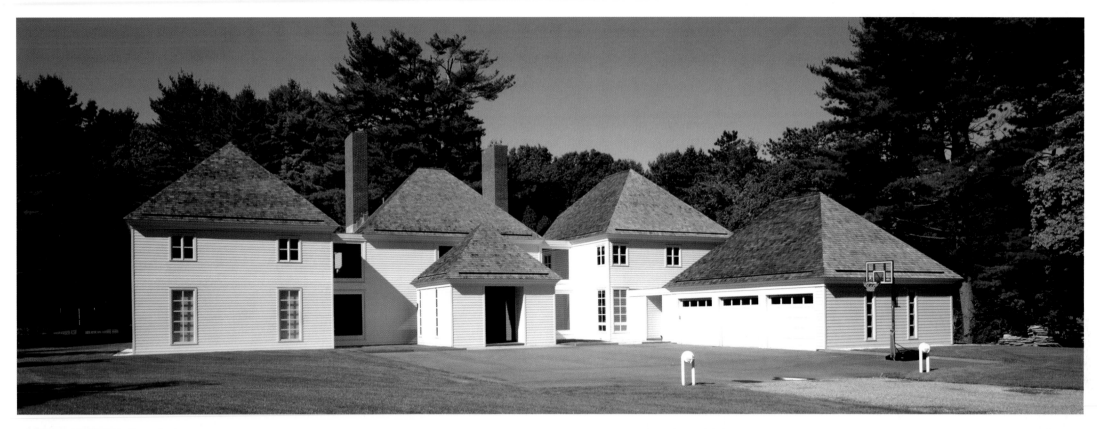

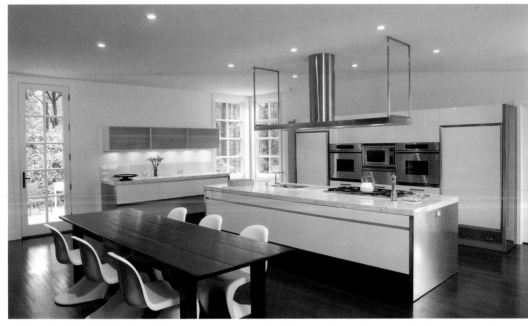

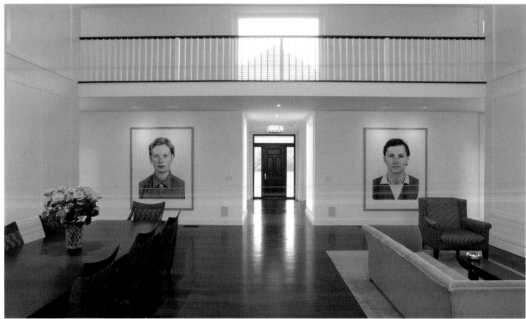

ABOVE: A series of pavilions, sans landscaping, emphasizes the simplicity of its geometry.
Photograph by Peter Kutscher

BOTTOM LEFT: Dark wood floors and furniture are set off by the stark white walls found throughout the home.
Photograph by Ken Spencer

BOTTOM RIGHT: The use of symmetry is evident and stunning in the great room design.
Photograph by Ken Spencer

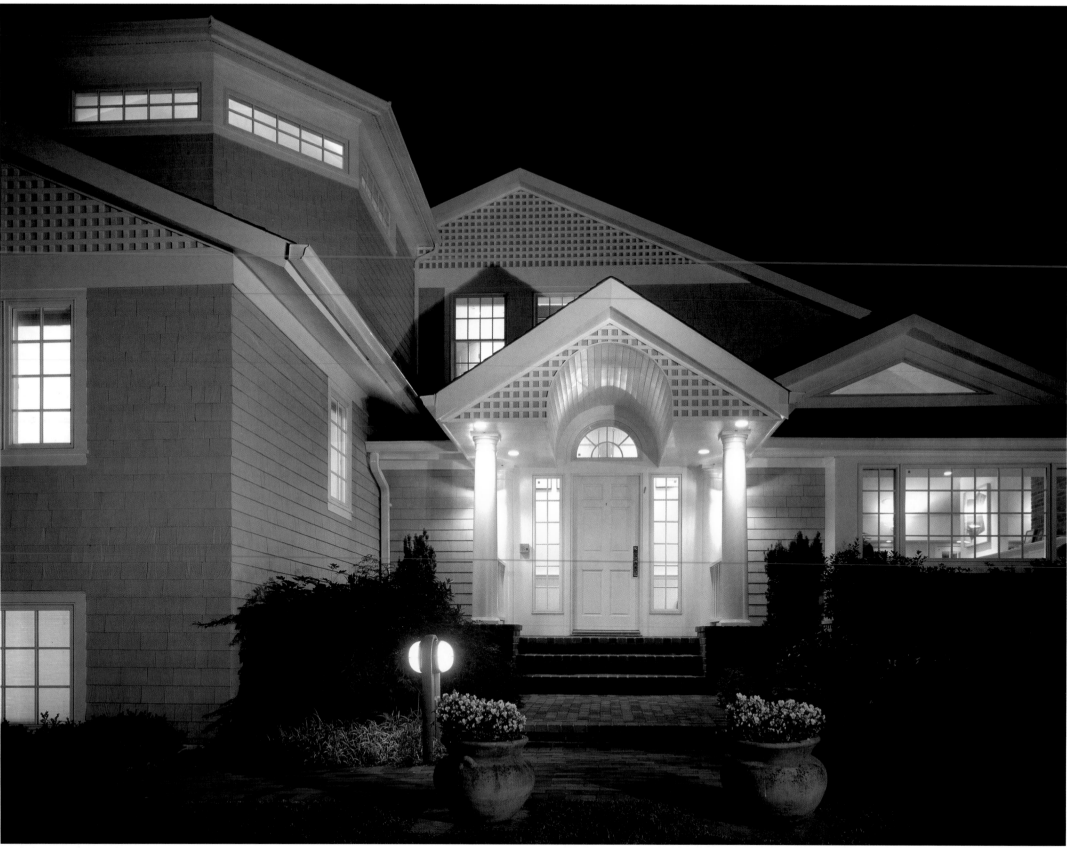

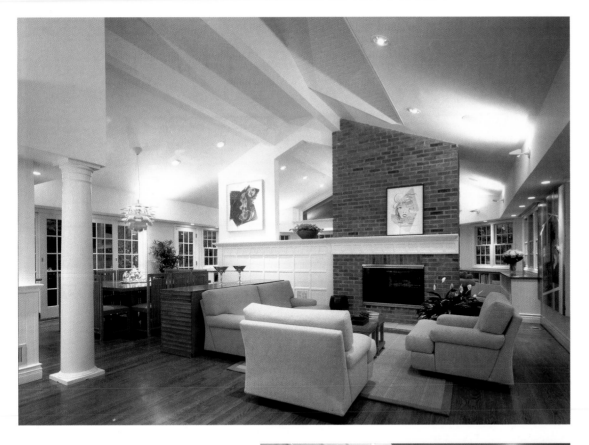

ABOVE: The shadow of multiple beams creates a complex sculpture with sunlight and other lights reflected on the cathedral ceiling. The low paneled wall and two-sided brick fireplace visually separate the open living room/dining room from the family room.
Photograph by Peter Paige

RIGHT: An elaborate corner post and rich stained red oak floors give warmth to this entryway. A full height grid of wall panelling leads one to the third floor master suite.
Photograph by Peter Paige

FACING PAGE: The exterior features an exuberant traditional Nantucket Shingle-style plus ten gables, many punctuated with latticework, Doric columns, divided light windows, white trim and paneling.
Photograph by Peter Paige

What one philosophy has he stuck to for years that still works today?
Embracing the idea that behavior and attitudes are influenced by environment, Marc and the entire Spector team have for 40 years designed spaces that inspire their occupants, evoke specific feelings, and are conducive to certain tasks. In short, the firm creates buildings that fuse function and emotion.

What does he find most rewarding about being an architect?
"Architecture is one of the few professions in which you get to create something that has permanence," Marc says.

Awards and recognition:
With more than 1,000 completed projects throughout the United States and five foreign countries, the creative and dynamic Spector Group garners international recognition for its work every year. It has earned more than 60 design awards in the United States and abroad, including numerous Gold and Silver AIA awards. Media coverage of Spector Group projects — corporate, government, educational, healthcare, and residential — is broad-reaching and includes feature-length articles in national and internationally circulated newspapers and magazines.

Spector Group

Marc B. Spector, AIA
3111 New Hyde Park Road
North Hills, NY 11040
516.365.4240

19 West 44th Street
17th Floor
New York, NY 10036
212.599.0055
www.spectorgroup.com

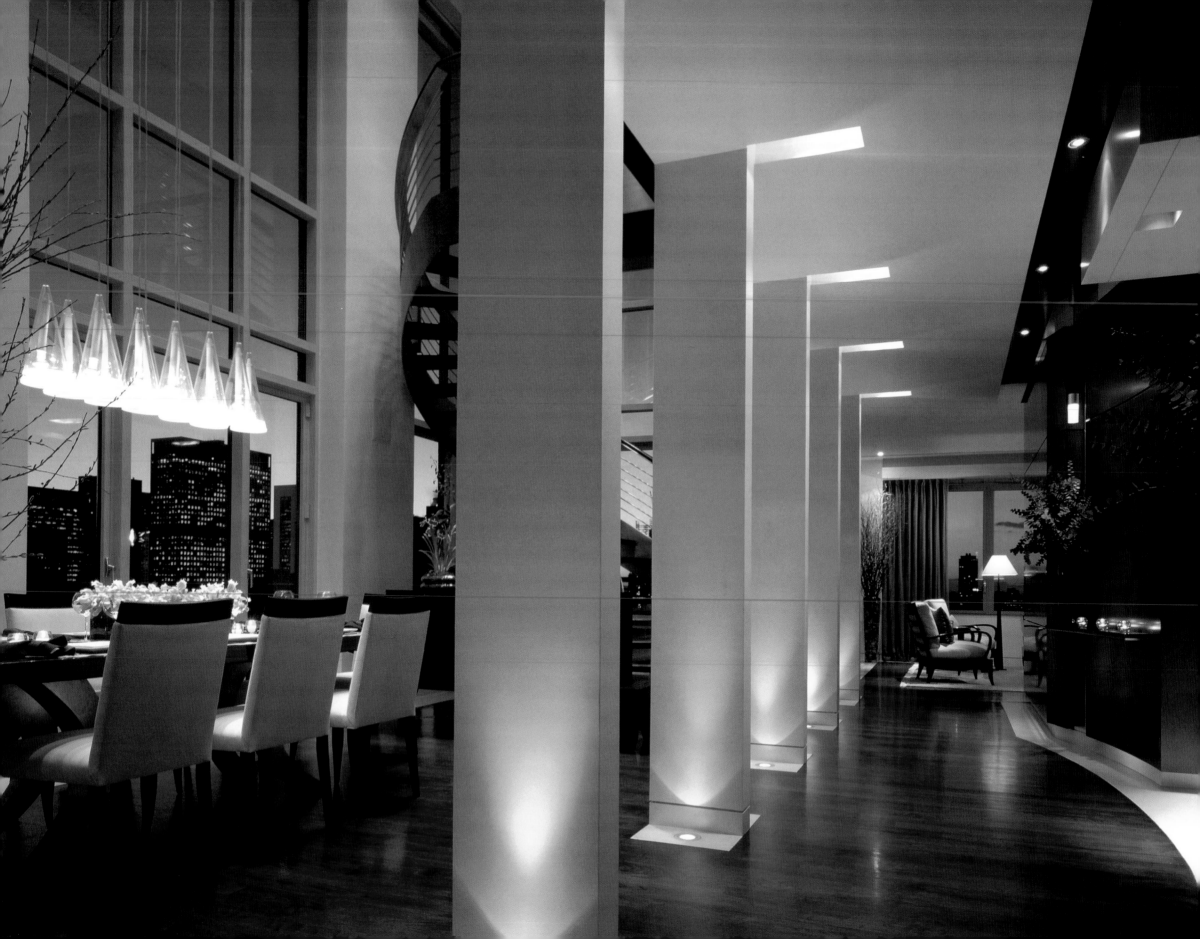

MARK STUMER & THOMAS MOJO

Mojo Stumer Associates

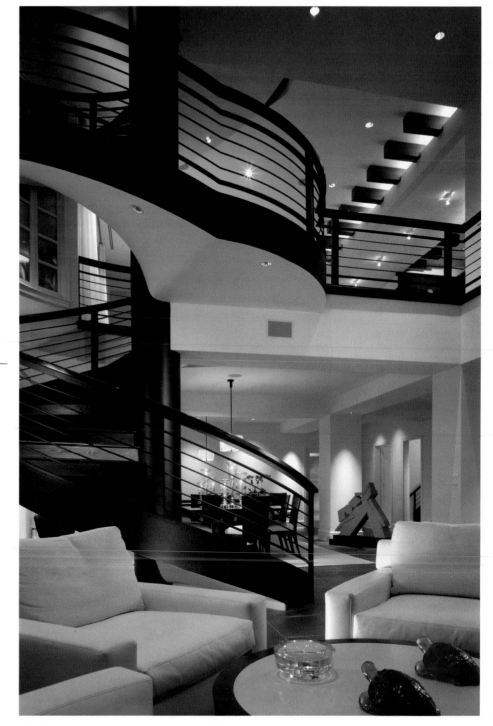

ABOVE: A spiral staircase graces the living area of this grand two-story residence.
Photograph by Phillip Ennis

LEFT: The renovation of an awesome New York City apartment involved relocating the stainless steel staircase, opening up the floor plan and updating finishes. With a warm and inviting ambience, the two-story dining space features grand columns.
Photograph by Phillip Ennis

Improving the quality of clients' lives through better and more creative architecture. That's the mission of Mojo Stumer Associates. It's stated boldly on the company website, and it's the driving force behind the 26-year-old firm founded by Mark Stumer and Thomas Mojo.

Upon its founding in 1980, the firm quickly gained a reputation as a leader in the design field and grew to be one of the most highly respected architectural firms in the country. From its inception, Mojo Stumer was created to be unique, combining quality architecture and interior design with complete project management systems. It is this three-pronged approach to the business that sets the firm apart.

Mark sees architecture as a holistic process in which architectural design does not end with a building form but includes the function and aesthetics of the interiors as well. Likewise, Thomas's philosophy is encompassing the exterior and the interior into one solution. By focusing not only on the

architecture but also interior design, Mojo Stumer complements the precise architecture of the houses it designs with a high level of interior detailing, resulting in an exquisitely finished home inside and out.

Modernists at heart, the architects appreciate the creativity and movement that style of architecture offers, and they are known for sensitively blending traditional and contemporary design. Since its inception, the firm has worked on a variety of building types, bringing 21st-century sensibilities to both commercial and residential projects, often turning vintage structures into modern marvels. A continuous push for more creative solutions and the best consultants in structural engineering, mechanical engineering, and landscape architecture enable Mojo Stumer to stay on the cutting edge of their profession.

LEFT: Lush landscaping complements the appealing front elevation.
Photograph by Phillip Ennis

FACING PAGE TOP LEFT: Modern lighting accentuates the large, two-table dining room.
Photograph by Phillip Ennis

FACING PAGE BOTTOM LEFT: A living area leads into the kitchen which boasts custom cabinetry and woodwork.
Photograph by Phillip Ennis

FACING PAGE RIGHT: Viewed from the staircase, a spacious living room features several comfortable sitting areas, large windows and a clean-lined fireplace.
Photograph by Phillip Ennis

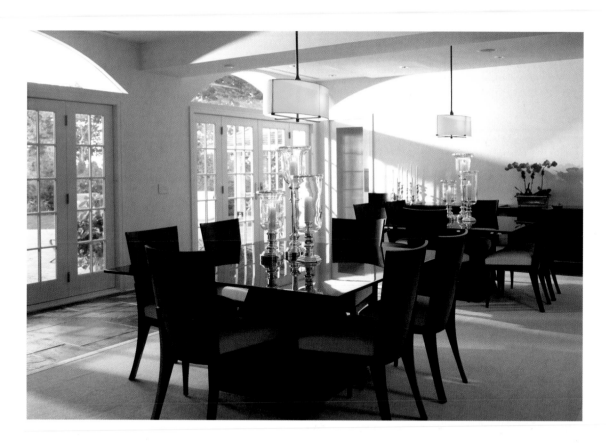

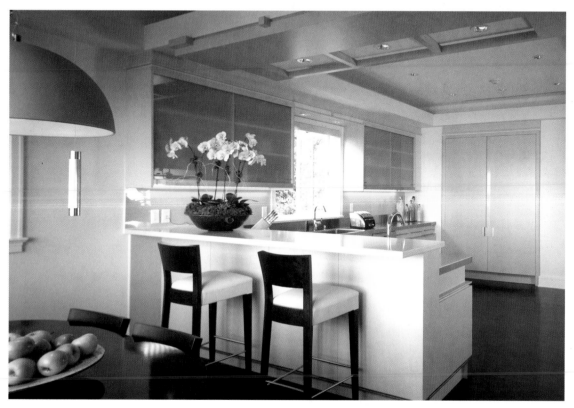

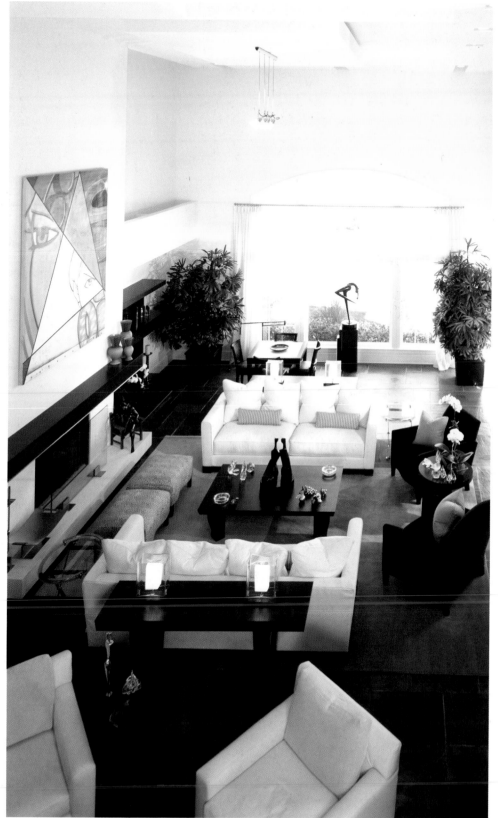

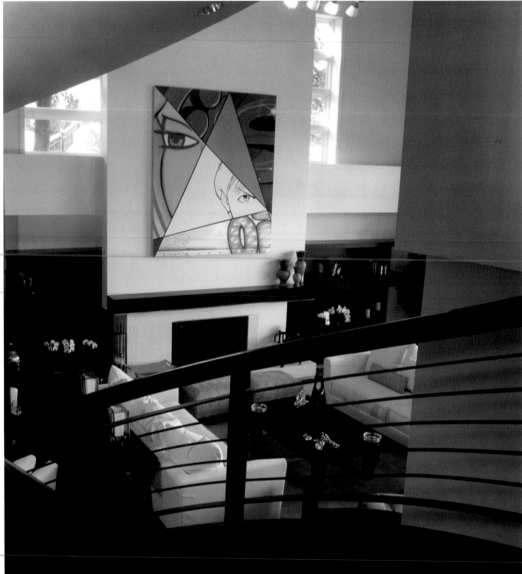

Before partnering in Mojo Stumer, Thomas and Mark were involved separately in design: Thomas in the realm of sophisticated, high-end office buildings and corporate headquarters; Mark at an architectural firm where he was lead designer on many award-winning projects. Today, they both are actively involved in setting the design direction at Mojo Stumer, overseeing their designs through their various phases and maintaining client contact throughout a project's duration.

Close communication is key to success, Thomas says. In fact, he tells architecture students that they might better major in psychiatry and minor in architecture. "If you can't go day to day talking and working with a client, all your architecture is for naught," he says.

A strong team is also essential. Thomas believes that the strength of the firm is in the quality of the people who work there. He and Mark have the help of five associates and a staff of more than 30 dedicated architects and interior designers, along with a highly competent office and financial management staff. Every project is tackled by a carefully assembled team — always supervised by one of the principals.

And it's clearly an approach that produces results. With more than 200 clients who live in the homes of their dreams, Mojo Stumer has won more than 60 national and regional architectural and interior design awards and has been widely published in national and international books, periodicals, and newspapers, including *Architectural Digest* and *Elle Décor*.

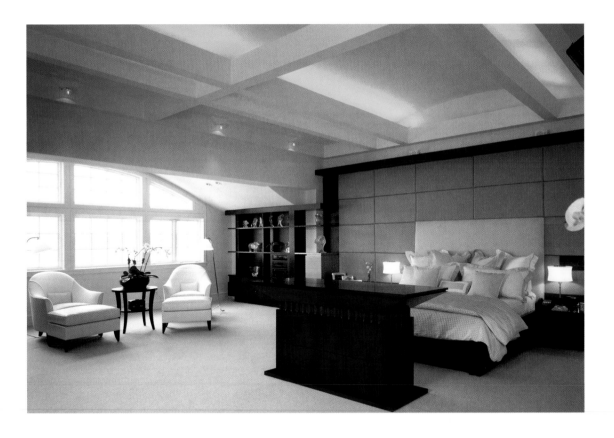

ABOVE: A popup television unit is the star of this master bedroom. The built-in shelving unit alongside the sitting area coordinates with other wooden accents.
Photograph by Phillip Ennis

RIGHT: With an ultra modern touch, the powder room blends glass, metal and wood finishes. A curvilinear sculpture further enhances the feel.
Photograph by Phillip Ennis

FACING PAGE LEFT: As observed from the living room, the floating ceiling plane with strategically placed lighting adds to the space's uniqueness.
Photograph by Phillip Ennis

FACING PAGE RIGHT: A custom staircase winds into the grand living room.
Photograph by Phillip Ennis

more about mark...

What personal indulgence does he spend the most money on?
Mark loves cars, particularly his 1969 Jaguar XKE convertible and his Porche.

When he's not working, where will you find Mark?
During his downtime, the architect spends time with his wife, Susan, and their 15-year-old daughter, Ylana.

What's the greatest accomplishment he's received professionally?
Once, an icon in the architectural world, upon introducing Mark to an editor, called him "a great designer."

What is the most impressive home that he's ever seen?
Of a splendid residence Richard Meier designed in Palm Beach, Florida, Mark says, "What space! What light! What a beautiful creation!"

What is the most unusual technique Mojo Stumer has used in one of his projects?
For a house in Palm Beach, Florida, Mark designed a sculpture of precast concrete and steel on a 20-foot fireplace wall.

What single thing would he do to bring a dull house to life?
Knocking down walls and opening up the floor plan improves traffic flow and gives space new energy.

Mojo Stumer Associates

Mark Stumer, AIA
Thomas Mojo, AIA
14 Plaza Road
Greenvale, NY 11548
516.625.3344
www.mojostumer.com

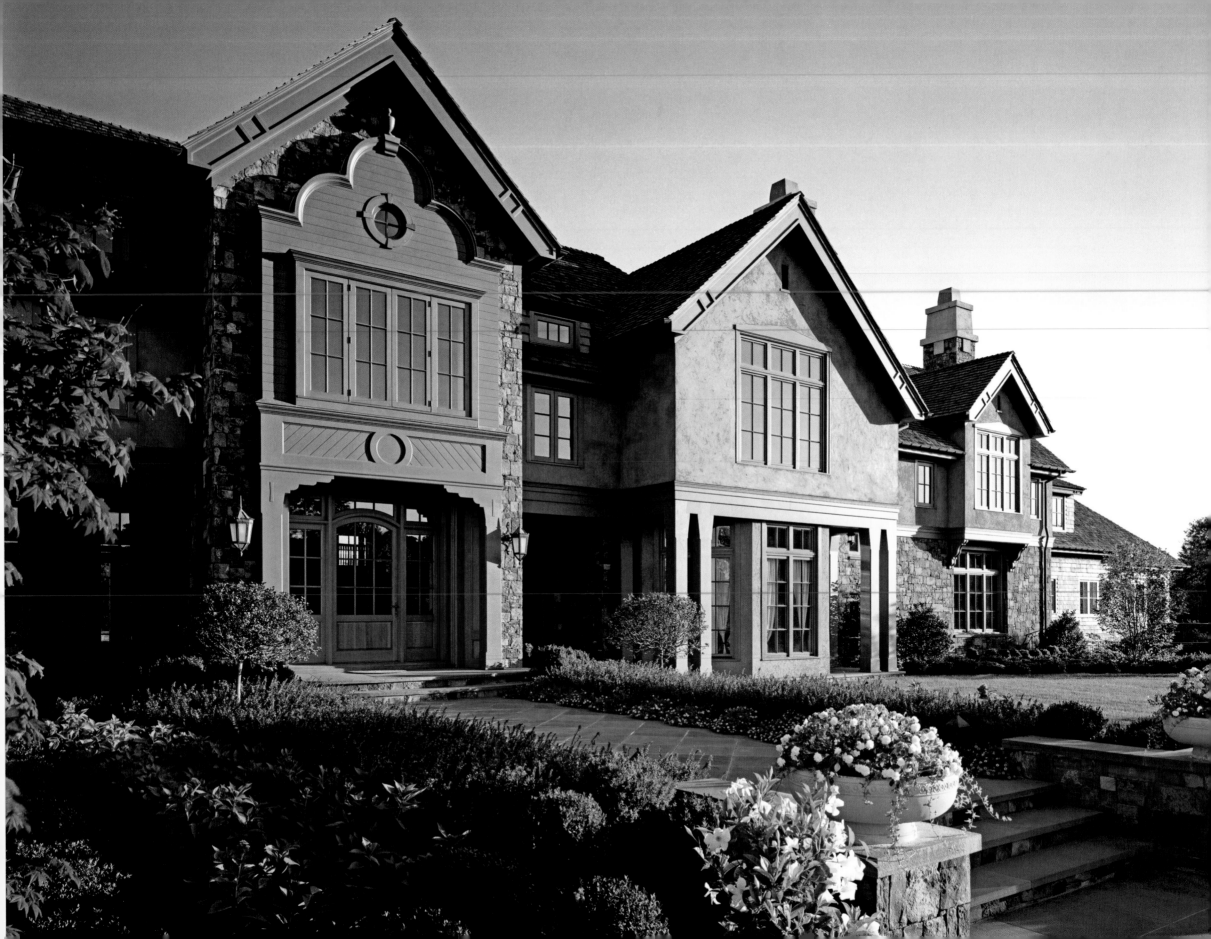

PETER H. COOK

Peter Cook Architect

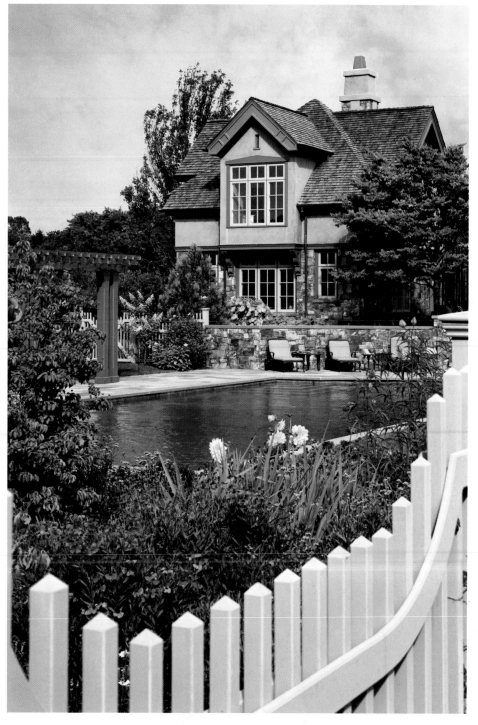

For architect Peter Cook, the Hamptons aren't just a place to live and work. Within the area reside not only his family and proudest professional achievements, but also his ancestry and career history. His middle and last names are on practically every other street sign. And Peter's portfolio comprises some of the primest real estate around.

A descendant of the families Cook, Halsey, and Ludlow, Peter's roots extend back more than 350 years in the Hamptons. Though the 46-year-old grew up in a New Jersey suburb, he spent summers in his late teens and early 20s on Long Island, laboring first as a carpenter and then as a designer for Bridgehampton builder William G. Thompson. "I believe these summers were the greatest influence in my decision to pursue the field of architecture," he says. And after living and working as a respected residential architect in the Hamptons for 24 years he believes that "few places would be as rewarding."

One might expect a firm bearing a distinguished name and with a noteworthy reputation to be large. But Peter Cook Architect is a boutique operation with a staff of six associates — all of whom have

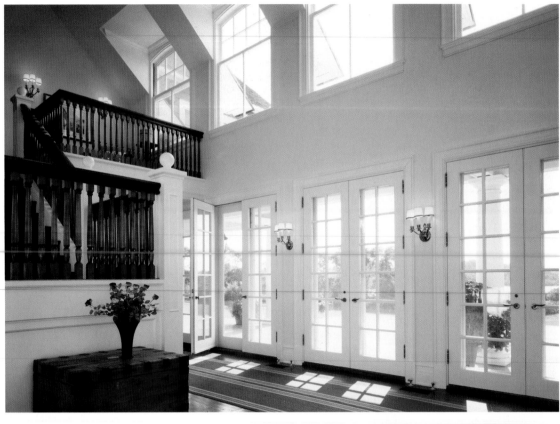

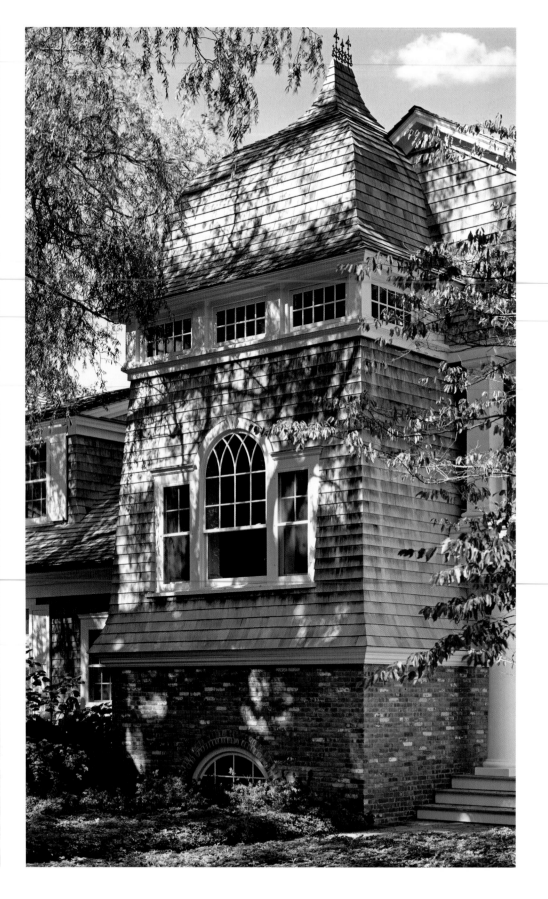

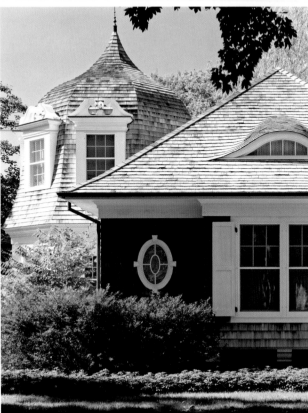

ABOVE: This sun-filled, two-story stair hall, captures unobstructed views over the rolling lawn and down to the banks of a "fabled" Eastern Long Island pond.
Photograph by Mark Samu

RIGHT: Characteristic of the eccentricities of the "Shingle style." An eyebrow window gently sweeps out of a simple hipped-roof and engages an ornately dormered onion-dome roof beyond.
Photograph by James Bleecker Photography

FAR RIGHT: With an arch-top window featured at the landing, and a clearstory band of windows along the frieze, circulation is celebrated in this wonderful stair tower.
Photograph by James Bleecker Photography

FACING PAGE: An intricate reclaimed-brick skirt and chimney anchors this elegantly detailed gambrel. The L-shaped entry nestles the motor court, keeping private the expansive water views beyond.
Photograph by Mark Samu

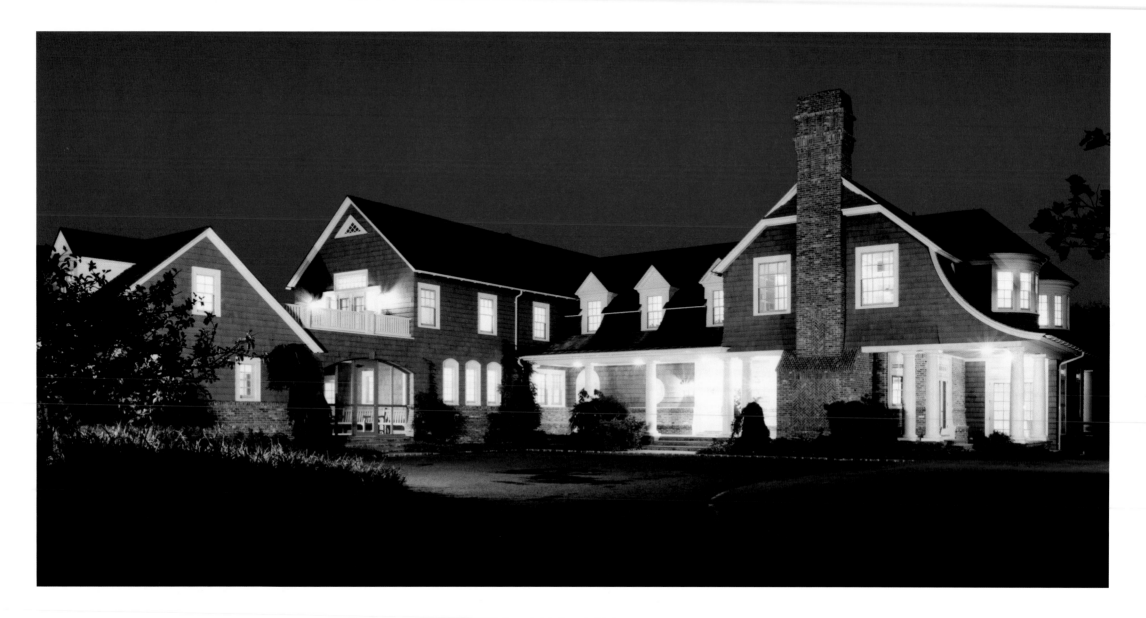

responsibilities ranging from design development to construction administration — and a project roster that never exceeds 10 of the choicest jobs.

Peter's firm is devoted to the art of fine home building, steering clear of what the architect calls stylized design and catering instead to clients who want homes customized down to the tiniest detail. "The design of a great home is the direct result of conscious decision-making and deliberate detailing," Peter explains. And though the company's designs are predominantly historical-based, Shingle-style houses and most often fall into the traditional category, Peter is equally comfortable doing more organic and contemporary work. Regardless of style, "We create houses that, in the end, people are happy about and enjoy living in," Peter says. "It is our job to exquisitely blend lifestyles and aspirations. Every one of our clients is house-proud and thrilled when we are done."

And how does he ensure client satisfaction? By beginning each project with a clean slate and an open mind, by letting the project site drive the architecture, and by carefully honing in on the things that really matter to the client then delivering those things in a superior fashion. Additionally, "a lot of what we do is experienced-based design," Peter says, adding that most of his firm's clients have children. That means his goal is to create special spaces that tap into people's emotions and become the fabric of cherished memories — places like a hidden room behind a bookcase where a little boy can hide, a sunny window seat in a teenage girl's room where she can read for hours, or a tricked-out back patio where a family can barbecue with friends. In meeting that objective, Peter not only builds houses, he also sets the stage for unforgettable moments.

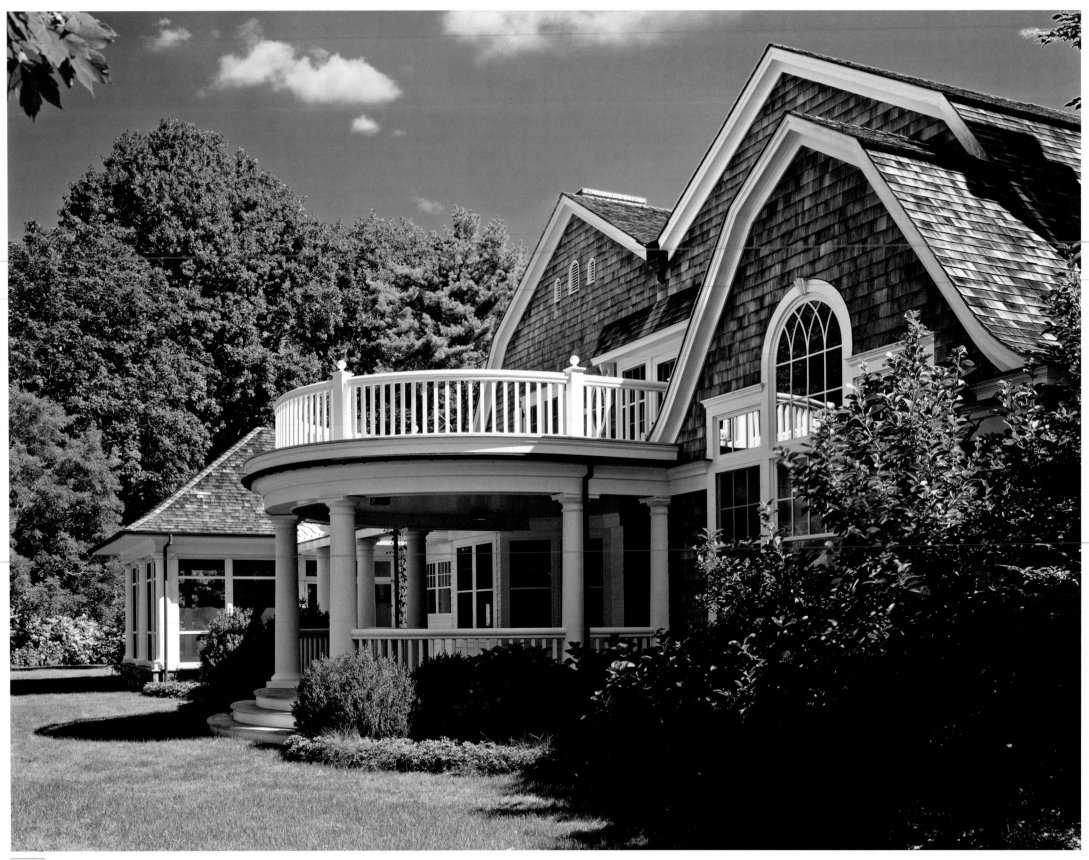

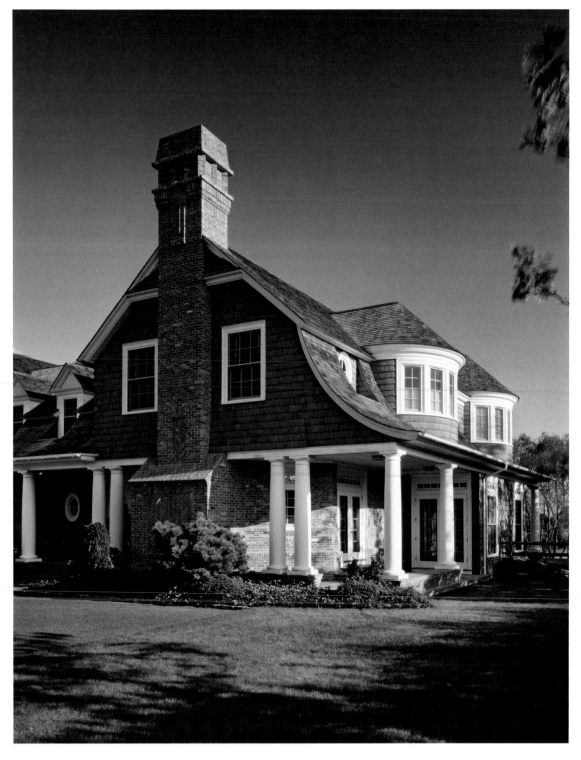

ABOVE: Attention to detail and craftsmanship are apparent in the brickwork, the round dormers and the millwork of the sweeping roof that delicately outlines this home.
Photograph by Mark Samu

FACING PAGE: Perfect for enjoying lazy summer days and ocean breezes, this circular porch is an extension of the view-through entry hall of this home.
Photograph by James Bleecker Photography

more about peter...

What is one thing that has greatly influenced his work?

Peter's childhood memories of the intimate nooks and corners so often found in the kinds of late 19th-century homes he grew up in shape his work even today. Window seats, grand stairway landings, secret service stairs, cubbie rooms, butler's pantries, splayed attic ceilings, such are the architectural elements that embrace the imagination of a child and make a house a home, he says.

What personal indulgence does he spend the most money on?

Peter is "the greatest father," says his wife, mom, supermodel and activist Christie Brinkley. The couple lives in Bridgehampton, in a house Peter designed, with their 8-year-old daughter and 11-year-old son. Catering to his kids is the architect's favorite way to spend time and money.

What's his favorite color?

Blue. "I love the sea — the freedom and openness it represents and the quality of light that it renders over the landscape," he says.

What is the greatest professional compliment that he's received?

Early in his career, Peter was recognized by *Progressive Architecture* magazine as a young architect to watch; a few years later, *Dan's Papers* twice named him Best of the Best. In addition, projects designed by Peter have been featured on the cover of *House Beautiful*, *Metropolitan Home*, *Elle Décor*, *Home Magazine*, and within numerous other publications, including *Architectural Digest*, *Town & Country*, *In Style*, *Departures*, and *Hamptons Cottages and Gardens*.

Peter Cook Architect

Peter H. Cook, AIA
280 Elm Street
Southampton, NY 11968
631.283.0077
www.petercookarchitect.com

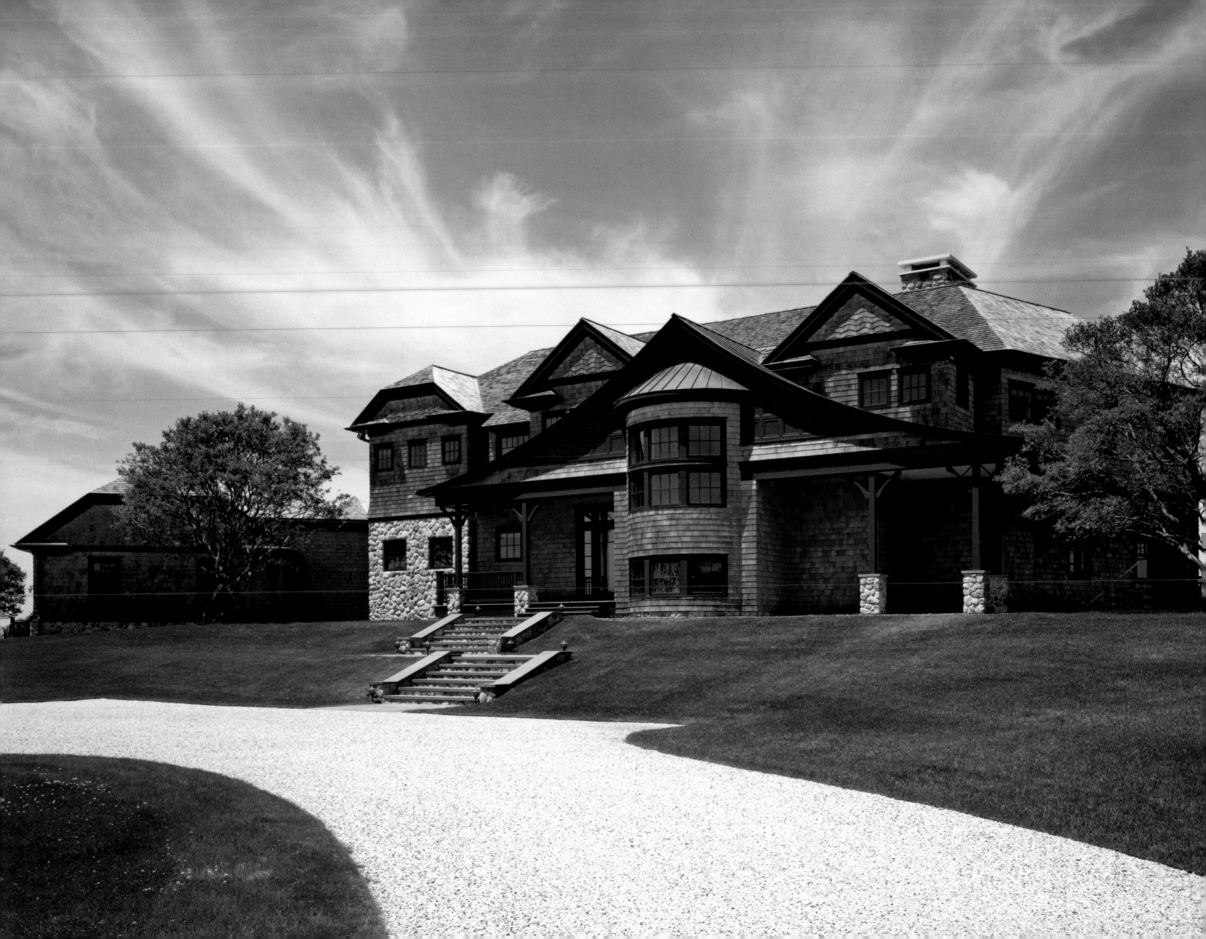

CHRISTOPHER DI SUNNO

DiSunno Architecture, P.C.

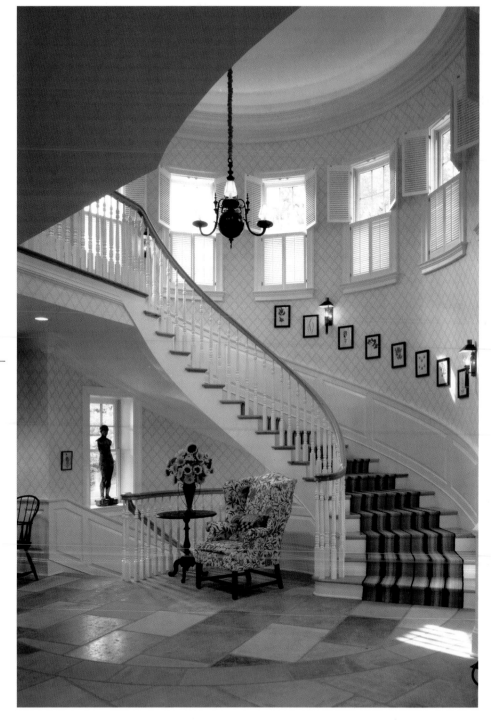

ABOVE: The curving stair mimicked by the inlaid limestone floor, recycled from an English castle is custom designed with no newel posts from its base through the top of the curved second floor hall balcony.
Photograph by James Yokum Photographer

LEFT: This Hamptons home was designed based on a conceptual essay about the meaning of the word harbor. Situated atop a knoll overlooking a marina, the sweeping custom copper roof reduces the scale of the house and conveys the three levels of the essay.
Photograph by Bates Photography

Christopher DiSunno grew up in the Hamptons, in one of the most charming villages on the East End of Long Island. His childhood home was a Techbuilt House, an early prefab modular home designed by Carl Koch, that sat right next to the beach in Sag Harbor.

It was a low-slope, straight-shot house with a wall of glass looking out over the Sag Harbor Bay. The entire living area was an uninterrupted space where the DiSunnos gathered together in the evenings. The Hamptons, the house, and the large family room had a big impact on Chris as a boy. It shaped his thinking and grounded his architectural sensibilities, although he was too young to know it at the time.

Today it's not hard to see the influence of his upbringing in the well-respected architect's work. His father founded DiSunno Architecture in 1983, and Chris became a partner in the firm in 1997, after completing his architectural apprenticeship in Dallas and Atlanta. Recently retired, his dad focused primarily on Shingle-style houses, but Chris leans more toward contemporary design, which, he says, in recent years has enjoyed increasing popularity in the Hamptons.

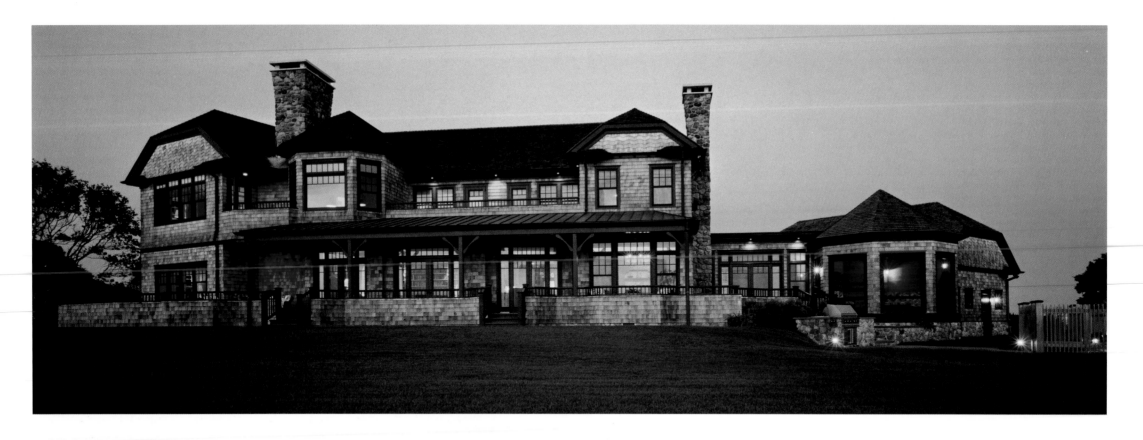

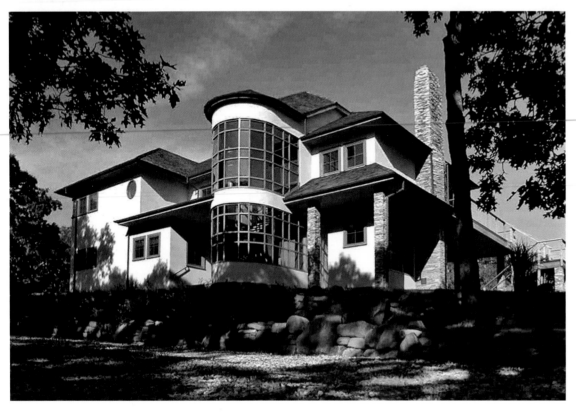

There are many things that Chris appreciates about contemporary design. For one, he likes the underlying conceptual creativity that parallels contemporary architecture. Contemporary designs are usually derived from a concept, whereas traditional architecture is based on form and precedent. He also enjoys the difficulty of detailing a very plain contemporary component. "Anything that strays from the ornate is something that touches me," he says. "It's not so much the simplicity, as it is appreciating how difficult it is to design something exceptional which appears really simplistic." There is also the human scale of a contemporary residence, which tends to be smaller and more concurrent with 21st-century living.

DiSunno Architecture, P.C., works on high-end projects in a range of styles and of varying sizes. Although the firm's portfolio of work serves to provide examples of things its architects are able to do, those examples are not necessarily things that need be repeated. Chris explains, "Many clients go to an architect and look at something and say, 'That's what I want.' When you are hiring an architect, you are doing more than picking a plan from a book. A house is something I make just for you. It should not be something off of a shelf," he says. The process of creating something unique in the world is what Chris loves most about architecture.

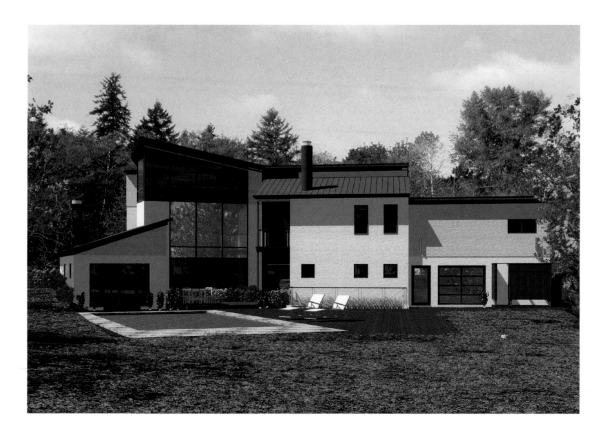

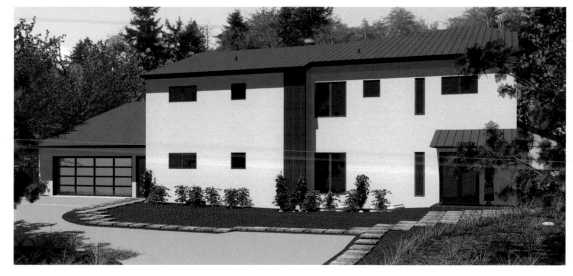

ABOVE TOP: Computer rendering of the back (north) façade of the DiSunno residence revealing the dynamic floor to roof glass curtain wall; living room pavilion and pool.

ABOVE BOTTOM: Computer rendering of the entry façade of Chris' new house (south). The concrete structure presents a subtle understated confidence divided by a wood veneer literally separating public and private spaces.

FACING PAGE TOP: The façade is designed to conceal the inhabitants from the houses below yet maintain magnificent views to the sunset over the water.
Photograph by Bates Photography

FACING PAGE BOTTOM: This contemporary Montauk residence found its form extracted from the components of the local fishing industry. The interior finishes are wood and exposed metal frame.
Photograph by Christopher DiSunno

When he's not working where will you find Chris?
The architect loves to sail, and if he's got free time and he's not sailing, he's reading about sailing or spending time with his wife and son.

What does Chris like most about being an architect?
Chris' job brings him a lot of joy. The process of designing and building a client's dream home is rife with rapturous moments: a client's excitement when the architect first presents the design, the first time a client realizes a space as it is being formed, and, perhaps the best of all, the final late-afternoon hours after a house is finished but before the client moves in. "It's akin to watching your child sleep," he says. "It's spiritual in a way. You've been through the trials and difficulties of creating this complex spatial machine, and it's resting."

What is the most unusual/expensive/difficult design technique that he's used in one of his projects?
As a forward-thinking architect, Chris tries to incorporate a few of the newest building products into each project. The latest is his own house — the first he's built for himself and his family. The entire house uses the principles of green architecture: Everything is constructed of recycled materials, the walls and floors are concrete, the windows are European vinyl, the roof is metal.

What does he like most about working in the Hamptons?
Hamptons homeowners are an interesting breed, Chris says. Wealthy and worldly, they are oftentimes very open with and trusting of their architect. "They allow us to do things besides recreate the wheel."

DiSunno Architecture, P.C.

Christopher DiSunno, AIA
92 Newtown Lane
East Hampton, NY 11937
631.324.6676
www.disunnoarchitecture.com

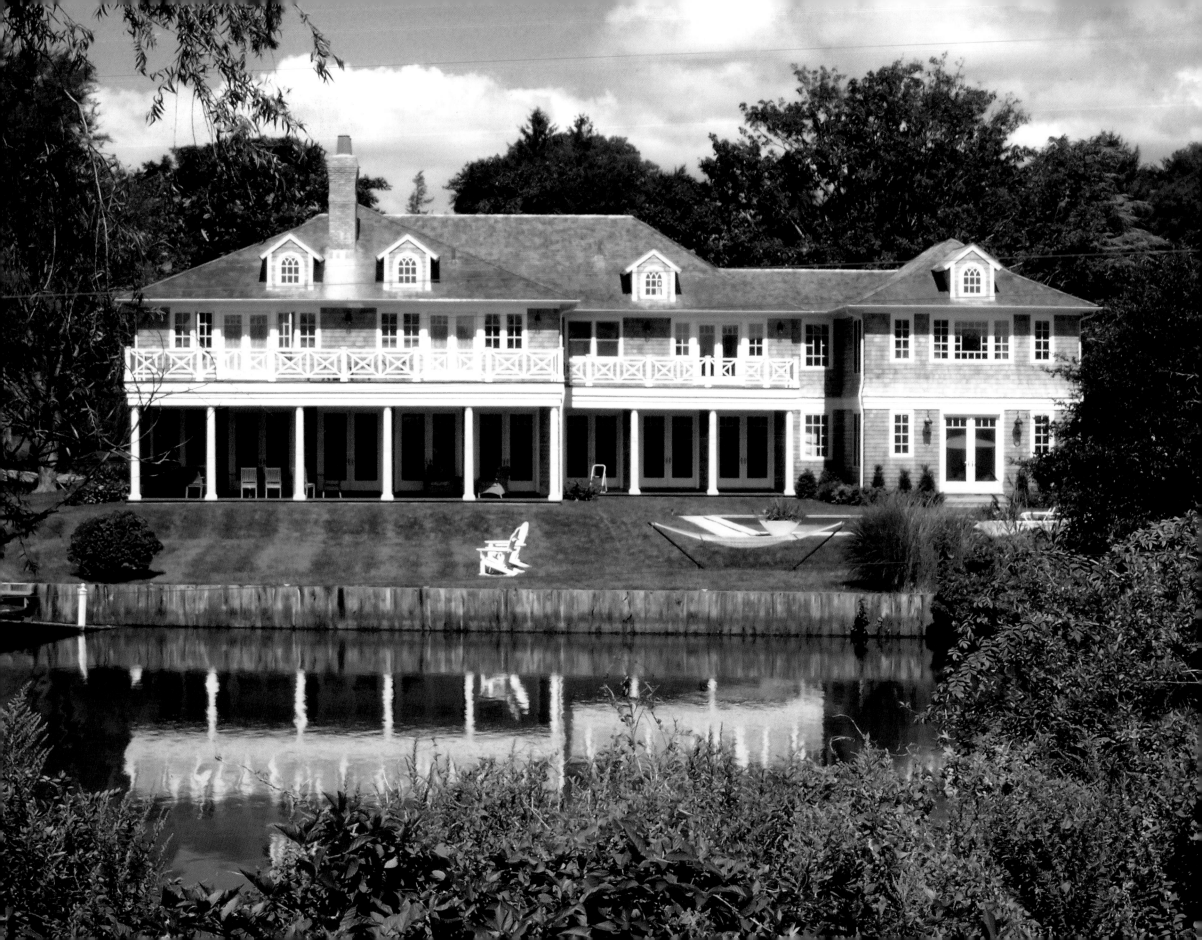

JOHN LAFFEY
John Laffey Architects, PC

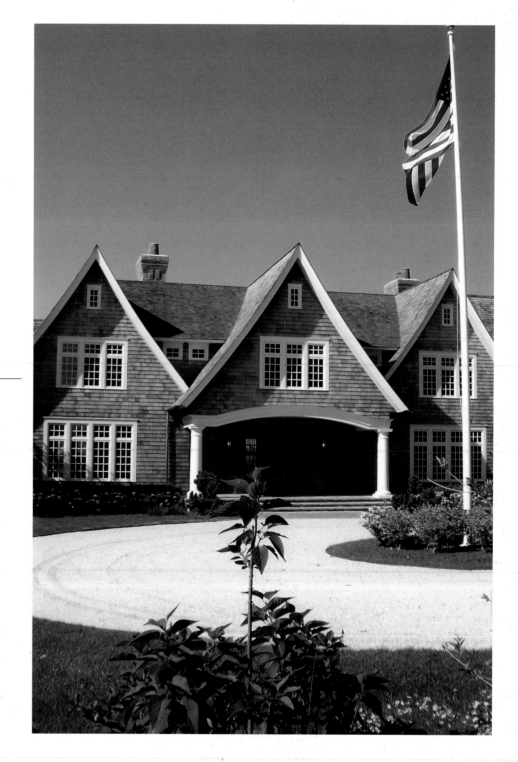

ABOVE: New residence in Southampton's Mecox Area.
Photograph by John Laffey Architects, PC

LEFT: Addition and renovation to Calf Creek residence.
Photograph by John Laffey Architects, PC

Unbeknownst to most of his clients, John Laffey did not originally aspire to be an architect. At one point in his life, the now 46-year-old professional considered obtaining a degree in psychology. Luckily for the people of Long Island — and for his potential psychiatric patients — John quickly changed his mind and graduated from New York Institute of Technology with an architectural degree. Now, more than two decades later, John is the sole proprietor of a flourishing architecture firm, and, as the cliché goes, business couldn't be better.

John Laffey currently resides in Southampton, a small village nestled on the eastern end of Long Island. He runs his business in Water Mill, a few miles east of his home. Clients go to John for traditional homes reflecting the colonial history of the Hamptons. Shingle-style homes are ubiquitous,

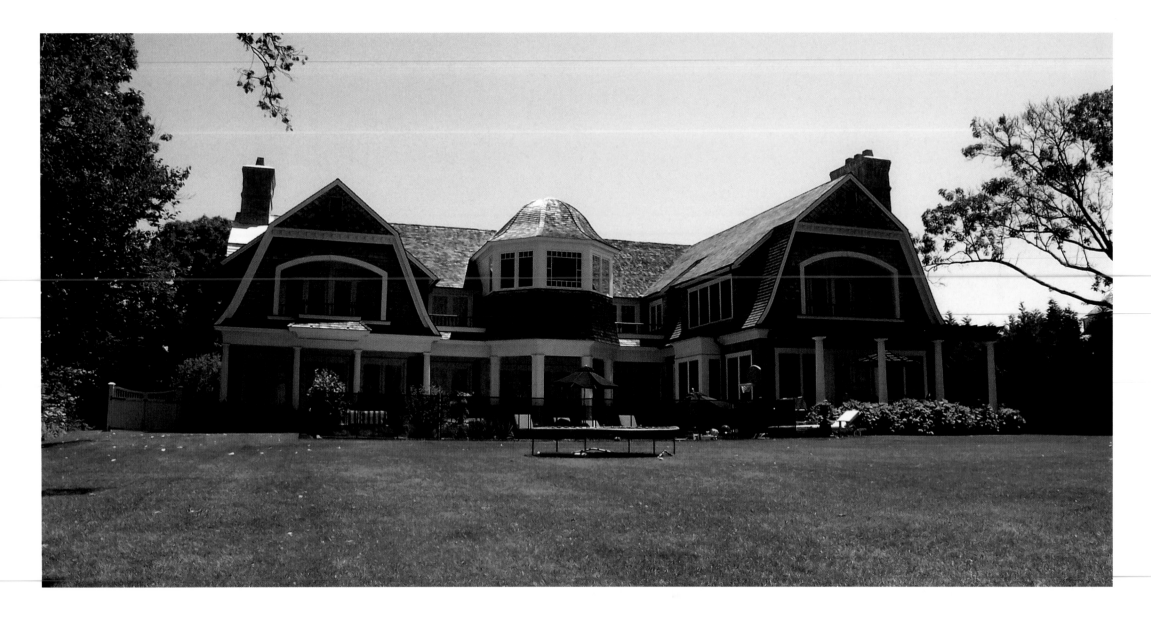

and John finds them romantic, authentic, and unpretentious. John is extremely passionate about his work and takes much into account before finalizing a design. He believes in taking the time to get to know his clients, carefully tailoring each project to exacting standards and relentlessly specifying the right materials. Clients enjoy the relaxed look and feel of John's houses.

Though John has a passion for architecture, he enjoys pursuing other pleasures. When not hard at work, John spends time at home with his wife, Carol, and their children, Kelly, Sean, and Katie. He can often be seen driving his convertible with Casey, the family dog, happily sitting on his lap.

John is currently living his dream. He has worked hard to earn a reputation as a respected architect. John loves the excitement of the design, the thrill of the build, and the friendship and gratification of the client. He hopes to continue to design houses for many years, and couldn't imagine his life any other way.

ABOVE: New residence on Noyal Bluff.
Photograph by John Laffey Architects, PC

FACING PAGE TOP: New residence in Easthampton's North West Woods.
Photograph by S.A.A.

FACING PAGE BOTTOM: New residence in Watermill's Deerfield Area.
Photograph by S.A.A.

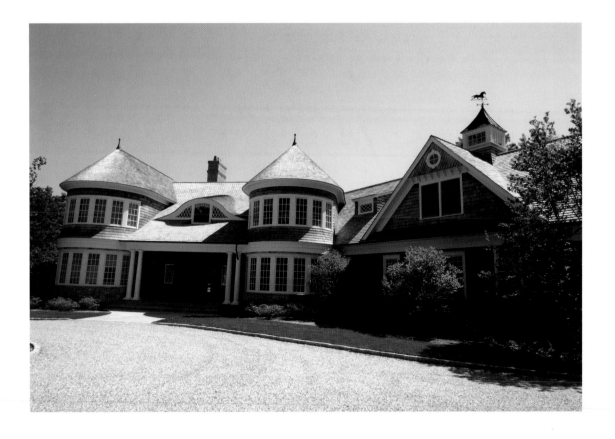

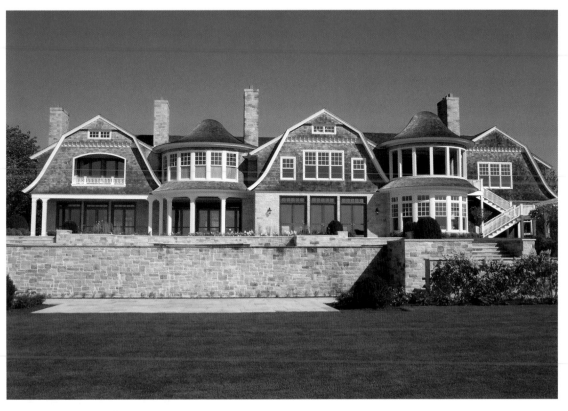

What color best describes him and why?

Green represents John's passion for life and his love of nature. He enjoys kayaking, biking, camping, fishing, and just about every other outdoor recreational pursuit.

What philosophy has he stuck to for years that still works today?

John believes in being true to your heart. He also goes by the motto that the road to success is always under construction.

What does John enjoy about his hometown?

John is particularly fond of the Southampton area because of its small-town vibe and for its diverse rural characteristics, especially the ocean, the woods, and the cliffs in Montauk. He feels that the light on the eastern end of Long Island is the best in the world.

Who had the greatest impact on his career?

John's father fostered his interest in architecture at an early age when the two would go to project sites together and experience the joy of the hands-on building process.

What is an interesting fact about the architect?

John has recently become a fixture on the Southampton High School track, reminiscent of his running days in high school, college, and at the 1985 New York City Marathon.

John Laffey Architects, PC

John Laffey, AIA

860 Deerfield Green

Water Mill, NY 11976

631.726.5108

www.johnlaffeyarchitects.com

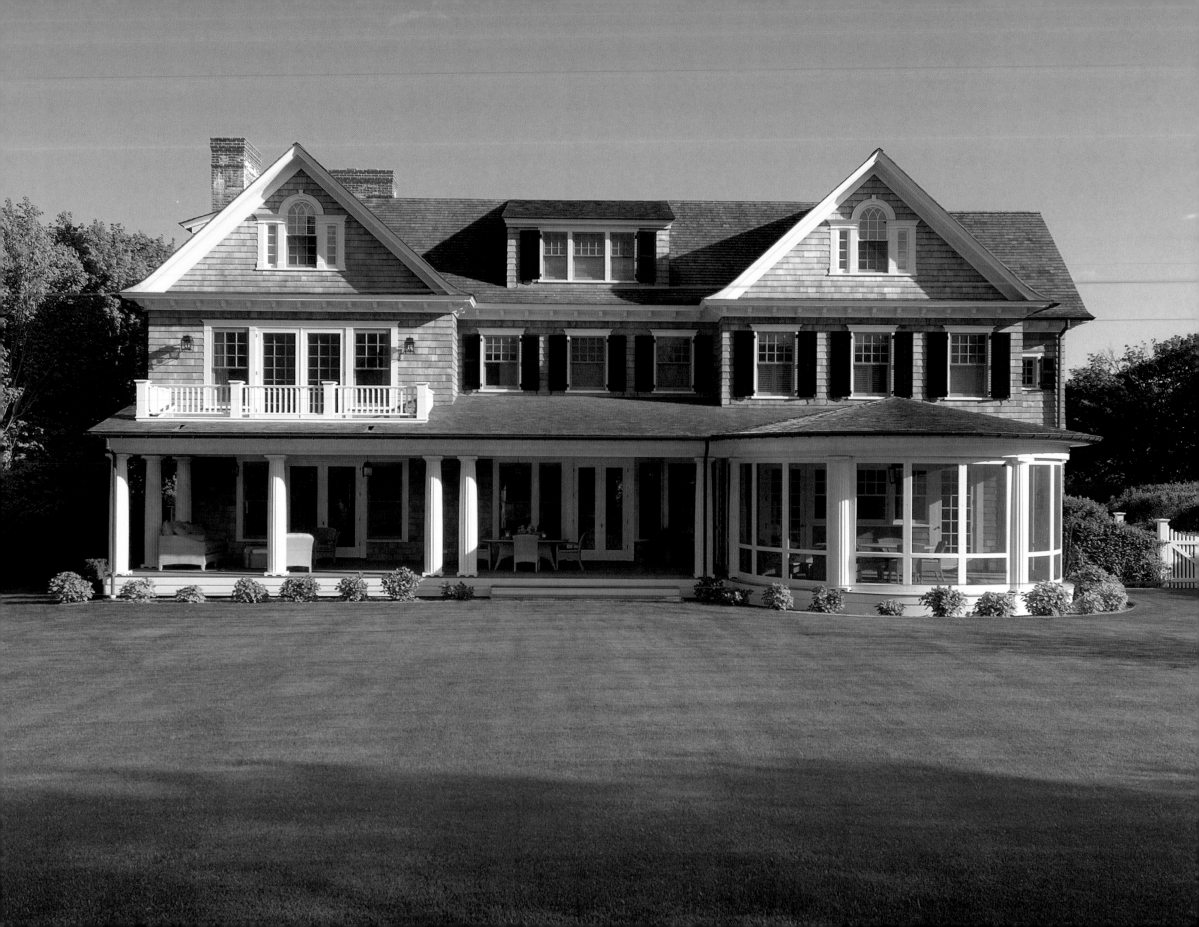

KATHRINE F. MCCOY

Kathrine McCoy Architect

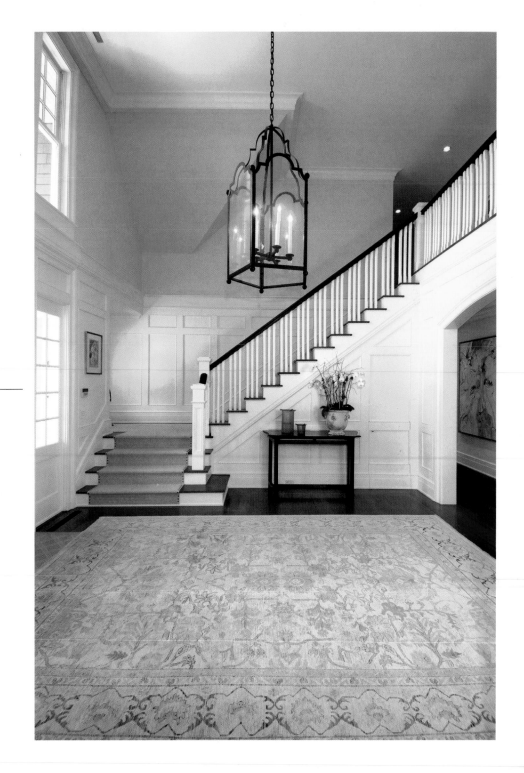

With an open mind and an open ticket, Kathrine McCoy departed Columbia University in 1989 for Australia. An architecture fellowship took her there, but the warm weather and the relaxed lifestyle kept her in place for a year and a half before she felt the pull of her hometown of Bridgehampton. Kitty's return to New York coincided with an article in *Metropolitan Home* magazine about a residential project she had completed before heading to Sydney. Though she had not planned to start her own architectural firm right away, circumstances conspired to bring about a budding practice. 15 years later, Kitty is one of Long Island's most respected architects.

Kitty calls the Hamptons "one of the most beautiful places in the world" and it, more than anything else, has had a big influence on her career. She loves the gracious aged summer cottages of Southampton and East Hampton, Sag Harbor's majestic whaling captain's homes, and the classic farmhouses with their barns and outbuildings in Sagaponack and Bridgehampton. She thrills to the vistas across the fields, the extraordinary quality of the light, and the way that the architecture is harmonious

ABOVE: Front entry stair hall with painted paneling.
Photograph by Ron Papageorge

LEFT: Rear view of residence with gracious covered porch and semi-circular screened porch.
Photograph by Ron Papageorge

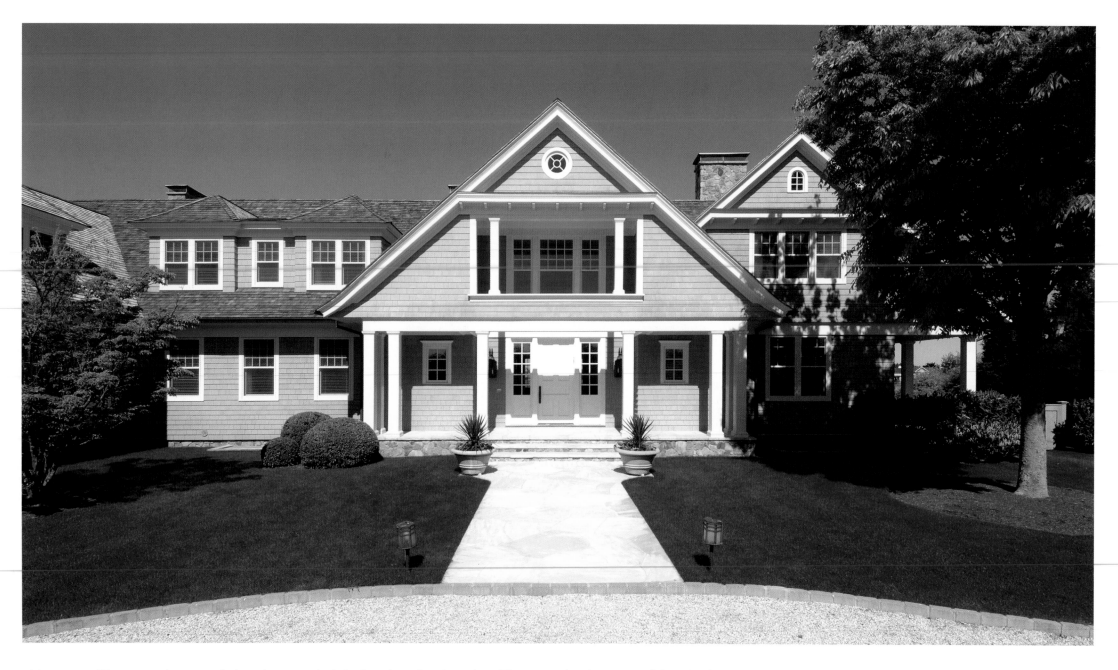

with nature. "For generations people here have used pitched roofs and cedar siding. There's a certain sort of language of style and materials that is consistent with the character of the area. It's the language I am most comfortable with and what I really enjoy," she says. If a potential client wants a slick, cutting-edge glass box, Kitty would refer them to someone else. Modern is simply not what she does best.

What she does do with great enthusiasm and aplomb, however, are timeless, traditional homes designed for modern living. An architect with a strong sense of place and proportion, Kitty heads up a small firm that focuses predominantly on new construction and provides a full range of services. The details that custom construction affords are her forte. Ever conscious of an agreed-upon design idea, concept, or direction, Kitty seeks to implement it throughout her structures, giving it life in even the smallest specifications. She also uses her experiences as a woman and a mother to bring insight to the practical, functional aspects of her designs, knowing that no matter how beautiful something is, if it doesn't work well she's failed her client. "It's not just about looking wonderful," she says. "It's also about the nitty-gritty of life."

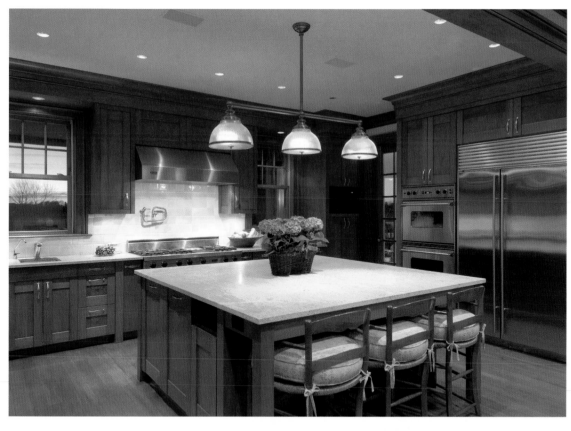

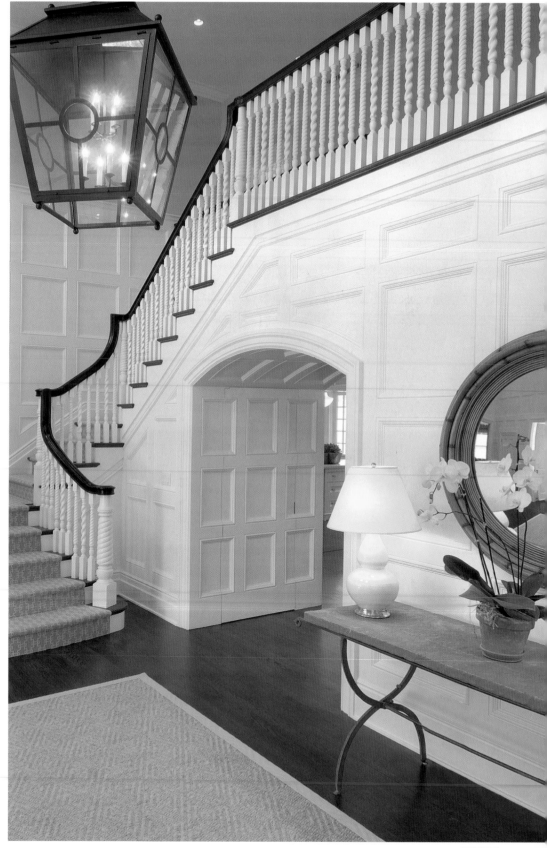

ABOVE: Custom cherry cabinetry throughout kitchen. Large island provides additional seating.
Photograph by Ron Papageorge

RIGHT: Bathroom with Carrera vanity top and tile.
Photograph by Ron Papageorge

FAR RIGHT: Front entry stair hall with arched opening to dining room beyond.
Photograph by Ron Papageorge

FACING PAGE: Front entry approach to new residence on the water.
Photograph by Ron Papageorge

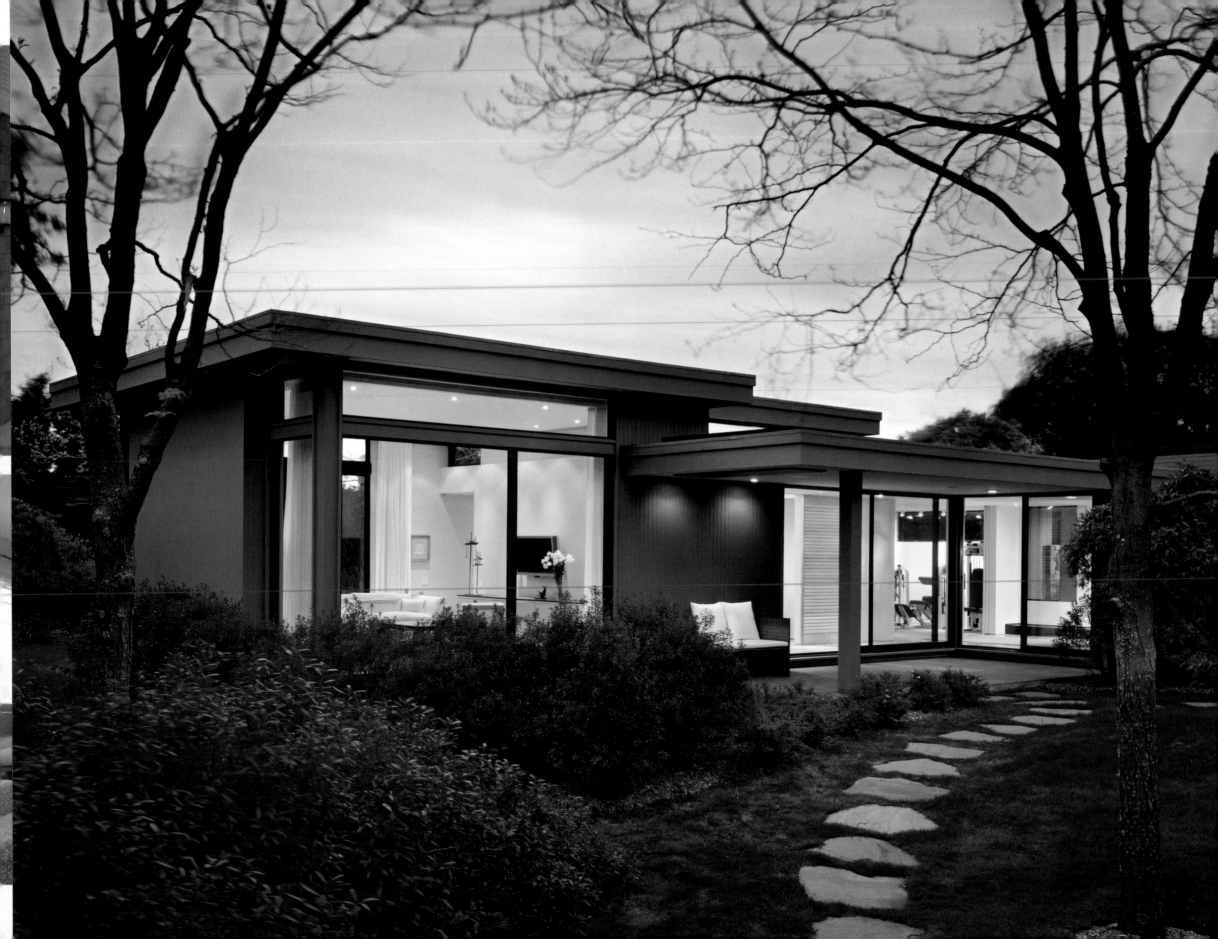

JAMES MERRELL

James Merrell Architects

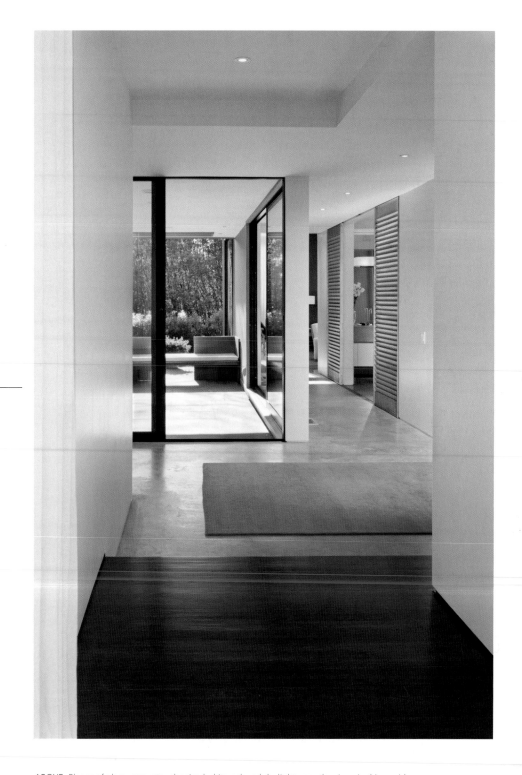

When James Merrell talks about his work, a theme quickly emerges. After only a few minutes with him, it becomes clear that the Sag Harbor architect, who has been designing award-winning residences and commercial buildings since 1988, values authenticity above all else.

His design philosophy — deliberate use of materials, structures that resonate with their settings, and a contemplative approach to every detail — bears the influence not only of his studies at Yale and Harvard and his time at New York City and East End architecture firms, but also of internships with environmental sculptors James Turrell and Eric Orr and in theater set design and construction at the Julliard School. Today, he spends most of his time working on projects in the Hamptons, striving to create houses that are true expressions of the people who live in them and that remain reflective of their historic landscapes.

ABOVE: Planes of glass, concrete, ebonized white oak and daylight wrap the views in this corridor.
Photograph by Carol Bates

LEFT: The Golub House is a garden-immersion experience.
Photograph by Carol Bates

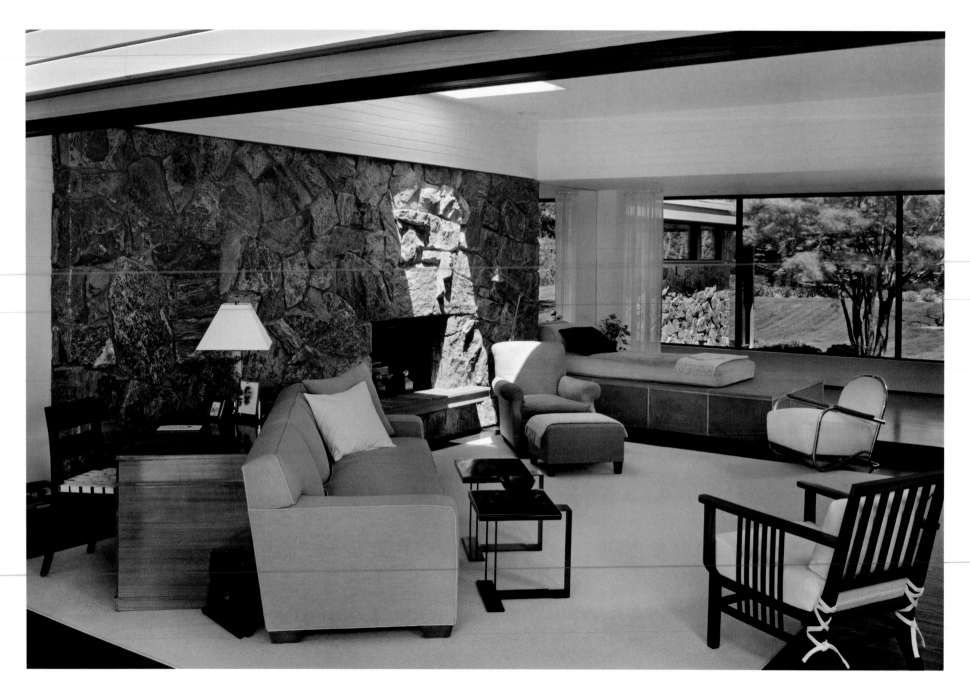

"I always ask, right off the bat, 'What materials are you drawn to? What sorts of spaces relax you?' Custom design, and second homes in particular, offer an open-ended opportunity for expression, yet people rarely let themselves think beyond the architectural cliches. It is my job to bring imagination back into the process," he says. To accomplish this, James puts pen and paper front and center. Real design exploration, he emphasizes, comes from drawing ideas, not from copying stylebooks.

The firm's projects all aim for an understated elegance. James' designs also exude a material richness. They are pared down yet not spare; striking without being flashy. "Such things don't happen by accident," he says. There is deliberate thought behind every element. "I sketch out and discard all the obvious solutions in order to find the exact right one. There is nothing I enjoy more: It is a labor of love."

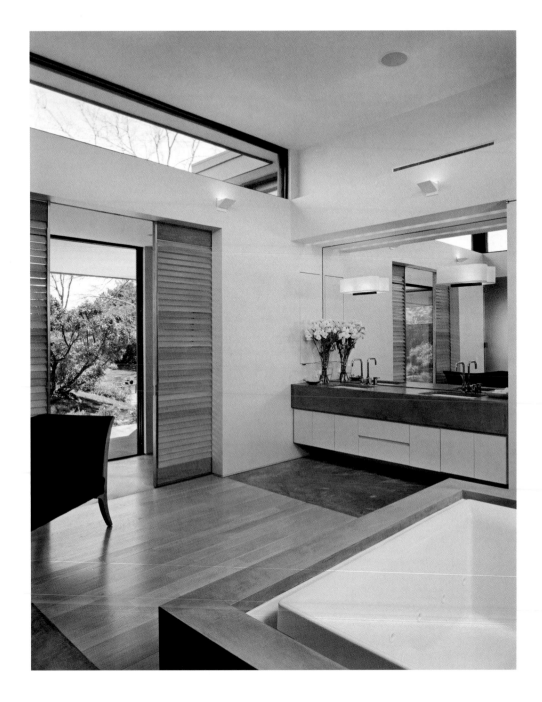

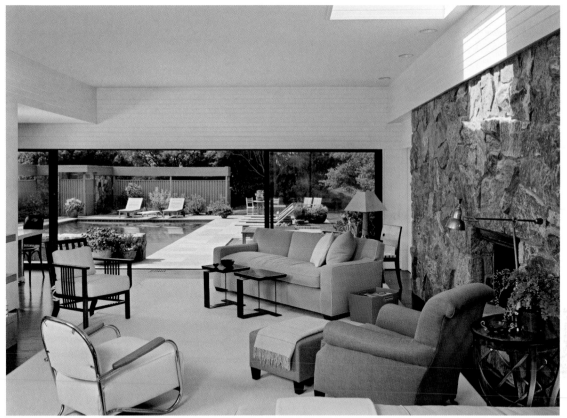

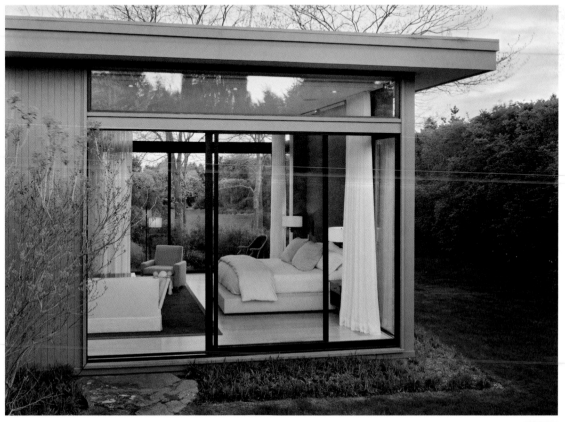

ABOVE: The master bath is like a private cabana opening onto the garden.
Photograph by Carol Bates

TOP RIGHT: Living room and pool-scape merge on a sunny morning. (Interiors by Tori Golub)
Photograph by Carol Bates

BOTTOM RIGHT: The master bedroom sits in a landscape which seems to flow through it.
Photograph by Carol Bates

FACING PAGE: Horizontal glazing and stone walls seem to intersect in this living room view. (Interiors by Tori Golub)
Photograph by Carol Bates

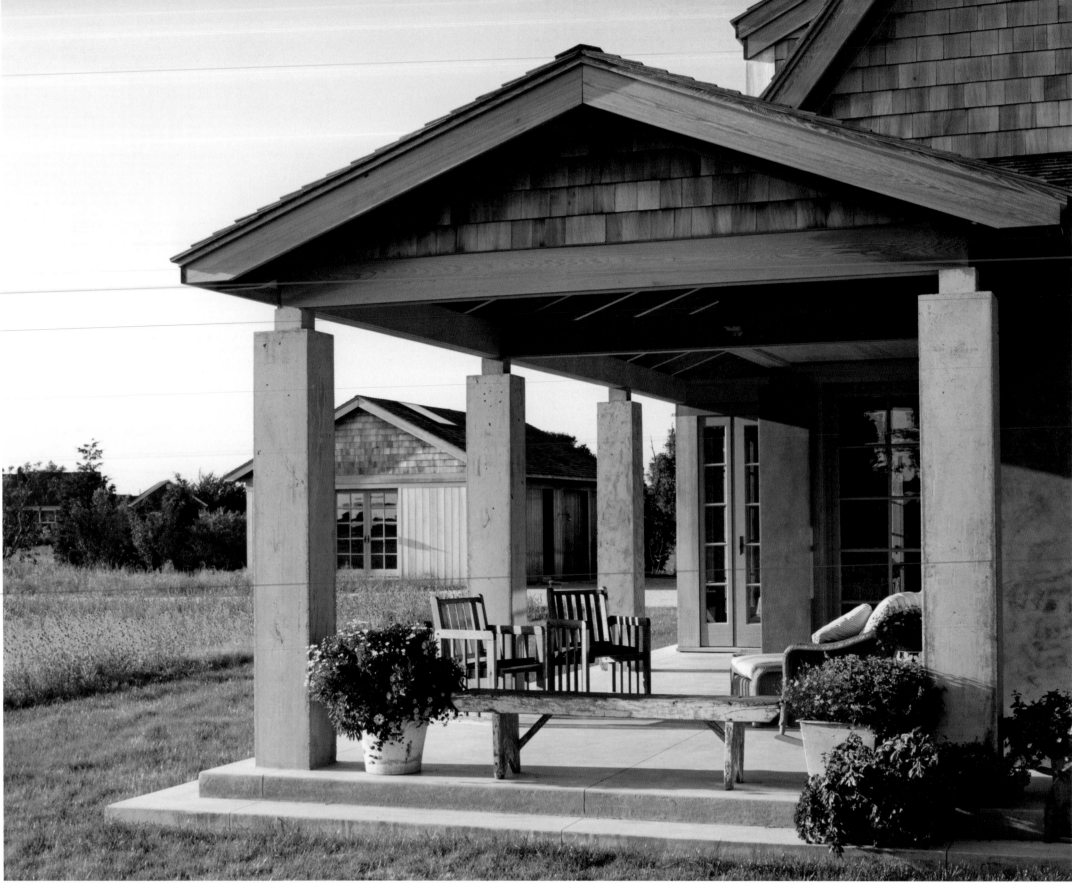

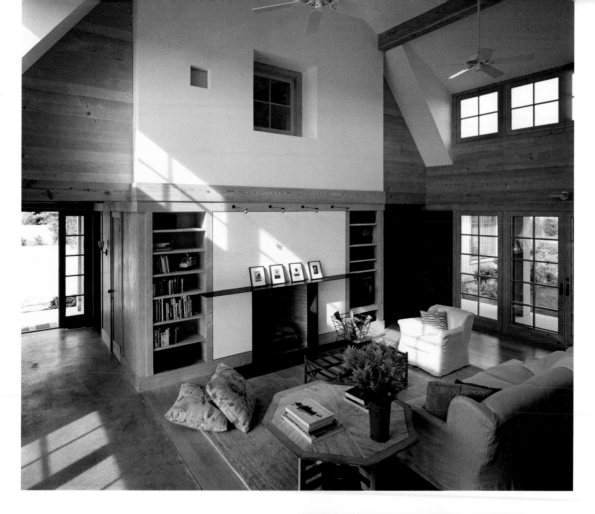

ABOVE: Interior woods are bleached twice, then waxed and buffed like furniture.
Photograph by Jeff Heatley

RIGHT: Architectural finishes and natural light decorate this house, creating a rich but restful experience.
Photograph by Jeff Heatley

FACING PAGE: The Sagaponack House is a meadow-immersion experience. Materials include natural concrete, weathered cedar and a stucco the color of river stones.
Photograph by Jeff Heatley

more about james...

Q&A

What is the highest compliment he's received professionally?
People often ask if his houses are renovations. Even during construction they have an authentic feel.

What book is he reading right now?
The House of Mirth, by Edith Wharton.

What is the most expensive/difficult technique he's used in one of his projects?
Authentic wood finishes often appear in the residences James designs. "They are expensive because they depend on love and elbow grease," he says.

Awards and recognition:
Several of his projects have received Archi design awards and commendations from the American Institute of Architects, Long Island Chapter. His work has been photographed for *Metropolitan Home, House & Garden, Country Living, Hamptons Country, Architektur & Wohnen, The New York Times, The Southampton Press*, and *The East Hampton Star*.

James Merrell Architects, PC

James Merrell, AIA
66 Main Street
PO Box 210
Sag Harbor, NY 11963
631.725.9842
Fax 631.725.5292
www.jamesmerrellarchitects.com

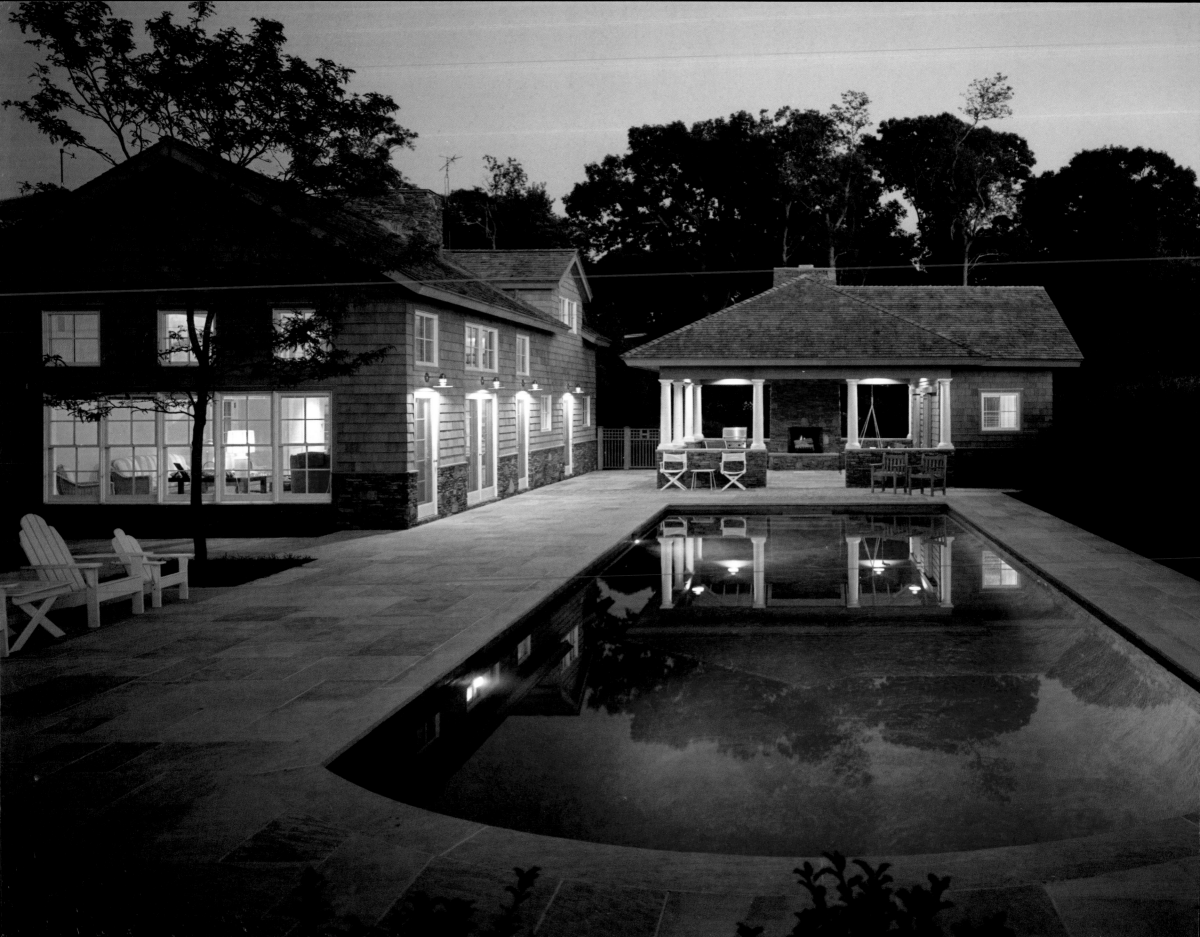

PAMELA POSPISIL & MICHAEL BROWN

Pospisil & Brown Architects, PC

Pamela Pospisil, founder of Pospisil & Brown Architects, PC, knows better than most the importance of well-designed space. Growing up on a 32-foot boat with her parents, two sisters, and the family dog, she lived in tight quarters without the modern conveniences of electricity or hot water, an experience that fostered intrigue and a lifelong interest in the built environment.

Since graduating from Cornell's School of Architecture in 1982, Pamela has worked in the Hamptons, designing renovations, additions, and new homes that address each client's specific needs whether practical, aesthetic or budgetary. Additionally, Pamela and Michael Brown, her partner, and a 1990 graduate of the Boston Architectural Center, concentrate on siting a structure, focusing on creative designs that are both sensitive to and take full advantage of the sun's orientation, topography, prevailing breezes, mature vegetation and, of course, the view.

ABOVE: Porcelain tile risers decorate this sunlit back stairway.
Photograph by Jeff Heatley

LEFT: Guest cottage and dining pavilion are two essential elements of this private entertainment facility.
Photograph by Jeff Heatley

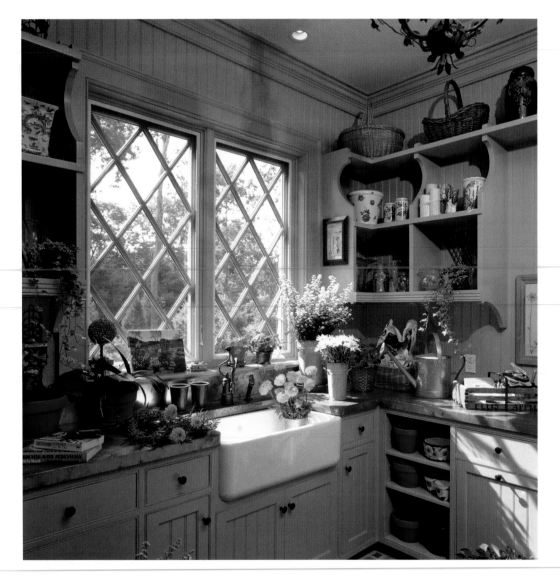

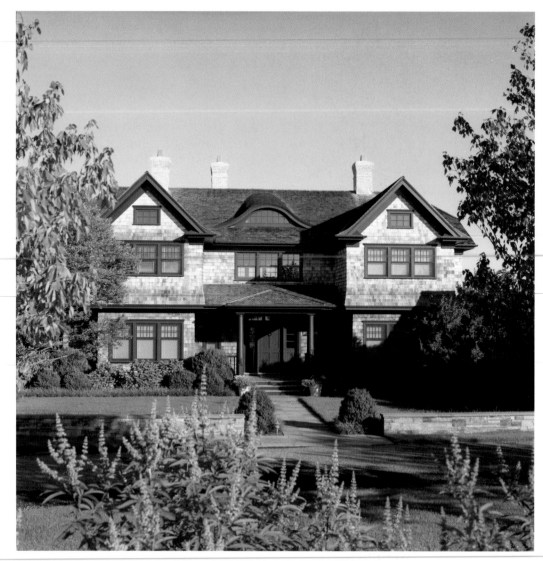

The key to the firm's great success can be directly linked to the architects' ability to listen intensely to the client, remain open-minded, and develop clear channels of communication. "If you're not listening, you're not fulfilling a fundamental ingredient to a successful relationship," Pamela says, adding that you first need to understand the desires of your client in order to interpret and translate them successfully into something three-dimensional.

As architects, Pamela and Michael perceive themselves as both teachers and tools in the design process. Never working with their own agenda, Pospisil & Brown's singular role is to give clients an end product they enjoy and of which they can be proud. "Residential design is very personal and, therefore, subjective," Pamela says. "When a client is proposing to renovate their home or construct a new residence, they are passionate about it and feel it from the heart." So do Pospisil & Brown.

ABOVE LEFT: Copper countertops, wainscoting, antique terra cotta tile, and detailed woodworking adorn this flower room.
Photograph by Jeff Heatley

ABOVE RIGHT: A desire for order and symmetry established a central entrance stair hall with a welcoming view through the house to the bay beyond.
Photograph by Jeff Heatley

FACING PAGE TOP: Beach cabana atop the dune crest enjoys commanding views of the Atlantic Ocean and Shinnecock Bay while mimicking details of its new residence beyond.
Photograph by Jeff Heatley

FACING PAGE BOTTOM: Entrance gates frame the view upon arrival to this Shingle-style residence with its arched drive-through to the garage courtyard.
Photograph by Jeff Heatley

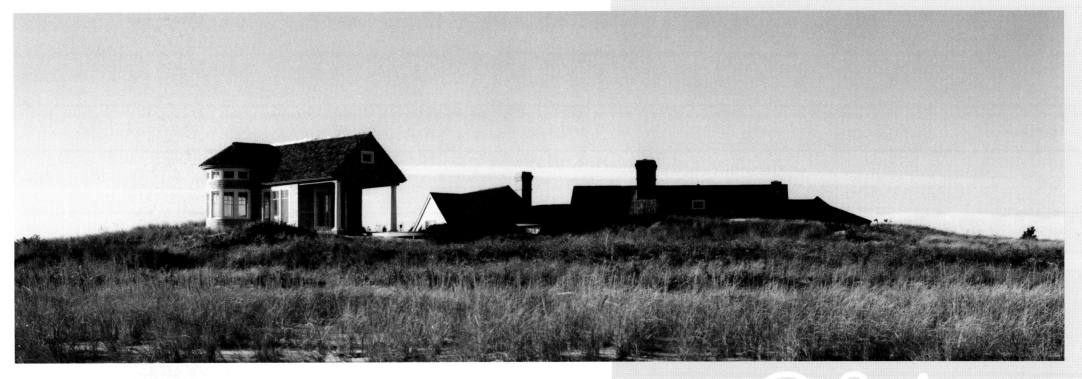

more about pamela & michael...
Q&A

What is the best thing about being an architect?

Well-rounded academically, both Pamela and Michael are skilled in math and the sciences, as well as the arts. Architecture allows them to combine both right- and left-brain propensities. They also enjoy working with people, getting to know them not just as clients, but as friends.

Publications:

Profiles of Pamela and the firm's projects have been featured in several local newspapers and national magazines, including *Houses in the Hamptons, Better Homes & Gardens*, and *Classic American Homes*.

Pospisil & Brown Architects, PC

Pamela Pospisil, AIA

Michael Brown, AIA

141 Hampton Road

Southampton, NY 11968

631.283.3465

www.pospisilbrown.com

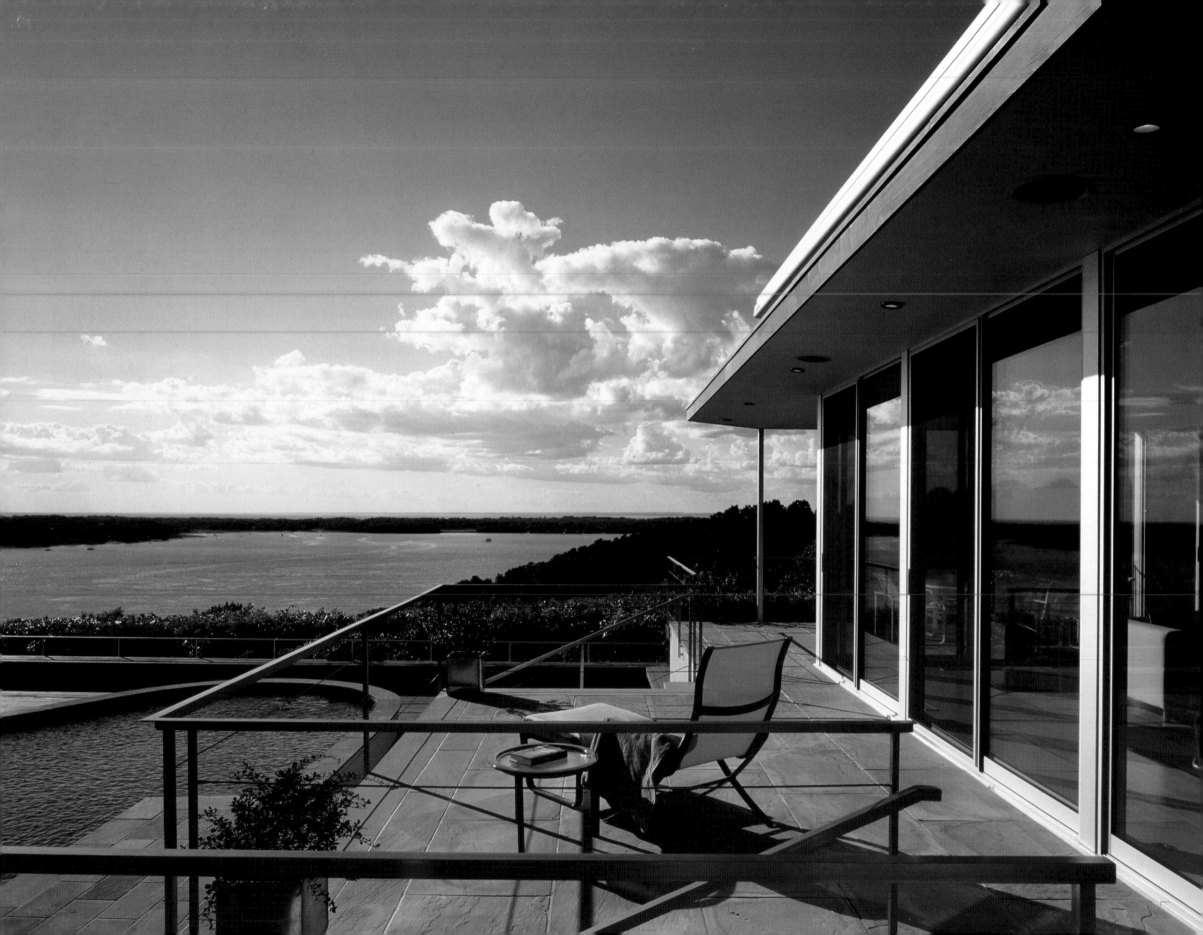

FREDERICK STELLE

Stelle Architects

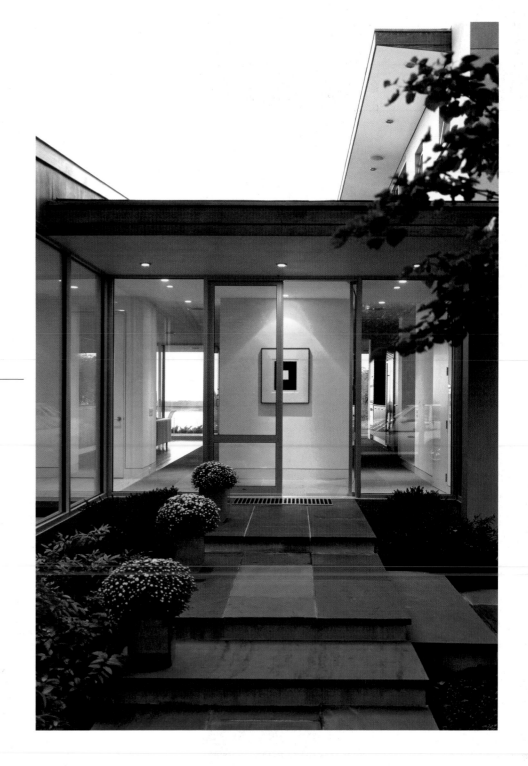

If Fred Stelle had his druthers, he'd be sailing right now. Out on his boat, traversing the ocean, island hopping, enjoying the sun and the salty air is where the architect is happiest. He first took to the water right after graduating from Syracuse University, and his favorite sport, he says, is an allegory for his career if not his life.

"Sailing is never the fastest way to get some place, and neither is great architecture. You can't know the outcome in advance; there's always a certain element of risk," he says. "But if you choose your course and stick to it, decide what needs to be done and then do it, over time you'll make great gains." Which is exactly what's happened in Fred's 30 years as an architect.

He began practicing in 1976, working in New York City with the famed Edward Larrabee Barnes, but IBM soon lured him away to oversee a $40 million job. This, he says, set him on a path of design-build projects. In 1984, with the desire to escape "the traditional leanings of Post Modernism" and the urge to be outside and physically involved in building things, Fred moved to eastern Long Island and opened Stelle Architects. Located in Bridgehampton since 1991, he's given up the construction side of his business but not

ABOVE: The sleek entrance gives a hint of the visual feast that lies within.
Photograph by Michael Grimm

LEFT: Life at the edge of the land, sky and water has an exciting simplicity on which the architecture does not intrude.
Photograph by Jeff Heatley

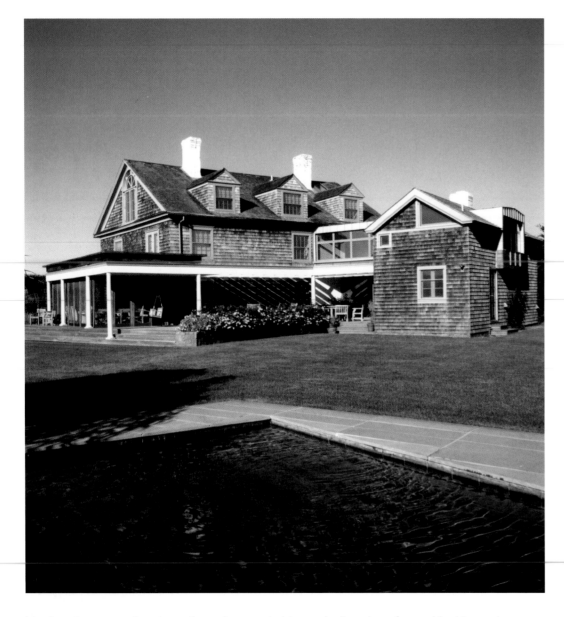

his devotion to small-scale projects that are, in his words, "modern, forward-looking, adventurous, and fun."

Today, Fred focuses strictly on good design. But 25 years of construction experience under his belt means that he is an informed architect, who provides detailed drawings and a seamless process for clients. "We can accurately predict from the beginning the costs and length of a project," he says. "We collaborate with builders from the very beginning of the project so there are few surprises."

Though his portfolio includes such highly regarded institutions as the DIA Foundation, The Ross School, Robert Wilson's Watermill Center, the Long Island Nature Conservancy, and the Expressive Arts Therapy Center and Apartment Complex in Zurich, Switzerland, much of his work is

residential — and virtually all of that is less than 3,000 square feet. "I am a believer that buildings don't enhance their sites," Fred says, adding that the object of each of his undertakings is not only to realize the client's program in clear, essential forms, but also to tread lightly on the land and minimize both the environmental and visual impact of his buildings. "The trick is knowing when to stop."

Though Fred relishes the fact that architecture is literally a constructive venture, he says that the joy of his job comes from the process of design as much as the end product. "It's never linear. Creativity is a patient search and it requires time, focus and the right conditions to make it happen. The unexpected is the great fun of it."

ABOVE: A seemingly contradictory glass bathroom uses translucent glass to achieve privacy.
Floating cabinets and fixtures preserve the transparency.
Photograph by Mancia / Bodmer

FACING PAGE LEFT: Three additions to this house are distinct in materials and details.
Photograph by Jeff Heatley

FACING PAGE RIGHT: Rain screen technology and durable low-maintenance materials define
the design of this beach house.
Photograph by Jeff Heatley

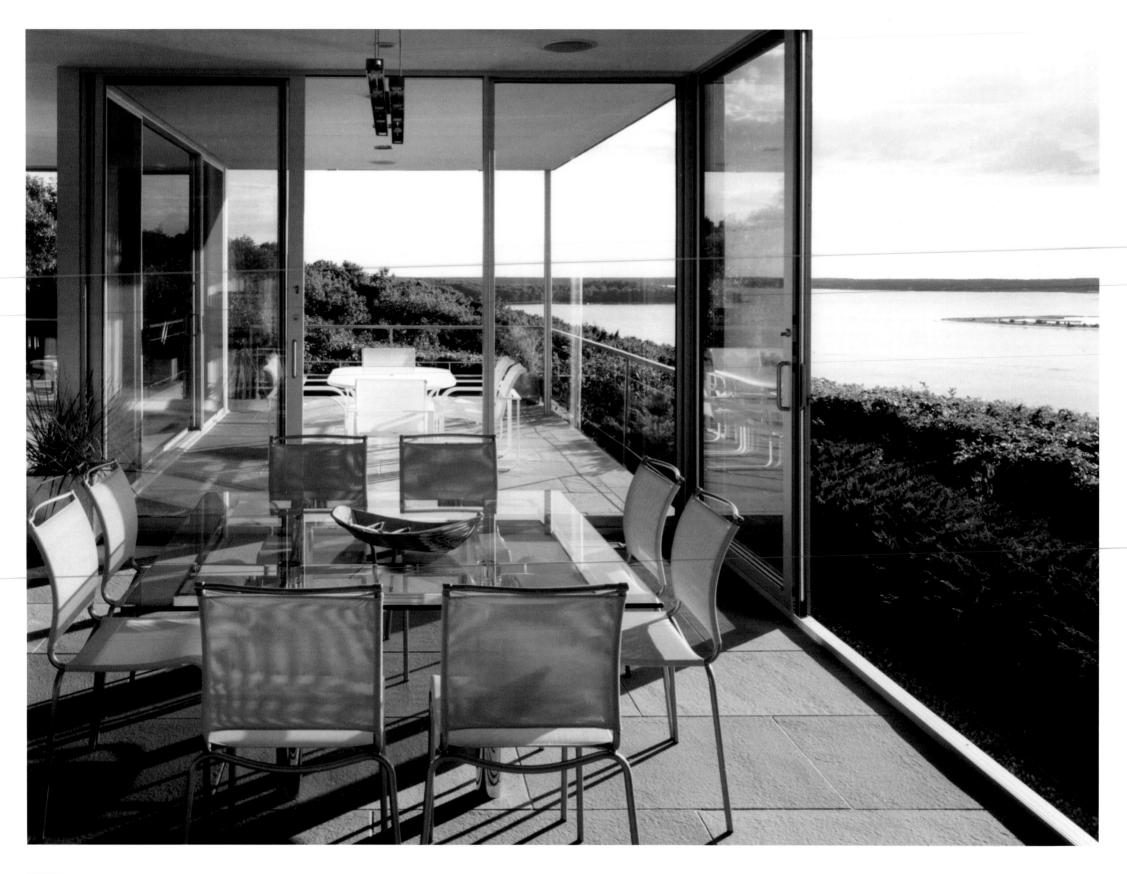

more about fred...

What do most people not know about him?

Fred is highly visible in his community — as a village trustee, head of a library committee, commodore at his sailing club — but the architect considers himself to be shy. "A little bit antisocial; I am not fond of big groups," he says. "I find solitude or one-on-one interaction more satisfying."

What does he like most about where he lives?

Fred makes his home, along with his wife, son, and two daughters, on the east end of Long Island, where farmlands, woodlands, and ocean and bay beaches remain untouched by suburbia. As a sailor, pilot and outdoorsman, he loves to commune with the natural world around him.

Awards and recognition:

In October 2005, Fred received the Architectural Achievement Award from the American Institute of Architects, an honor presented to an architect who has produced distinguished architecture consistently for at least 10 years. His work has been featured in such publications as *Architectural Record, Architectural Digest, The New York Times, Architecture Boston, Residential Architect, Custom Home, Grand Designs, The Guardian, Hamptons Cottages & Gardens, HamptonStyle, The Southampton Press, The East Hampton Star* and others.

ABOVE: This sleek kitchen conceals many appliances and functions under counters or behind cabinet doors. Note the custom pulls.
Photograph by Jeff Heatley

RIGHT: Fred Stelle.
Photograph by Jeff Heatley

FACING PAGE: Consistent use of materials inside and out creates delightful ambiguity in the location of spaces.
Photograph by Jeff Heatley

Stelle Architects

Frederick Stelle, AIA, NCARB
48 Foster Avenue
Bridgehampton, NY 11932
631.537.0019
www.stelleco.com

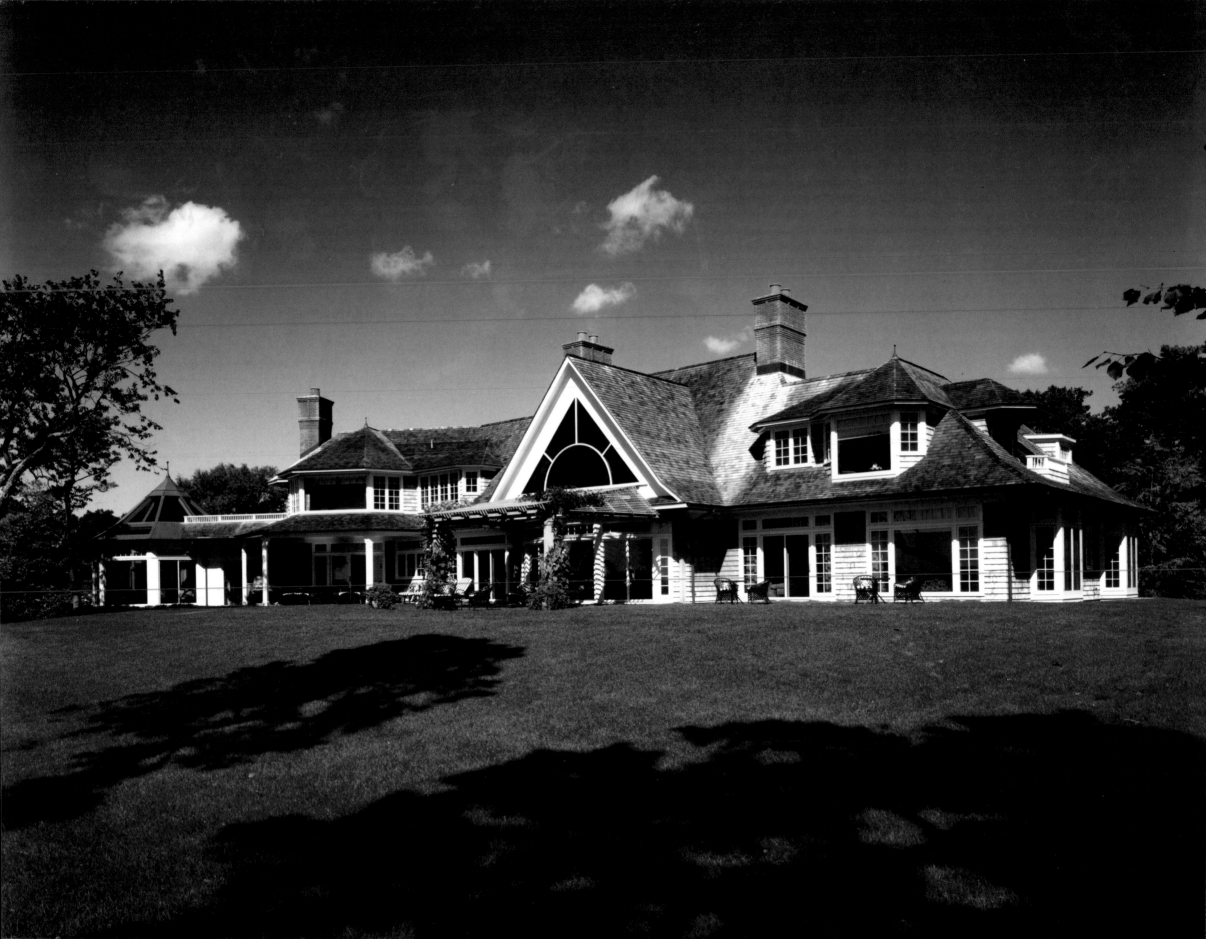

GREGORY ZWIRKO & ROBERT ORTMANN

Zwirko & Ortmann Architects, P.C.

Forward-thinking with a respect for the past. That statement concisely sums up the philosophy and work of Zwirko & Ortmann Architects. The firm's architecture is characterized by both historical consciousness and an awareness of today's energy concerns. Balancing the seemingly contradictory interests is a challenge, says Greg Zwirko. "You can't just put a wind generator on top of an East End Shingle-style house."

Greg moved to Long Island in 1969, after graduating from Kent State University, to apprentice with his uncle, Alfred A. Scheffer, who'd been an architect in East Hampton since 1948. He worked side by side with his uncle until his death in 1976, developing a deep sense of history and an appreciation for the type of extraordinary interior detailing for which Scheffer was known. Greg brought in Bob Ortmann as an associate in 1980 and partnered with him in 1988, in what is now one of the leading architecture firms in the area.

ABOVE: Detail of main entry, showing leaded glass transoms inspired by the motif of the restored lanterns. *Photograph by Jeff Heatley*

LEFT: Post-Modern waterside view, with large expanses of glass capturing pond and ocean views beyond. *Photograph by Jeff Heatley*

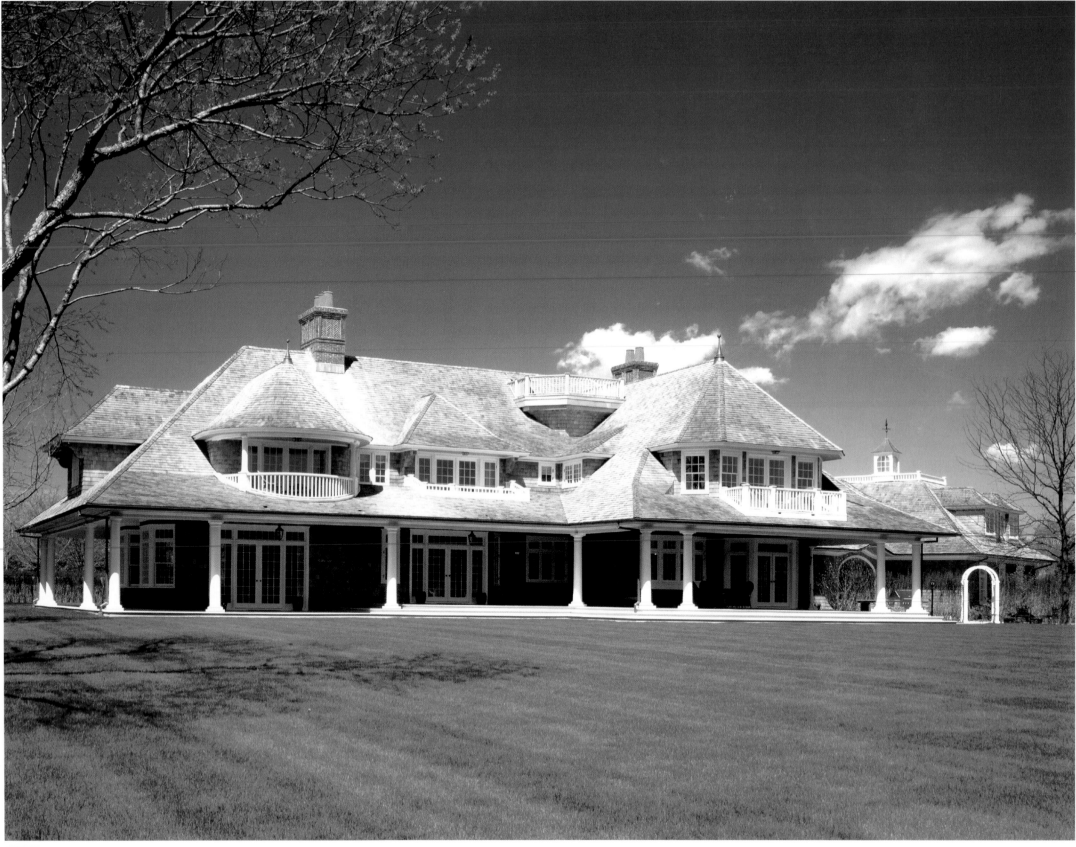

ABOVE: View from main approach.
Photograph by Mario Novak

RIGHT: Cupola and dormer detail.
Photograph by Mario Novak

FAR RIGHT: Interior view of semi-circular main stair tower with custom wood paneling.
Photograph by Mario Novak

FACING PAGE: View from rear lawn. Showing extensive covered porch at kitchen, dining and living rooms. The second floor features walk-out balconies and there is a Captain's walk with ocean views.
Photograph by Mario Novak

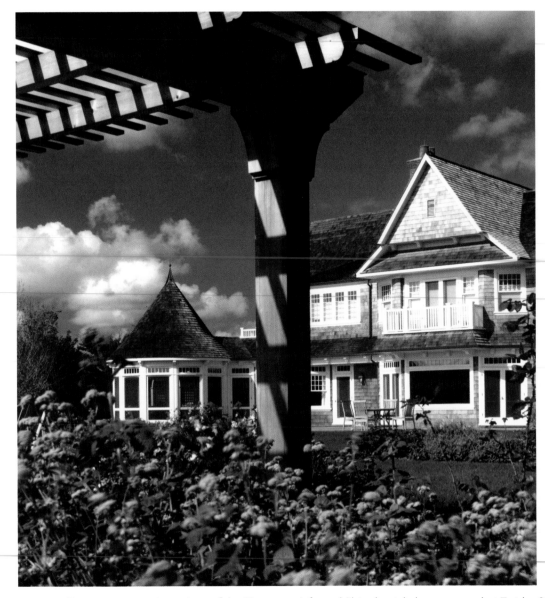

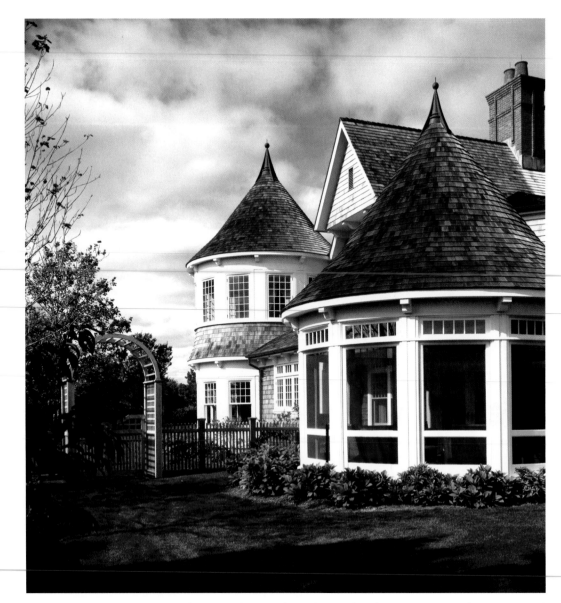

Contemporary adaptations of the Hamptons's famed Shingle-style homes are what Zwirko & Ortmann's clients seek. Whether Post-Modern or more traditional, a restoration or new construction, the designs of the firm are sensitive to the area's history, the client's wants and needs, and the environment. The common thread that runs through each project from the largest to very modest is the attention to detail both inside and out — a reflection of Greg and Bob's respect for architecture's ability to stimulate the senses and affect how we experience the world.

As a team, Greg and Bob, along with three associates, are involved in every project the full-service firm takes on. Their skills are complementary — Greg's three-dimensional hand drawings are like little storybooks; Bob is a technology whiz — and they believe that an amalgam of ideas results in a stronger design.

Although the majority of their work is residential, they do take on commercial projects. And one of their more unusual and fascinating jobs, and certainly an aggregate effort, is the Montauk Point Lighthouse Reception Center, which is a modern earth structure built in 2005. Greg woke up in the middle of the night with the idea for the flat-roof, low-profile building after reading about a war bunker once nestled in the same hill. Understated and unobtrusive, Greg was told by a Montauk Point Historical Society member that it's been a great success.

That's, of course, what Greg and Bob want to hear all of their clients say when they look at and live in the houses designed by Zwirko & Ortmann Architects.

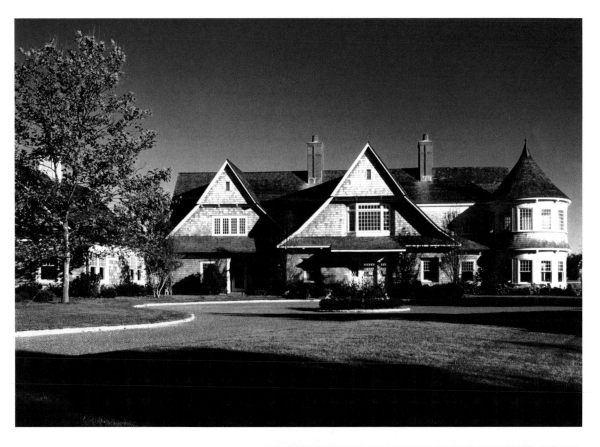

What personal indulgence do they spend the most money on?
Both architects are sportsmen who like to be outside as much as possible. Bob is an avid golfer and skier. Greg likes to golf as well as go fishing and scuba diving.

What color best describes them and why?
Greg has a keen interest in eco-friendly designs that use the earth, wind generators, and solar systems. He relates most to shades of green. Bob leans toward blue, the color of the sky.

What single thing would they do to give life to a dull house?
Bob believes that situating windows to capture a view or take advantage of the most delightful angle of the sun makes all the difference between dreary and dreamy. Remaining true to a green theme, Greg says the fastest way to lend intrigue would be with the introduction of an arbor and lattice, in combination with integrated photovoltaic cells.

What book has had the greatest impact on the Greg and Bob?
Both men name *The Fountainhead*, Ayn Rand's fictional account of the struggles of an architect and the battle between individualism and collectivism, as having had a tremendous influence on them personally and professionally. Greg first read the book while in architecture school.

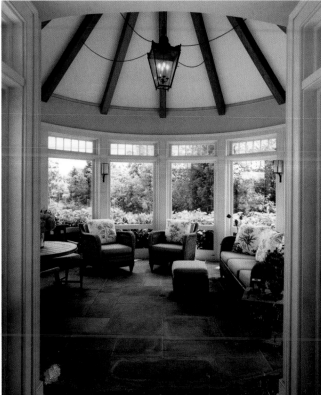

ABOVE: English inspired Shingle-style cottage with romantic roofline.
Photograph by Jeff Heatley

RIGHT: Interior of sunroom screen porch, with removable glass panels in place. With radiant heat bluestone flooring.
Photograph by Jeff Heatley

FACING PAGE LEFT: Waterside view from pergola at pool house.
Photograph by Jeff Heatley

FACING PAGE RIGHT: Whimsical cone-shaped roofs at turret and sunroom screened porch.
Photograph by Jeff Heatley

Zwirko & Ortmann Architects, P.C.

Gregory Zwirko, AIA
Robert Ortmann, AIA
219 Pantigo Road
East Hampton, NY 11937
631.324.1088
www.zoarchitects.com

PUBLISHING TEAM

Brian G. Carabet, Publisher
John A. Shand, Publisher
Phil Reavis, Executive Publisher
Paul Geiger, Senior Associate Publisher

Mary Elizabeth Acree, Graphic Designer
Michele Cunningham-Scott, Graphic Designer
Emily Kattan, Graphic Designer
Elizabeth Gionta, Managing Editor
Aaron Barker, Editor
Rosalie Wilson, Editor
Allison Hatfield, Editor
Kristy Randall, Production Coordinator
Laura Greenwood, Production Coordinator
Jennifer Lenhart, Traffic Coordinator
Carol Kendall, Project Management
Beverly Smith, Project Management
Carol Bates, Contributing Photographer

PANACHE PARTNERS, LLC
Corporate Office
13747 Montfort Drive
Suite 100
Dallas, Texas 75240
972.661.9884
Fax 972.661.2743

www.panache.com

Jay Haverson, *Haverson Architecture and Design,* page 97

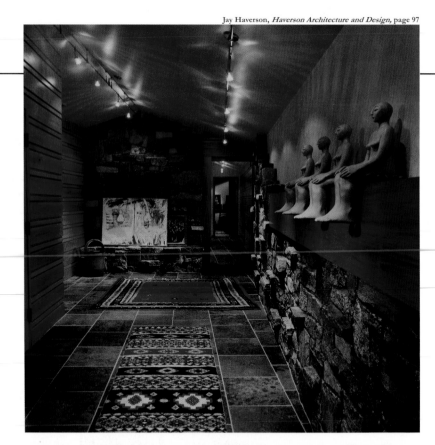

Stuart Narofsky, *Narofsky Architecture and Design, PC,* page 47

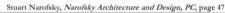

INDEX OF DESIGNERS

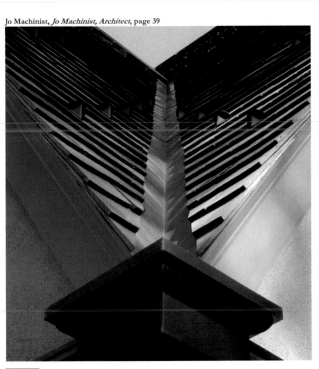

Jo Machinist, *Jo Machinist, Architect,* page 39

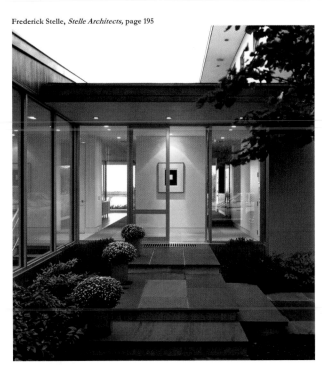

Frederick Stelle, *Stelle Architects,* page 195

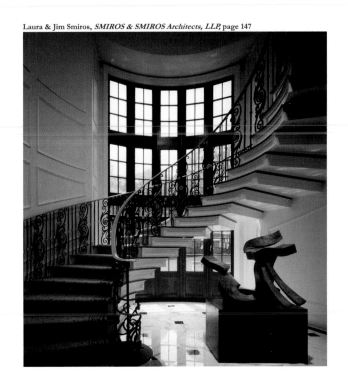

Laura & Jim Smiros, *SMIROS & SMIROS Architects, LLP,* page 147

The PANACHE Portfolio

The catalog of fine books in the areas of interior design and architecture and design continues to grow for Panache Partners, LLC. With more than 30 books published or in production, look for one or more of these keepsake books in a market near you.

Spectacular Homes Series

Published in 2005
Spectacular Homes of Georgia
Spectacular Homes of South Florida
Spectacular Homes of Tennessee
Spectacular Homes of Texas

Published or Publishing in 2006
Spectacular Homes of California
Spectacular Homes of the Carolinas
Spectacular Homes of Chicago
Spectacular Homes of Colorado
Spectacular Homes of Florida
Spectacular Homes of Michigan
Spectacular Homes of the Pacific Northwest
Spectacular Homes of Greater Philadelphia
Spectacular Homes of the Southwest
Spectacular Homes of Washington DC

Other titles available from Panache Partners

Spectacular Hotels
Texans and Their Pets
Spectacular Restaurants of Texas

Dream Homes Series

Published in 2005
Dream Homes of Texas

Published or Publishing in 2006
Dream Homes of Colorado
Dream Homes of South Florida
Dream Homes of New Jersey
Dream Homes of New York
Dream Homes of Greater Philadelphia
Dream Homes of the Western Deserts

Order two or more copies today and we'll pay the shipping.

To order visit www.panache.com or call 972.661.9884.

PANACHE
PARTNERS LLC

Creating Spectacular Publications for Discerning Readers